ROMAN PAINTING

ROMAN
PAINTING

ROGER LING

The right of the
University of Cambridge
to print and sell
all manner of books
was granted by
Henry VIII in 1534.
The University has printed
and published continuously
since 1584.

CAMBRIDGE UNIVERSITY PRESS

CAMBRIDGE

NEW YORK PORT CHESTER

MELBOURNE SYDNEY

Published by the Press Syndicate of the University of Cambridge
The Pitt Building, Trumpington Street, Cambridge CB2 1RP
40 West 20th Street, New York, NY 10011, USA
10 Stamford Road, Oakleigh, Melbourne 3166, Australia

© Cambridge University Press 1991

First published 1991

Printed in Great Britain by
BAS Printers Limited, Over Wallop, Hampshire

British Library cataloguing in publication data
Ling, Roger
Roman painting.
1. Europe. Ancient wall-paintings
I. Title
751.7′3′0937

Library of Congress cataloguing in publication data
Ling, Roger.
Roman painting / Roger Ling.
p. cm.
Includes bibliographical references.
ISBN 0 521 30614 0 – ISBN 0 521 31595 6 (pbk)
1. Painting, Roman – Themes, motives. I. Title.
ND120.L56 1990
759.937–dc20 89-36871 CIP

ISBN 0 521 30614 0 hardback
ISBN 0 521 31595 6 paperback

BA

TO MY PARENTS
who have provided a generous gift
towards the cost of producing the colour plates

CONTENTS

Contents

Colour plates I *to* VIII *between pp.* 80 *and* 81

Colour plates IX *to* XVI *between pp.* 176 *and* 177

PREFACE

This book has been a long time in gestation. It was originally planned in 1972, but owing to the pressure of other commitments did not get beyond the drawing-board stage till 1986–7, when I was granted a year's leave of absence by the University of Manchester. That I was ever able to bring the project to completion was due in no small measure to my colleagues, notably Professor C. R. Dodwell and Dr T. C. B. Rasmussen, for enabling me to take this leave, and to the Research Awards Advisory Committee of the Leverhulme Trust for granting me a Senior Research Fellowship for the year. I held the Fellowship in the University of Cambridge, where I owe a further debt of gratitude to the staff of the Classics Faculty Library, to Dr and Mrs A. J. Graham and to Dr E. B. French for hospitality and help in various forms.

Several friends have read parts of the book and given advice on matters of both substance and presentation; I am especially indebted to Dr Mary Beard, Mr L. Biek, Dr W. Ehrhardt, Professor Anne Laidlaw and Professor A. F. Wallace-Hadrill. None of these should, of course, be held responsible for the errors and infelicities that remain. My long-suffering wife, Lesley, has read the whole text and been a constant source of support and constructive criticism, as well as tolerating my prolonged absences with her usual stoicism. I must also thank several generations of students who have provided a testing-ground for my ideas: notably in earlier years Piers Rawson, Colin Wiggins, Inge Wintzer, Tina Baddeley, Carole Long, Hilary Barr and Jane Wilkinson, and more recently Philip Peirce. Final thanks must go to those friends with whom I have shared general discussions on Pompeian painting, such as Dr Alix Barbet and Professor Dr V. M. Strocka, and to all those, too numerous to mention, who have helped me in the task of obtaining illustrations (in addition to those already named I would like to single out Miss Amanda Claridge, Dr P. G. P. Meyboom, Dr Eric Moormann and Professor W. J. T. Peters).

My interest in Roman paintings was first fired by a visit to Naples Museum in 1961 and subsequently fostered by the books of Curtius and Schefold, with their contagious enthusiasm for the subject and their fine sensitivity to stylistic nuances. Since then I have had excellent opportunities to improve my acquaintance with the material at Pompeii, thanks to my involvement with the British survey in the House of the Menander, launched by Dr J. B. Ward-Perkins and encouraged by successive Archaeological Superintendents and Directors: Professor Fausto Zevi, Dr Maria Giuseppina Cerulli Irelli, Dr Baldassare Conticello, Dr Stefano De Caro and Dr Antonio Varone. All this has provided an excellent springboard for teaching Roman painting, but the absence of any adequate text-book in English has long been a source of frustration; student courses have had to be sustained by a diet of odd articles and picture-books eked out with potted translations in typescript. It is to fill the gap that the present volume has been composed. It lays no great claims to originality, but sets out to provide an overview of the subject in the light of the most recent discoveries, and at the same time to introduce it to a public which is largely uninitiated. If it succeeds in rousing even a few readers to share its author's fascination with ancient painting, the long period of gestation will not have been in vain.

Manchester, November 1988

ix

GLOSSARY

acroterium (*-a*) crowning sculpture or ornament at the apex and angles of a pediment

aedicula (*-ae*) ornamental pavilion-like structure, especially as a frame for a picture or figure

ala (*-ae*) open recess at the side of the *atrium*

arabesques decorative forms composed of flowing plant-tendrils

architrave horizontal beam resting on column-capitals, the lower part of the entablature

atrium (*-a*) hall with a central roof-opening and a catch-water basin (*impluvium*) beneath; the traditional focus of the Italian house

bacchante see maenad

caldarium (*-a*) hot room in baths

candelabrum lamp-stand, or similar ornament in painting

caryatid sculptured female figure used as an architectural support

centaur mythical creature, part man and part horse

cithara (*-ae*) concert lyre

clipeata (*-ae*) *imago* (*-ines*) a portrait-bust painted or modelled upon a shield

coffers recessed panels in ceiling-decoration

cornucopiae horn of plenty, emblem of fruitfulness and abundance

cryptoportico underground, or partially underground, corridor

dado the lower part of a wall, and especially the clearly differentiated base zone in a tripartite scheme of wall-painting

dentils tooth-like blocks on the underside of an Ionic cornice

Durchblick (*-icke*) 'view through', a term used by German art historians to describe each of the apparent openings, often decorated with perspectival architecture, between the main fields (*Vorhänge*) in Fourth Style wall-decorations

emblema (*-ata*) inserted panel, especially one in fine mosaic at the centre of a pavement

entablature the horizontal superstructure carried by a colonnade, normally consisting of architrave, frieze and cornice

exedra (*-ae*) an open-fronted room or recess, often situated in a peristyle

fauces entrance-passage of a house

frigidarium (*-a*) cold room in baths

gorgoneion (*-a*) mask of Gorgon, a mythical creature whose gaze turned viewers to stone; used as a decorative motif in Roman art

griffin mythical winged creature with the body of a lion and either the head of an eagle (when associated with Apollo) or that of a lion (when associated with Dionysus)

grotesques decorative forms, half-animal and half-vegetal

guilloche plait-pattern; ornament consisting of two or more interweaving strands

herm pillar of stone surmounted by a sculptured head or torso

ingenuus (*-i*) man of free birth

lotus Egyptian water-lily; an ornament based on its flower

lozenge diamond shape; rhombus

lunette semi-circular or segmental shape at the end of a vaulted ceiling

maenad female devotee of the god Bacchus (Dionysus)

meander ornament like a labyrinth, created by lines turning in and out and crossing one another

modillion bracket supporting the projecting part of a cornice

nimbus (*-i*) disc of light surrounding the head of a deity or the like

nymph female spirit inhabiting water, sea, woods, etc.

nymphaeum (*-a*) decorative fountain; room or court containing such a fountain

oecus (*-i*) saloon; large living-room used frequently for entertainments and dining

opus sectile decorative technique of cut stone used for paving or wall-veneer

orans (*-antes*) figure with arms raised in prayer

orthostate one of a series of vertical slabs in the lower part of a masonry wall; painted imitation of such a slab

palaestra (*-ae*) exercise ground in gymnasium or baths

palmette ornament shaped like a palm-leaf

paratactic arranged in repeating series (of wall-decorations which lack a centralised scheme)

pediment gabled space at each end of a ridged roof

pedum (*-a*) throwing-stick like a shepherd's crook, carried especially by satyrs

pelta (*-ae*) light shield, especially (in artistic use) of a distinctive crescent shape with one or two semi-circular recesses cut in the upper edge

peristyle courtyard or garden enclosed by colonnades; the colonnades round such a court

pinax (*-akes*) panel-painting, often equipped with wooden shutters

podium raised platform, especially one supporting columns in front of a wall

pozzolana volcanic ash found near Pozzuoli (Puteoli)

predella narrow frieze between the dado and main zone of a wall-decoration, containing figures or ornaments

procoeton (*-ones*) antechamber, front part of a room, especially a bedroom

satyr woodland spirit, in form part human and part bestial, belonging to the circle of the god Bacchus (Dionysus)

scaenae frons façade of the stage building in a Roman theatre, often elaborately decorated with screens of columns and niches containing statues; backdrop of a theatrical stage

scenographic based on, or resembling, the backdrop of a theatrical stage

sistrum (*-a*) ceremonial rattle used in the cult of the Egyptian goddess Isis

socle base zone of a wall-decoration: cf. dado

spandrel triangular space between an arch or other curving shape and a rectangular frame enclosing it

sphinx mythical creature with (winged) lion's body and woman's head

stucco fine lime-plaster, especially as a medium for decorative work in relief

syrinx (*-inges*) musical pipes ('pipes of Pan')

tablinum (*-a*) large room at the rear of the *atrium*, originally the chief bedroom, later the room where records were kept

Tapetenmuster 'wallpaper pattern', a term used by German art historians to describe painted designs based on a network of geometric shapes (squares, circles, polygons, etc.), often embellished with floral or vegetal ornaments

telamon sculptured male figure used as an architectural support

tepidarium (*-a*) warm room in baths

tessera (*-ae*) one of the small cubes of stone or glass which go to make up a mosaic

tholus (*-i*) small circular building, frequently with columns

thyrsus (*-i*) wand carried by devotees of the god Bacchus (Dionysus) consisting of a fennel-stalk surmounted by a pine-cone

tondo (*-i*) circular panel

triclinium (*-a*) dining-room, so called from the three banqueting couches against the side and rear walls; later the principal reception room of a house

trompe l'œil form of painting which produces an illusion of reality so as to 'deceive the eye'

vignette unframed scene or decorative design isolated in a blank field

villa country house; farm

volute decorative form, spiral in shape

Vorhang (*-hänge*) 'hanging' or 'curtain', a term used by German art historians to describe the main fields in a Fourth Style wall-decoration when they appear like hangings attached to a continuous scaffolding of perspective architecture: cf. *Durchblick*

Note. For other names or terms of classical mythology and history the reader should consult reference-works such as the *Oxford Classical Dictionary* (2nd edn, Oxford 1970). In the present book spellings are given in the Latin form rather than the Greek; and for the names of deities I have normally preferred to use the Roman equivalent (e.g. Venus for Aphrodite), except where the context seems to dictate otherwise.

MAPS

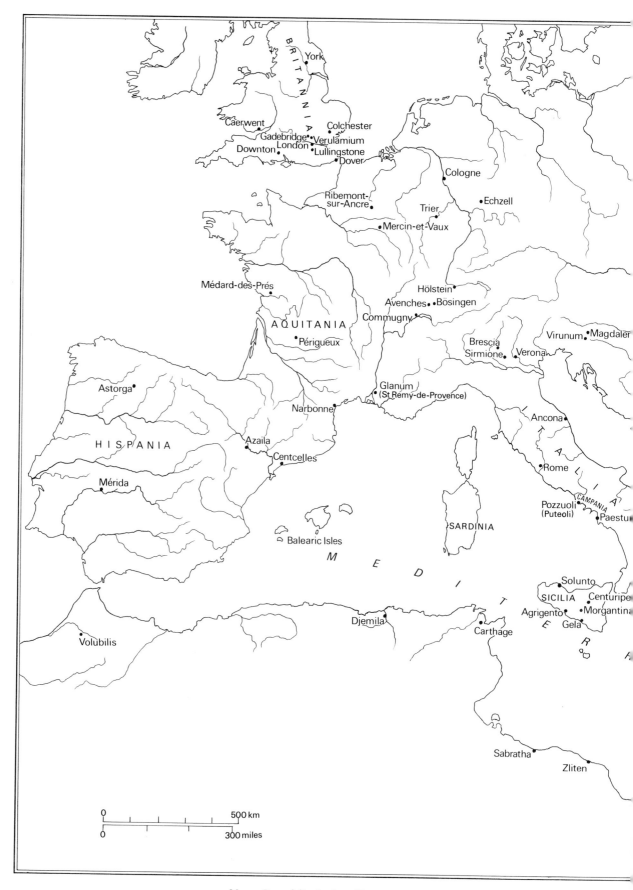

Map 1 General distribution of Roman painting.

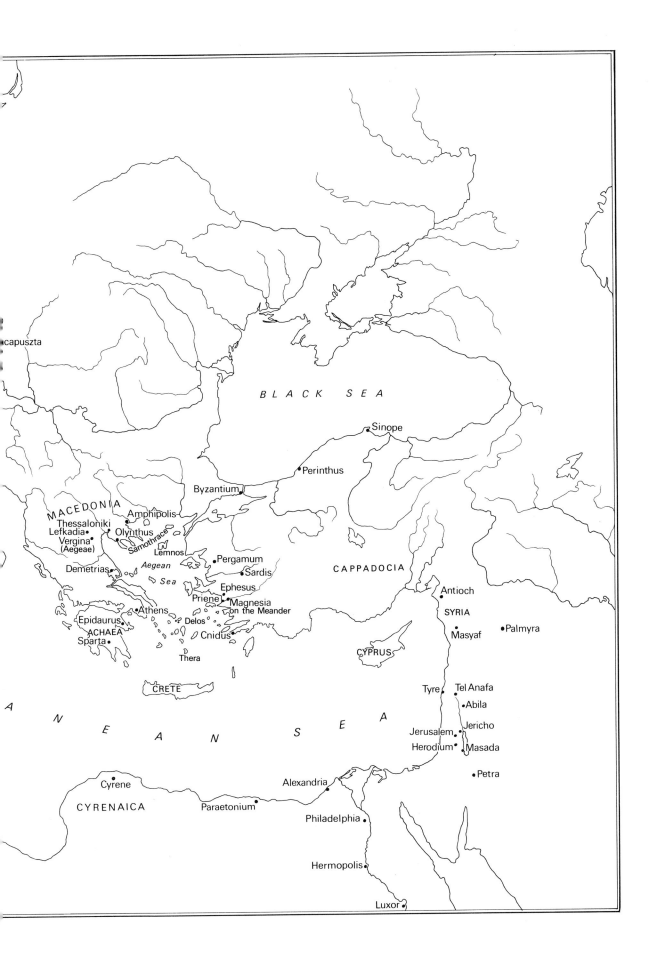

capuszta

BLACK SEA

Sinope

Perinthus

Byzantium

MACEDONIA
Thessaloniki Amphipolis
Lefkadia
Vergina Olynthus
(Aegeae) Samothrace
 Lemnos
Demetrias Pergamum
 Aegean Sardis CAPPADOCIA
 Sea
 Ephesus Antioch
 Priene
 Magnesia SYRIA
Athens on the Meander
Epidaurus Masyaf Palmyra
 ACHAEA Delos
Sparta Cnidus CYPRUS
 Thera

 CRETE Tyre Tel Anafa
 Abila
A Jericho
 N E A N S E A Jerusalem
 Herodium Masada

 Petra
 Cyrene Alexandria
CYRENAICA Paraetonium
 Philadelphia

 Hermopolis

 Luxor

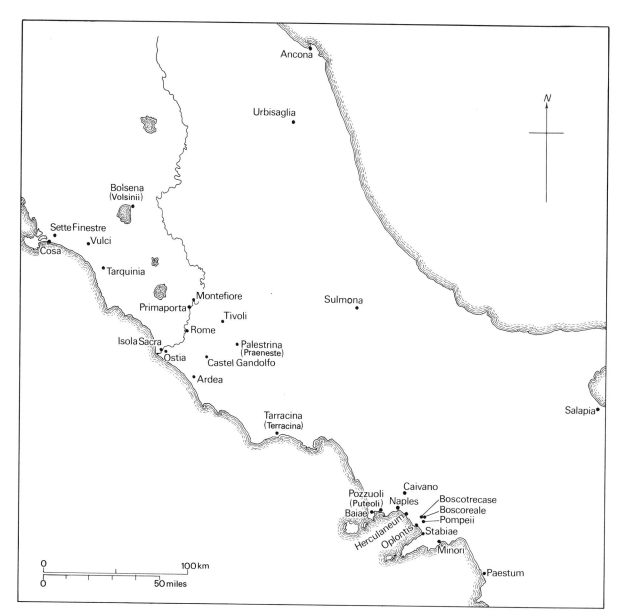

Map 2 Roman painting in central Italy.

Introduction

The history of Roman painting is essentially a history of wall-painting carried out on plaster. This is partly a condition of what has survived, but also partly a reflection of the true state of the pictorial art in the Roman period.

Portable pictures, executed on wooden panels or the like, had been a major art form in Classical and Hellenistic Greece, especially from the late fifth century onwards; and when the Romans conquered the Greek world during the last couple of centuries B.C. they competed avidly to acquire samples of famous masterpieces, old or recent, for their picture-galleries or for public display; Julius Caesar, for example, paid a small fortune for two paintings by Timomachus of Byzantium to exhibit in his temple of Venus Genetrix in Rome. But during the first centuries B.C. and A.D. panel-painting seems to have declined in importance. From now on the contemporary painters of note – men such as Studius, Famulus (or Fabullus), Cornelius Pinus and Attius Priscus – were all mural painters; and the switch in direction is registered by Pliny the Elder who, writing in A.D. 79, bemoans the contemporary fashion for painting walls and praises the wisdom of earlier times in prizing panels, which made an artist 'the common property of the world'. The vigour of wall-painting at this time is chronicled by the surviving material. With the evolution of the decorative schemes known as the four Pompeian Styles, which open the wall in illusionistic recession or embroider it with sumptuous flights of fancy and polychrome ornamentation [Pls. I–VIII], painters working in the service of Roman patrons broke new ground in the history of ancient art. Panel-pictures were now replaced by a new phenomenon: permanent pictures as centre-pieces in mural decorations, executed in fresco on the plaster. These pictures were in many cases replicas or pastiches of 'old masters', but they were at the same time essential parts of the decorative schemes in which they were set, to which they were more or less well adapted in composition, style and colouring.

Paintings on wood and other materials still, of course, continued to be produced; we have some surviving examples, notably a series of portraits set in mummy-cases in Egypt, where the unusually dry climatic conditions have favoured survival. But such pictures were evidently of minor importance: all the signs are that the more vital and prestigious work was carried out on walls.

It is therefore with wall-paintings that this book will be concerned. To be more specific, it will be concerned very largely with wall-paintings as interior decoration in houses, villas and palaces.

It is true that paintings were applied both on internal and on external surfaces, but the latter have, for obvious reasons, rarely survived; and, where they have survived (as in the streets of Pompeii), it is clear that less care was expended on them – presumably because of their vulnerability to weathering and vandalism. In the safety of the interior, however, a patron was prepared to invest more money in good quality decorations. The finest specimens of Roman mural painting were all executed in enclosed spaces (usually roofed though sometimes unroofed) within buildings.

The importance of houses, villas and palaces again reflects a bias in usage. The types of buildings which have yielded paintings run through the whole gamut from temples and other public buildings to houses and tombs. But the grander public buildings were frequently decorated in more expensive materials, notably marble veneering, or, if they were plastered, the plaster was worked and painted to simulate either veneer or ashlar masonry, as befitted monumental structures. Chamber-tombs, the homes of the dead, were sometimes elaborately painted, particularly in the second century A.D.; but more commonly they received a simple treatment, since they were not places much frequented by the living, and, moreover, the piercing of the wall with burial-niches limited the painter's freedom of action; only the vault offered scope for more complex schemes. The principal buildings decorated by the Roman wall-painter were, therefore, residential – whether the mansions of Republican nobles, the palaces of the emperors or the houses of the bourgeoisie.

The role of Roman wall-painting in the decoration of domestic interiors merits further comment. Four main general points may be made.

Firstly, the extent to which ancient houses were painted

far exceeds that in later societies. The excavations at Pompeii and Herculaneum, relatively prosperous but by no means exceptional towns, provide a vivid illustration of this point; in fair-sized houses almost every room, whether large or small, was painted, and even in the smallest houses there were at least one or two painted rooms. Only kitchens, latrines and store-rooms generally lacked paintings altogether. A similar situation presumably existed in all comparable towns of the same period. In today's world the concept of specially commissioned frescoes throughout an ordinary town house seems almost incredible.

Secondly, the quality of decoration varied from room to room. The major rooms of the house, such as the *atrium* (main hall with a central light-well), the *tablinum* (large room at the back of the *atrium*), the peristyle (colonnaded garden), *oeci* (saloons or sitting-rooms), *triclinia* (dining-rooms) and important bedrooms, received the finest treatment, as measured in terms of the richness of colouring, the complexity of ornamentation and the presence of mythological pictures. The lesser rooms were progressively simpler in their decoration, right down to the slave bedrooms, painted at the most with systems of bands and stripes containing small sketchy vignettes on a plain white background. More will be said of this at the end of Chapter 11. From the outset, however, it is important to note that we shall be concentrating on just one end of the spectrum: the more elaborate decorations. It is these that are artistically interesting and enable us to observe the changing fashions of different periods. But we must not forget that there is an equally large number of simple decorations in which no real stylistic development can be measured – the paintings of what German writers call the 'Nebenzimmer' (subsidiary rooms).

Thirdly, given that paintings decorate rooms, one should not think of them in isolation. They must be considered in relation to the architectural settings in which they were intended to be seen: how are they adapted to the size, shape and function of the room, to the source of light, or to the amount of light available? They must also be considered in relation to the other forms of interior decoration with which they are combined; all are complementary aspects of single decorative ensembles. This means looking both at pavements, normally executed in mortar (with or without inset patterns of stones), in mosaic or in *opus sectile* (cut-stone work), and also, where the evidence is available, at ceiling- and vault-decorations. These are often themselves painted and must be considered together with the walls, though their poor survival-rate hampers analysis. But other media too are employed, notably stuccowork; and it is interesting to observe how the different colour effects and decorative conventions of fresco and stucco operate in conjunction. Ideally, in addition to decorations on architectural surfaces, we should also consider paintings in relation to the furniture and loose furnishings, ornaments and statuary of the house; but these are the components of the decorative ensemble on which we are least well informed. Our survey of other media will therefore be confined to the various types of paving, especially mosaic, and to stuccowork.

Fourthly, as features of the domestic environment, paintings can be expected to reflect the tastes and aspirations of the householders who commissioned them. This book will be concerned chiefly with the history of styles; but some attention must be paid to such questions as why patrons wanted to adorn their best rooms with grand architectural fictions or baroque fantasies, why they preferred particular mythological or landscape pictures, and what principles dictated the combinations of pictures and other motifs which were chosen for particular rooms. We should remember that the paintings did not exist in a vacuum but were part of a life-style. They are a crucial aspect of Roman culture and a potentially invaluable source of information on social attitudes.

In considering these general points it is important to stress the limitations and bias of the evidence. Though more durable than wood and other organic materials, painted plaster can fade and shatter, and its role as a surface-decoration on walls and ceilings exposes it to the risk of ruin. Many of the Roman paintings that we study have survived only as fragments in archaeological deposits, and often these fragments are too few to provide more than a few excerpts from a scheme (indeed, till recent times, little attempt was made to collect and preserve them). By contrast, mosaic pavements are disproportionately well represented in the archaeological record because they were sealed and protected when buildings collapsed (and because, unlike the more valuable *opus sectile* and wall-veneer, they were not worth the trouble of salvaging). The major exception to the rule that paintings are poorly preserved is provided by the remains of Pompeii, Herculaneum, Stabiae and the surrounding region, buried by the eruption of Mount Vesuvius in A.D. 79. Here we have hundreds of complete or near-complete wall-decorations, not to mention many ceiling-decorations, all datable to the last two centuries B.C. and the first A.D. This creates a major imbalance in the chronological and geographical spread of our material. For the early part of the period under review, and for one small region of Italy, there is an abundance of evidence, which has enabled the working out of a pattern of stylistic evolution. After A.D. 79, however, the material is scattered and normally extremely difficult to date, so it becomes impossible to establish a reliable chronological sequence. Inevitably, therefore, we find ourselves concentrating on the period down to A.D. 79 and on the paintings of Pompeii.

The buried cities, of course, provide unique opportunities. Here, and only here, is there sufficient evidence to make an effective study not only of the development of fashions in painting but also of the architectural and decorative setting and of the role of murals in a house's

social fabric. Here alone we can get a clear idea of the changing nature and function of panel-pictures and of other genres of painting within the decorative scheme (though even here the clarity of our vision is impaired by the fact that many of the best known pictures were cut out of the walls for Bourbon kings in the eighteenth and nineteenth centuries). At the same time we must remember that neither Pompeii nor Herculaneum was a major centre and that the murals of the cities are not in the first rank of Roman art; they are essentially the products of jobbing craftsmen. For wall-paintings of higher quality we must turn to the decorations of imperial residences in Rome, such as Augustus's properties on the Palatine and the fabulous Golden House of Nero, both partly preserved by their incorporation in the substructures of later buildings.

Pompeii's real value is as an index of middle-class taste in one of the crucial phases of ancient civilisation: the period of Rome's transition from Republic to Empire. In the second and first centuries B.C. Roman power gradually extended to include the coastlands of the whole Mediterranean – despite the inadequacies of a city-state administrative system and the potentially disastrous rivalries of military potentates. Under Augustus (31 B.C.–A.D. 14), who emerged as victor from a long series of civil wars, the conquests were consolidated within more or less fixed frontiers and this 'empire' provided with a stable and effective form of government suited to its needs – a government based on a series of regional units ('provinces') with long-serving governors and professional officials responsible to the emperor in Rome. The result was a lasting peace interrupted, during the lifetime of Pompeii, only by a year of civil war (A.D. 68–9) which put an end to the dynasty established by Augustus (the Julio-Claudians) and ushered in a new dynasty (the Flavians) founded by Vespasian. Culturally this period saw the emergence of Rome from the shadow of Greece. In the Republican age the Romans had been swept with a passion for things Greek: Roman writers adapted or translated Greek literature; Roman thinkers modelled their ideas on Greek philosophy; wealthy Roman nobles collected Greek artworks or copies of them. By the early Imperial period, however, a new Roman cultural identity had emerged, incorporating major contributions from Greek literature, art and thought, but with indigenous elements too, and expressing an essentially Roman outlook. One has only to think of Virgil's *Aeneid* or the Ara Pacis Augustae (Altar of Augustan Peace) in Rome to appreciate the synthesis which was achieved.

It is during this crucial phase of transition that Roman painting emerged from its Greek roots and forged an independent character for itself. Indeed it is this phase which sees all the most vigorous and fruitful developments in the medium; after A.D. 79 there was a decline in creativity and a tendency to uninspired reworking of old formulae. Pompeii, therefore, gives us an unrivalled glimpse of what was happening at a time of central importance in the history of the art form.

The nucleus of the study of wall-painting in this period is the sequence of four manners, or 'styles', first worked out by the German scholar A. Mau in 1882. The chronological succession has often been challenged, for example by A. Ippel (1910) and L. Curtius (1929), but recent research, in particular by H. G. Beyen (1938 and 1960), F. L. Bastet and M. De Vos (1979) and W. Ehrhardt (1987), has been able to confirm the basic validity of Mau's system by a detailed analysis of the incidence and combinations of the various patterns, motifs and colour-schemes, together with judicious interpretation of archaeological evidence. Conservative or antiquarian decorations did occur – imitation Second Style at the time of the Fourth Style, for example – but this does not affect the main evolutionary thrust. Our first major task, therefore, will be to review the four styles in turn, illustrating the typological development within a broad chronological framework, but making no attempt to lay down too precise a chronology, given the undeniable co-existence of progressive and conservative workshops and the deliberate variations in type of decorations within a single programme. Since, however, many elements within the four styles are indebted to earlier art we must begin by looking at the pre-existing traditions from which Roman painters drew inspiration.

I

The antecedents

The fundamental prerequisite for the mural compositions of Roman times was the pictorial achievements of the Greeks. One of the recurrent themes of Roman wall-decoration was the incorporation of figures painted in the Greek style and, most characteristically, of panels based on famous Greek pictures. These were rarely close replicas (see Chapter 6), but they normally reproduced general compositional devices or specific figure-types inherited from the original, and they invariably depended upon the Greek mastery of naturalism and illusionism; what is more important, they arose from a desire on the part of Roman patrons to surround themselves with an aura of great Greek art – the same 'nostalgia', or intellectual snobbery, that prompted the collection of classicising statuary or silver plate.

By the universal consent of the ancient writers, the great age of Greek painting spanned the late fifth and fourth centuries. It was during this period that artists gradually acquired their complete armoury of illusionistic techniques. The principles of linear perspective were explored for the representation of buildings; volume was suggested by the use of shading and highlights; the setting of figures and objects in space was indicated by cast shadows. Painters such as Zeuxis, Parrhasius, Pausias, Nicias, Apelles and Protogenes became celebrated for their ability to create the appearance of reality and of the third dimension upon two-dimensional surfaces. Many of their works, carried out primarily on panels and therefore capable of transference from one city to another (thus helping to create the conditions for the growth of an art market and inflating both values and reputations), acquired the status of world-famous masterpieces. It was, in short, the golden age of picture-painting.

Most of this achievement is lost to us. The original panels no longer survive and we are forced to imagine what they were like from their influence upon minor works, such as paintings in tombs and on gravestones, from echoes in other media, such as vase-painting and mosaic, and from the information provided by authors like the Elder Pliny, the thirty-fifth book of whose encyclopaedic *Natural History*, written shortly before his death in A.D. 79, con-

tains a rag-bag of information on the history of painting, culled mainly from earlier writers. Some perception of a masterpiece of the late fourth century can, however, be obtained from the so-called 'Alexander mosaic' found in the House of the Faun at Pompeii [1]. Nearly six metres long by over three metres high, this is almost certainly a close copy of a painting commissioned by Alexander or one of his successors to commemorate the great king's victories over the Persians; it is an astonishing *tour de force* which conveys the full chaos and confusion of battle with a mass of struggling and falling soldiers and of plunging and rearing horses. The horses in particular display a mastery of foreshortening and chiaroscuro.

The repertory of subjects too was largely complete by 300 B.C. By far the most important were those from mythology and history; but during the fourth century others had come to prominence, notably personifications and portraits. We also hear of playful and idyllic paintings, such as Zeuxis's study of a centaur family or Timanthes' picture of a sleeping Cyclops with satyrs measuring his thumb, in which the old monsters of mythology were brought down to a human level and treated almost whimsically. Among the minor subjects are Pausias's flower-pieces and Parrhasius's erotica (including at least one picture of a sexual perversion featuring a pair of lovers from Greek legend). Some painters also experimented with landscape. A frieze on the façade of a tomb in the Macedonian royal necropolis at Vergina (ancient Aegeae) shows a scene of hunting in which the action is taking place in a wood, the trees of which are more or less correctly related in scale to the huntsmen and so positioned as to appear almost as important as they are; moreover, the bold use of foreshortening gives a very real impression that the figures are moving in and out of the trees [2]. The successful integration of figures and environment here marks the beginning of the process which eventually led to Roman landscape painting.

For the third, second and early first centuries B.C. (the so-called 'Hellenistic' period) the literary record is patchy, and it is difficult to know what developments, if any, took place in figure-painting. From Pliny it appears that a few

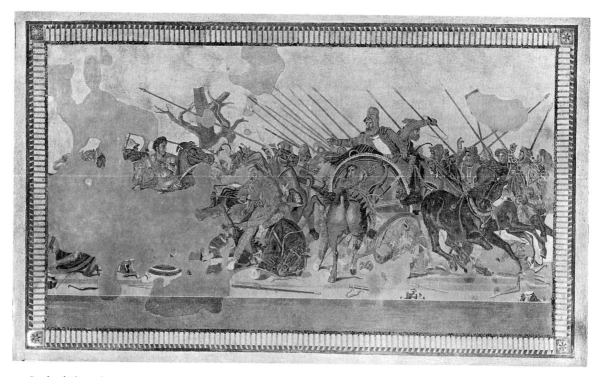

1 Battle of Alexander against the Persians. Mosaic from the House of the Faun at Pompeii. Late 2nd or early 1st century B.C. Naples, Archaeological Museum. H. 3.42 m.

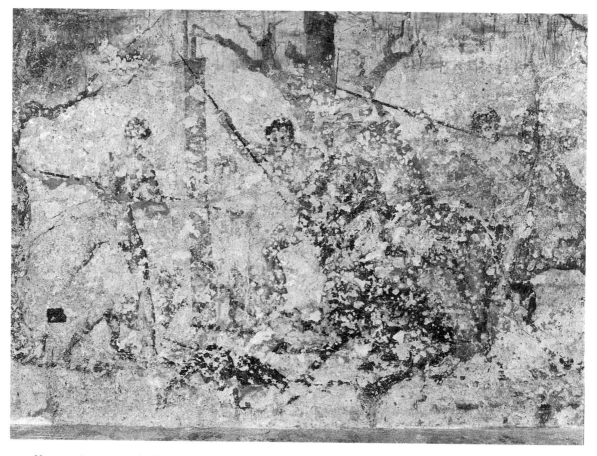

2 Huntsmen in trees. Detail of frieze on façade of so-called Tomb of Philip at Vergina. Second half of 4th century B.C. H. 1.16 m.

new genres emerged, such as caricature, everyday life and still life; but there is no surviving evidence for these before the Roman period. Such painting as exists is of limited interest. The wall-paintings of this period rarely allowed scope for representational art; the normal fashion was for decorations in the Masonry Style, to be discussed in the next chapter, in which the sole place for figures was a narrow frieze in the middle part of the wall. Other figure-painting is found on gravestones, albeit mostly in the form of simple one- or two-figure commemorative subjects; only the stone of Hediste from Demetrias in Thessaly (third century), in which the background of the funerary scene shows an opening into a further room with a glimpse of another doorway containing an onlooker, offers an indication of the kind of elaborate architectural interiors which must have occurred as backdrops in major art, as for example in Aetion's painting of Alexander's marriage with the oriental princess Roxane. Otherwise our knowledge of figure-painting in the Hellenistic period is derived chiefly from echoes in floor-mosaics. Mosaic pictures such as the little New Comedy tableaux by Dioscurides of Samos from

the so-called Villa of Cicero at Pompeii [235] are clearly close copies of painted panels, to which they achieve a degree of fidelity remarkable for so awkward a medium. So too with the only mosaic picture to be described in ancient literature, a study of doves on a bowl in a pavement by Sosus of Pergamum; virtuoso details, like the shadow of a bird's head on the water mentioned by Pliny, and the highlights glinting on the bronze of the bowl, revealed by the surviving Roman copies, could hardly have been invented by a mosaicist.

Two much larger mosaic pictures, laid in the late second-century sanctuary of Fortune at Praeneste (Palestrina) in Italy, provide evidence for further genres of painting. The first, woefully incomplete, showed a kind of seascape in which the water was filled with various species of fish and marine life, as in an aquarium. The encyclopaedic quality suggests a pictorial prototype created in one of the great centres of Hellenistic learning such as Alexandria. The second and more complete mosaic is a pictorial map of the Nile [3]. Rising at the top and reaching its delta at the bottom, the river winds its way past numerous vignettes

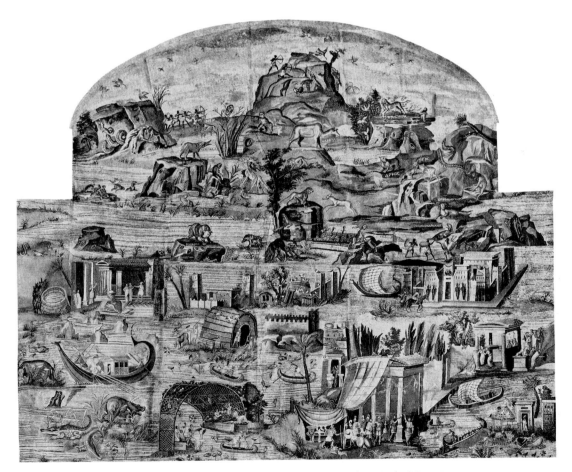

3 Nile mosaic, Palestrina. Late 2nd century B.C. Palestrina, Palazzo Barberini. 6.56 × 5.25 m.

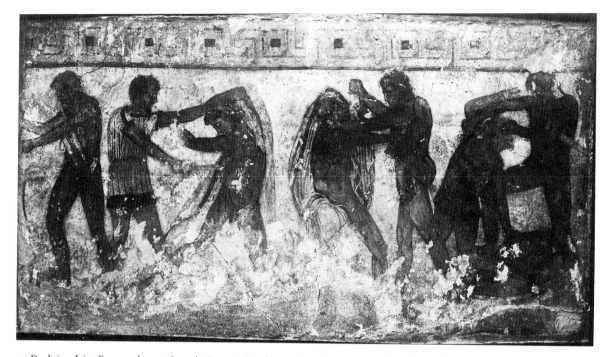

4 Duels involving Etruscan heroes, from the François Tomb at Vulci. 4th century B.C. Rome, Villa Albani (formerly Torlonia Museum).

representing the landscape and settlements along its course; recondite details are provided with labels in Greek. The genre of painting represented here, whose home was unequivocally Alexandria, was perhaps related to illustrated maps, the existence of which is implied by a passage in the *Geography* of Claudius Ptolemy (second century A.D.).

It has been suggested that the reason that Sosus's doves panel, alone of all Greek mosaics, gets a mention in Pliny is that it had been brought from its original setting in Pergamum to adorn some building in Rome. Certainly many of the famous Greek paintings known to Pliny were known to him primarily because he had seen them in Rome; and we may well suspect that it was precisely the old masters which were available in Italy which exercised the most influence upon the patrons and practitioners of the wall-painting produced there during the first centuries B.C. and A.D. For the capital Pliny gives us long lists of pictures on display in or before his time. These included at least four paintings by Apelles, at least two by Zeuxis, one by Parrhasius (not counting two more in the emperor Tiberius's private collection), three by Aristides and four by Nicias. The early Hellenistic artist Antiphilus was represented by at least six panels. These numbers could, of course, have been much larger, given that many of the pictures in Pliny's lists for which he gives no location may also have been in Rome, and indeed that many additional pictures must have existed which he never mentions. There will certainly have been old masters in other Italian cities too. Any pictures in Naples or Puteoli (Pozzuoli) could have

been a readier source of iconographic material for the wall-painters of Pompeii and Herculaneum than the works in Rome; and that picture-collections, both public and private, existed in these cities under the Empire is corroborated by Petronius's fictional account in the *Cena Trimalchionis*, probably set in Puteoli, of a gallery containing works by the Greek masters, and by Philostratus the Elder's description of a gallery in a Neapolitan villa. Zeuxis's painting of the child Hercules strangling snakes, which may have been reflected in one of the pictures of the House of the Vettii at Pompeii [Pl. VIIIA], may still have been exhibited in the city of Agrigentum in Sicily, to which the artist had presented it. There need thus have been no shortage of Greek panel-paintings through which the technical achievements and the artistic repertory of the great masters could have been transmitted to the decorators of Roman Italy.

Alongside the mainstream of Greek picture-painting there was also an Italian pictorial tradition which preceded the emergence of the distinctive Roman mural styles of the late Republic and the early Empire. Here paintings on walls were already important.

The surviving material comes from funerary contexts. In the earliest examples, the most notable of which are the murals in the Etruscan chamber-tombs at Tarquinia and painted slabs from the lining of graves at Paestum, the style and subject-matter are clearly indebted to the Greek tradition and there is very little that rises above the mediocre. Only towards the end of the fourth century and in the Hellenistic period do we get hints of a greater independence,

with the emergence of new subjects based on local history and ceremonial. Foremost among these are the paintings from the 'François Tomb' at Vulci, now convincingly dated to the fourth century B.C., which include episodes from early wars between the Etruscans and Rome [4], balanced on the opposite wall, in a kind of legendary parable, by a scene of the Greek hero Achilles butchering Trojan prisoners; the Roman foes, worsted by the local heroes Caile and Aule Vipinas (Caelus and Aulus Vibenna) with the aid of their ally Macstrna (Mastarna), are shown receiving the same treatment as the Trojans from whom they claimed descent. Later, during the third and second centuries B.C., there are two or three painted tombs at Tarquinia which put the emphasis on the career and prestige of the dead man, with illustrations of funerary processions containing figures in military or civil dress [5]. The biographical overtones of these paintings, and their representation of human figures with all the trappings of secular office, show a different outlook from the art of Greece and the eastern Mediterranean, which remained permeated with the old generalisations of myth and allegory. In Italy

there was a greater interest in the documentation of events and achievements – an interest which extended to the faithful reproduction of minor details of dress and appearance. It was this which gave rise to other branches of the Roman-Italian art tradition: honorific portrait-statues and ultimately historical relief sculpture. Doubtless the processional friezes of the Tarquinian tombs had their counterparts in Rome; the style of the paintings, in which the angles of the heads are deliberately varied and the effect of crowding is suggested by the inclusion of background figures between and behind those of the foreground, clearly foretokens the great processional reliefs of the Ara Pacis (13–9 B.C.), and the obvious inference is that the latter were influenced by a pre-existing Republican tradition of painted processions.

From Rome we have some fragments of mid Republican historical painting and literary evidence for more. The surviving material consists of fragments of painted wall-plaster from tombs in a cemetery on the Esquiline. The largest piece [6], perhaps datable to the third century or the first half of the second, shows parts of four superposed

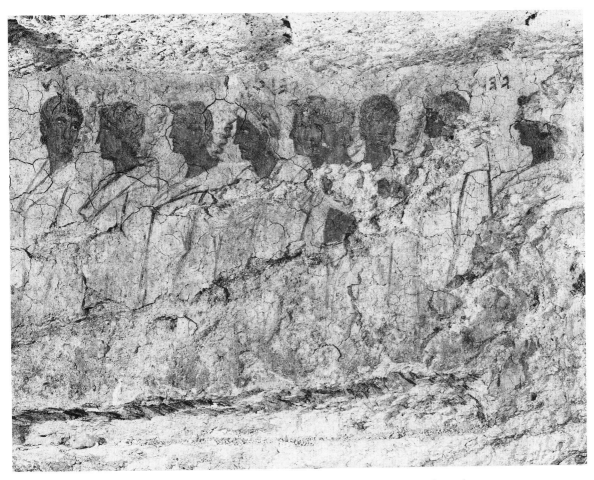

5 Funerary procession. Detail of frieze in Tomb of the Conference, Tarquinia. Late 2nd or early 1st century B.C.

6 Historical painting from tomb on the Esquiline, Rome. 3rd century or first half of 2nd century B.C. Palazzo dei Conservatori. H. 87 cm.

latter belongs to a distinguished family which produced several leading generals of the third and second centuries; so it is attractive to conclude that M. Fannius, who could be the owner of the tomb from which the paintings come, is shown receiving honours from his military commander in recognition of distinguished service. The individual figure-types and the use of chiaroscuro show strong Greek influence, but the documentary character, affirmed by the inscribed names, corresponds to Roman-Italian requirements. A further distinctive feature of the paintings, the hierarchical variation of scale whereby the principal actors occupy the full height of the frieze while the onlookers and most of the figures in the battle-scenes are shown smaller, is paralleled on several central-Italian reliefs of the early Imperial age; so this too may reflect a local artistic tradition at variance with the Greek.

From a neighbouring tomb come tantalising fragments of other historical paintings: a battle-scene, followed by a triumphal procession, and a figure apparently being crucified, the punishment normally meted out to rebellious slaves. Once again we cannot know what precise events were being depicted, but the documentary character of the scenes is unmistakable.

The literary evidence, too, refers to paintings of historical subjects, albeit displayed in public places rather than hidden in tombs. Here one important class is formed by murals in Roman temples. Varro, for example, reports seeing cavalrymen of a type known as *ferentarii* represented in the decoration of the old temple of Aesculapius, built in the early third century; since the figures were apparently provided with labels, like those of Fannius and Fabius in the Esquiline fragment, it is possible that the context was some historical battle-scene. The lexicographer Festus refers to paintings of Roman generals celebrating 'triumphs' (ritual victory parades through the streets of Rome) in two temples dedicated probably in 272 and 264. Livy tells us about a painting of a victory feast in the streets of Beneventum which the general Tib. Sempronius Gracchus commissioned in the temple of Liberty to commemorate his defeat of the Carthaginians in 214.

Closely related to these murals were panel-pictures, which like the murals were normally exhibited by victorious generals to flaunt their achievements. Pliny records three examples which were set up in public buildings. The first was a picture displayed by M'. Valerius Maximus Messalla in 264 on the side wall of the Curia Hostilia (the original senate-house of Rome) to illustrate a battle in Sicily in which he had defeated the Carthaginians and Hieron, the ruler of Syracuse. His precedent was followed by L. Cornelius Scipio Asiaticus in 189 when he put up a picture in the Capitol of his victory in Asia; and after him L. Hostilius Mancinus, who had been the first to force an entrance into Carthage in 146, celebrated this event by exhibiting in the Forum a picture of the storming of the city (he even stood next to his picture and described details

friezes representing historical subjects of some form, including a battle-scene in front of a walled city and two scenes of parley or presentation involving a pair of labelled figures. In the best preserved section M. Fanio, wearing greaves, a yellow loin-cloth and a blue cloak, receives something from the hand of Q. Fabio, who is in the full Roman ceremonial dress of toga and tunic, while a bank of spectators watches from the right. Above this a similar figure in greaves, loin-cloth and blue cloak, but now equipped also with a large oval shield and plumed helmet, offers his hand towards a toga-clad figure holding a spear; this time the inscriptions are less complete, but the letters ... ANIO can be discerned against the left-hand figure, who may therefore again be M. Fanio. Behind him is a fortified city with civilians looking over the battlements. The precise subject of the paintings is disputed, but M. Fanio (Fannius) and Q. Fabio (Fabius) have good Roman names, and the

to the watching public, a piece of self-advertisement which won him the consulship at the next election). Similar to these pictures must have been a panel recorded by Livy portraying Sempronius Gracchus's conquest of Sardinia which was set up in the temple of Mater Matuta in 174. The tradition of commissioning paintings of military campaigns was closely bound up with the celebration of a triumph, for such war pictures were evidently carried in the procession. The first specific reference which we have to this practice is in connection with the triumph of Scipio Africanus in 201, but his example was copied by later victors. Some of the panels already referred to, such as that of Asiaticus, may indeed have been painted originally for triumphs. In the case of the paintings carried in Pompey's triumph at the end of the Mithridatic Wars in 62 we have a detailed description. 'Images were carried of those who were not present, Tigranes and Mithridates, showing them fighting, being defeated and fleeing. Even the besieging of Mithridates and the night of his flight and the silence [perhaps personifications] were represented. Finally it was shown how he died, and the girls who chose to die with him were painted in the same picture, and there were paintings of the sons and daughters who had died before him, and images of the barbarian gods with their traditional paraphernalia.' Similar paintings of the deaths of his foes were carried by Julius Caesar in his triumph of 46 B.C.

Such historical subjects play almost no part in the private wall-decorations with which this book is mainly concerned. Nor indeed do specifically Roman legends; apart from a painted frieze in a late Republican or early Augustan tomb on the Esquiline, which is thought to tell the story of the foundation of Rome (p. 111), and from some half-dozen panels in the wall-decorations of Pompeii, the most notable of which are a Third Style mythological landscape representing the legend of Romulus and Remus, and a Fourth Style picture of the wounded Aeneas, indebted to a passage in Virgil's *Aeneid*, the subject-matter of surviving figure-paintings is overwhelmingly Greek. Greek art and culture clearly exercised a dominant influence upon the taste of private patrons in Roman Italy, whether they were members of the aristocracy or of the bourgeoisie. But it is not impossible that indigenous traditions had some effect upon the *way* in which the subjects were painted. Two kinds of representation found in Roman painting for which there is no obvious antecedent in known Greek art are continuous narrative within a single panel and the combination of different viewpoints for various parts of a picture. Both

are restricted to compositions with landscape settings, and both are dictated by a desire to tell a story as clearly and completely as possible, even if this means sacrificing semantic logic and visual consistency. In the first, two or more episodes of a story, taking place at different moments in time, and often involving the repetition of the same figures, are set in one great sweep of landscape, as if they are simultaneous occurrences. In the second, while the figures are shown in 'normal' perspective, that is at the viewer's eye-level, the landscape background, and in particular any buildings, boats or the like, rise up the picture in vertical, or bird's-eye, perspective. It is not difficult to see how the kind of representations necessitated by paintings of military campaigns would have favoured these forms of treatment. Indeed the descriptions given by ancient writers strongly presuppose their use. Sempronius Gracchus's painting of the conquest of Sardinia, for example, is said to have had 'the form of the island of Sardinia, and on it representations of battles'; this sounds rather like the illustrated maps which may have inspired the Nile mosaic at Palestrina, with the difference that the illustrations would here be narrative or historical rather than topographical. At any rate it is hard to conceive how the subject could have been tackled without a combination of diverse viewpoints, predominantly bird's-eye for the background and 'normal' for the figures, and without a telescoping of the chronology (since the battles could not all have taken place at once). Similarly Mancinus's picture of the storming of Carthage showed 'the layout of the city and depictions of the attacks'; once more one imagines that the city was represented in some form of map-like projection, while the figures of attackers and defenders were rendered in conventional perspective – rather like the later scenes in relief sculpture of cities being besieged on Trajan's column and on the Arch of Septimius Severus. It is significant that the one painting from Pompeii which can be considered as 'historical', the picture of a riot which happened in the local amphitheatre in A.D. 59, employs precisely this combination of different perspectives.

More will be said about single-panel narrative and the use of incoherent perspective when we come to deal with mythological landscape pictures in Chapter 6. In the meantime we must turn from figure-painting to decorative schemes, and trace the mainstream development of Roman wall-painting down to the destruction of Pompeii. This means reviewing the four Pompeian 'Styles'.

2

The First Style

The effective history of Roman wall-painting begins with the First Pompeian Style, which is the Italian version of a style current throughout the Hellenistic period and throughout the areas under Greek influence. In its original form this consists in the translation of the features of monumental ashlar masonry into a mode of interior decoration; and for this reason it can more aptly be described as the 'Masonry Style', especially in those areas of the Greek world where it retained a close allegiance to the syntax of real masonry.

The beginnings of the style are shrouded in uncertainty. Some of its essential features appear in fragments of stucco-work found in the Agora in Athens, sealed in the construction platform of a building that was evidently being put up during the last quarter of the fourth century B.C.; and examples from the north of Greece (Olynthus and Samothrace) have been ascribed to the middle and second half of the century; but some of the material in question is extremely fragmentary and the archaeological contexts insecure. The most we can say is that the style had appeared before the end of the fourth century and was well established round the Mediterranean during the third and second. In the East there is a long series of good examples from sites in south Russia, Asia Minor (notably Pergamum, Magnesia on the Meander, Sardis, Priene and Cnidus), the Aegean (notably Delos and Thera) and Egypt (Alexandria). In Sicily it is known from Agrigentum, Gela and Morgantina; in Italy from Salapia (in Apulia), Pompeii, Herculaneum, Tarracina (Terracina), Praeneste (Palestrina), Rome and Cosa (on the coast of Tuscany). Specimens have even been found in the south of France, in Spain (at Azaila) and in north Africa (at Carthage). The western sites did not lag far, if at all, behind the cities of the East. The villa at Salapia is thought to belong to the second half of the third century and to have been destroyed by Hannibal in 217 or soon after; and the House of Ganymede at Morgantina, some of whose walls were decorated in the Masonry Style, was probably built about 250 and destroyed when the city was captured by the Romans in 211. The Phoenicians of north Africa seem to have acquired the style at a remarkably early date. Fragments of Masonry Style plaster have been recovered from late fourth-century contexts in the excavations at Carthage, while literary evidence appears to confirm that houses in the surrounding countryside were being decorated in a similar manner by 310 B.C.

The essential characteristic of the style is that it employs stucco as a medium for imitating courses of ashlar block-work and other architectural elements; these are modelled in relief, the margins of the blocks being recessed in the manner of undressed or 'drafted' masonry (though with a purely decorative neatness); and colours are applied to suggest the use of different types of stone.

7 Delos, House of the Trident, room *j*: reconstructed wall-decoration. Late 2nd or early 1st century B.C.

In the Aegean versions, best known from the late second- or early first-century decorations on Delos, the formula clearly betrays its debt to monumental masonry [7, 8]. It consists, from bottom upwards, of three main elements: large panels known as 'orthostates', one or two narrow string courses or friezes, and a series of regular courses of isodomic blockwork. This arrangement closely reflects the structure of monumental buildings like the Tholus at Epidaurus (mid fourth century) and the Hieron and Arsinoeum at Samothrace (respectively last quarter of the fourth and first quarter of the third century) – the last two of which employ decorative drafting like that of the stuccoes. Ultimately the general syntax may perhaps be traced back to primitive building styles in which a wall base consisting, in section, of pairs of vertical stone slabs (the orthostates) crowned by a line of flat capping stones (the string course) carried a superstructure of unbaked brick. In addition to these basic components Masonry Style stuccowork normally placed a shallow plinth beneath the orthostates, perhaps corresponding to a horizontal seating course found frequently in this position in real architecture; while at the top of the wall there was either a smooth frieze surmounted by a projecting cornice or, in the more elaborate decorations, some form of miniature Doric or Ionic order. That this latter feature may once again have been borrowed from monumental architecture is suggested by the occurrence of a real gallery decorated with engaged columns as a crowning element in the walls of the Arsinoeum at Samothrace.

If the syntax of these decorations was that of monumental masonry, the idea of employing an architectural theme more familiar from exteriors as an ornamental device for interior surfaces was obviously in itself a departure from purely structural principles. Further factors emphasise the independence of stuccowork. Of particular importance is the unusual elaboration of the string course, which was doubled and even trebled, and at the same time singled out for special pictorial treatment; at Delos the friezes in this position carried not only conventional patterns such as illusionistic meanders and series of blocks painted with veining to suggest variegated marbles [19], but also floral decoration and figure-subjects [7], including Cupids hunting or engaged in activities of everyday life, theatrical scenes and mythological battles. In most cases the friezes were given further prominence by the use of framing mouldings with painted enrichments (heart and dart, egg and dart, guilloche). It is no coincidence that this special decorative emphasis, to which the rest of the wall served merely as a foil, was situated approximately at eye-level; one senses how what was originally a structural formula was modified to create a visually attractive milieu for the householder. A further factor which accentuates the divorce between Masonry Style stuccowork and its structural prototypes is the role of polychromy. In addition to the variegated marbling and other brightly coloured motifs in the string courses, the blocks were rendered in a rich array of reds, yellows and blacks; and in some cases the drafted margins were thrown into sharp contrast with the main surface of a block by being given a different colour. Despite the occasional use of different-coloured stones in monumental architecture, the kind of bright colour schemes employed in the mature Masonry Style were foreign to real masonry; indeed some of the colours were of a garishness that no natural stone could ever have possessed.

In the West decorators seem to have broken further away from the rules of monumental masonry. At Cosa, remote from Greek centres, one or two schemes curiously remained closer to the Greek models than their counterparts in Campania. There is evidence in one case for the use of patterns in relief (meanders and floral motifs) on string courses, a device which had prototypes in stone architecture, and which is paralleled in Masonry Style stuccoes from south Russia, Priene and Athens, as well as from the Apulian villa at Salapia, but which is unknown at Pompeii and Herculaneum. In the House of the Skeleton (SUNY House), dated about 85 B.C., the decorators apparently followed the east Mediterranean fashion of putting a richly painted zone above the orthostates; this consisted of a string course carrying a green and white meander in perspective, and above it a course of variegated and plain-coloured blocks treated as alternate 'stretchers' and 'headers' – long horizontal and short vertical rectangles. Higher up came a frieze with a continuous decoration of Cupids picking flowers between the loops of an undulating garland, painted (like similar friezes at Delos [7]) on a black ground. Alongside these east Mediterranean features, however, appeared others that were distinctive: a high socle, here divided by grooves into alternate red and purple panels; the use of frames in relief to enclose the orthostates; and the employment of the expensive pigment cinnabar (vermilion) in place of the red ochre normally found in eastern decorations. The use of headers and stretchers, too, though paralleled in the East, is not the normal rule there.

The decorations of Pompeii and Herculaneum, chiefly second- and early first-century in date, included some of the same distinctive elements, and added their own variations. Since the material from these sites is plentiful and relatively well preserved, it is possible to summarise the principal features which set the Pompeian [9] apart from the Aegean [8] versions of the Masonry Style.

In the first place the proportions of the elements are different. The low plinth of the East is replaced by a high plain socle which pushes the orthostates up nearer to the middle of the wall; the orthostates are often, correspondingly, reduced in height (though not in [9]), taking the form of broad, low rectangles rather than the high square or vertical rectangles of the East; and the frieze zone declines in importance, being reduced to a single course of blocks in slightly greater relief than the rest or to a narrow string course, or even in some instances being omitted altogether. Conversely an extra string course is sometimes added

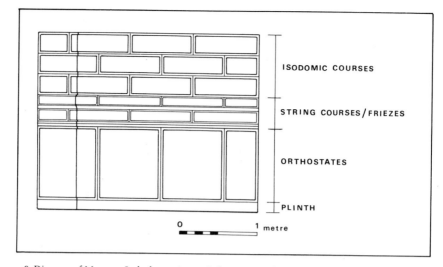

8 Diagram of Masonry Style decoration on Delos (House of the Comedians, room Q). Late 2nd or early 1st century B.C.

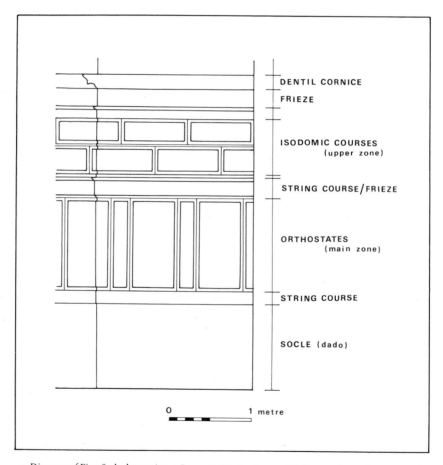

9 Diagram of First Style decoration at Pompeii (VI 16, 26, *œcus* N). Late 2nd or early 1st century B.C.

beneath the orthostates. The divorce from structural logic is manifest. The traditional supporting element in the pattern, the orthostates, lose their meaning; while they remain in relief, the socle beneath them is usually flat, thus leaving them, as it were, suspended above a void. At the same time, in moving higher on the wall, they begin to assume more prominence in the design; the way is set for the threefold division of dado (socle), main zone (orthostates) and upper zone which is fundamental to the later styles.

Secondly, there are differences in the treatment of decorative details. While upper-wall mini-colonnades are comparatively rare, cornices are found not only at the top of the decorated area (leaving a plain zone between this and the ceiling, against which a further cornice may occur) but also at other points within the decoration, notably above the frieze or string course above the orthostates. Characteristic of these cornices, especially the upper ones, is their adornment with Ionic dentils, a motif seemingly less popular in eastern versions of the Masonry Style. The framing of the orthostates with raised borders and the breaking up of courses of blockwork into headers and stretchers, features which have already been observed at Cosa, are further details which appear now and then at Pompeii (cf. [Pl. IB]) but are not characteristic of the East.

At Pompeii even the orthostates are sometimes alternately broad and narrow [9, 10], thus foretokening an important rhythmic pattern of the later styles. Finally, and with similar effect, there is a greater tendency to break up the walls of peristyles with series of pilasters or semi-columns imposed on the design [Pl. IA]. Although this motif has an obviously architectonic function, in that the pilasters and semi-columns respond to the real columns of the peristyle, it seems also to have answered an aesthetic need felt more strongly in Pompeii than in Delos for strong vertical accents in the decorated surfaces. The same result is achieved, perforce, in the side walls of *atria*, where regular series of doorways interrupt the pattern [11]. In each case the discontinuity is emphasised by the treatment of each stretch of wall as a self-contained unit; the ends of blocks are made to coincide as far as possible with the structural caesuras, and the cornices are terminated short of them so that they appear as short ledges floating in mid-air. The articulation of the wall-surface by a screen of columns and pilasters is an important decorative idea bequeathed to the Second Style. Overall, the features under discussion – multiplication of cornices, framing of orthostates, alternation of wide and narrow elements, and introduction of strong vertical divisions – have the effect of breaking up the pattern into

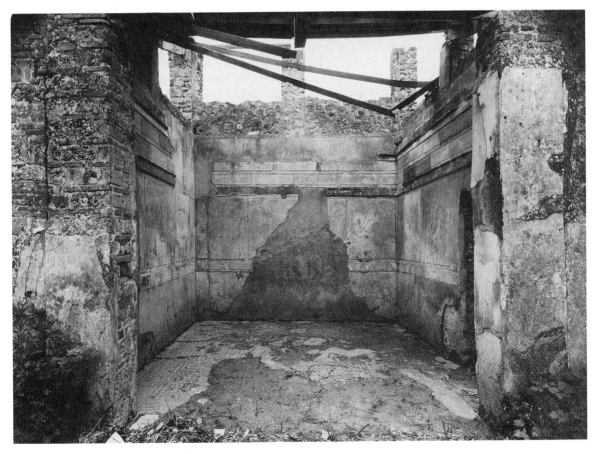

10 Pompeii VI 2, 13, general view of *tablinum*. Late 2nd or early 1st century B.C.

15

11 Pompeii VI 2, 4 (House of Sallust), First Style decoration in *atrium*. Late 2nd or early 1st century B.C.

smaller units and dispersing the decorative emphasis away from the frieze to various other parts of the design.

Thirdly, the colouring is less consistent and coherent than in the East. In the East, for all the richness of the colouring, the systems are usually coloured in such a way as to reinforce the structural logic; thus the orthostates are all in one colour, while the isodomic blockwork too tends to show uniformity of colouring, or at least a rhythmic alternation of colours, one for each course (cf. [7]). Only the frieze or friezes employ richer variations of colour. At Pompeii and Herculaneum, however, blocks in the same course can be painted in different colours, often apparently in quite random sequence, while the variegated effects of coloured marble or alabaster, confined in eastern versions principally to the orthostates and frieze-zone, are scattered through all levels of the decoration [Pl. 1]. Thus in the *atrium*, *alae* and *tablinum* of the House of Sallust at Pompeii the socle and orthostates are consistently coloured respectively yellow and black (a favourite scheme), but the blockwork of the courses above shows a bewildering variety of hues; on the walls of the *tablinum* [Pl. 1B], for example, the sequence in the first course is (from left to right) purple, yellow, green and red, in the second purple, green, red, yellow and purple again, and in the third (above a narrow string course and a cornice) purple and three successive, different types of marbling. In the *fauces* (entrance-passage) of the Samnite House at Herculaneum, above the same combination of a yellow socle and black orthostates,

there are two series of blocks, respectively green, white, red and purple, and red followed by two different varieties of marbling. The colour sequences in such decorations may be repeated on the opposite wall in mirror-image, yellow opposite yellow, purple opposite purple, and so forth, or alternatively in reverse mirror-image, that is in diagonal correspondence; in either case the underlying rationale is not immediately apparent and the viewer gets an impression of disunity and disorder. Once again the western decorator has sacrificed simplicity of structure for a freer, more discontinuous effect.

Fourthly, even if the patterns and colours within a wall are less clearly structured, the Pompeian decorator normally seeks to unify each wall with its neighbour. In the East, perhaps because stuccoists were still conscious that they were borrowing a pattern from exterior architecture, each wall was treated as a separate entity; hardly any element was allowed to turn the corner or to interrelate with elements on the adjacent wall. At Pompeii, however, where stuccoists had achieved a greater degree of emancipation from their architectural models, it was a natural step to acknowledge that their art form had now graduated from the imitation of ashlar façades to a mode of interior decoration with its own rules and logic, and accordingly to confer a kind of structural unity upon the room. We therefore sometimes find the isodomic blockwork appearing to interlock at the corners, as might happen in real construction; one course ends with a complete drafted block, and the

next appears to penetrate behind the face of the adjoining wall. Alternatively the blocks are shown as turning the corners, which achieves an even more emphatic enclosure of the space.

All these features indicate the more experimental approach of the western decorators, who were ready to move away from the canons of real masonry and achieve new syntheses from the common repertory of motifs. But nothing illustrates their boldness more than the way in which they used painted patterns and representational subjects. Whereas such motifs were confined in the East, with very few exceptions, to the friezes above the orthostates, they appear at Pompeii at various levels in the scheme and often in quite illogical roles. Of the purely abstract patterns the most striking is the cubic design reproduced on socles in the House of the Faun and two other houses [12]; derived from a motif common in pavements of the time, it is formed from diamond shapes in three colours so arranged as to produce an optical effect of perspective. Painted garlands and plant-scrolls are also attested, both in the conventional

position above the orthostates (where a particularly fine specimen enlivened with a profusion of flowers, birds and insects is visible in a dining-room in the House of the Faun) and also in a narrow frieze under the cornice at the top of the decoration (House of Sallust). More interesting than all of these, however, are the subjects painted on the orthostates and blockwork. Here, in deference to the architectural character of the style, painters shaped figures or objects from the veins of painted marble or alabaster: the pools of a yellow marble may take the form of a bird, or those of a purple one simulate a winged figure; in a bedroom of the House of the Four Styles a well-preserved orthostate of alabaster carries what appears to be a fringed scarf hanging from a peg [13]. Alternatively a monochrome technique was used to suggest that the blocks were carved in relief. By this means it was possible to introduce quite elaborate figure-scenes: examples known from nineteenth-century water-colours [14] show a libation-pouring woman and a standing winged youth in green monochrome, a Victory leading a peacock by a cord in yellow, and (in the House of the Faun) a gathering of centaurs in red with yellow veining. Sometimes there is no pretence of a natural play of veins or of the working of the stone in relief, and figures stand out in one colour against a background of another. The more adventurous representations seem to have been restricted to the course of blocks immediately above the orthostates, which means that they occupied an analogous position to the figure-paintings of eastern centres; but the idea of putting them on drafted blocks rather than in a smooth frieze and the fiction of forms emerging from the veins of the marble has no known parallel in the Aegean. Once again we receive confirmation of the independent spirit of the region.

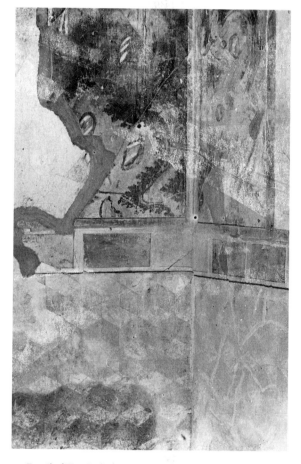

12 Detail of First Style decoration with perspectival cubes on socle and (?)marine forms on orthostates. Pompeii VI 16, 26, *tablinum*. Late 2nd or early 1st century B.C.

13 Detail of orthostates with painted scarf amid marble veins. Pompeii I 8, 17 (House of the Four Styles), bedroom 15 (alcove). Late 2nd or early 1st century B.C.

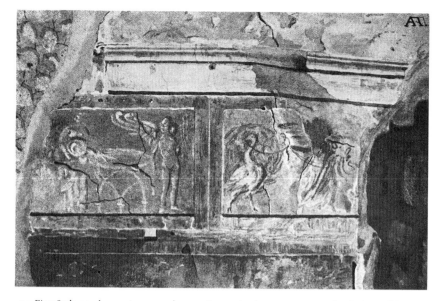

14 First Style panels carrying monochrome pictures (19th century water-colour). Pompeii VI 14, 40. Late 2nd or early 1st century B.C.

In the hands of western decorators, therefore, the Masonry Style graduated into an essentially new mode of interior decoration. It must be stressed that this was no inexpensive or inferior style. Though in one sense a cheap substitute for fine masonry, in that it gave an impressive and pseudo-monumental finish to what were usually walls of rubble construction, it certainly belonged to the top rank of decorative craftwork: the careful preparation of the plaster layers, the fine burnishing of the surfaces, the deep and even application of the colours, the precise trimming of the drafted margins, the deft handling of the painted detail – all reveal standards of technical excellence which must have involved a considerable outlay of time and money. If a householder wanted a cheap form of interior decoration, he would go for something rather simpler, such as a plain plaster surface with blockwork indicated by incisions and limited colouring.

What of the ceiling- and floor-decorations which accompanied stuccowork of the Masonry Style? About ceilings we have little information. Hellenistic vaulted tombs in Macedonia and Alexandria present various forms of painted systems: networks of hexagons, octagons or lozenges, chequerboards, imitations of coffering and imitations of woven tapestries. But from the private houses which have produced the best examples of the Masonry Style the only direct evidence is some fragments of plaster from Priene which took the form of white coffers with blue fields and some stucco compartments at Salapia with a hole in the centre for the application of a rosette or similar ornament in relief. These suggest that the imitation masonry of the walls may sometimes have been combined with imitation coffering on the ceiling – a natural state of affairs,

given that stone or wooden coffering was the normal form of ceiling-decoration used in buildings of monumental masonry. Alternatively the stuccoed walls could have carried ceilings of real wooden panelling or coffering; this was certainly the case in the ideal Hellenistic house described by the Roman architect Vitruvius, where the peristyle porticoes are 'decorated with stuccowork, both plain and in relief, and with coffers of fine joinery'.

Of the pavements the most remarkable and expensive were those of mosaic and the so-called *opus sectile* (cut-stone work). The latter was rarely used except to render the pattern of perspectival cubes whose pictorial version has already been mentioned; an excellent specimen, carried out in pieces of white limestone and grey and green slate, remains in the *tablinum* of the House of the Faun [15]. In mosaic, however, there was a wide range of patterns and motifs, some of them, such as the illusionistic meander and the peopled plant-scroll, shared with wall-painting. The most popular fashion, both in the eastern Mediterranean and in Italy, was to create mosaic pictures or *emblemata*, often replicas of well-known paintings, to be inserted as centre-pieces in the floor, surrounded by bands of floral and geometric ornament or by plain surfaces on which couches and other furnishings could be set. These *emblema* mosaics were evidently a luxury, confined to a few important rooms in the wealthiest houses; the House of the Faun, with eight or nine specimens, including the exceptional Alexander mosaic [1], was by far the most richly endowed private residence known to us in the Hellenistic world. More commonly rooms of the First Style were paved with mortar. This might contain different aggregates – crushed pottery or tile-fragments, limestone and, in the Vesuvius

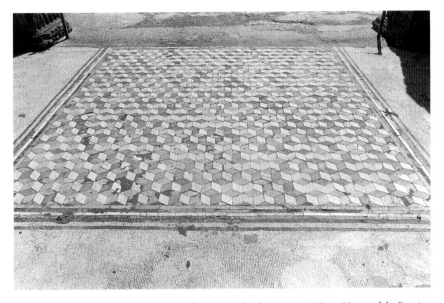

15 *Opus sectile* pavement with pattern of perspectival cubes. Pompeii VI 12 (House of the Faun), *tablinum*. Late 2nd or early 1st century B.C.

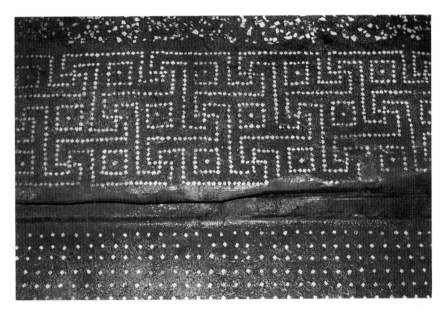

16 Detail of pavement showing patterns of *tesseræ* set in mortar. Pompeii VI 9, 3/5 (House of the Centaur), bedroom 3 (threshold between *procœton* and bed-alcove). Late 2nd or early 1st century B.C.

region, lava – and it was frequently decorated with patterns of inset *tesserae* (meanders, diamonds, scale-patterns and grids of spaced *tesserae*) [16]. Another type of paving, half-way between sectile and mosaic, consisted of small chippings of limestone, white or both white and coloured, laid in a dense irregular pattern like the modern 'crazy paving'; in various derivative forms this non-geometric, non-representational style of floor-decoration was destined to enjoy more success in the ensuing period.

As a general rule the walls, ceilings and floors of the Masonry Style formed complementary ensembles; the ceilings seem, like the walls, to have been decorated with designs based on architectural forms, and the floors were mostly covered with simple and unobtrusive patterns designed not to distract from the polychromy of the walls. Only the *emblema* pavements introduced a more disturbing note. The representation of pictures on the floor may have been, in large measure, a response to the limited oppor-

17 Pompeii VI 9, 3/5 (House of the Centaur), bedroom 3. First Style decoration, with bed-alcove at left and *procæton* at right. Late 2nd or early 1st century B.C.

18 Stucco lattice-work balustrade. Herculaneum V 1–2 (Samnite House), *atrium*. Late 2nd or early 1st century B.C.

tunities of including pictorial subjects in Masonry Style wall-decorations; but the element of illusionism which they contained created an uncomfortable effect of recession within that surface which above all others should appear solid and stable; besides, a picture normally imposed a specific viewpoint on the spectator, thus creating conflicts with other elements in the design, such as scrolls and perspectival meanders or dentils in the frames, which were represented so as to be readable from all sides.

A reason for the use of a picture in the centre of the pavement, or indeed for the use of any distinct and emphatic motif, figurative or geometric, in this position, was the desire to provide a decorative focus for the diners in a *triclinium*; thus the picture is often oriented not towards the entrance of the room but towards the couches at the back. Similar relationships between decoration and room function can also be discerned in the treatment of the wall-decorations in this period. Rhythmic series of pilasters or semi-columns were, as noted above, a characteristic of peristyles, answering to the real columns of the porticoes and enhancing the grandeur of the environment. Most characteristic of all, however, was the treatment of bedrooms. Here the alcove for the bed, architecturally distinct from the rest of the room by reason of its raised floor and its independent, lower ceiling (often vaulted), received a separate design on a smaller scale; and the division was emphasised by pilasters at the sides of the opening [17]. The use of painting and mosaic to mark off the settings of beds and couches was to remain a standard feature during the Second Style (pp. 48–9).

Towards the end of the Masonry Style we meet with harbingers of the Second Style. Already in the late third century B.C. there is evidence that wall-painters sometimes suggested architectural elements by illusionistic means; in a tomb at Lefkadia in Macedonia which has been dated to this time the walls between the funerary niches are articulated by pilasters painted in perspective on a flat surface, and painted, as in the Second Style, with the shadows falling away from the doorway and converging on the central point of the rear wall. Moreover, the pilasters are set above a marbled dado, they are linked by garlands hanging from one to the next, and the corner pilasters turn the angles so as to be shared by adjacent walls – all features which recur in the Second Style. But the effect of depth is rudimentary, and there is no suggestion that the dado is a projecting podium or that the pilasters stand on it; besides, it is a very simple scheme, for which there is no known parallel among the scores of house-decorations surviving from Delos and other Hellenistic centres; so it is best to think of it as a bold but seldom repeated experiment which has no relation to the emergence of fully illusionistic architectural schemes. None the less it provides an interesting foretaste of what painters might achieve when, for one reason or another, they set their minds to replacing the actual projection and recession of stucco relief with the suggestion of three-dimensionality by purely pictorial means.

More significant are the hints of illusionism within true Masonry Style decorations. The engaged colonnades of the upper zone are in themselves an illusionistic element in that they imply that the intervening spaces represent openings; this is stated quite clearly in the Samnite House at Herculaneum where the engaged colonnade which appeared on three walls of the *atrium* formed a visual continuation of a real gallery which opened in the fourth, even

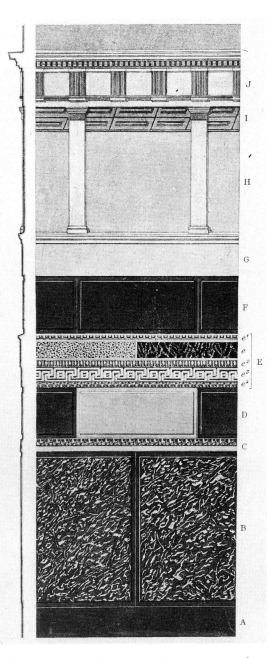

19 Delos, House of the Dionysus, room D: reconstruction of wall-decoration. Late 2nd or early 1st century B.C.

to the extent of reproducing its lattice-work balustrade in stucco relief [18]; and in a bedroom in the House of Sallust the semi-columns are superimposed on continuous courses of blockwork, which must, therefore, be envisaged as belonging to a further plane. One or two Aegean examples actually combine the stucco architecture with illusionistic painting. In a decoration from the House of the Dionysus at Delos [19] the interspaces of an order of pilasters in the upper zone contained ceiling-coffers painted in perspective, implying that the viewer looked through the pilasters and saw a ceiling receding behind them. More interesting still are fragments of First Style plaster from the Pompeion in Athens. Found in a destruction deposit associated with Sulla's sack of the city in 86 B.C., they include remains of a frieze of marbled and plain-coloured blocks in which part of the drafting, instead of being carried out in relief, is simulated by shadows and highlights – a pure Second Style motif. Further fragments from the same context show illusionistic coffering and part of a cornice painted in perspective. Here then, no later than the early first century B.C., we see the beginnings of a clear movement away from the laborious technique of modelling in stucco towards the greater freedom of *trompe l'œil* painting.

3

The Second Style

The Second Style emerged in the early first century B.C. Pompeii, which had hitherto been an autonomous city in alliance with Rome, was punished for its resistance in the Social War by the planting of a Roman colony in 80 B.C., and it was in buildings put up or remodelled by the colonists that the first firmly dated examples of the new style occur. To the same period or a little earlier, to judge from the structural technique of the rebuilding with which they are associated, must be dated the early Second Style decorations in the so-called House of the Griffins in Rome. From these beginnings the style can be traced through numerous examples in Rome, Pompeii, Sicily, central and northern Italy and the south of France, to the mid Augustan age (late first century B.C.).

There can be little doubt that the lead in the evolution of wall-decoration now passed to Italy and remained there at least till the end of the Pompeian period; with the concentration of much wealth and patronage in the hands of the Roman nobility and Italian mercantile classes, it was natural that Italy should attract the ablest artists, many of them Greeks, and should become the melting-pot for new artistic ideas. Recent attempts to revive the old view that the Second Style was evolved in the East and came to Italy second-hand fail to carry conviction. Such examples as are known from Greece and the East are relatively simple, the equivalent of the very earliest phases in Italy; and their dating need in no case be earlier than the mid first century B.C.; indeed they may have been inspired from Italy (cf. pp. 169–71).

The typological development within the style has been analysed in detail by the Dutch scholar H. G. Beyen. He divides it into two main stages, the first of which represents a steady progression from a 'closed' to an 'open' wall, while the second marks a change of direction back towards a closed wall but with the emergence of a new focus, the central picture, and of a new aesthetic, in which pattern and colour become more important than the semblance of reality. Within these two principal phases Beyen distinguishes, respectively, three and two sub-phases, each of which is epitomised by a small group of principal monuments. There was clearly a good deal of overlapping between the phases, and it would be rash to establish too precise a chronology for individual decorations; but Beyen's framework will provide a useful working basis for a review of how the style evolved. The first phase may be dated roughly from the time of Sulla to that of Caesar (c. 80–c. 40 B.C.) and the second to the years of the Second Triumvirate and the early part of the reign of Augustus (c. 40–c. 15 B.C.).

First phase

The essential characteristic of the Second Style is that it achieves the imitation of architectural forms by purely pictorial means; in place of the modelled stuccowork of the First Style, it uses flat plaster surfaces on which projection and recession are suggested entirely by shading and perspective. At first (Phase IA) the effects pursued are relatively simple. A good example is a wall-decoration in the Capitolium at Pompeii, known from a nineteenth-century drawing, which showed a straight transcription of a First Style scheme into two-dimensional painting. High red orthostates alternated with narrow marbled strips in the main zone, and above came a shallow frieze containing a painted meander, a course of headers and stretchers in alternate colours, and finally a broader frieze surmounted by a modillion cornice indicated in perspective.

Here all the elements are on one plane and any illusion of projection, apart from the cornice, very limited. In two rooms of the House of the Griffins in Rome, however, a second plane is introduced. The imitation wall is, as it were, pushed into the background by a screen of columns resting in one case on a continuous podium, in the other on individual pedestals, and carrying an entablature which runs across to pilasters in the angles. The spatial illusion in the decoration with the podium (room IV) [20] is less pronounced, because both the podium and the architrave seem very shallow; in addition the cornice between the columns is divided into short independent stretches which are represented so as to appear to project at least as far as the columns; the latter must, therefore, be imagined as engaged to the wall like the similar stucco semi-columns and pil-

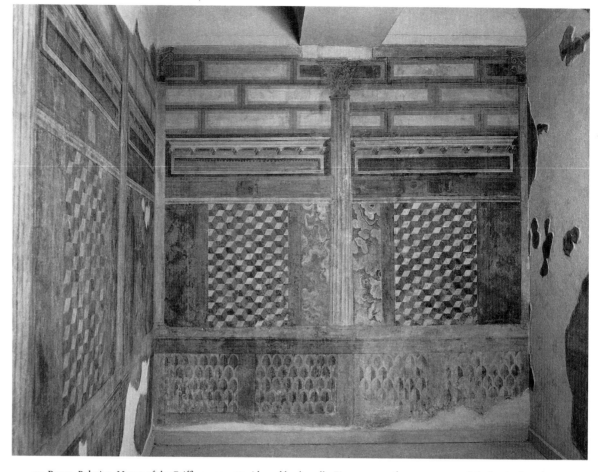

20 Rome, Palatine, House of the Griffins: room IV, side and back walls. First quarter of 1st century B.C. Palatine Antiquarium.

asters in the First Style. In room II [21], on the other hand, the columns with their strongly projecting pedestals are shown standing proud of the wall, while rows of perspectival ceiling-coffers indicate the depth of the ceiling behind the entablature. In each room the lighting is in most respects made to coincide with the actual light-source, and the main lines of perspective are symmetrical about the central axis. The whole scheme is enriched with dazzling polychromy incorporating imitations of breccias, veined marbling and coloured alabaster as well as plain red, yellow, green and purple stones; in addition the cubic pattern familiar from sectile paving [15] appears both in the dado and (in room IV) in the orthostates, painted in red, black and white; and the dado of room IV borrows another motif from pavements: scale-pattern (imbrication). In composition, the principle of the tripartite division into dado, main zone and upper zone is now firmly established, while there are clear signs of a preference for a tripartite lengthwise division too, with a central orthostate carrying a different colour or pattern from those at the sides. The first step is thus taken towards the centralised schemes which were to

remain the dominant principle of composition in rooms of limited size.

In the next stage (Phase 1B) the centralised principle was more explicitly stated; at the same time the play of advancing and receding forms grew more complex, and the upper part of the wall was opened to suggest a glimpse of a world outside the room. The chief representative of this moment in the development is the Villa of the Mysteries at Pompeii, where at least a dozen rooms, including the *atrium* and the peristyle, were decorated in one operation, perhaps datable some time in the late 60s or 50s B.C. Alongside simple schemes of imitation blockwork, some of which introduce the interesting mannerism of a single dominant colour pervading every level (so that we can speak of a 'blue room' or a 'yellow alcove'), we find a number of decorations in which the main zone, again set behind a colonnade and crowned by one or two courses of coloured blockwork and an illusionistic cornice, is turned into a screen-wall, above which a further plane of architecture is visible. In its simpler form this further plane is a 'room beyond a room', with masonry walls and a coffered ceiling. In its more complex

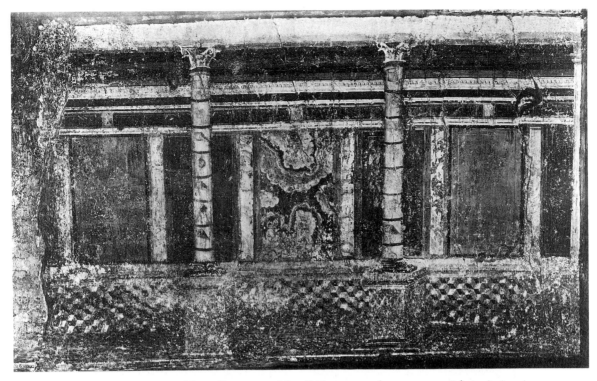

21 Rome, Palatine, House of the Griffins: room II, left wall. First quarter of 1st century B.C. Palatine Antiquarium.

form we are vouchsafed a view into a colonnaded court-yard with blue sky above it [22]. The spatial recession of these further planes is indicated by a system of linear perspective which, for the back walls at least, is based in all essentials upon a single central vanishing point; on the side walls, however, it is sometimes 'asymmetrical' (with the lines of recession leading to one side: see p. 51). The suggestion of space is enhanced by the use of light. The 'outdoor architecture' is rendered in lighter, less emphatic colours than the nearer planes, suggesting the brightness of the world beyond the screen-wall.

Particularly complex schemes are presented in the two bed-alcoves of bedroom 16. In each of them the overall frame of the wall is formed by an entablature carried on single pilasters at the angles; but this merely represents the foreground plane, behind which come two or more further planes of architecture. On the rear wall of Alcove A [23] four equally spaced columns and the screen-wall behind them share the burden of an entablature which projects and recedes to form a series of three bays spanned by coffered vaults. On that of Alcove B [Pl. IIA] the four columns appear again, but here the side intercolumniations are spanned by horizontal entablatures, and the central one, which is wider, by an arch; behind them we see no less than three planes of architecture – pairs of columns projecting forwards, the basic screen-wall, and in the background a *tholus* (columnar rotunda) set in an open courtyard. The

side walls of the first alcove show yet another formula: a columnar porch framing a doorway. Once again a court is visible at the rear.

These schemes reflect a new sense of liberation among wall-painters, who seem almost to have revelled in their ability to break down the barriers of enclosing space. Their virtuosity in the handling of perspective is matched by a prodigality in the use of colour; the fictive architecture is rendered in a dazzling, and rather overwhelming, display of vermilion, purple, green, yellow and black. Elsewhere in the house we see the first appearance of figure-paintings in Roman mural decoration. The most famous example is the Dionysiac frieze in the large *oecus* at the south-west corner of the villa; here the architectural scheme is reduced to a projecting podium and a flat panelled wall with brilliant red orthostates against which stands a continuous series of figures, a little under life-size [104–5, Pl. IX]. At the top of the preserved part of the wall runs a narrow frieze of Cupids hunting among vine-scrolls, reminiscent of the Masonry Style decorations of Delos. A neighbouring bedchamber is decorated in very similar fashion, except that the figures are reduced to isolated individuals (a dancing satyr, a priestess, bacchantes) or pairs (Silenus supporting a drunken Dionysus, Silenus and a satyr) set statue-like on bases, while the upper part of the wall is opened illusionistically to show the familiar colonnaded court.

The developments of Phases IA and IB reached a

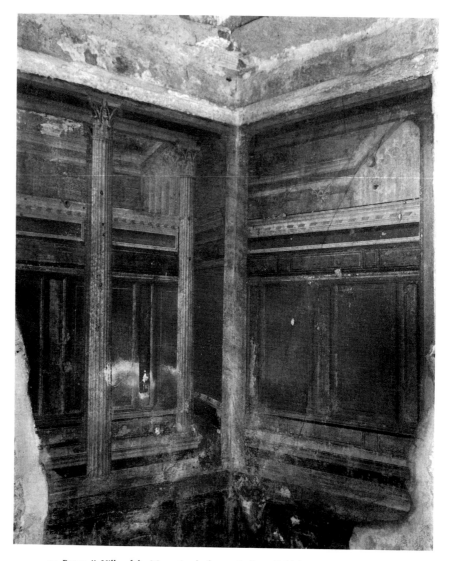

22 Pompeii, Villa of the Mysteries, bedroom 8, alcove B (right corner). *c.* 60–50 B.C.

culmination in Phase IC, represented by the paintings of the villa of P. Fannius Synistor at Boscoreale and the sumptuous villa of the Poppaei at Oplontis, respectively north and west of Pompeii and both perhaps datable to the 40s B.C. [24–8; Pl. III]. Here the whole wall is dissolved in elaborate displays of illusionistic architecture. Included are many of the distinctive motifs already seen in the Villa of the Mysteries: intercolumniations spanned by arches or vaults, projecting pairs of columns supporting independent and functionless pieces of entablature perpendicular to the main order, glimpses of the upper part of a *tholus* set in a colonnaded court, pediments with their lower part cut away, and especially doors framed by columns, now often the focal point of the scheme. At the same time there is a richer use of exotic elements and ornamental detail; the columns, for example, are often painted, like the block-

work, to suggest exotic materials such as alabaster and red granite, and sometimes further enriched with gilded tendrils set with coloured gems. At times the effect begins to stray into the realms of fantasy. Figures of sphinxes, griffins and the like [24] are set on entablatures in imitation of *acroteria* (crowning sculptures), but rendered with a vivacity which makes their meaning ambiguous: are they simply sculptures or are they alive? The same ambiguity affects the caryatids supporting the modillions of the cornice in the west wall of the *triclinium* at Boscoreale, and especially the winged figure perched on a great disc in the fictive opening at the centre of the same wall [Pl. IIIA]; the variety and movement of the former, and the illogicality of the latter, which appears suspended in mid-air with no architectural function, suggest a hazy boundary between real and surreal. The architectural framework is also enlivened with

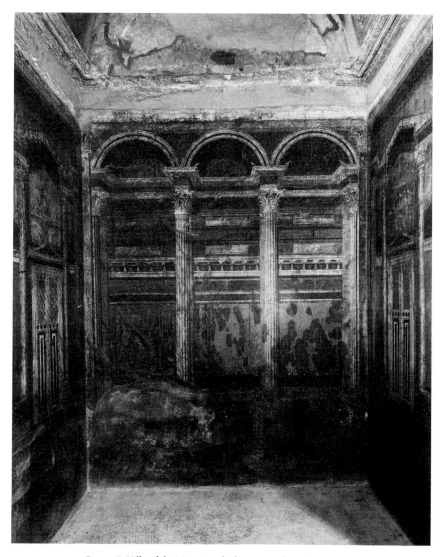

23 Pompeii, Villa of the Mysteries, bedroom 16, alcove A. *c.* 60–50 B.C.

independent accessories: shields, masks and garlands hanging from architraves; bronze vessels, bowls of fruit and theatrical masks resting on top of screen-walls or crowning entablatures; baskets of fruit, torches, cylindrical boxes and incense-burners standing on the podium in front of the screen-wall. These objects can be interpreted as votive offerings, household ornaments or the like, but among them perch live birds (cf. [Pl. IIB]), a clear indication of the freer rein that the painter is allowing his imagination.

The villa at Oplontis contains five rooms with extensive remains of Second Style paintings. These vary from the relative simplicity and intimacy of bedroom 11 and the small dining-room (23) to the majesty of the *atrium* (5) and the great *oecus* (15). Bedroom 11, with its two bed-alcoves decorated in different manners, recalls most closely the paintings of the Villa of the Mysteries, but the imaginary

openings are more extensive, the screen-wall being replaced by a low parapet or curtain which allows a virtually uninterrupted view into the colonnaded court behind. The decoration of room 23 is noteworthy for its bold alternation of different-coloured orthostates (yellow, red, purple and turquoise) and for the beautiful quality of its accessory details, including a basket of fruit covered by fine gauze and a glass bowl containing golden pomegranates and purple plums. On the side walls [25], where the normal columns are replaced by slender pillars, the openings are restricted to small 'windows' in the central part of the scheme, and a solid wall of purple masonry rises above. On the back wall [Pl. IIIB], however, much of the upper part of the decoration, both above and below the entablature of the main columnar structure, is opened up to reveal the receding colonnades of a grand courtyard;

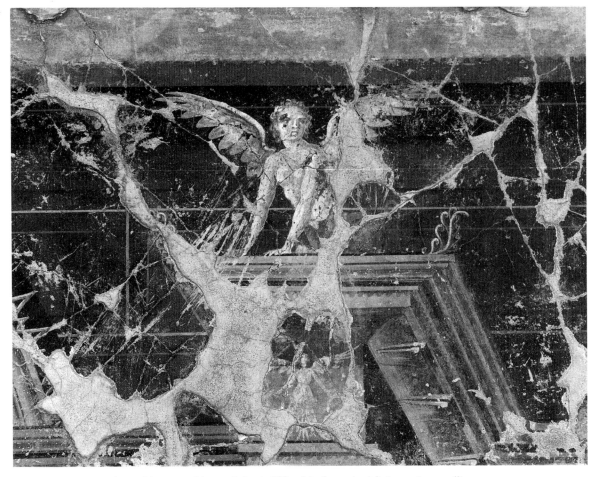

24 Crouching sphinx on entablature. Oplontis, Villa of the Poppaei, *triclinium* 14 (west wall). *c.* 50–40 B.C.

only the central pavilion is, paradoxically, filled in with masonry which forms a backdrop for a theatrical mask displayed on a ledge. An interesting detail of this room (repeated also in room 14) is the painting of monochrome landscapes upon the orthostates [148]. In the *atrium* only the lower part of the decoration survives. It shows a 'closed' architecture of advancing and receding surfaces with a panoply of grand columns framing fictive doors approached by flights of steps. In the *oecus* (15), on the other hand, much of the wall is opened up once more [26]. The great height of the decoration allows a soaring architecture, with double-storeyed porticoes in the background seen through two tiers of 'windows' in the foreground. At the centre a portal with open gates and an arched opening above reveals a gilded tripod on a cylindrical base set in a sacred grove; and at either end a wall painted in perspective projects forwards, prolonging the line of the background portico; from it hangs a line of shields. Amid all this architectural grandeur theatrical masks and framed pictures are exhibited at the sides of the openings. Peacocks and smaller birds perch on ledges.

The villa at Boscoreale yielded Second Style paintings from at least nine rooms, including the *fauces* and the peristyle. Fragments of these are now dispersed among various European and American museums. Alongside simple 'paratactic' (repeating) schemes, with or without screens of illusionistic columns and hanging festoons of fruit and flowers, there were three decorations of a more elaborate kind. The first two need not detain us here. The *triclinium* (G) [Pl. IIIA], already referred to, contained painted architecture similar to that of the rooms at Oplontis, with centralised perspective converging on a gate or door. The great *oecus* (H) had large-scale figure-paintings of the same kind as the Dionysiac mural in the Villa of the Mysteries, but with the continuity of the earlier frieze replaced by separate groups between columns, and with the solid red background substituted in at least one intercolumniation by the illusion of an outside setting (pp. 104–7).

The third decoration, that of bedroom M, now reconstructed in the Metropolitan Museum of Art, New York, merits a fuller description. Since the entrance wall

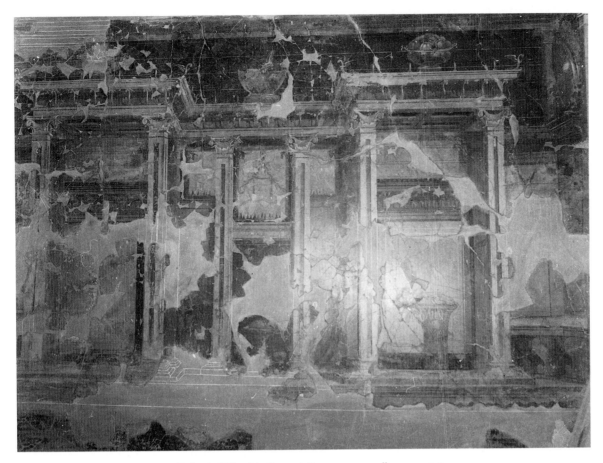

25 Oplontis, Villa of the Poppaei. Room 23, east wall. *c.* 50–40 B.C.

consists only of a pair of short responds, decorative interest is focused on the three remaining walls. Here the rear (northern) part of the room, designed to contain the bed, is differentiated from the front part, or *procoeton*, which is roughly three times as deep. Each section receives an independent treatment, though as normal the left wall mirrors the right. Most conventional in terms of the decorations already considered are the narrow units at either end of the bed, which show a view into a courtyard containing a *tholus* [27]. Here the opening is still restricted, with a parapet blocking the lower part, and the space above the pediment closed with courses of masonry. In the *procoeton*, however, virtually the whole of the wall above the podium is thrown open to an outside world [28]. The surface is divided by columns ornamented with golden tendrils into three panels; in the central one, behind a recessed forecourt, we see a sanctuary containing a statue of a goddess within a sacred two-pillar monument; and at the sides there are groups of small buildings, incorporating balconies, tower-like structures and porticoes, piled in apparent confusion up a hillside. The panels are broadly symmetrical and unified by a common central perspective, though most of the small buildings show inconsistencies of detail. On the rear wall of the room appears a different theme. Like the side walls of the *procoeton*, the surface is divided by columns into three panels which form openings to an outside world; this time, however, the emphasis is on a rustic or garden environment rather than on architecture. Most complete are the side-panels, in each of which the dominant feature is a rocky grotto overgrown with ivy and peopled with birds [27]; the sole signs of man's intervention are a marble fountain within the grotto and a pergola covered with vines on the hillside above. In the central panel a large window leaves little space for painting, and all that remains is part of a garden arcade seen above a low parapet supporting a bowl of fruit.

The Boscoreale bedroom represents the climax of the progression towards an 'open wall': in half a century the Second Style had advanced from the reproduction of simple masonry or marble veneer to a fully pictorial illusion of buildings set in space. This remarkable revolution has prompted various theories about possible sources of

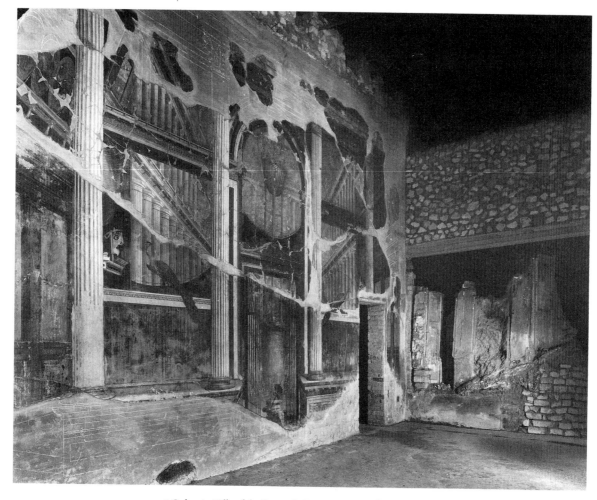

26 Oplontis, Villa of the Poppaei. *Oecus* 15, east wall. *c.* 50–40 B.C.

inspiration. The most widely held view, championed by Beyen, is that the determining influence was the painting of theatrical sets – an idea given some support by passages in Vitruvius, who actually refers to 'open places like *exedrae*' (but not other types of rooms) being painted with 'stage-fronts in the tragic, comic, or satyric manner', and elsewhere describes the three types of scenery in terms which remind us of Boscoreale. Other scholars, notably K. Schefold, place emphasis on the influence of Hellenistic monumental architecture, and especially on that of Ptolemaic Egypt, to which they ascribe many of the 'baroque' motifs found in Second Style wall-painting. A third school of thought, whose leading proponent is J. Engemann, considers that the most important influence came from the architecture of contemporary Italy. Each of these theories has been supported by detailed and impressive arguments, and each of them is to some extent valid. Stage-paintings, Hellenistic architecture and Roman Republican architecture may all have contributed some-

thing to the melting-pot from which the Boscoreale decorations emerged. Engemann's most notable service has been to demonstrate how the various elements of Second Style architecture evolved organically, step by step, from the simple imitation wall of the House of the Griffins to the complex perspectival illusionism of Oplontis and Boscoreale; for every development there is a logical precursor in the previous stage. In such a continuous evolution it is obviously unreasonable to look for wholesale imitation from any single external source. The Second Style establishes its own rules and its own aesthetic, culling ideas from various sources so as to develop a decorative vocabulary which is broadly based upon architectural forms but which never sets out to transcribe real architecture; it borrows elements from the Italian repertory (for instance Tuscanic capitals in the *tholus* court at Boscoreale), from Hellenistic palaces and precincts (the exotic materials, the ivy-entwined columns and so forth), and from the decorations of the stage (which may indeed have been a means

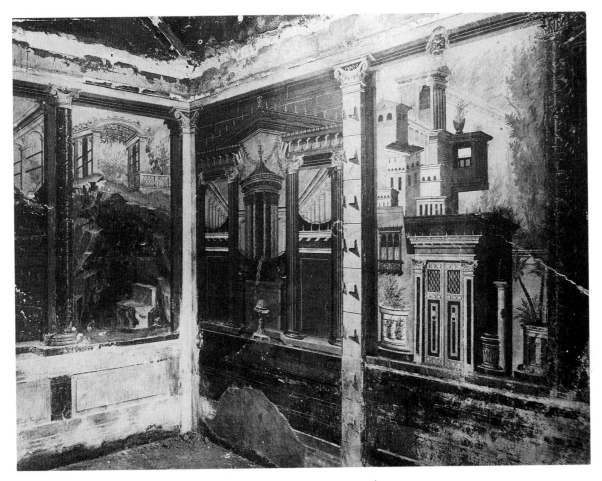

27 Boscoreale, Villa of P. Fannius Synistor. Bedroom M, north-east corner. *c.* 50–40 B.C.

of transmission of Hellenistic architectural details); but it welds them into an essentially new and independent mode of expression.

This new form of decoration, like the First Style, is only superficially realistic. The forms are certainly architectural and the architecture could have functioned in reality; but the overall effect is 'larger than life'. The grand proportions, the sumptuous materials, the sculptural detail, the religious bric-à-brac, and even the birds scattered within the painted structures have the effect of enhancing the environment – of transporting the householder to a world of almost magic luxury. What this evoked for him may easily be imagined. It probably conformed to his half-conceived notions of the palaces of Greek mythology and of the splendour of Hellenistic royal courts or the fabulous mansions of the potentates of contemporary Rome – notions which would have been instilled in him by poetry and other literature, as well perhaps as by the paintings of stage scenery. This role of wall-painting in appealing .to a kind of romantic mystique among the cultured classes

is something that we shall meet again in later periods.

Whatever the tastes or aspirations to which it appealed, the importance of the new architectural style in purely artistic terms can hardly be exaggerated. While many individual components, including its figure-friezes, had Hellenistic antecedents, the idea of opening up the whole wall by means of a more or less systematic and optically convincing illusion of spatial recession was without precedent in mural decoration. As the authors of this breakthrough, the anonymous Graeco-Roman wall-painters of late Republican Italy anticipated the achievements of Masaccio and his imitators by over fifteen centuries.

Second phase

After Boscoreale, one or two special varieties of decoration apart, the Second Style preferred to concentrate upon the structural patterns obtainable from the main architectural framework, and gradually the principle of the closed wall

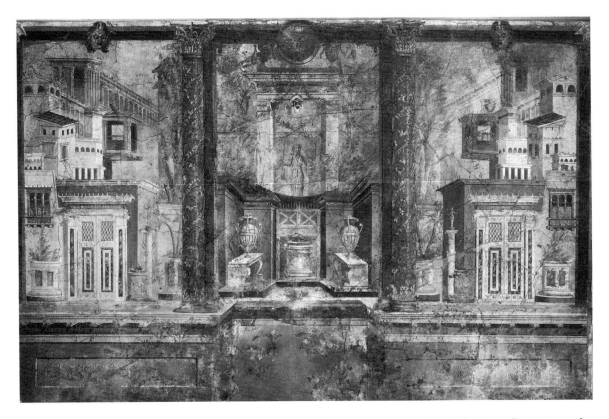

28 Boscoreale, Villa of P. Fannius Synistor. Bedroom M, west wall of *procœton. c.* 50–40 B.C. New York, Metropolitan Museum of Art, Rogers Fund 1903 : 03.14.13.

29 Heraldic pair of elephants. Pompeii I 6, 4 (House of the Iliadic Shrine), *œcus p* (originally part of House of the Cryptoportico). *c.* 40–30 B.C.

(which had never disappeared in places where the new manner was deemed unnecessary or unsuitable) began to win the day.

In Phase 2A (late 40s and 30s B.C.) the change of direction is clearly established. This can be illustrated from the House of the Cryptoportico at Pompeii. The most important room (in a part of the house later divided off to become the House of the Iliadic Shrine) contained large-figure red-ground paintings in the manner of the Mysteries frieze and the Boscoreale *oecus*, here dominated by seated figures (poets and Muses?) and a pair of majestic elephants with Cupids as mahouts [29]. Otherwise two types of decoration are represented. The first carries forward the tradition of simple paratactic schemes adorned with garlands already observed at Boscoreale. In the cryptoportico which gives the house its name and in the *oecus* at its south-eastern extremity, a scheme of this kind is articulated not with columns but with herms (pillars of stone surmounted by busts) [30]; the main zone is in each case relatively plain, with purple orthostates in the cryptoportico and a continuous yellow surface in the *oecus*, but the lower zone shows a new decorative boldness, with a perspectival meander in the cryptoportico, here running between the bases of the herms, which rest uneasily on a black band at the bottom of the wall, and with a continuous vegetal scroll in the *oecus*, here adorning the black face of the podium which supports the herms. The figural element is confined to a frieze or panels at the top of the main zone, in the position where one might otherwise have expected an illusionistic opening to a vista beyond the wall (cf. [Pl. XB]).

The second type of decoration develops out of perspectival schemes of the kind used at Oplontis and in the *triclinium* at Boscoreale. Good examples can be reconstructed from remains of paintings in the ante-room and the *frigidarium* (cold room) of a small bath-suite which opens off the cryptoportico. As in the previous phase, the structure of these decorations [31] is based on centralised perspective with advancing and receding forms, involving projecting wings and glimpses of colonnades in the background, and 'baroque' devices such as broken pediments and jutting entablatures which support nothing but a crowning sculpture. What is fundamentally new is the use of this kind of architecture as a framework for figure-paintings and especially for a single dominant picture. The central pavilion of the canonical tripartite structure was occupied by a tall gable-topped panel containing a figure-scene in an outdoor environment (not restored in [31]). Though presented as if seen through a window in the wall, this scene was probably to be conceived primarily as a great picture lodged in the architecture (cf. pp. 112–13). The side wings contained isolated figures. Those of the ante-room repeated more explicitly the pictorial metaphor of the central panel, being represented on a white background surrounded by an ornamental frame. Those of the *fri-*

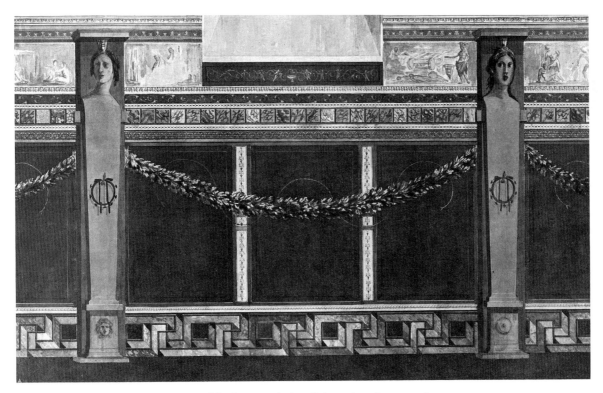

30 Pompeii I 6, 2 (House of the Cryptoportico), wall-decoration of cryptoportico. *c.* 40–30 B.C.

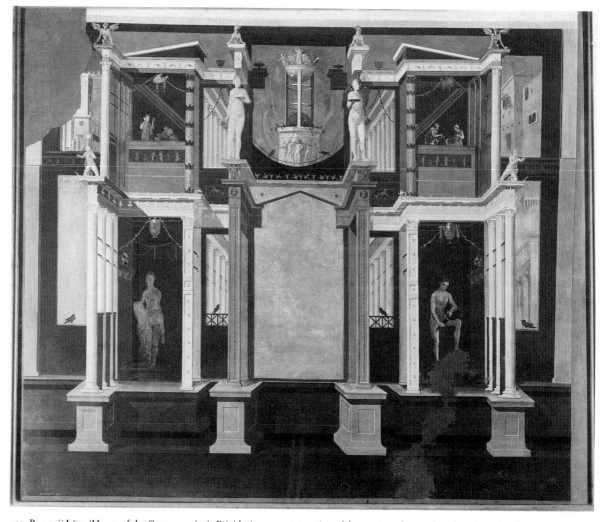

31 Pompeii I 6, 2 (House of the Cryptoportico). *Frigidarium*: reconstruction of decorative scheme of north and south walls. *c.* 40–30 B.C.

gidarium were shown as statues standing within alcoves [31]. In either case the basic formula of a focal picture with subordinate figures at the sides was one which was destined to become very common in centralised schemes of the ensuing period.

One result of the use of architectural forms as a framework for figure-paintings is that the illusionistic piercing of the wall becomes less important. The only openings which remain are above and between the pavilions and at the outer edges of the design; most are no more than narrow slits. Along with the reduced emphasis on space and distance goes an increase in ornamentation and a tendency to treat the architectural forms more fancifully. Columns become taller and slenderer; supporting figures, male and female (telamons and caryatids), sometimes take their place; one pair of columns is encased, plant-like, in a series of calyces; and friezes are decorated with floral and vegetal

ornaments or with 'grotesques' (creatures whose bodies tail off into volutes).

Further Pompeian decorations belonging to phase 2A appear in half a dozen houses. A wall from a house at the western edge of the city (now in Naples Museum) [32] shows a central picture in which the *tholus* of earlier wall-piercing perspective has become the subject of an applied panel containing small figures of worshippers; the side wings are adorned with game suspended on hooks. An oddity found here and in the baths of the House of the Menander is the appropriation of the illusionistic podium for a pictorial treatment with riverine subjects including ducks and reeds. Although these can be interpreted as a surface-decoration applied on the face of the podium, none the less the use of a spatial composition on what is in theory the foundation of the fictive architecture strikes odd; it is one more sign of the breakup of the structural syntax on

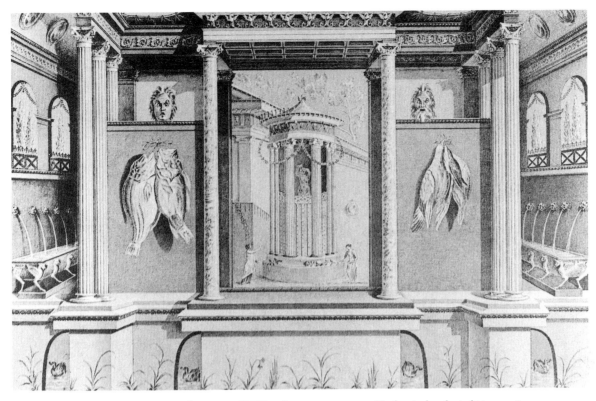

32 Second Style decoration from Pompeii VII Ins. Occ., 39. *c.* 40–30 B.C. Naples, Archaeological Museum 8594.

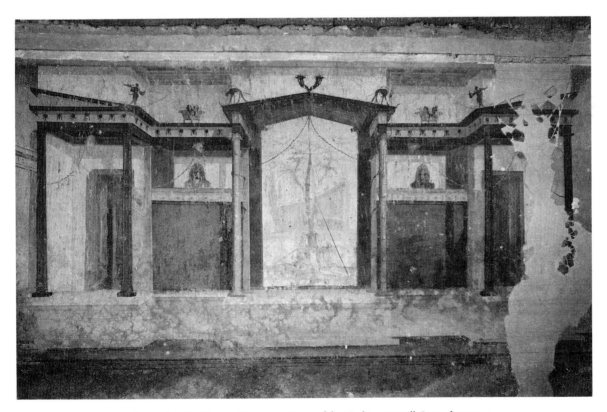

33 Rome, Palatine, House of Augustus. Room of the Masks, west wall. Soon after 30 B.C.

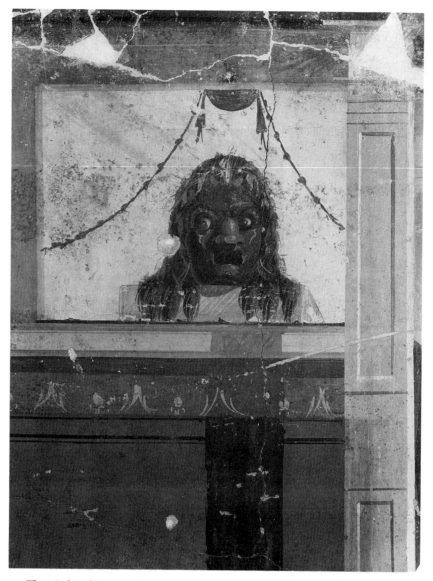

34 Theatrical mask. Rome, Palatine, House of Augustus. Room of the Masks, south wall. Soon after 30 B.C.

which the Second Style was initially based. Other Pompeian decorations introduce further anomalies in this position: mythical monsters and bronze vessels, or ships' prows seen through arches.

Outside Pompeii the sole paintings which have been ascribed to this phase are the Odyssey landscapes, discovered in 1848 in a building on the Esquiline in Rome and subsequently removed to the Vatican Museum. Though the bulk of the decoration from which they came was never salvaged, the general setting is known. The landscapes formed a frieze in the upper part of a Second Style scheme; divided into separate panels by red pilasters seen in perspective, and surmounted by illusionistic ceiling-coffering, they

were evidently conceived as belonging to an outside world visible beyond the enclosing walls; as such they differed from the comparable friezes or panels in the House of the Cryptoportico, which must be envisaged as simulating paintings applied within the imitation architecture. Their content and artistic significance will be examined in a later chapter (pp. 108–11).

The final phase of the Second Style (2B: late 30s and 20s B.C.) sees the dissolution of architectural illusionism. Columns and similar architectural elements become less substantial and real; increased emphasis is placed upon flat surface effects and upon ornamental patternwork, especially that based upon floral or vegetal forms; and large

central pictures tend to dominate the design.

A number of fine examples have been revealed in Augustus's properties on the southern flank of the Palatine. Of prime importance is a complex of rooms adjacent to, and aligned upon, the temple of Apollo which the emperor (then Octavian) vowed in 36 B.C. in a part of his house which had been struck by lightning; the temple was completed in 28 B.C. and the rooms must be ascribed to the same time or immediately after. They have now become known as the 'House of Augustus'. The decoration in the so-called Room of the Masks [33] displays its parentage in perspectival Second Style architecture, with tripartite structures based on projecting pavilions and screen-walls supporting masks [34] in the interspaces; but the supporting columns and pillars have become abnormally flimsy; the openings above the screen-walls reveal only alcoves, not views into an outside world; the colours of the columns, pillars and superstructure are improbably lurid (bright yellow and vermilion); the *acroteria*, insubstantial volute-legged creatures painted reddish brown, make little pretence of being plausible sculptures; and the whole composition focuses on tall pictures of rustic shrines, which while appearing to be seen through the wall, as if through a window, are painted on a white ground which militates against any real sense of a spatial setting. Other rooms retain more solid columns, which are executed in more sober colours, and sometimes put together in structures very reminiscent of those at Oplontis and Boscoreale; but the large central picture is now a regular feature, vistas

beyond the wall are reduced to a minimum, and finely painted chains of flowers and buds adorn both friezes and pillars.

Four rooms in another part of the Palatine complex, long known as the 'House of Livia', and possibly indeed the quarters of Augustus's consort, have paintings at a similar stage of development. The most elaborate, those of the so-called '*tablinum*' [35], belong to an architectural scheme with grand central pictures of which two survive: Polyphemus and Galatea (cf. [113]) on the rear wall and Argos and Io on the right. The structures in which they are set are predominantly closed, the wall surfaces being painted red, but narrow openings at the end of the long (right) wall and in the upper part of the scheme reveal outlooks on to further buildings, now populated with small figures. Otherwise the typical features of the late Second Style are present: elongated columns, often with vegetal sheaths around their shafts; a winged caryatid too insubstantial ever to have performed a supporting function; grotesque creatures squatting on entablatures; chains of stylised floral ornaments; and pure flights of fancy such as pediments in the form of a head with outspread wings or of a mask of Medusa (Gorgon) flanked by a pair of volute-tailed lion-griffins. A second room contains a simple version of a similar architectural scheme, with pictures of rustic sanctuaries like those of the Room of the Masks in the central position. In a third room there is a repeating scheme with a screen of columns linked by fruit garlands in front of orthostates, the same basic formula as used in

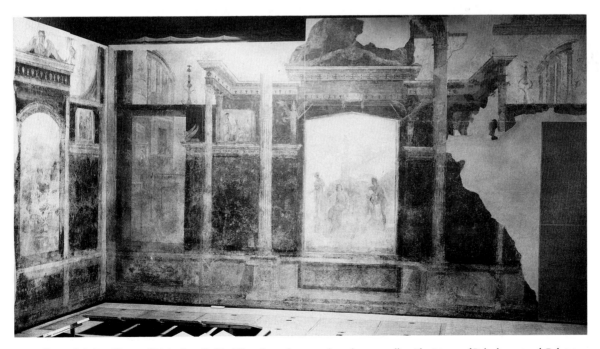

35 Rome, Palatine, House of Livia. So-called '*tablinum*', south-east and south-west walls with pictures of Polyphemus and Galatea (left) and Argos and Io (facing). Soon after 30 B.C.

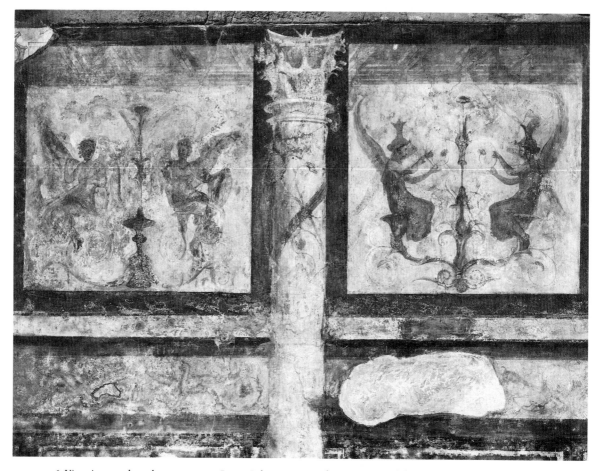

36 Victories seated on plant-ornaments. Rome, Palatine, House of Livia. Room to left of '*tablinum*'. Soon after 30 B.C.

the *fauces* and peristyle of the Boscoreale villa; here the orthostates are white with purple borders, and the main interest is provided by the frieze above, which depicts Egyptianising landscapes in yellow monochrome [149]. The fourth room is decorated in a basically similar manner, except that the garlands are omitted, the colour scheme is much richer (the orthostates are a reddish purple with green and red borders), the columns are more thoroughly vegetalised, and the yellow landscapes are replaced by pairs of monsters in heraldic opposition. The panels at the top of the wall [36] show Victories sitting on volutes at either side of vegetal candelabra (lamp-stands).

It was against such fantasies that the traditionalist Vitruvius, writing at this very time, delivered his well-known passage of invective: 'On the plaster there are monsters rather than definite representations taken from definite things. Instead of columns there rise up fluted reeds; instead of gables, decorative appendages with curled leaves and volutes. Candelabra support shrine-like forms, above the roofs of which grow delicate flowers with volutes containing little figures seated at random. There are also

stalks carrying half-figures, some with human, some with animal heads. Such things neither are, nor can be, nor have been.'

It is ironic that Vitruvius's patrons were evidently in the vanguard of the movement away from architectural 'realism'. Particularly instructive is an upstairs bedroom in the House of Augustus. Here, in a decorative scheme which has been put together from fragments [37], the projecting elements are reduced to a shallow columnar pavilion at the centre and a single column at either side, while the spatial effects are limited to perfunctory recesses with ceiling-coffers at the top left and right. Otherwise the whole emphasis is upon colour, pattern and the central picture, for which the pavilion is little more than a frame. The ornamental character of the scheme is reinforced by the leafy calyces which grow at intervals round the columns or wrap themselves round the entablatures, and by the conversion of the upper part of the decoration into a series of independent compartments with different-coloured backgrounds (yellow, black, red and white) carrying various fantastic ornaments – vases sheathed in foliage and

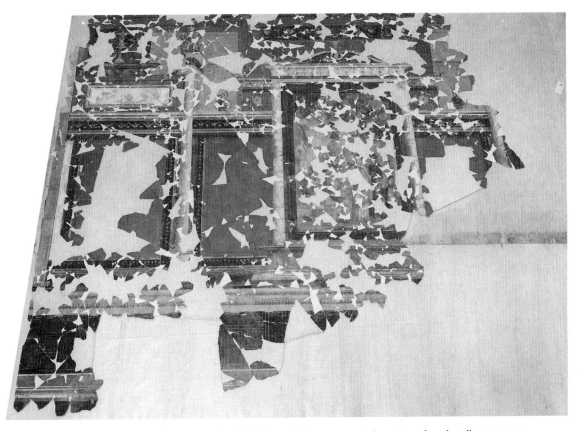

37 Rome, Palatine, House of Augustus. Upstairs bedroom (15), reconstructed decoration of south wall. *c*. 30–20 B.C.

sprouting volutes [Pl. IVA]; great, plastically rendered plant-concoctions incorporating *uraei* (sacred Egyptian snakes), Egyptian crowns and the like; friezes composed of heraldic pairs of griffins with Egyptian crowns and ritual buckets between them, or pairs of swans alternating with lotus flowers containing tiny wine-jars; and pediments formed by intertwining volutes. This particular decoration, which may perhaps be a little later than the more restrained paintings in the ground-floor rooms, has already in effect moved away from structural formulae into a world of pure invention. The strongly Egyptianising flavour reflects a fashion which became especially popular in the decorative arts after the annexation of Egypt in 31/30 B.C.

Rather similar in its disregard of architectural convention and in its choice of ornament is the large room commonly known as the 'Aula Isiaca', barely 100 metres from the House of Augustus and probably part of the same imperial complex. Here the columns of the architecture have become even more elongated and vegetalised, and some are transformed into candelabra [38]. Ornamental friezes and panels proliferate, with plant-forms and chains of stylised lotus flowers and volutes prominent, all exquisitely rendered in tones of lilac, pale green and yellow; the Egyptian influence is clearest in a frieze composed of

uraei, Egyptian crowns and beaked water-jugs at the top of the wall, but is also traceable elsewhere, for example on some of the columns, where the distinctive double-feather crown of the goddess Isis recurs. Most striking of the anti-architectural trends, however, is the use of a uniform white background. This creates an ambivalent sense of space, since the white tends to suggest a world beyond the immediate columnar framework, yet it appears not only in the upper zone, where an opening is to be expected, but also in the main zone, where none can be intended. To increase the ambivalence, this main zone formerly carried mythological landscape paintings (now mostly faded away), rendered as if they passed behind the columns, but floating in the white field in such a way as to counteract the effect of a real vista seen through the wall. The central pavilions in each wall contained independent pictures, here apparently filling their fields; only the one in the apsidal end wall shows any legible remains of its contents – a landscape of rocks and water, containing torches, an altar, a shepherd's crook and other objects. The podium on the same apsidal wall was decorated with water-scapes (cf. p. 34), to which a specifically Nilotic reference is given by the inclusion of pygmies and a hippopotamus.

That the developments seen in the imperial properties

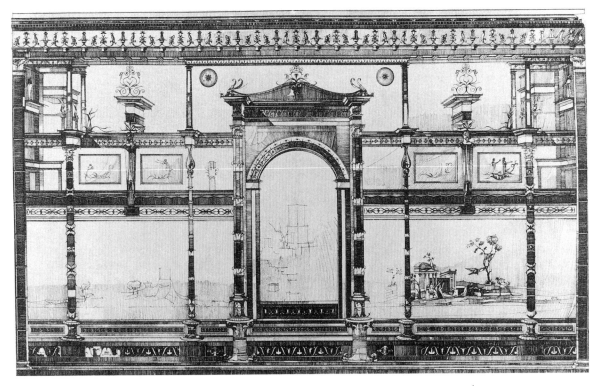

38 Rome, Palatine, Aula Isiaca. Reconstruction of decoration of long wall (drawing). Soon after 30 B.C.

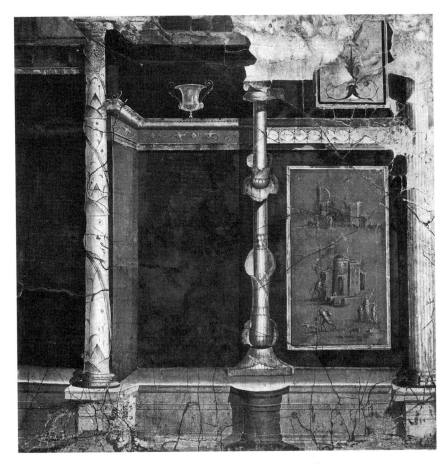

39 Late Second Style decoration with monochrome landscape, from villa at Portici. *c.* 20–10 B.C. Naples, Archaeological Museum 8593. H. 2.09 m.

of Rome also percolated to Campania is indicated, for example, by a decoration from a villa near Herculaneum [39] which contains vegetalised columns and other ornaments similar to those of the House of Livia and the Aula Isiaca, together with blue monochrome landscape paintings descended from prototypes like those at Oplontis. At Pompeii an *oecus* in the House of Obellius Firmus combines richly ornamented columns, including some covered in scale-pattern (cf. p. 59), with a flattening of the podium which takes away the structural basis of the projecting elements above.

Perhaps the last paintings that can fairly be referred to as Second Style are those of a villa discovered in the grounds of the Villa Farnesina on the right bank of the Tiber in Rome. By this stage the principle of the flat, two-dimensional scheme in which colour and ornament are paramount, has virtually won the day. The most elaborate decorations, those of two matching bedrooms (B and D), are ostensibly architectural, but the perspective has been so underplayed that the projecting pavilions with their pedestals and entablatures seem barely to stand out from the rest of the wall [40]; they serve merely as frames for figure-paintings – large mythological pictures in the focal positions, statues of Isis growing from vegetal candelabra at the sides, erotic panels and theatrical scenes above. The emphasis is upon a rich patchwork of colour, in which vermilion is dominant but panels of yellow, black, white

and sky-blue (here found in Roman painting for the first time), form rhythmic blocks within the overall design. These panels almost invariably have frames in contrasting colours, and most of them contain delicately drawn patterns of rosettes, palmettes, lotus flowers, volutes and the like. A favourite ornament, susceptible of countless variations, consists of alternating elements radiating spoke-like from a central rosette along the cardinals and diagonals of a square.

In other rooms single-colour schemes are favoured. In bedroom E the colour is white, and a very simple centralised design is focused on a pavilion containing a picture of a rustic sanctuary; the projection of the podium is once more played down, and the supporting elements include spindly candelabra and grotesques of the type which scandalised Vitruvius. In the large *triclinium* (C) we meet one of the earliest black-ground decorations known in Roman painting [41]. In this case practically all illusion of depth is suppressed: the podium becomes a flat dado decorated with a fine linear meander and surmounted by bands of yellow and turquoise; the columns become exaggeratedly slender candelabra crowned with statuesque figures; and the entablature is reduced to narrow bands in blue, red and yellow. The scheme is paratactic, with ivy and plane-branches slung between the candelabra; a figure-frieze runs immediately below the 'entablature'; and spread over the fields in the middle of the wall are delicate land-

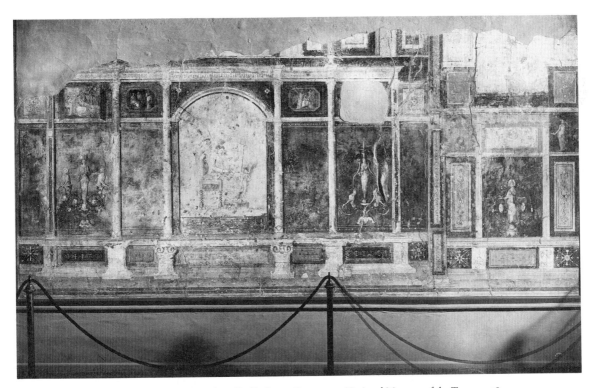

40 Rome, Farnesina villa, side wall of bedroom B. *c.* 20 B.C. National Museum of the Terme 1128.

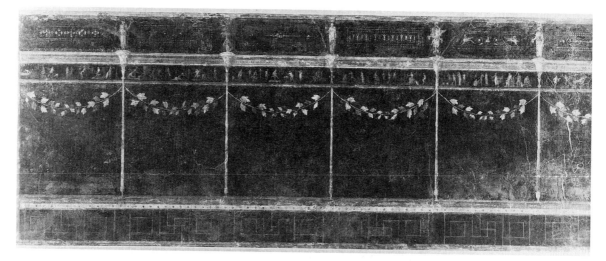

41 Rome, Farnesina villa. *Triclinium* C, left wall. *c.* 20 B.C. National Museum of the Terme 1080.

scapes with tiny figures. The whole decoration is unified by the all-pervading blackness, on which the figures and ornaments are carried out with jewel-like precision in bold yellows, browns, whites and blues.

A similar paratactic scheme, here with a white ground, comes from the long corridor F–G. In this case the fields in the main part of the wall are empty, and the landscapes are placed in the frieze above, where they alternate with still-life compositions [151, 164]. The candelabra are interrupted, immediately below the frieze, by supporting figures which hold the usual garlands spanning the intervening spaces. In the dado there are panels containing stylised plant-motifs. The overall effect of this decoration is naturally quite different from that of the black room, but the means of expression, involving fine dividing bands in bright colours, subtly painted floral ornament, deft and miniaturistic figure-work, and broad areas of plain background which stress the solidity of the wall, are identical. The architectural style is in eclipse, and we are entering a new phase in the history of Roman wall-painting.

Ceiling-decorations

In a period when wall-paintings depended for their effect upon the imitation of architectural forms, it was natural that the decoration of ceilings, as in the previous period, should be influenced by their treatment in monumental architecture. The surviving remains are exiguous, but such evidence as we have reveals that the predominant theme was imitation coffering and panelling. As time went on the general formula was relaxed to admit a greater variety of shapes and a wider range of figured and ornamental representations within the coffers, so that the dissolution of architectural form on the walls was accompanied by a sim-

ilar loosening of the restraints in ceiling-decoration. An important factor in this equation may have been the application of coffering to vaults, a structural form which became increasingly common in domestic architecture during the late second and first centuries B.C. The anomaly of using a mode of decoration designed for flat ceilings upon surfaces which were curved must in itself have exercised a liberating effect on the imagination of the artists.

Of the surviving remnants of ceiling-decorations of the Second Style, a large proportion is not painted but in stucco relief. This medium, which was mostly unaided by colour and relied for its effect upon the play of light and shade on the white of the plaster, allowed a truer approximation, in physical terms, to the stone and wooden coffers of monumental architecture than could the pictorial medium. Already in the House of the Griffins the concrete vaults were decorated with stucco panelling and coffering, whose indebtedness to wooden ceilings is demonstrated by incised diagonal lines at the corners imitating the joints of fine carpentry. As yet there seems, from the surviving fragments, to have been little or no embellishment within the coffered and panelled framework; but by the middle of the first century B.C. it was normal for stucco coffers to be framed with egg-and-dart enrichments and to contain reliefs of armour or plant-forms [42]. In the House of the Cryptoportico, where half a dozen stucco vault-decorations are partially preserved, the strong relief which characterised earlier coffering has been replaced by shallower frames, and the decorative forms have become extraordinarily rich and varied, with coffers of numerous shapes (large and small squares and oblongs, lozenges, concave-sided diamonds, roundels and hexagons) and a wealth of inset reliefs (rosettes, garlands, leaf-sprays, double oak-leaves, thun-

42 Frascati, so-called Villa of Galba, stucco vault-decoration. Second quarter of 1st century B.C.

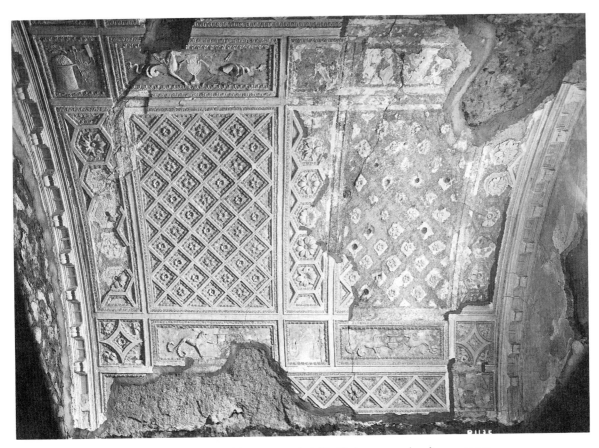

43 Pompeii I 6, 2 (House of the Cryptoportico). *Tepidarium*, stuccoed vault. *c.* 40–30 B.C.

derbolts, dolphins and various assemblages of inanimate objects, including shields and armour, cult-implements, attributes of deities and the equipment of athletics). In the finest decoration, that of the *tepidarium* (warm room of the baths) [43], a series of narrow rectangular fields contains traces of figure-reliefs, including pairs of monsters posed heraldically one on either side of an amphora (wine-jar).

Such coffer-schemes were also rendered pictorially, with the added flexibility afforded by the use of colour and by the illusionistic possibilities of the medium. Fragments of painted coffering survive in the vaults of two bed-alcoves in the villa at Oplontis, and in an arch soffit in the House of Popidius Priscus at Pompeii, each time with shading to suggest the volume of the frames and with painted mouldings and floral or other motifs inside the fields. The coffers consist exclusively of squares or long rectangular fields. The same was true of the painted vaults of an underground chamber-tomb excavated at Montefiore just north of Rome in 1960. Though these paintings have been abandoned to ruin, colour photographs taken soon after the excavation show how the basic scheme of yellow and purple coffer-frames, enriched with *trompe l'œil* mouldings, was supplemented by a full range of colours (blue, red, green, black and yellow) for the interior surface of the fields and for the ornaments painted within them.

In the House of Augustus there are remains both of stucco coffer-schemes very close to those of the House of the Cryptoportico and of illusionistic painted coffering. The vault of the ramp leading from the house to the temple of Apollo was decorated with a painted pattern of square and rhomboidal coffers, whose relief was suggested not only by the use of shading but also by means of perspective, the inner mouldings being arranged in some cases so as to appear hidden by the main frames [Pl. IVB]. This illusionism was again, however, accompanied by a polychromy which set it apart from similar decorations in stucco relief; the frames were rendered in shades of red, yellow and white, the inner mouldings in orange, yellow, pale blue and pale green, the fields and ornaments of the coffers in purple, black, white and yellow. Whether such richness and variety of colouring reflected the treatment of actual ceilings in timber, it is impossible to know for certain; but representations of coffered ceilings in Second Style murals show no trace of it. We may suspect that the painter's inventiveness was carrying him away from the conventions of the media which had originally inspired him.

The vault-decoration of the upstairs bedroom in the House of Augustus, like its wall-paintings, appears to have

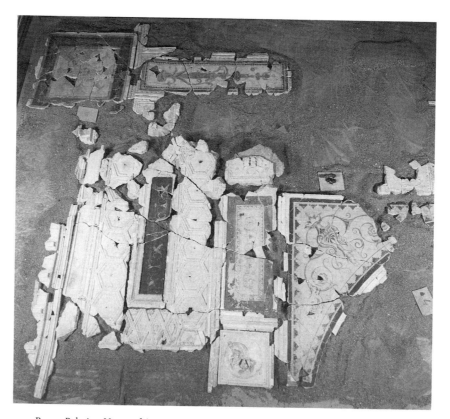

44 Rome, Palatine, House of Augustus. Upstairs bedroom (15), fragments of ceiling-decoration. *c.* 30–20 B.C.

been more advanced than those of the ground floor. Here for the first time we meet a fully integrated composition of painting and stucco relief. The main frames are in stucco relief, very similar in form to those of the *tepidarium* in the House of the Cryptoportico, while the fields are decorated either with white stuccowork, including networks of lozenges and hexagons, again reminiscent of the Pompeian decoration, or with painted florals and arabesques. The latter, carried out on both white and coloured grounds, are precisely and delicately rendered in red, pink, yellow and pale green with white highlights. Although difficult to assess in its present fragmentary condition [44], this ceiling was evidently in its complete state a masterpiece of its kind, with carefully balanced emphases of whiteness and polychromy combining with the wealth of exquisite detail to produce an unprecedented blend of richness and elegance. Its layout, too, broke new ground [45]. In the central area a rectilinear system based on a grid of squares was overlaid by a pair of concentric roundels in such a way as to produce a complicated interlocking of square, oblong and curvilinear fields focused on a central tondo (which contained some kind of painted figure-scene). Centralised vault-designs were destined to enjoy great popularity in the Imperial age (pp. 87–91, 178–81, 188).

Another vault-decoration which combined stucco relief with colour was that of the room in the Villa of Livia at Primaporta (*c.* 20 B.C.) which yielded the famous garden paintings (pp. 149–50). Here only the lowest part of the scheme, with a series of square or rectangular panels, alternately white and coloured, is preserved, and it is not clear what happened in the upper parts. In the surviving panels, however, the colour is used not for painted detail but as a plain background to white stucco relief, in this case a series of Victories poised on low candelabra.

Other vault-decorations from the final years of the Second Style are executed either totally in stucco relief without the aid of colour or totally in painting. They show how each medium had by now acquired its own language. From the Farnesina villa come the remains of several decorations executed in delicate, all-white stuccowork, masterpieces of their medium; the old coffer-grid still forms the basis of the designs, but the deep frames have been replaced by shallow channels, giving greater prominence to the egg and dart and other enrichments of the inner mouldings, while the square units have been merged to form systems of fields so complex (including large and small squares and oblongs, T-shaped and H-shaped fields, and long friezes, sometimes with right-angled bends) that the underlying grid is barely discernible. Above all, the figured and ornamental reliefs (landscapes, Dionysiac scenes, Victories with candelabra, busts, grotesques and floral motifs) [46] have become the dominant element in the composition.

The vault of the Aula Isiaca, on the other hand, shows the possibilities of the pictorial medium. Here all vestiges

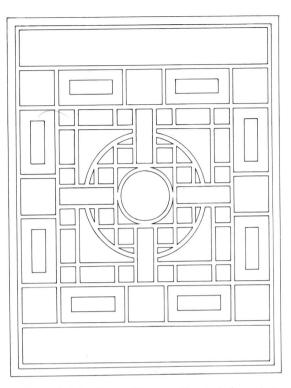

45 Rome, Palatine, House of Augustus. Upstairs bedroom (15), scheme of ceiling-decoration. *c.* 30–20 B.C.

of coffering have disappeared, and we are presented with the remnants of an extraordinarily free decoration dominated by organic forms and by a great snaking ribbon in blue, gold and pink [47]. The ribbon ran round the edges of the surface and also delineated a frieze or a series of panels at either end, in which were set half-plant, half-animal motifs; further baroque fancies, involving sprawling tendrils, lotus calyces and the foreparts of birds and deer, grew diagonally from the corners of the central area towards some unknown focal element. All this was rendered in bold, sweeping forms, fully modelled with shadows and highlights, against a white background. The exuberant imagination of these paintings contrasts startlingly with the remaining vault-decorations of the Second Style; but the fact that a large-scale floral composition is known from a Macedonian painted vault of the Hellenistic period may serve to remind us how imperfect is our record. Such floral paintings, perhaps inspired by woven or embroidered hangings, could have continued as a separate tradition alongside coffer or coffer-derived schemes, possibly (as in the Macedonian tomb) in association with plain or simply decorated walls; they would then have been available to inspire the decorators of the Aula Isiaca at a time when the canons of architectural wall-painting, to which coffering was particularly appropriate, were being broken down.

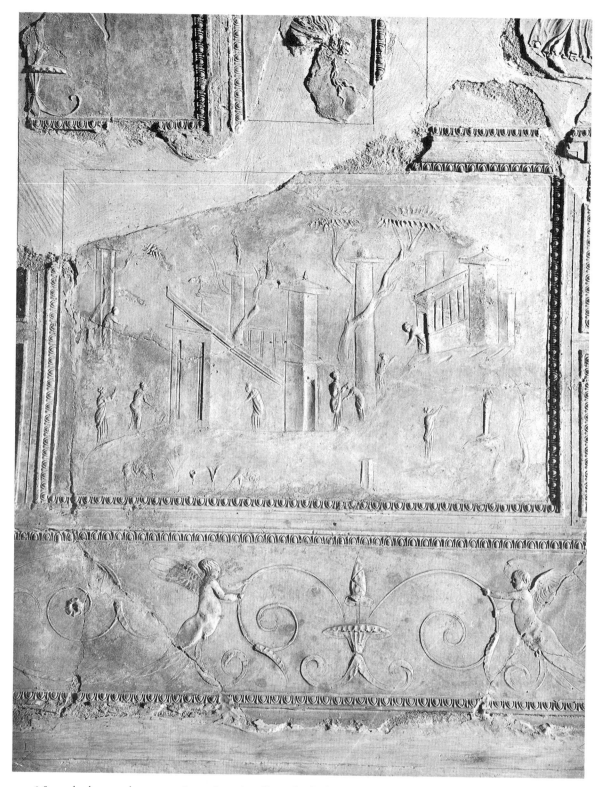

46 Stucco landscape and grotesques. Rome, Farnesina villa, vault of bedroom D. *c.* 20 B.C. National Museum of the Terme 1037.

47 Detail of painted vault. Rome, Aula Isiaca. Soon after 30 B.C.

A corollary of the use of vaulting is the creation of lunettes, semi-circular or segmental fields above the end walls of the room. Since these fields lay outside the continuous scheme of the walls and could be conceived as belonging in some sense to the structure of the ceiling, they were often decorated in stucco relief, a medium which otherwise in this period rarely ventured on to walls. Whether decorated in stucco or painted, the lunettes were always treated in separate fashion from the remaining fields. In the House of the Griffins two of them were occupied by large heraldic groups, a pair of peacocks and the griffins which have given the house its name (a device foreshadowed in a Hellenistic tomb in Alexandria); and a third contained an acanthus plant with spreading tendrils inhabited by birds. These symmetrical designs, well suited to the shape of the field, were executed in white relief on a red background. In the House of the Cryptoportico the lunettes of the *tepidarium* show traces of large-scale figure-scenes executed in stucco relief on a white ground; the best preserved represented Cupids struggling to lift the gigantic quiver of Hercules (Heracles) in a perfunctory landscape setting. In the House of the Menander there was another figure-scene, this time painted; its subject was the story of Hercules' rescue of Deianira from the clutches of the centaur Nessus. In the tomb at Montefiore there was at least one painted heraldic group (two peacocks facing a wine-cup), but the other lunettes contained series of sketchily painted birds perched among rocks and flowers and a still life of trussed game-birds and fruit.

All these themes show a remarkable contrast with the basically architectural repertory of the walls and vaults. Even if the griffins and plants of the House of the Griffins

can be explained as respectively standing upon and growing out of the imitation masonry of the wall below, no such interpretations can be offered for figure-scenes and groups of birds in landscape settings, which are clearly independent compositions placed there without any pretence of rationality. Once more we must be wary of believing that the Second Style is a literal and consistent transcription of architectural reality; it remains first and foremost a style of painted wall-decoration, subject to its own conventions and its own internal logic.

Context

As wall-paintings acquired ever greater visual and artistic interest, there were changes in the nature of pavements. Figurative themes in general, and pictorial *emblemata* in particular, became less common, and the plainer, non-representational types of floor-decoration almost totally supplanted them. Mortar floors with patterns of inset *tesserae* remained popular, and the range of patterns employed became more varied, with pieces of coloured stone being inserted. Other favourite types of flooring included patchworks of coloured stone fragments set in backgrounds of irregular chippings or (generally black) *tesserae* and patterns of oblong *tesserae* arranged to produce a basket-weave effect. To offset the polychromy of the walls, black and white designs were especially favoured. These were generally carried out in conventional tessellated mosaic – either plain white, with perhaps a black border and a regular sprinkling of black *tesserae*, or in the form of black linear patterns (hexagonal networks, lozenges set in rectangles, a star-like arrangement of lozenges within a circle, patterns of chequers and triangles and so forth) on a white ground. Where figure-subjects occurred, they were often simple subjects in the context of this black and white style, either in pure black silhouette or in restricted colours such as black with some red and grey; good examples are offered by the marine fauna and fishermen in the pavement of the House of the Menander *caldarium* (hot room), and the bath-attendant with oil-flasks and body-scrapers in the entrance-passage of the same room.

Just as the general renunciation of illusionism and polychrome figure-work in Second Style pavements was a response to the increased elaboration of painted walls, so too the popularity of plain white stuccowork on vaults may have been due to the same factor. Both pavements and ceilings played their part in achieving a pleasing colour balance within the overall decorative scheme. In other respects too attempts were sometimes made to harmonise the decorations of walls, floor and ceiling. This could be achieved by direct visual links, as for example in room II in the House of the Griffins, where the pattern of cubes in perspective used on the painted podium of the walls is repeated for a pavement *emblema*. Alternatively it could be achieved by making supporting members in the wall-paintings

48 Pompeii I 6, 2 (House of the Cryptoportico). *Oecus* at south-east end of cryptoportico, fragment of stuccoed rib and cornice. *c.* 40–30 B.C.

correspond to decorative emphases in the vault-decoration, as happened in the *oecus* at the south-east end of the Pompeian cryptoportico; here the herms carrying entablatures on their heads were painted directly beneath, and thus appeared to carry, a series of stuccoed ribs in the vault [48].

More generally there seems to have been a certain degree of exchange of patterns and ideas between the different surfaces and media. This is particularly true of ceiling- and floor-decorations. A number of mosaic pavements of the first century B.C. (cf. [49]) reproduced more or less closely the coffer-systems of wooden, stuccoed and painted ceilings, including the typical ornaments within the fields – rosettes, shields and thunderbolts. In accordance with the general tendency of Second Style pavements, this type of decoration moved away from an illusionistic and polychrome treatment in the first half of the century towards a two-dimensional black and white technique in the second half; and the imitative coffer-frames tended in the later ver-

sions to be reduced to conventional patterns. The second half of the century also saw the appearance in mosaics of several other patterns which had served their apprenticeship on vaults: networks of hexagons, an eight-lozenge star set in a roundel, a diagonally placed square with incurving sides. All of these motifs, found in the stuccoed vaults of the House of the Cryptoportico, can be paralleled in the contemporary pavements of the same house, notably in the suite containing the room of the elephants. The mosaic versions are very sober in comparison with their stuccoed and painted counterparts, being mainly black and white, and lacking the enrichments and internal ornaments of the ceilings, but it is not hard to believe that mosaicists had got the general designs and shapes from their colleagues in the other media.

Between wall-paintings and the decorations of floors and ceilings there was less cross-fertilisation: the architectural structures shown on vertical surfaces were not in themselves suitable subjects for representation on these other surfaces. Obviously decorative subjects which were part of the general repertory of the arts in the first century B.C. found their way into all the media; the armour represented in both stucco vaults and mosaic pavements, for example, appears in a painted frieze on the walls of the *atrium* of the Villa of the Mysteries; while vegetal and floral ornaments, including garlands of fruit and flowers, occur both in the stucco vaults of the House of the Cryptoportico and on numerous wall-paintings. But these themes were the common coin of their time; numerous parallels can be cited in the other decorative arts, relief sculpture for instance. A more specific borrowing may be detected in the representation of ships' prows seen through arches on one or two mosaic pavements; this motif, found in the socle of a couple of wall-decorations (cf. p. 36), could well have been taken by the mosaicist from painted prototypes. And as the Second Style became increasingly divorced from its architectural *raison d'être* and admitted a greater number of purely ornamental elements, the links between the decorations of walls and ceilings became more numerous. In the Aula Isiaca and the upstairs bedroom of the House of Augustus there are close family resemblances between some of the painted floral and vegetal motifs on the walls and those on the vaults. In the Farnesina villa the same is true despite the difference in media: the stucco landscapes, grotesques and radiating floral ornaments of the vaults were clearly planned by the same directing intelligence, if not actually executed by the same artists, as the comparable painted motifs on the walls.

As decorators sought in many cases to fit together the different components of a décor so as to produce a harmonious ensemble, so too they took care to adapt these decorations to the architectural context. The most characteristic form of this adaptation was the use of paintings and pavements to stress the functional divisions in bedrooms, dining-rooms and *oeci*. The arrangement of bed-

49 Tusculum, mosaic panel from a pavement imitating ceiling coffering. Mid 1st century B.C. National Museum of the Terme 1238. H. 1.01 m.

rooms in the time of the First Style has been mentioned above (p. 21). During the Second Style the floor of the bed-alcove was not normally raised, but it continued to be set off from the rest of the room by its lower, vaulted ceiling, and the distinction was now more clearly stated in the floor- and wall-decoration. Illusionistic pillars and pilasters painted on the walls, and a change of pattern in the pavement, often accentuated by an ornamental threshold, marked the transition from the *procoeton* to the alcove, and the paintings inside the alcove adopted a different, generally smaller-scale and often more elaborate, decorative scheme from those outside. The Boscoreale bedroom was a case in point [27]; the triptychal scheme on the side

walls of the *procoeton* was separated from the *tholus* court and fountain grottoes of the bed-alcove by a pillar which reached down to floor level (as opposed to the columns, which rested on a podium); the change of subject was accompanied by changes in the decoration of the podium, not to mention the use of an independent system of perspective for the painted buildings; and the mosaic pavement, otherwise totally white apart from a black border in the *procoeton*, was crossed by a threshold band of coloured scale-pattern. Similar functional relationships can be observed in the bedrooms of the Villa of the Mysteries and the villa at Oplontis, which each contained a pair of alcoves in adjacent walls. Here the walls of the alcoves received complex architectural schemes while the *procoeton* was distinguished not only by the larger scale and greater simplicity of its decoration but also by striking changes of colour; in room 16 of the Mysteries villa, for example, the vermilion orthostates and multi-planar perspectives of alcove B [Pl. IIA] contrast sharply with the large yellow orthostates and simple 'closed wall' of the main part of the room.

In *oeci* and dining-rooms there were similar divisions into a forepart and inner part, the latter of which was frequently spanned by a vault. In relation to bedrooms, however, the space ratio was naturally reversed, since the antechamber functioned merely as a passage or service area, while the rear part had to house the couches of the guests or diners; thus where a bed-alcove need be only a third or a quarter of the area of the *procoeton*, the inner part of the *oecus* or dining-room accounted for more than half of the space available. Otherwise it was defined by identical means to the alcove in bedrooms – by a change of wall-decoration marked by painted pillars or pilasters, and by a mosaic threshold across the floor. A well-preserved example appears in the dining-room 14 in the villa at Oplontis, where the walls of the forepart of the room are decorated with a simple system of orthostates, while those of the area reserved for the diners have elaborate architectural schemes with a central portal and perspectival recession; the dividing point is marked by a band of meander in the pavement [50]. Even more striking is the articulation of the room of the elephants in the House of the Cryptoportico at Pompeii. This *oecus*, originally entered from the south, was turned round when the house was divided, and access was provided by a new door at the north end of the west wall; but the original format with an antechamber at the south and the main reception area behind it remained enshrined in the wall-paintings and mosaic pavement. The antechamber had a plain white pavement and walls decorated with a simple scheme of orthostates; the reception area, marked off by a mosaic threshold containing a plant-scroll, was decorated with the large-figure murals already mentioned (p. 33) and with an elaborate pavement compounded of various geometric patterns.

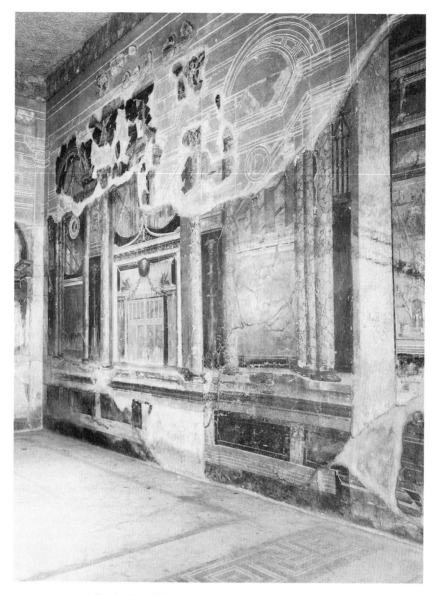

50 Oplontis, Villa of the Poppaei. *Triclinium* 14, east wall. *c.* 50–40 B.C.

Examples such as these could be multiplied. In some *oeci* the functional differentiation is further emphasised by the introduction of actual columns to support the vault of the reception area [51]; here the decorative divisions became even more important because the painted pillars on the walls answered to the real supports at the front of the hierarchically emphasised space, while the decoration of the pavement was inevitably adapted to take account of, and to effect a visual unity between, these supports.

In more general respects too the decorations of the Second Style took account of their architectural context. For example, paratactic schemes were preferred for passages (cf. [30]) and peristyles, where they emphasised the continuity of the wall and (in peristyles at least) set up a rhythmic correspondence to the colonnades, with painted columns opposite the real ones. Where such schemes occurred in other kinds of room, it was probably because the length of the walls was so great as to be unfavourable to centralised arrangements (as in the Farnesina black *triclinium*) or because the room in question was an open-fronted *oecus* or *exedra* in a peristyle (cf. [51]), and it was felt desirable to harmonise its decoration with that of the walls to left and right of the entrance. In small or enclosed rooms centralised schemes were favoured, if only because the limited length of the walls posed less problems for the rendering of the linear perspective which fashion deman-

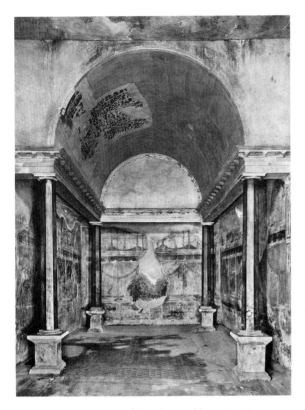

51 Pompeii V 2, i (House of the Silver Wedding). View into *œcus* 4. Mid 1st century B.C.

and *oeci*, is 'asymmetrical perspective', that is the treatment of the side walls with lines of recession whose vanishing point or axis is not at the centre but at the rear corners [22; Pl. IIA]. Such schemes favour the viewpoint of a person looking outwards from the bed-alcove or resting-point at the back of the room. Since there is usually a broad doorway providing a view into the open air, the perspective is consciously related to the viewer's gaze towards a panorama. On the back wall, however, the perspective is centralised, in deference to the viewpoint of someone first entering the room.

Finally the matter of lighting. We have already noted (pp. 21, 24) how the shadows in architectural wall-paintings tend to fall away from the actual light-source in a room; in most instances this is the doorway, but in the bedroom at Boscoreale it is a window in the rear wall. Decorations also to some extent took account of the amount of light available. Thus gloomy rooms such as cryptoporticoes were often lightened by the use of white-ground wall-paintings (the Farnesina villa) or at least by white stucco-work on the vault (the House of the Cryptoportico). The use of black, on the other hand, was recommended by Vitruvius for winter dining-rooms, partly to avoid discoloration by the smoke from lamps and braziers, and partly perhaps because black would tend to retain the heat. Such rooms in addition faced south, in order to take advantage of the low winter sun; so the availability of direct natural illumination would have compensated for the sombreness of the colour scheme. It is significant that at least three of the surviving decorations of this period in which black played a prominent part were in south- or south-west-facing dining-rooms or *oeci*. In the Villa of the Mysteries (*oecus* 6) and in the House of the Epigrams (room 14) there were black orthostates, respectively in the front part of the room and in the rear part, while the Farnesina *triclinium* received an all-black decoration – a forerunner of several such schemes in the succeeding period.

ded; longer walls would inevitably (unless they were very high, as in the great *oecus* at Oplontis) have flattened the lines of recession and made the perspective less successful.

Sometimes the actual organisation of the perspective seems to have been adapted to the context. A peculiar feature of the early Second Style, found especially in bedrooms

4

The Third Style

Decorations such as those of the Farnesina villa were already transitional from the Second to the Third Style, since the schemes in certain rooms (notably the black *triclinium* and the white corridor F–G) had more or less renounced the tradition of architectural illusion. Within the next few years the Third Style had become the dominant fashion in Roman-Italian wall-decoration, a primacy which it retained at least till the middle of the first century A.D. During this period it achieved as widespread a popularity as its predecessor. Versions of it are found in all parts of Italy and in the northern provinces (Chapter 8). But the bulk of the material comes from Pompeii and its vicinity, and it is primarily upon this that any study must be based.

The detailed chronology of the style has long been a matter of controversy. Absolute dates are few and mostly confined to the early years. The simple decoration in the burial-chamber of the pyramid of G. Cestius Epulo, outside the Ostia Gate of Rome, must be dated no later than 12 B.C., because an inscription on a statue-base found at the foot of the pyramid names Augustus's minister Agrippa, who died in that year, as one of Cestius's heirs. The fine early Third Style paintings from the villa ascribed to Agrippa's son, Agrippa Postumus, at Boscotrecase, three kilometres north-west of Pompeii, may be dated soon after 11 B.C. on the basis of stamped tiles found there which name the consuls of that year (and which were manufactured on Postumus's estate). Identical tile-stamps were found in the so-called Caserma dei Gladiatori (Gladiators' Barracks) at Pompeii, and it is possible that here too, though the 'Caserma' probably existed earlier, there were building operations soon after 11 B.C. with which the early Third Style paintings in a *triclinium* at the north-east corner of the peristyle may be associated. For the later development of the style there are hardly any external dating criteria, and the chronologies which have been proposed are dependent on hypotheses as to the likely pattern of evolution and to the date of the beginnings of the Fourth Style. This has now been shown beyond reasonable doubt to have reached Pompeii before the earthquake which seriously damaged many buildings in the city in A.D. 62 (pp. 72, 75); it was probably already the leading fashion by the 50s, so its pre-

decessor, the Third Style, was effectively coming to an end in the 40s.

The two fullest and most up-to-date analyses are those of F. L. Bastet and W. Ehrhardt. The former proposes a five-part classification structured very similarly to that of Beyen for the Second Style: that is three stages in which the style developed to maturity, and two in which it 'declined'. Phases 1A (dated approximately 20–10 B.C.) and 1B (*c.* 10–*c.* 1 B.C.) mark the progressive disintegration of architectural elements and their replacement by non-functional ornament; Phase 1C (*c.* A.D. 1–*c.* 25) sees the culmination of this process in a harmonious and fully two-dimensional manner; and Phases 2A (*c.* A.D. 25–*c.* 35) and 2B (*c.* A.D. 35–*c.* 45) are characterised by the gradual breakup of the style, with the return of architectural elements and a greater complexity of colouring and construction. Ehrhardt's scheme differs in several respects, notably in allowing more overlapping with the Second Style at the beginning and with the Fourth Style at the end, and in admitting a degree of revival of earlier schemes and motifs in the later years of the style. Unlike Bastet he stresses the structural plausibility of the decorative framework when conceived in terms of materials such as wood, ivory, gold and glass; only the proportions are exaggerated in their thinness and the statics therefore unrealistic.

For our purposes it will be sufficient to pick out the general features of the style with the aid of a few selected examples. These are grouped in two main phases, divided roughly at the death of Augustus.

First phase

The chief characteristic of the Third Style is that it rejected illusionism in favour of surface effects and fastidious ornament. While the 'projecting' podium of the Second Style gave way to a flat black dado with linear decoration, the architectural structures which had rested upon it were largely replaced by bands of delicate polychrome motifs; only the central pavilion retained its architectural form, but with columns too tall and spindly to be credible as supports, with all suggestion of depth and volume reduced to

the minimum, and with the central picture within the pavilion much more explicitly represented as a framed panel. Hints of perspective lingered in the upper zone, generally on a white background, but the forms were now of a matchstick thinness and functionally unreal. In regard to decorative syntax, the zones (dado, main zone and upper zone) are more clearly distinguished than heretofore, often by means of contrasting colour schemes; and there are frequently independent friezes, again distinguished by colour, along the foot and the top of the main zone. Overall the effect, especially in the first phase, was restrained and elegant, with solid areas of red, black and white predominant; while the marvellous richness of the ornamental detail, rendered with miniaturist precision, was carefully subordinated to the general design. Empty space no longer worried the painters: the outer parts of the main zone were left largely untenanted, with the statuesque figures or framed panels which had occupied this position in the late Second Style being reduced to small floating figures in the middle of their fields, or being omitted altogether. The painted pictures of this period were equally restrained. A favourite device was to put a mythological scene in a landscape setting which dwarfed the protagonists, but in which the effects of space and distance were blunted by the classical grace of the figures and by their tendency to be confined to a shallow 'stage' within the picture-field, with rocks and trees blotting out the horizon behind them. These 'mythological landscapes' will be discussed in Chapter 6.

One form of decoration especially popular in the early years of the Third Style was the so-called 'candelabrum style', which as its name implies consisted of simple schemes articulated by candelabra. This had already appeared in late Second Style contexts, for example in the Farnesina villa, where the murals of the black *triclinium* [41] and the white corridor were to all intents and purposes candelabrum decorations; and at Pompeii it appears cheek by jowl with paintings in the late Second Style in adjacent rooms of the House of Paquius Proculus, presumably redecorated in the years round 20 B.C. or soon after. Here the candelabrum decoration was on the east wall of the *tablinum*; it contained a central field framed by candelabra, while further, isolated candelabra at the sides were surmounted by winged figures, all on a white ground. The dado, black and completely flat, was decorated with a panel containing a female grotesque between two centaurs and with a pair of telamons. Another candelabrum scheme of sorts is our first externally dated Third Style decoration, that of the pyramid of Cestius (shortly before 12 B.C.). Again on a white background, it showed a paratactic arrangement of orthostates and narrow vertical panels decorated with candelabra; within the orthostates were small female figures and vases.

A fine specimen of the candelabrum manner, boldly original in its conception, occurred in the *triclinium* at the north-east corner of the Caserma dei Gladiatori (soon after 11 B.C. ?). Here the walls were divided by fluted stucco pilasters into an antechamber, painted black, and the dining area, which was left white [52]. In the former the main figure-subject, opposite the entrance, was a female herm holding a garland, while the upper zone contained a pair of female heads ending in volutes; in the latter the side walls were divided by two slender green candelabra which rose into the upper zone and were crowned with winged female grotesques, while the interspaces contained isolated figures – maenads, a female seated on a volute-base, and further females standing on pedestals with stringed instruments in their hands. The back wall, also white, was decorated with a sacred landscape in vignette-form at the centre, a hanging garland at each side, and various fanciful figures holding fine tendrils in the upper zone. Further decorations of this type could be added, but the basic features are already clear. The painter eschews all suggestion of depth and virtually all semblance of reality; in their place he stresses the solidity and impenetrability of the wall by means of broad areas of a single colour, and uses figures and ornamental motifs, mostly selected from the world of fantasy, as pure surface-decoration.

The candelabrum style can probably be seen as the sequel to the simple paratactic decorations of the Second Style; indeed the garlands hanging between the candelabra of the Caserma dei Gladiatori *triclinium* directly recall the identical motive in those earlier schemes. Conversely the numerous decorations with a central columnar pavilion, or *aedicula*, flanked by plain fields at the sides are descended from the Second Style's centralised schemes. An early Third Style mural in Region V at Pompeii, now faded out of sight but known from a nineteenth-century drawing [53], shows a close relationship to the paintings of the previous phase. Although the socle has acquired the new standard form of facing, black with fine linear patterns, its upper crowning retains some rudimentary depth to support the columns and candelabra of the main zone, and the central *aedicula* has a coffered ceiling in perspective. Further reminiscences of the late Second Style are panels and friezes with stylised floral motifs on both white and coloured backgrounds, and a pediment formed by winged grotesques and a central head, a motif found in the '*tablinum*' of the House of Livia. In the upper zone, however, though the perspective is more developed and the architectural heritage more clearly affirmed, none the less the slenderness and unreality of the structures, in which the supporting function is performed by needle-thin candelabra embellished with calyces and volutes, takes us into a world of fantasy. The architecture, moreover, has lost much of its rhyme and reason; it is ostensibly logical in its arrangement, but the accumulation of different architectural motifs and their combination with blocks of colour (red, blue, green, white) used in an incongruous manner has the effect merely of producing an interesting pattern.

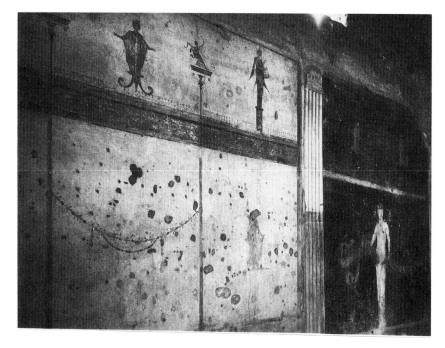

52 Pompeii V 5, 3 (Caserma dei Gladiatori). *Triclinium n*, detail of east wall. Soon after 11 B.C.?

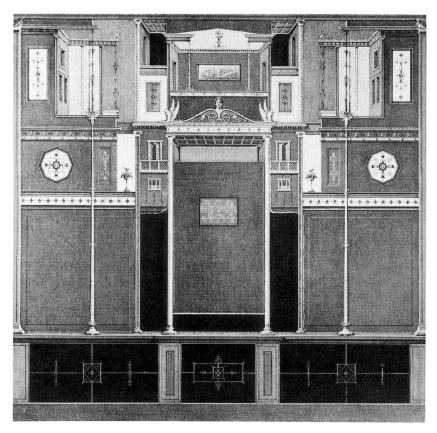

53 Pompeii V 1, 14, early Third Style wall-decoration (lithograph). Late 1st century B.C.

54 Egyptianising scene. Boscotrecase villa, black room (15), north wall. Soon after 11 B.C. New York, Metropolitan Museum of Art, Rogers Fund 1920: 20.192.3.

The painter's allegiance to structural realism is finally abandoned.

The finest achievements of the early Third Style are the decorations from the villa of Agrippa Postumus at Boscotrecase, probably to be dated soon after 11 B.C. This villa was destroyed in 1906, but paintings salvaged during excavations between 1903 and 1905 found their way to Naples Museum and the Metropolitan Museum of Art, New York, and it is possible to reconstruct the schemes of three rooms more or less in their entirety. The first was black; only the dado, a dark purplish red with linear patterns carried out in white, diverges from the predominant tone. Divisions were effected by matchstick-thin columns and candelabra, the former supporting rudimentary *aediculae* which contained the main representational subjects – exquisite landscape vignettes in red, yellow, blue and green [152]. A minor role was played by a pair of Egyptianising cult-scenes in little yellow panels [54]. The second room [55] was red, apart from a black dado and from the central pictures, which contained bucolic landscapes in

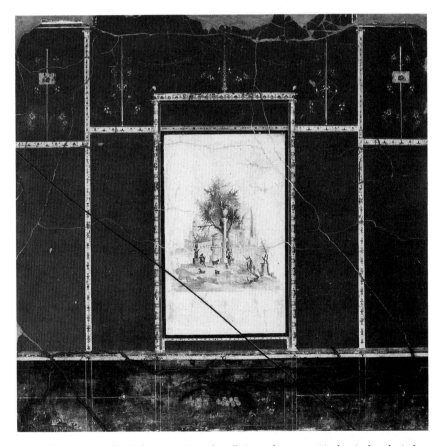

55 Boscotrecase villa. Red room (16), north wall. Soon after 11 B.C. Naples, Archaeological Museum 147501. H. 3.31 m.

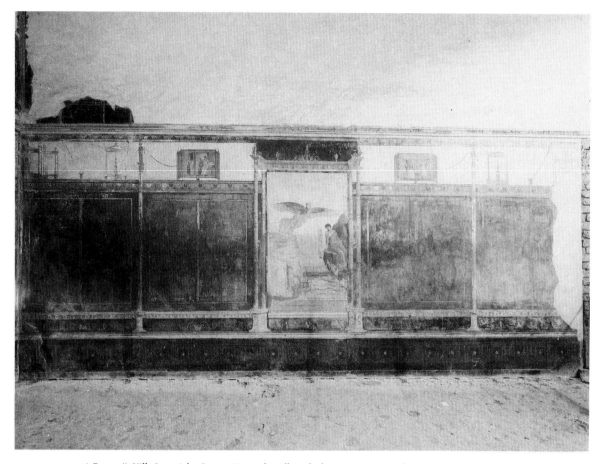

56 Pompeii, Villa Imperiale. *Oecus* (A), south wall. End of 1st century B.C. or beginning of 1st century A.D.

greens, browns and yellows floating on a white ground (cf. [153]); the columns of the central *aediculae* and the various vertical and horizontal dividing bands within the scheme showed the characteristic Third Style embellishment, with intricate patterns of banding and other ornaments, heart-shaped, bell-shaped and so forth, in red, yellow, purple and green on a white ground. In the upper zone there were slender poles twined with tendrils, some of which supported little tablets decorated with theatrical masks or griffins. The third room, less of which is preserved, was dominated by two great mythological landscape paintings showing Polyphemus's love for Galatea and Perseus's rescue of Andromeda (see p. 114); these were evidently surrounded with white, but there were red fields at the sides, bisected by candelabra from which hung garlands. A yellow frieze ran above, containing little black panels with masks, pairs of griffins and further Egyptianising figures.

A bare description does scant justice to the delicacy and beauty of the painting. Figures and ornaments alike were rendered with a sureness of touch and (what was one of the hallmarks of the Third Style) a meticulous attention

to detail; the plant-forms and dividing bands in particular were carried out with lines which are often pencil-thin, and every element is precisely spaced and sized. All this is thrown into relief by the liberal use of empty space; broad areas of the wall are left in the black or red of the ground colours, totally devoid of decorative elements.

Another series of paintings which must be ascribed to the early Third Style are those of the first phase of the so-called Villa Imperiale at Pompeii, an Augustan mansion terraced into the city-walls next to the Marine Gate. The most complete and most important decoration is that of the central *oecus* (A) [56]. Though the upper part of the wall and the vault were redecorated at the time of the Fourth Style (see pp. 87–9), the dado and main zone preserve the original scheme (restored on the north wall and part of the east) in which three grand mythological pictures with a Cretan theme are set in a clearly constructed zonal system. Here, in contrast to Boscotrecase, the main zone, painted vermilion, is provided with a narrow frieze along its foot (the 'predella') and is differentiated by colour from the frieze above, which has a white ground suggestive of the illusionistic openings of the Second Style though now

treated merely as a neutral backdrop. The predella, perhaps partly a relic of the upper surface of the Second Style podium, is decorated with acanthus scrolls and tiny figure-scenes, all on a black ground. The frieze contains a few independent architectural structures, a series of six panel-pictures, and little caryatids holding garlands, an idea prefigured in the Farnesina paintings. Otherwise virtually the only ornaments in the whole scheme are the fine linear meander with star-like rosettes in the dado and the delicate polychrome bands which run along the top and bottom of the main zone and along the entablature of the central pavilions. These pavilions, like those at Boscotrecase, project upwards into the frieze, while the caryatids stand on columns which rise through the main zone, thus achieving a visual integration between the two separately coloured zones.

A very similar decoration was applied in a *triclinium* in the same house [228], with the differences that the main zone was red ochre rather than vermilion, the dado was black rather than purple, and the central panels took the form of mythological landscapes rather than scenes with large figures; how the frieze was decorated is uncertain, since it was replaced at the time of the Fourth Style, together with the upper zone. Elsewhere in the house a bedroom [70] was provided with a relatively modest white-ground candelabrum scheme. Here the main zone was plain apart from garlands in the bed-alcove and small figures, mostly removed in antiquity, in the forepart of the room; decorative interest was instead focused on a frieze carrying pictures, and on the upper zone, which contained fantastic architecture.

Characteristic of all the Third Style rooms in the Villa Imperiale is the fact that the sections of the main zone to left and right of the central *aedicula* were invariably turned into large framed fields by the addition of linear borders. These fields, unadorned save for small emblems at the centre, represent a clear statement of the primacy of surface-decoration: the wall is closed with solid 'slabs' once more, just as it was in the early Second Style. The closure is now indeed even more complete than in the Second Style, whose orthostates passed behind a screen of columns, whereas the new framed fields actually alternated with the flimsy columns and candelabra of the design, thus appearing to be on more or less the same plane.

A further decoration which should probably be ascribed to the Augustan period is a wall from the House of Spurius Mesor at Pompeii, reconstructed in a colour lithograph published by Mau [Pl. VA]. This shows a slightly busier effect than the specimens considered so far. In addition to the fine polychrome entablature of the central pavilion, with its little squares and rosettes in a pattern of pink, green, yellow and white, the linear borders of the red side fields are interrupted by further squares and little medallions containing floral motifs in yellow and white on a green ground, and the predella changes colour from yellow to purple beneath the central picture. The upper zone, again white, but now more sharply marked off from the main zone by a continuous horizonal division, carries exaggeratedly slender architectural forms and candelabra, linked by horizontal rods and embellished with vegetal sprigs, vases and parakeets; the architecture is rendered in perspective, but the unreality of the proportions and the broad expanse of white deadens any effect of recession. There is figure-work in the predella (still lifes and birds with fruit), in the side fields (floating Cupids) and in the narrow black frieze between the main and upper zones (more birds and still lifes). The central pictures, now in Naples Museum, showed rather gauchely painted scenes of an expiatory sacrifice and of a Greek pulling an Amazon from horseback.

The paintings of the early Third Style, roughly contemporary with the middle and later years of the reign of Augustus, are the pictorial equivalent of the Augustan classicism embodied in sculpture and the other arts. The characteristics of this style are its fondness for Classical Greek and Hellenistic forms (especially in the depiction of figures), its harmony and self-control, its richness of ornamental detail yet overall severity. In painting it manifests itself chiefly in a reaction against effects of volume, space and atmosphere: witness the treatment of the fantastic architecture in the frieze and upper zone, with its fragile but firmly rendered forms and total lack of aerial perspective. The figure-painting too largely eschews effects of volume and space. This is true not only of the compositions in the central pictures (pp. 118–19), but also of the figures used in other parts of the scheme. The small Cupids, landscape vignettes, Egyptianising figures, griffins and suchlike which appear in the middle of fields are reduced by their isolation and the unreality of their coloured backgrounds virtually to the role of abstract ornaments; and the figures and objects represented in the predella and frieze are depicted on a tiny scale, in widely spaced series, and with a single fine ground line, so that they too appear to be little more than ornaments applied to the surface, even when (as in the Villa Imperiale *oecus*) they are engaged in integrated scenes of action. Above all they are rendered in a style that subordinates plastic form to precision and clarity of outline. The result is a quality of classic stillness and elegance that was never equalled in Roman painting.

Second phase

In the middle and late stages of the Third Style, coinciding broadly with the reigns of Tiberius, Caligula and Claudius, there was a gradual reaction against the elegance and discipline of Augustan work. A greater variety of ground colours was used (including occasionally blue and green, rarely found at other periods), and these colours were alternated more freely within the zones, always on the basis of a symmetrical arrangement, but inevitably producing

effects which were more bitty and less simple. The use of yellow, unfashionable in the early Third Style, became increasingly popular. At the same time ornamental detail grew more complex, with a marked tendency to the proliferation of leafy tendrils and similar vegetal motifs, and hints of perspectival recession crept back into the wall. The central picture-panel remained almost *de rigueur* but its form and content began to change: the vertical oblong of the Augustan period gave way to a squatter format, while the shallow, almost two-dimensional compositions of the earlier time were opened up, with figures being set at different levels, foreshortening and oblique constructions being introduced, and stronger contrasts of light and shadow being used to give the figures volume (cf. pp. 119–23).

An early example of this process of dissolution may be recognised in a *triclinium* in the so-called House of Epidius Sabinus at Pompeii, which can be studied in Sikkard's drawings (cf. [Pl. VB]). Here signs of restlessness appeared at various points in the decoration: a series of luxuriant plants, freely rendered and of diverse species, grew in the dado; an apparently random sequence of disparate motifs, including bird-scenes, stylised plant-forms, geometric motifs and a little formal garden with fences seen in perspective occupied the panels of the predella; and perspectival screen-walls with windows were set in the side wings of one of the central pavilions. The black side fields were adorned with vegetal motifs, including diagonal rods with looping tendrils – the first oblique elements to break the pattern of horizontals and verticals hitherto supreme. In the forepart of the room a new motif, destined to enjoy great popularity in the late Third Style, was a pair of busts (Bacchus and Ariadne) set in a small square panel.

Increasing complexity and overloading of detail characterise a number of other Pompeian decorations which must be ascribed to the late 30s or 40s. In the House of Sulpicius Rufus, while the dado remains comparatively simple with mainly geometric patterns, the rest of the wall shows rhythmic alternations of colour which take us away from the restfulness of the early phases of the style; the upper zone in particular now incorporates blocks of colour in place of the earlier all-white ground, and the result is a new heaviness of effect and a new tension between perspective and surface-decoration. In the upper zone of bedroom *h* [57], for example, there is a framework of delicate perspectival pavilions but the division of the background into areas of red, yellow, pale blue and white, some of which are hung with festoons or decorated with still lifes, leaves the viewer in total confusion as to which parts are to be conceived as openings and which as solid barriers. In the *triclinium* (*e*) [Pl. VC] the upper zone is predominantly red, as are the side fields in the main zone, but two panels at the centre show disconcerting glimpses of colonnades and interiors receding in perspective on a blue ground: are they real structures seen through windows, or simply pictures

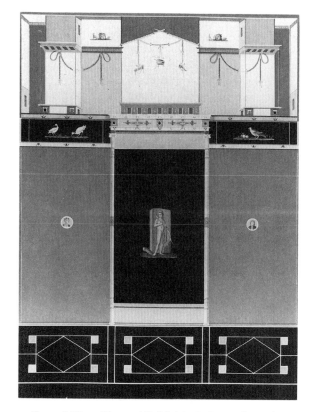

57 Pompeii IX 9, c (House of G. Sulpicius Rufus). Bedroom *h*, west wall (colour lithograph). Second quarter of 1st century A.D.

attached to the red background? Further representations of columnar buildings at the sides are more clearly categorised as independent panels by their smaller scale and their ornamental frames; on the south wall each panel has its own centralised perspective, and the buildings contain small figures, so the meaning is not in doubt.

In the House of the Priest Amandus, a well-preserved *triclinium* [58] contains three large mythological landscapes, two of which are compositionally related to the paintings in the villa at Boscotrecase (cf. pp. 114–16); but that the ensemble is in fact considerably later than Boscotrecase is indicated by the nature of the fourth picture in the room, a large-figure composition with chiaroscuro forms and virtually no landscape setting. A post-Augustan dating is reinforced by the rich and rather heavy-handed use of colours. The landscape pictures themselves are painted in stronger and warmer hues than their prototypes at Boscotrecase, and the decorative scheme as a whole is more hectic, the central pictures being provided with broad red frames within their pavilions, the red fields at the sides receiving black frames, and the entablatures of the pavilions being divided into a somewhat lurid sequence of small compartments in yellow and purple, blue and red, and white and blue. More significant is the use of yellow

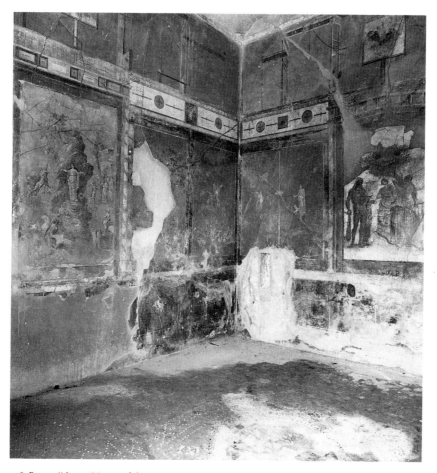

58 Pompeii I 7, 7 (House of the Priest Amandus). *Triclinium b*, north-west corner, with pictures of Perseus and Andromeda (left) and Hercules in the garden of the Hesperides (right). *c.* A.D. 40–50.

as a continuous background in the upper zone. Rarely used for other than subsidiary details in the early Third Style, this colour was destined to become one of the favourite backgrounds of the Fourth Style.

A much finer decoration, but equally symptomatic in its different way of the changes in taste which paved the way for the emergence of the Fourth Style, is that of the *tablinum* in the House of L. Caecilius Jucundus [59]. The predominant background colours are red and black, used in almost equal measure, though with black preponderant in the predella and red in the main zone; but these backgrounds are subordinate to the rich profusion of ornament. In addition to the columns supporting the central pavilion, which have the normal delicate banding and polychrome detail, there are two larger dividing columns whose shafts are imbricated like the trunks of palm-trees (a motif which may go back to ornamental palm-columns in the festival pavilions of Ptolemaic Egypt), and these are accompanied on either side by ornamental bands containing tiny

gorgoneia (gorgon-masks), animals, lyres and so forth, on backgrounds of green, gold, purple and white; elsewhere, bracketed to the columns, spread beneath the central picture-panel, and above and below the side fields, there are innumerable tiny vegetal and animal motifs, often put together in the most fanciful concoctions, and invariably tricked out with bright colours (mainly red, green and purple). The whole display is a *tour de force* of inventiveness; the artist's imagination has indeed begun to run away with him, and one yearns for the clarity of Boscotrecase and generally for the early Third Style's capacity to subordinate subsidiary ornament to the overall design. Besides the abundance of decorative detail, a new elasticity is imparted by the bowing of the upper and lower edges of the side fields to give the effect of a curtain or awning pinned at the corners and billowing in the wind; characteristically the nature of the segmental fields so created is left unclear, because on the one hand their white ground suggests space, while on the other they are occupied by conventional orna-

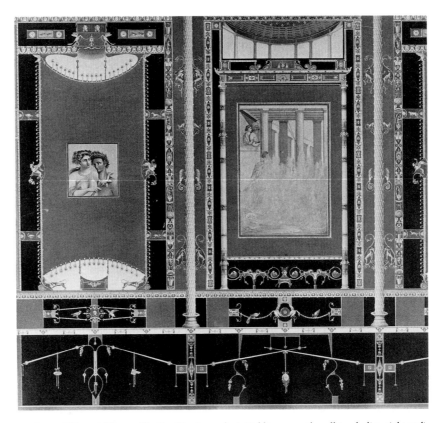

59 Pompeii V 1, 26 (House of L. Caecilius Jucundus). *Tablinum*, south wall (excluding right end). *c*. A.D. 40–50.

ment – a shell at the top, two pairs of animals and a panel containing a winged head at the bottom. The ornamental effect is strengthened by the rows of peacock-feathers with which the curving edges are trimmed. Less unequivocal is the 'window' above the panel in the central pavilion, which reveals the inner face of a dome supported by columns – a clear sign of a reawakened interest in illusionistic openings through the wall. The central picture-panels, typically for the late Third Style, are reduced in height and show mythological scenes in an interior setting. The side fields repeat the theme of pairs of busts in square panels already observed in the House of Epidius Sabinus.

The *locus classicus* for the late Third Style is the House of M. Lucretius Fronto, where several rooms were decorated in this manner, presumably about A.D. 35 to A.D. 45. The complexity of the decorations varies from room to room. The *atrium* (at the left in [Pl. VIA]), with an alternation of large black fields and yellow vertical strips containing delicate polychrome ornament, is one of the simplest; only the upper zone is enriched with the usual insubstantial architecture, albeit still on a black ground. The figural interest, apart from swans and eagles in the upper zone and from gorgon- and panther-masks and lyres in the poly-

chrome strips, is confined to tiny birds and animals at the middle of the black fields. Much more complex are the decorations of bedroom g and the *tablinum*. In both rooms the central picture has been reduced to a small square, or approximately square, panel set in the middle of a plain-coloured field; and in both the scheme depends upon a rhythmic alternation of colours which is a far cry from the homogeneous systems of the early Third Style. The bedroom [60] carries these colour contrasts (yellow, black and red) into the upper zone, which is further integrated with the main zone by the physical overlapping of certain elements – notably the central pavilion itself, which is surmounted by a superstructure borne by caryatids. The *tablinum* [Pl. VI] is the most ornate decoration in the house, with a dazzling display of red and black fields divided by polychrome bands of floral and abstract ornament, among which a pattern of daisies and yellow fruits set on a backdrop of leaves is particularly striking. There are now clear signs of a changing spirit in mural decoration. The black socle, taking over a motif normally used on the predella, is opened up to show a garden in perspective, its enclosure fence recessed in a central niche which contains a marble bowl; further perspective is introduced in openings to left

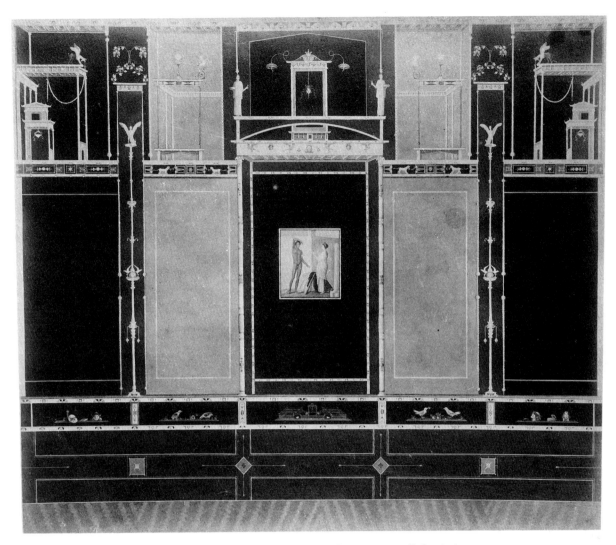

60 Pompeii V 4, a (House of M. Lucretius Fronto). Bedroom 5, west wall (drawing). *c.* A.D. 40–50.

and right of the central pavilion, where we get glimpses of a colonnade which seems to curve backwards in a great semi-circle behind the wall; and the whole of the upper zone is united in the most visually consistent display of advancing and receding architecture to have been produced since the time of the Second Style. Admittedly the structures remain too flimsy and bizarre to pass as real buildings, and the effect of recession is counteracted by the use of blocks of red, black and yellow for the background; but the artist's growing disenchantment with the restraints of pure surface decoration is readily apparent. At the same time he is not prepared for a wholesale return to the perspectival illusionism of the Second Style. The trend, in the main zone at least, is towards an alternation of broad fields, carrying panel pictures or vignettes, and narrow openings containing rudimentary architecture. In these schemes the role of

the pictures is decisive, since it was a desire to retain a kind of screen or curtain (German 'Vorhang') on or in front of which they could be hung which limited the decorator's scope to introduce the illusion of receding planes.

One last Third Style house which may be mentioned is the House of the Orchard or the Floral Bedrooms. As well as two bedrooms which were decorated with garden paintings (pp. 151–2), this modest residence in the eastern part of Pompeii boasted a fine black *triclinium* containing mythological landscapes [61]. The black ground, here used at all levels (dado, main zone and upper zone), is a convention which goes back to the late Second Style (pp. 41–2) and had reappeared at Boscotrecase (with a purple dado: p. 55) and in several other Third Style decorations, including a room with Egyptianising detail in the Villa of the Mysteries (with a white upper zone); interestingly, the

present example reproduces almost verbatim the scheme and several of the ornamental motifs used in an Augustan decoration in the House of the Beautiful Impluvium. But the handling is less fine and delicate than in earlier work: the structural detail is heavier and fuller, the ornamental figures are larger and more eye-catching, and the colours, with red and yellow predominant, are warmer and more vigorous. Typical is the flying Cupid in the forepart of the room, which has a more vibrant sense of movement than any previous emblem. The restraint of the early Third Style is giving way to a new exuberance, destined to find its fulfilment in the Fourth Style.

Ceiling-decorations

The growing decorative freedom discernible in vault- and ceiling-decorations in the late Second Style was carried further during the Third. At the same time the rift between the conventions of stuccowork on the one hand and painting on the other grew wider – even though painted detail

was sometimes used, as it had been in the House of Augustus, to supplement schemes in stucco.

Stuccowork, broadly speaking, clung to schemes of rectangular panels with frames in low relief, usually embellished with egg-and-dart mouldings, and containing figures and ornaments. As compared with the Farnesina stuccoes, subsequent developments were largely, so far as our evidence allows us to judge, in the direction of greater simplicity. The vaults of the so-called Underground Basilica outside the Porta Maggiore in Rome, probably a grand funerary monument of the late Tiberian period, show the general trend, with effects of recession being shunned and motifs being isolated in cushions of empty space [62]. Groups of figures become evenly spaced rows; background settings are reduced to the bare minimum; arabesques are converted into tight, stylised ornaments of palmette, lotus and volute. Roundels or diamond-shaped compartments are inserted for variety or special emphasis, and the largest and most important fields begin to be set in the middle of the vault, with problems of orientation countered by the

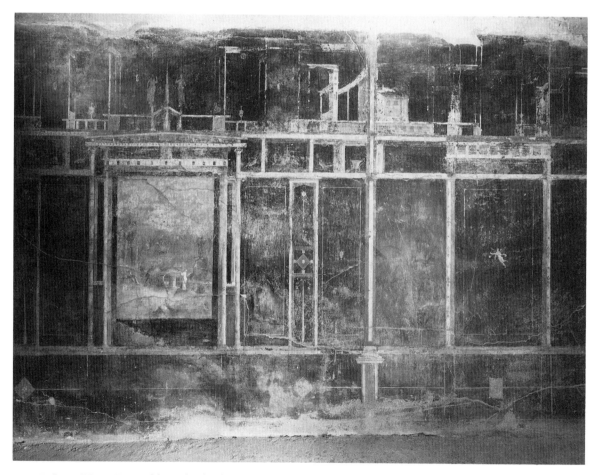

61 Pompeii I 9, 5 (House of the Orchard). Black *triclinium* (11), east wall, with picture of Daedalus and Icarus. *c.* A.D. 40–50.

62 Rome, Underground Basilica at Porta Maggiore. Detail of stucco decoration of central vault.
c. A.D. 20–30.

use of flying figures and other subjects which do not impose an inflexible viewpoint on the spectator. In the main hall of the Basilica, which had no direct natural lighting, the stuccowork was entirely uncoloured; but in the ante-room and in the vault of the near-by tomb of the family of L. Arruntius, the consul of A.D. 6, it was combined with painting. The whole range of possibilities was present – reliefs on coloured grounds, reliefs on white grounds, painted ornaments on coloured grounds and painted ornaments on white grounds; but the colour was used as a discreet accessory, generally in alternate panels, and often only in the frames of those panels. The result, in combination with the delicate and well-spaced reliefs, was a characteristic Third Style restraint.

Painted ceilings, meanwhile, were going their own way. Now that the restrictions of Second Style illusionism no longer applied, painters began to explore a whole new range of decorative treatments. The Third Style therefore represents an important moment in the history of ceiling-painting: from now on the old principle of *trompe l'œil*, most evident in the reproduction of coffering, was finally supplanted by purely ornamental arrangements of pattern and colour. The new freedom had been announced in the vault of the Aula Isiaca, but there the surrealistic vegetation had been given three-dimensional form by highlights and shadows, while its large scale and fluidity had reduced the background to insignificance. In the Third Style, by contrast, respect for the surface was paramount; as on the walls, all figures and other motifs were small and unobtrusive, and no element was allowed to set up an illusion of depth sufficient to pierce the visual barrier imposed by

a continuous neutral background, generally of white or black.

The different kinds of painted ceiling-decoration can be summarised under three main headings: centralised arrangements of figures and ornaments, all-over patterns and organic compositions.

The centralised schemes, the most important for the future development of ceiling-painting, consisted of concentric borders or symmetrical groups of figures or panels distributed on four sides of a central field, either a square or a roundel; at this stage, if we can trust our limited evidence, the background was normally white, but by the period of transition to the Fourth Style other colours were coming into play. Already in the tomb-chamber of the pyramid of Cestius there seems to have been a simple version of the type. All that survives are figures of Victory set on the diagonals of the vault, and traces of rectangular framing above their heads; an old report that there was a representation of Cestius at the centre cannot be confirmed. From what remains it is clear that the white of the background dominated over the figure-work. Similarly with the later examples of centralised decorations, all from Pompeii or Herculaneum. At Pompeii the segmental vault of bedroom II in the House of G. Julius Polybius [63, 64] shows a very simple arrangement of long rectangular panels and small squares round the edges of a surface which was otherwise undecorated save for a central square compartment and for ornaments along the axes. The frames consist merely of purple stripes, with inner lines for the panels at the edges. The effect is astonishingly light after the ceilings of the Second Style, and the figures and orna-

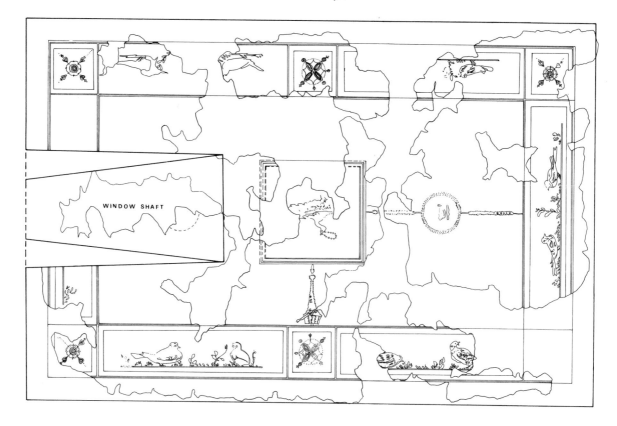

63 Pompeii IX 13, 3 (House of G. Julius Polybius). Bedroom II, vault-decoration (restored from fragments). Second quarter of 1st century A.D.

64 Pompeii IX 13, 3 (House of G. Julius Polybius). Bedroom II, detail of vault-decoration (reconstructed fragments). Second quarter of 1st century A.D.

ments (pairs of birds with plants in the rectangles, floral motifs in the small squares, a flying swan in the central field) are painted with a matching delicacy. A favourite Third Style motif is the basket containing a tall leafy cone which appears on the short axis of the vault. A somewhat similar ceiling, but recalling in its use of colour the part-painted stucco vaults mentioned above, adorns a bedroom in the House of the Wooden Partition at Herculaneum. Like a number of ceilings in that city, this retains a distinct treatment of the bed-alcove, which is spanned by a segmental vault between flat margins at each end, while the *procoeton* has a flat ceiling at a higher level. Each surface is treated independently, but the general format is similar, with a roundel in the central position and tiny medallions, hexagons and the like spaced round it [65]. The white of the background is dominant, but the small shapes are filled in with colour (pale green, purple, pale blue) to create discreet accents within the design. The interspaces are occupied by little animals, peacock-feathers and delicate interweaving tendrils, some of the loops of which are also filled with colour.

The second type of ceiling-decoration, the all-over pat-

tern (cf. [69]), can to some extent be linked with the coffer tradition of the Second Style; indeed in certain examples the lines of the design are coloured differently as if to suggest light and shade. But the patterns employed are mostly too tight-knit and complex to be literal translations of coffer-schemes, and the unreal use of colour – generally yellow, purple and white on a black ground – is certainly an invention of painters. Any 'shading' would therefore seem to be a pictorial convention to lend vivacity to a purely abstract design. Among the patterns which survive are a network of lozenges, squares and triangles; the same, but with roundels substituted for the squares; an all-over system of contiguous octagons; and a network of overlapping octagons. The compartments, however small, contain white spots or rosettes.

The final class of ceiling-decoration, the organic composition, was based upon floral and vegetal forms arranged not in formal patterns but with all the disorder of nature. A precedent is known in stuccowork of the late Second Style: namely two soffits in the baths of the House of the Menander at Pompeii, which were decorated with reliefs of sprawling vine-tendrils. But the first painted ceiling of this type belongs to the tomb of Pomponius Hylas on the Via Latina, just inside the later walls of Rome. The main vault-decoration [66] consisted of far-spreading, informal vine-scrolls populated with Cupids and birds; while further, similar scrolls, here containing a pair of Victories and a wingless female figure, occupied the semi-dome of an apse. The delicate style of painting and the spaciousness

65 Herculaneum, House of the Wooden Partition. Bedroom 2, ceiling-painting (detail). Second quarter of 1st century A.D.

66 Rome, *columbarium* (communal cremation-tomb) of Pomponius Hylas, detail of painted vault-decoration. Between A.D. 19 and 37.

tal quality of this floral 'carpet' is conveyed by the lack of connecting branches or stems and by the conventional purple background. The flat surround is divided into geometric shapes, including lozenges at the sides and squares at the corners, rendered in a colour scheme dominated by red, purple and yellow, with white in the interstices. The coloured fields are again adorned with floral and foliate motifs. The fineness of the ornamental detail is typical of the Third Style, but the richness of the palette, and particularly the combination of red, purple and yellow, points ahead to the Fourth.

Context

While ceiling-decorations became more diverse and imaginative, pavements remained conservative, with geometric patterns the preferred choice, executed either in black and white mosaic, or with lines of *tesserae* set in mortar. The pictorial *emblema* finally disappeared, rendered redundant by the triumph of the painted picture in wall-decoration. The floor-decoration of the period was now unequivocally two-dimensional and predominantly monochrome.

None the less, the influx of coloured alabasters and marbles to Italy which is a feature of the early Imperial period was not without its effect on paving. *Opus sectile* seems to have become more common than before, and it is probable that a wider range of materials was employed. Unfortunately the value of these materials led to their being salvaged in antiquity, so that we are often left with only the imprints of the pieces of stone in the underlying mortar; but that the more expensive coloured stones began to play a role in Third Style pavements is confirmed by the appearance of offcuts and small panels set in other types of paving at Pompeii. Several *emblemata* of coloured marble, found primarily in *oeci* and *triclinia*, can be dated to this time, and scattered pieces are incorporated in pavements of mortar, especially within the compartments of geometric patterns formed by inset *tesserae*. One or two complete pavements in coloured marble, for example in Pompeii VII 12, 26 and in the baths of the Villa 'Pisanella' at Boscoreale, may also go back to the Third Style, though the majority belong to the Fourth.

A certain amount of polychromy was therefore admissible in floor-decoration, at least in the grander rooms (and perhaps primarily in the later years of the style). But the general rule was simplicity of both pattern and colouring. Similarly with most ceiling-decorations. Here the dominant accent, whether the technique was painting or stucco relief, was usually provided by the white of the plaster, which picked up the white of the upper zone in the wall-decoration. Where another colour prevailed, as in the black-ground ceilings already referred to, this was often because the same tone was the basis of the wall-paintings; for instance the black ceiling with vines in the House of

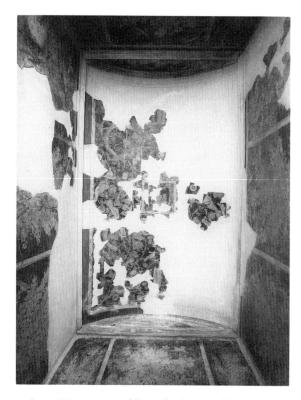

67 Pompeii I 9, 5 (House of the Orchard), vault of black bedroom (12). *c.* A.D. 40–50.

of the scheme, which permits no violation of the neutral white background, are hallmarks of the Third Style, to which the tomb must also be ascribed on epigraphic grounds (the earliest epitaph is dated between A.D. 19 and 37). Rather denser and more luxuriant are the vines on the vault of one of the bedrooms with garden paintings in the House of the Orchard at Pompeii [67]; but once again there is a respect for the inviolability of the surface, here achieved by the use of an impenetrable black ground. The vines harbour birds, Cupids and Dionysiac bric-à-brac, including theatrical masks, musical instruments, vases, drinking-horns and mystic chests; and in the central position is a square field with Dionysus (Bacchus) himself seated on a panther. The effect recalls Bacchic arbours or 'caves' known from ancient literature.

One other ceiling-decoration which may be mentioned partakes of the characteristics of both the centralised and the organic categories. This is in a bedroom in the House of the Theatrical Panels (or of Casca Longus) at Pompeii [68]. Like several later Pompeian ceilings it combines a flat surround and a recessed central part, here covered by a shallow vault. In the central part is painted a thick sprinkling of leaves and flowers, amid which can be discerned the imprints of stucco reliefs representing Venus and a couple of Cupids (the first known example of the use of stuccowork within a pictorial composition); the ornamen-

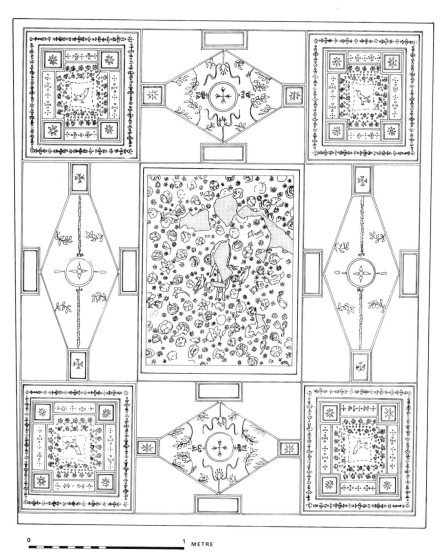

0 1
METRE

68 Pompeii I 6, 11 (House of the Theatrical Panels). Bedroom 2, ceiling-decoration
(reconstruction). *c.* A.D. 40–50.

the Orchard at Pompeii echoes the black ground behind
the fruit-trees painted on the walls, and a black vault with
a network of overlapping octagons in the villa at Minori,
on the south coast of the Sorrento peninsula, is part of a
general black décor. There seems, then, to have been some
attempt either (as in the Second Style) to make the ceilings
offset with their whiteness the polychromy of the walls or
to make them repeat the colour scheme of the wall-
decoration. Harmonisation of colour could also be accom-
panied by links in theme, as demonstrated most forcibly
by the vines and fruit-trees in the Pompeian bedroom.

It is possible that some of the repeating patterns used
in ceiling-paintings were inspired by similar networks in
decorated pavements, though the versions in mosaic and

other paving techniques were (not surprisingly) simpler and
with a totally different colour effect. Certainly inspired by
mosaic are an all-over meander painted in red on a yellow
ground in the Pompeian house VIII 2, 30 and a couple of
specimens of a pattern of eight-lozenge stars alternating
with squares, both on a black ground, in the House of
Julius Polybius [69] and the House of the Cabinet-Maker.
The all-over meander had already, in its various forms,
enjoyed a long history in floor-decoration, going back to
the period of the First Style; and the pattern of eight-
lozenge stars enclosing squares, first found in pavements
of the Augustan period, was destined to become the most
popular of all mosaic designs. The isolated occurrence of
these patterns in a few Third Style ceilings suggests that

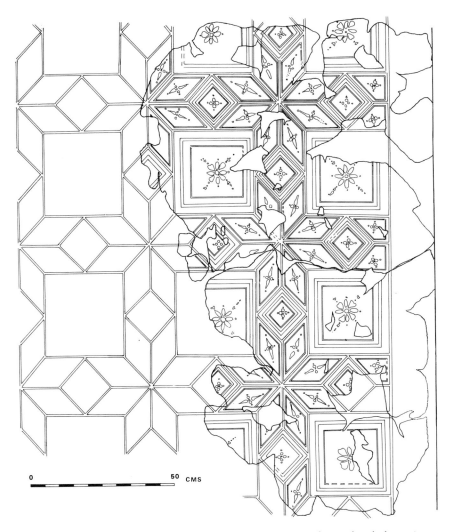

69 Pompeii IX 13, 3 (House of G. Julius Polybius). Room EE, part of painted vault-decoration restored from fragments. Third quarter of 1st century A.D.

floor-decoration, which during the previous period had apparently taken ideas from ceilings (p. 48), was now exerting some influence in the opposite direction.

There, is, of course, despite general differences in design, much common ground between painting and stuccowork in this period – notably in the sharing of figure-types and ornaments. Most striking is the way in which these two media collaborated in their functional roles. Not only did stucco reliefs appear in conjunction with painted backgrounds and with pictorial ornament on the ceiling, but they now began to move down on to walls. In the Underground Basilica of the Porta Maggiore the wall-decoration of the ante-room was partly painted, partly in relief, while that of the main hall was decorated completely in white stuccowork, with motifs including landscape vignettes, portrait-busts and tables carrying games-prizes. The use of

stuccowork on walls, here restfully balanced by expanses of empty space, imparted a sense of movement which, when combined with colour, could easily lend itself to compositions of excessive richness. As such it was destined to enjoy particular favour during the following period.

It seems to have been a corollary of the victory of ornament over illusionism in wall-decorations of the Third Style that the painters now began to pay less regard to their architectural context than before. Admittedly there were occasional instances where painting was made especially appropriate to its setting, as when the niches of the so-called Auditorium of Maecenas at Rome were decorated to look like windows opening on to a garden. Admittedly, too, it was still normal, as it had been in the Second Style, to reserve paratactic, or at least less emphatically symmetrical, schemes for rooms 'of passage' (*fauces*, *atria*, peristyles

and corridors) while symmetrical systems were confined to enclosed rooms (cf. [Pl. vɪA]). The latter policy, however, was a matter partly of decorative convenience and partly of common sense: it was much easier to expand a scheme to cover a long surface by means of repetition or alternation than to compose an elaborate system of balancing elements about a central focus; conversely, it was logical to keep symmetrical decorations for rooms where people would linger and could appreciate the whole wall with one sweep of the eye, rather than to apply them to spaces which were generally seen in passing (and which were often interrupted by numerous doorways). There was certainly now no question of making fictive architectural elements correspond to the real columns of a peristyle or to the ribs of a vaulted ceiling, as had the herms and columns of the Second Style: the Third Style had dispensed with realistic architecture, and though its paratactic schemes were articulated by regular vertical accents in the form of narrow panels containing candelabra or fine polychrome ornament, which in some sense performed a similar role to the old columns and pilasters, these remained purely conventional and, when they appeared in a peristyle (as happened in the House of the Cithara Player at Pompeii), they were spaced without relation to the columns.

In other respects, too, wall-decorations became increasingly independent of their context. For example the Second Style rule that black fields were favoured in south- or south-west-facing dining-rooms (p. 51) no longer held good. In the Third Style Pompeii presents instances of black being used for a special recherché effect in all sorts of rooms, including the peristyle of the House of the Bronzes, the *tablinum* of the house I 2, 24, the *atrium* of the House of M. Lucretius Fronto and a northward-opening *triclinium* in the House of the Centaur. This was one more aspect of the more imaginative, more purely decorative approach of the new style: colour schemes were switched from room to room even more freely than in the previous phase, simply for the sake of variety. Witness the red and the black rooms at Boscotrecase: though situated side by side, virtually identical in form and proportions, and opening through identical doors on to the same south-facing portico, these had colour schemes which were more or less diametrically opposed.

What of the relation between painting and the function of space in bedrooms, dining-rooms and saloons? In bedrooms the demarcation of a bed-alcove by architectonic and decorative means continued from the Second Style, but became less universal and less systematically applied. Possibly in some cases householders wished to 'keep their options open' with regard to the position of the bed or even with regard to the use of the room as a bedroom at all. Of the rooms which still retained a specific bed-alcove one of the more striking is room II in the House of Julius Polybius at Pompeii, where the position of the bed at the back of the room is clearly marked by shallow recesses in

both side walls; the corresponding section of the mosaic pavement is left plain, in contrast to the *procoeton*, which has a geometric pattern; and the walls at the head and foot of the bed are illusionistically opened up with garden paintings, in contrast to the yellow walls of the *procoeton*. Despite these distinctions, however, the whole room including the bed-alcove was spanned by a single continuous vault [63]. In the white bedroom in the Villa Imperiale there is no basic colour distinction between the alcove and the main part of the room; but the alcove [70] had a lower ceiling, so the frieze and upper zone of its paintings are set correspondingly lower than in the *procoeton*; and its main zone lacks emblems, figure-work being concentrated in panels in the frieze, no doubt to make allowance for the presence of a bed. In the bedroom with a segmentally vaulted alcove in the House of the Wooden Partition at Herculaneum (p. 64) the distinction between bed-space and *procoeton* expressed in the treatment of the ceiling was reflected by a change of syntax in the wall-paintings; the pavement, on the other hand, presents a single network of pattern over the whole room. Conversely, in a bedroom in the Pompeian house I 11, 12 the bed-space, which was vaulted, is marked off by slender painted pillars on the walls and by a plain area in the decorated pavement; but the syntax of the wall-painting is identical, with plinth, dado,

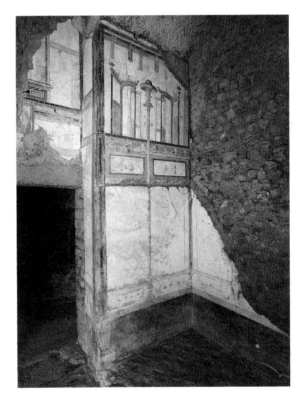

70 Pompeii, Villa Imperiale. Bedroom (B), north-east corner, showing part of main wall (left) and end of bed-alcove (right). End of 1st century B.C. or beginning of 1st century A.D.

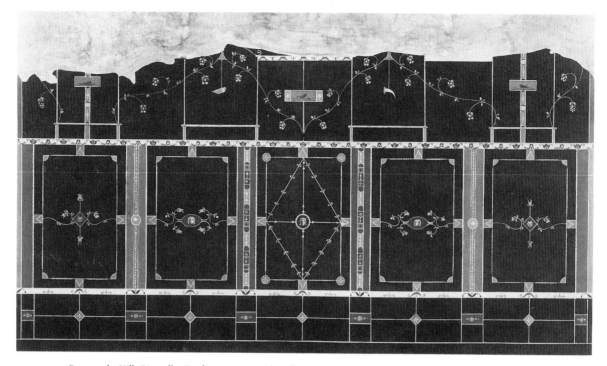

71 Boscoreale, Villa Pisanella. *Triclinium* (10), north wall (colour drawing by V. Esposito). First half of 1st century A.D.

main zone and frieze of equal height; only certain small colour distinctions and the presence of a painted landscape in the frieze of the *procoeton* reinforce the functional differentiation. In the House of the Orchard the position of the bed in the two rooms with garden paintings is indicated solely by undecorated areas in the pavements (in one case reinforced by a step in level); the ceilings are continuous and the wall-decorations have symmetrical tripartite schemes which take no account of the hierarchical division of space within the room. Similarly with the polychrome bedroom (g) in the House of Lucretius Fronto [60]: the painted scheme is centralised with relation to the wall as a whole, not to an area of circulation in front of the bed. Naturally, the smaller the bedroom, the less likely was any attempt to differentiate a bed-space; many bedrooms were less than three metres square, which meant that the *procoeton* would have been scarcely deeper than the alcove; it was natural, therefore, to decorate all the walls in similar fashion rather than to place a clumsy emphasis on one part of the room.

A similar loosening of the relationship between functional organisation and decorative schemes is discernible in *oeci* and *triclinia*. In several murals (as well as pave-

ments) we still find a shallow 'antechamber' treated distinctly from the rest of the room, for example in the Caserma dei Gladiatori at Pompeii, where the distinction is emphasised by an abrupt change of colour from black to white [52]. But there is no clear evidence that the two areas of such rooms were often differentiated in terms of structure, that is by their relative height or by changes in the form of the ceiling; and an important factor in the bipartite nature of the wall-decoration was in several cases the position and size of the entrance, which occupied one side of the antechamber and therefore itself promoted a caesura at the appropriate point. In some later *triclinia*, indeed, such as those of the House of the Priest Amandus and of the House of the Cabinet-Maker at Pompeii and of the Villa 'Pisanella' at Boscoreale [71], the whole length of the wall was occupied by a single centralised, usually five-part, scheme – this despite the asymmetrical decoration of the pavements, which clearly marked out the position of the dining area in the rear part of the room. As with bedrooms, this lack of liaison between wall-painting and the allocation of functional space was to become the normal state of affairs in the period of the Fourth Style.

5

The Fourth Style

The Fourth Style, being the last of the fashions of interior decoration to reach Pompeii and Herculaneum, is the best represented in the archaeological record; many decorations in the older styles were inevitably replaced before A.D. 79, whether as a result of wear and tear or in consequence of structural alterations; and, though imitations of the First, Second and Third Styles are not unknown, the majority of householders preferred to follow the latest taste. Perhaps it is because of the abundance of surviving material that we are able to appreciate the diversity of decorative schemes in this period better than in any other; but there is good reason to believe that the Fourth Style was in fact less homogeneous than its predecessors. Whereas the Second Style had been dominated by the principle of architectural illusionism, and the Third had created a purely ornamental canon based upon colour, miniaturism and the impenetrability of the surface, the Fourth was eclectic, taking elements from what went before and putting them together in new and often unexpected ways; at the same time previously untried ideas, such as the extension of geometric networks from ceilings to walls to create the so-called 'wallpaper pattern', came into play.

In its most elaborate forms the Fourth Style revives the Second Style theme of an open wall, while retaining the flimsy, fantastic architecture of the Third Style. A small number of decorations, probably not among the earliest, show the whole wall dissolved once more to create a monumental architectural setting in which figures are set freely, as if in a real environment. Much more common is a system in which the architecture is glimpsed through narrow openings ('Durchblicke') which alternate with broad tapestry-like fields ('Vorhänge') carrying picture-panels or floating figures; here the upper zone picks up the architectural theme, though not necessarily in structural liaison with the main zone and not necessarily with much pretence to perspectival coherence; the dado on the other hand remains flat and purely decorative. This second kind of decoration develops out of the late Third Style, in which it had been foreshadowed by paintings such as those of the *tablinum* of the House of Lucretius Fronto at Pompeii [Pl. VI]. But there are a number of more or less important

changes. In syntax the symmetrical schemes (which continue to be used for closed rooms) show less emphatic centralisation than before: the central picture is usually smaller than its Third Style counterpart and often scarcely more dominant than the motifs in the side panels. In colour the effects aimed at are warmer, with a greater use of yellow and white alongside the black and red favoured by the Third Style; the brilliant polychromy of Third Style ornament, with its juxtaposition of blues, reds, greens, golds and purples, is replaced by a more restricted palette; the architectural forms in particular, previously white with coloured patterning, tend to become a uniform golden yellow. The nature of the ornament also changes. Vegetal or semi-vegetal motifs, including garlands and the ever popular grotesques, become more luxuriant and free-flowing; decorative figures, of which there are now great numbers, perched on entablatures and floating in fields, become larger and more animated, with volumes suggested by quick strokes of light and shade. Perhaps most characteristic of all are the ubiquitous 'embroidery borders', borders with repetitive patterns which appear as if stencilled on to the background. These are normally carried out in a single colour – on red and black grounds yellow [Pl. VIIB], on white either red or yellow, on yellow white – and they serve both as frames at all levels of the wall and as linking elements between panels and *aediculae* in the dado and upper zone. Their most important role, however, is as borders for the *Vorhänge* of the main zone, where they supplant the linear or vegetal frames used in the Third Style.

Generally speaking the new style is less disciplined and more capricious than its predecessor; it has been well characterised as a 'baroque' reaction to the Third Style's 'mannerism'. At its best it can be dazzling and delicate; at its worst garish and overwhelming. Alongside fine workmanship there is also much that is careless or second-rate. The desire for bold and impressive effects, coupled perhaps with the pressures of increased demand (cf. pp. 84, 220), led to a decline in the high standards maintained by previous periods.

For the dating of the Fourth Style we have a number of clearly defined reference-points. In Rome there are the

decorations of Nero's palaces. The Domus Transitoria (the 'House of Passage', so named because it was built to join the Palatine to the Esquiline Hill) was destroyed by the great fire of A.D. 64, having probably been begun about A.D. 59 or 60, when the emperor's megalomania first came into the open. The Domus Aurea (Golden House) was started after the fire and seems to have been lived in, thus in its essential parts completed, by Nero's death in 68. Though it evidently continued in use till 104, and some rooms show a second period of decoration, the greater part of the work is homogeneous, so must be considered Neronian. In Pompeii, Herculaneum and Stabiae the eruption of 79 provides a cast-iron *terminus ante quem*, while the earthquake of 62 adds further definition: decorations which show signs of earthquake damage and subsequent restoration or abandonment are presumably datable before 5 February 62, and conversely any decorations applied over the sort of makeshift repairs that can be identified as resulting from earthquake damage are presumably later. Still greater precision is possible if painting can be seen to have been actually in progress at the time either of the eruption

(as in the Pompeian house I 3, 25) or of the earthquake (as in the House of the Iliadic Shrine and probably I 11, 17). The Fourth Style did not, of course, stop in 79 but continued at least till the last years of the century, as is demonstrated by scattered remnants of decorations outside Campania, for instance on the Palatine in Rome and in Domitian's villa near Castel Gandolfo, built between 81 and 90.

Because of the heterogeneous nature of the style, and of the shortness of its lifetime in the buried cities, it is difficult to establish a pattern of evolution. None the less, the increasing weight of the evidence in favour of a beginning as early as the 40s or early 50s has helped to clarify the situation somewhat, and it is now possible to try to distinguish the early from the mature forms of the style.

Transitional and early decorations

Transitional work, datable roughly to the 40s, combines Third Style ornament with new patterns and a new restlessness. Certain decorations, for example those of a *triclinium*

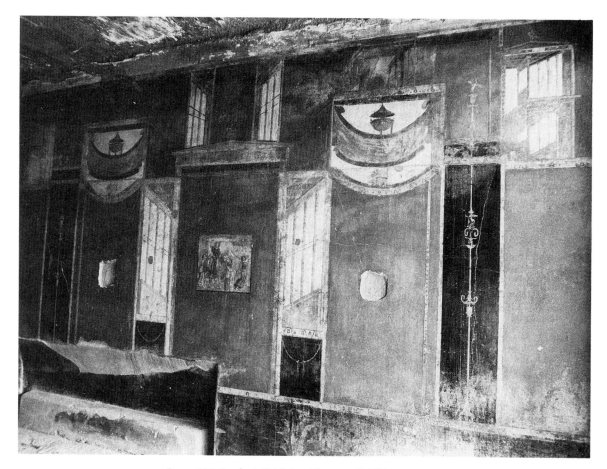

72 Pompeii I 8, 8–9 (bar). *Triclinium* (*d*), east wall. Mid 1st century A.D.

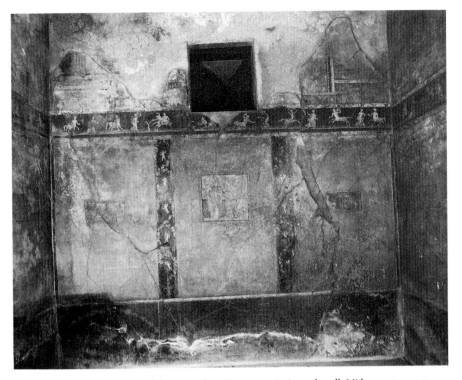

73 Pompeii I 10, 4 (House of the Menander). Green *œcus* (11), north wall. Mid 1st century A.D.

in Pompeii I 8, 8–9 [72] and of a shop attached to the House of the Tuscanic Colonnade at Herculaneum, show the development of the *Durchblick* and of window-like effects in the upper zone; the use of a white ground for the perspectival colonnades therein, in place of the black ground in the House of Lucretius Fronto, enhances the feeling of spatial recession. Other decorations introduce more complicated colour schemes; in a *triclinium* in the House of the Mirror at Pompeii, for instance, the main and upper zones are divided into areas of red, yellow and black in almost equal measure, and some of the fields of the main zone are half one colour and half another, the boundary being marked simply by a slender candelabrum. Curving and diagonal lines become more frequent, especially in the dado and upper zone, and are frequently expressed in vegetal terms, whether as garlands or as *thyrsi* (Dionysiac wands) or simply as rods with tendrils growing from them.

Above all, the ornamental frames and borders begin to change. While the characteristic Third Style columns, slender and white with polychrome decoration, are retained, their detail becomes less careful and they frequently lack an entablature, serving merely to separate one field from another. Horizontal divisions between the dado and main zone, and along the top and bottom of the frieze, are effected by narrow white or cream bands decorated with stylised lotus and other floral motifs in red, purple and green. The greatest elaboration is reserved for the borders of the main fields, which are rendered either in the form of vegetal tendrils, sometimes curving inwards to create concave-sided shapes, or as broad golden-yellow volute and palmette patterns painted with metallic sharpness, evidently in imitation of gilded bronze. Fine examples of the latter occur in the *atrium* of the Villa 'Varano' at Stabiae, where they are combined with tiny cornucopiae, wine-cups and pairs of little white swans, and partly filled with colour (red, green and black) [Pl. VIIA]; they stand midway between the exuberant polychrome plant and animal ornament of the House of Caecilius Jucundus [61] and the monochrome grotesques and embroidery borders [Pl. VIIB] of the ensuing period. More sober are the borders in the House of the Mirror *triclinium*, with little stylised lotus and palmettes growing from a straight line, another theme destined to be taken over and debased by later painters.

A particularly fine specimen of the transitional phase is the green *oecus* in the House of the Menander at Pompeii [73]. Apart from a purple dado and a red-ground frieze carrying imitation stucco reliefs, this room is decorated almost entirely in green, one of the few examples of such a colour scheme known to us; only the vertical strips which divide the fields of the main zone are black, with miniaturist ornament in the manner of the Third Style, including (on the back wall) Cupids in the spirals of a vine-scroll, and (on the side walls) profile busts in oval compartments, fron-

tal sphinxes, and birds and animals perched on tendrils. Within the main fields are picture-panels, square at the centre of the wall and oblong at the sides. Although *Durchblicke* are lacking, and even the upper zone is largely devoid of perspectival effects, there are many clear signs of the advent of the Fourth Style: the use of arched garlands in the dado; the sketchy, almost impressionistic style of the landscapes and genre scenes in the little oblong pictures; the largish figures and small square format of the central panels; the relatively big scale and animated forms of the isolated figures in the upper zone; and the vigorous movement and foreshortening of the imitation reliefs in the frieze, which represent centaurs seizing Lapith women at the wedding of Pirithous. The borders in the main and upper zones prefigure the embroidery patterns of the next phase but are subtler and more detailed and are executed with the metallic sharpness characteristic of Claudian and early Neronian times.

To the end of the transitional phase we may ascribe the paintings of the upper peristyle of the Villa 'San Marco' at Stabiae, to be dated on the evidence of tile-stamps prob-ably no later than A.D. 54. These have a fully fledged *Vorhang* and *Durchblick* system. The *Durchblicke* contain two-storeyed pavilions shown in perspective, closed at the bottom by a low parapet and adorned at the top by a hang-ing garland – both favourite devices of the style. The archi-tectural forms, however, lack the complexity and baroque fantasy of later examples, and much of the subsidiary orna-ment recalls the tradition of the previous period.

Throughout the Neronian period (A.D. 54–68) the Fourth Style remains carefully painted, with delicacy and lightness its guiding principles. Borders are simplified into chains of grotesques or embroidery patterns, but are still sharply and precisely drawn: good examples can be seen in the upper zone of a decoration in the House of Neptune at Pompeii [74], where the grotesques take the form of confronting birds and wine-jars, painted with highlights to suggest the reflecting surfaces of gilded bronze, while the embroidery borders consist of series of squares containing rosettes and of triangles containing palmettes. Upper zones in general become light and transparent, with combinations of archi-tectural structures and two-dimensional frameworks

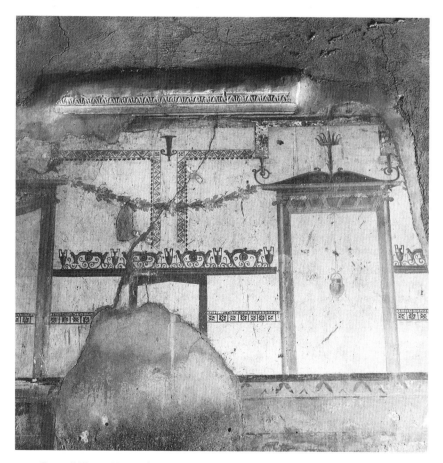

74 Pompeii VI 5, 3 (House of Neptune). Room *b*, north wall, central part of upper zone. Mid 1st century A.D.

enlivened with stock motifs – hanging garlands, prancing goats, flying swans, suspended shields and drinking-horns, griffins perched on corners and so forth. The result is an ambivalent airiness in which space is suggested but the wall is not really opened. This effect is frequently picked up by the *Durchblicke* in such a way as to suggest that the *Vorhänge* are true curtains suspended on frames in front of a continuous other-world of fantasy architecture.

Nowhere is this more clearly illustrated than in the *alae* of the famous House of the Vettii at Pompeii [75]. Here, in a decoration securely dated before the earthquake of 62 by structural alterations and repairs which in turn ante-date the decorations of the remaining rooms, a series of large yellow tapestries with lace-like borders and red sur-rounds appears to be set up in front of a low parapet, with glimpses of shimmering space between and above them. Every second tapestry curves inwards at top and bottom as if caught by a mysterious wind. At the middle of the fields are set little oblong panels with groups of fighting cocks and prizes on a purple ground and medallions containing *gorgoneia* and other masks.

The same general principles of decoration are repeated in the *triclinium* of the House of the Prince of Naples, also at Pompeii, but a totally different quality is conferred by the use of heavier frames, stronger colouring and an all-white background; there is almost no perspective, and the result is a much more even (and less legibly structured) tracery of ornament [76]. Square mythological pictures are set in the central fields, one of which echoes the subject of a picture in the green room of the House of the Menander, Perseus seated with Andromeda and holding the mask of Medusa aloft. In the side fields are floating Cupids with various attributes, a motif already popular for this position in the Third Style [Pl. VA; 58, 61] and still more so in the Fourth. The dado is purple with rectangular frames containing plants beneath the *Durchblicke* and compositions of garlands and embroidery borders between.

The paintings of Nero's palaces in Rome, though naturally of higher quality than much of the work at Pompeii, echo many of the same compositional formulae and exploit a similar decorative repertory. The main differences are the pervasive and exuberant use of grotesques and arabesques, and the regular enrichment of the painting with other materials, namely coloured glass, stucco 'cameos', and gilded stucco mouldings. Much of our evidence relates to vaults (pp. 86–94), but in the Golden House, at least, enough is known of the wall-decorations from old engravings and from the surviving remains for us to be able to formulate some conception of their original appearance. They include virtually the whole repertory of schemes exploited in the Fourth Style and can be regarded as standing at the beginning of the period of its maturity, to which we now turn.

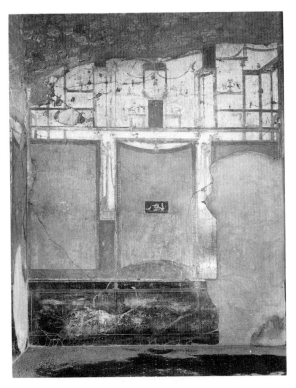

75 Pompeii VI 15, 1 (House of the Vettii). *Ala h*, south wall (with blocked doorway at right). Between *c.* A.D. 50 and 62.

Mature period

A feature of this period (the bulk of the examples belong after A.D. 62) are the Fourth Style 'scenographic' decorations: that is decorations in which the wall is opened up illusionistically by means of perspectival architecture amid which figures are set as if in a real environment. Examples appear in the Golden House, both on white and on coloured grounds. In the corridor now numbered 55, above a marble facing over four metres high, the fictive architecture took the form of two storeys of continuous openings separated by piers; the lower series contained doorways with figures standing in them, while further figures appeared on terraces above. Here, as frequently in this period, the structural divisions were emphasised by the use of stucco: in front of the piers were delicate columns executed in relief. In a neighbouring corridor (50, formerly 19) [77] there was another two-storeyed framework, again above a high marbled dado and again using stucco relief, but this time more richly coloured and with a complicated arrangement of projecting and receding pavilions, amid which figures standing in doorways were interspersed with others within tall window-like openings which revealed further architecture behind. At Pompeii the most famous example of this genre appears in a bedroom of the House of Pinarius Cerialis, where grand columnar structures of

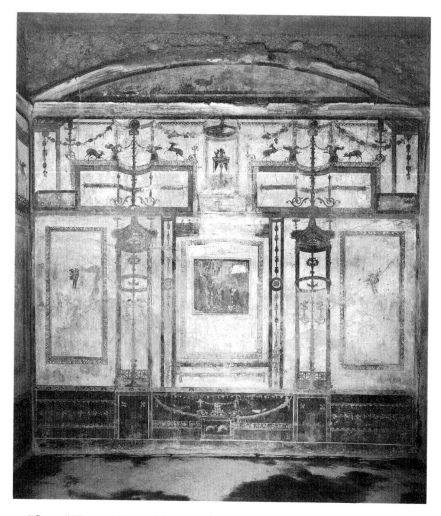

76 Pompeii VI 15, 7–8 (House of the Prince of Naples). *Triclinium k*, east wall. Between *c*. A.D. 50 and 62.

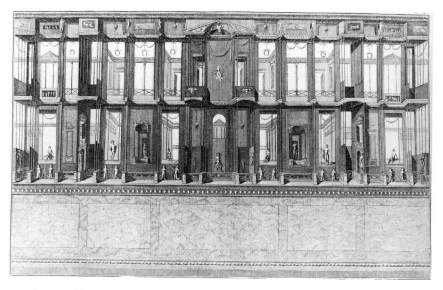

77 Rome, Golden House. Wall-decoration of corridor 50, formerly 19 (engraving, back to front). Between A.D. 64 and 68.

greenish grey and golden yellow, with a red background, form a setting for scenes from Greek myth: the imprisonment of Orestes and Pylades among the Taurians [131], the love of Attis for the nymph Sagaritis, and another which is too badly damaged to be identified. In the House of Apollo a rather similar decoration in a garden bedroom shows the story of Marsyas and the contest of Venus with the evening star Hesperus [132].

The presence of figures distinguishes these Fourth Style architectural compositions from those of the Second Style, which normally left the architecture unpopulated, save by birds; and the position of the figures, often standing in doorways like actors about to emerge on to a stage, or looking over balustrades like spectators in the 'boxes' of a Roman theatre, has prompted the theory that they were inspired by the theatrical stage. But any links with the theatre are loose. The architectural forms derive from the traditions of Third and Fourth Style wall-painting, not from the columns of an actual Roman *scaenae frons* (stage backdrop); they are too tall and frail to be real, and their cornices and pediments are embellished with equally unreal plant and animal forms. In the Golden House figures set

in pavilions or doorways are used as repeating motifs to cover long walls and it is more likely that they are introduced as staffage to enliven the architecture than that figures and architecture together form a coherent theatrical theme. The isolation of such figures indeed militates against a dramatic function. Even when they are united in a common story, like the Marsyas and Venus *v.* Hesperus paintings of the House of Apollo, the individual protagonists are normally spaced out, one per pavilion or opening, in a distinctly untheatrical manner. Only in Pinarius Cerialis's bedroom is the distribution more plausible, with the figures divided into three groups, one in a central doorway, and the others on a stage-like foreground at the sides. But even here, at least in the Orestes scene, the components have been cannibalised from a well-known panel-picture (cf. pp. 126–7) – as indeed have the single figures used in other schemes, such as that of the House of Apollo. In other words the genesis of these decorations is pictorial, not theatrical; as in the Second Style, any reflection of the theatre is indirect and secondary, a by-product of the combination of different elements taken from the repertory of wall-painting: the architectural framework comes first, the

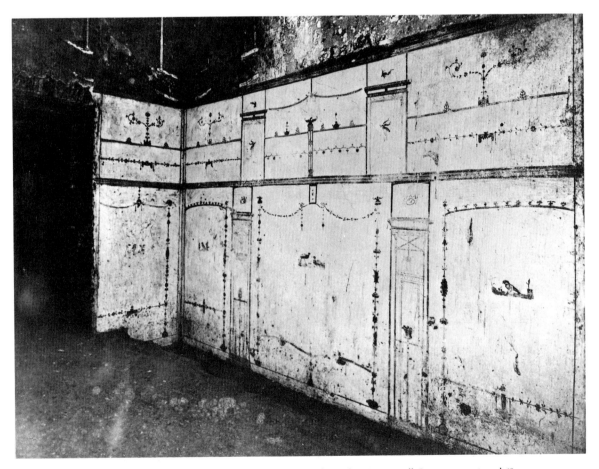

78 Rome, Golden House. Room of the Birds (room 71, formerly 57), east wall. Between A.D. 64 and 68.

79 Psyches picking flowers. Pompeii VI 15, 1 (House of the Vettii), *œcus q*. Soon after A.D. 62.

figures are added for interest and variety, and the theatrical effect is an almost fortuitous consequence.

Alongside such 'scenic' decorations the system of large tapestry-like fields and narrow intervals, with or without architectural perspectives, remains the most popular variety of wall-painting. The examples in the Golden House are simple white-ground schemes in minor rooms, such as that 'of the Birds' [78]. Much more elaborate are the decorations of the principal rooms in the House of the Vettii at Pompeii. The splendid *oecus* at the north end of the peristyle is decorated with large vermilion fields carrying picture-panels (now missing) and pairs of floating lovers, and with black intervals adorned with candelabra; along the bottom runs a black predella containing the famous scenes of Cupids engaged in various trades and activities [Pls. VIIC, XIVC; 179], while little mythological pictures [80, 130] and groups of Psyches picking flowers [79] occupy the positions beneath the candelabra. The dado is again black, with a decoration which includes figures as well as conventional motifs; the upper zone, like many of this period, including the remaining fine rooms of the Vettii, adopts the 'scenic' formula of figures distributed among architectural structures painted on a white ground. The whole scheme is tricked out with exquisite ornamental detail; the embossed work on the gilded candelabrum bases and the ubiquitous plant-tendrils are especially fine [80]. The delicacy of the painting matches the best work of the Third Style, even surpasses it; but the fluidity and plasticity of the decorative elements, their predominantly yellow colouring in lieu of the former polychromy, and the vigorous and well-rounded quality of the figures are a world away from Third Style formulations. The decoration of the *atrium*, or what is left of it, shows a similar use of black and vermilion and a similar richness of ornament. It is noticeable that here, as generally in the Fourth Style, the vignettes which appear in the predella and other positions have lost the neatness and wide spacing of the previous period; figures and objects are more tightly and irregularly grouped, with a certain degree of overlapping, cubic objects are shown in perspective, and in place of a precise ground line we find a kind of platform viewed slightly from above.

Two other grand rooms of the House of the Vettii are the *triclinia n* and *p* which open at either end of the east arm of the peristyle. In each case the main focus of interest is the trio of mythological paintings, probably based upon Greek old masters, which gives the room something of the semblance of a picture-gallery; but these paintings are merely the centre-piece of highly ornate decorations replete once more with ornamental detail. Room *p*, the 'Ixion Room' [81], has a scheme of red and white fields, the red carrying the mythological panels, the white decorated with floating duets (satyrs and personifications of the Seasons) similar to those of the *oecus*. The interspaces are occupied by 'windows' opening above pale blue parapets crowned with paintings of sea battles and still lifes. The dado is painted in imitation of coloured marbles (cf. p. 95). In the 'Pentheus Room' (*n*), instead of an alternation of *Vorhänge*

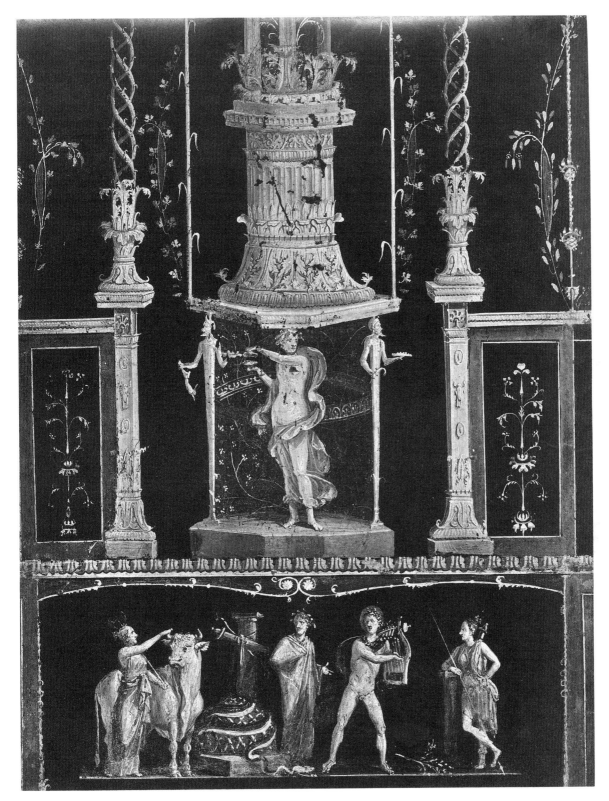

80 Pompeii VI 15, 1 (House of the Vettii). *Oecus q*, detail of east wall. Soon after A.D. 62.

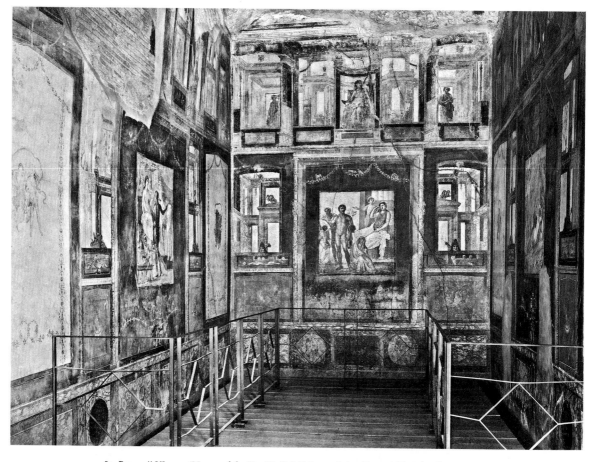

81 Pompeii VI 15, 1 (House of the Vettii). *Triclinium p* (Ixion Room). Shortly after A.D. 62.

and narrow *Durchblicke*, the effect is of a continuous yellow wall with windows in it [Pl. VIIIA]; these windows occupy the whole width of the side fields, and on the left and right walls they are as prominent as the central picture, whose importance is indicated merely by the use of a shallow framing *aedicula*.

More conventional *Vorhang* and *Durchblick* schemes appear in the Vettii peristyle [Pl. VIIIB], where the fields are black with red frames, and the intervening prospects have yellow parapets across them; the illusion of space in the openings is reinforced, as in the *alae*, by the continuation of their white background along the top of the main zone. The fields contain Dionysiac and other figures, still lifes and groups of divine attributes, and the yellow parapets are decorated with masks of Medusa and Oceanus painted in monochrome to suggest relief. Such rhythmic schemes, capable of almost endless repetition, even when, as here, they show a tendency to axial symmetry in their perspective and in the distribution of their subjects, lend themselves to the walls of peristyles. A very similar decoration is applied in the peristyle of the House of the Dioscuri

at Pompeii, with the differences that the *Vorhänge* are yellow and are scalloped at the tops, enhancing the resemblance to tapestries, while the *Durchblicke* contain still lifes, represented as shuttered panels standing atop the parapets.

The range of variations upon the *Vorhang* and *Durchblick* formula is remarkable. The architecture in the *Durchblicke* is now relatively sober and sturdy, now fantastic and intricate; it appears with or without parapets, with or without figures or painted panels, with or without trees or other ornaments. The *Vorhänge* seem now solid and impenetrable, now light and elastic; they carry mythological panels, small landscapes or still lifes, single figures of all types, tondi containing busts (single or paired), vignettes and isolated birds or animals; and their borders form rectangles or concave-sided figures [82], or lozenges with little arcs cut into the angles [83]. The upper zone and dado are similarly varied. In the former there may be relatively convincing perspectival architecture, or purely conventional frameworks of pattern, or disconcerting compromises between the two, always enlivened by the standard

IA Pompeii IX 3, 2. First Style wall-decoration in garden (colour lithograph). Late 2nd or early 1st century B.C.

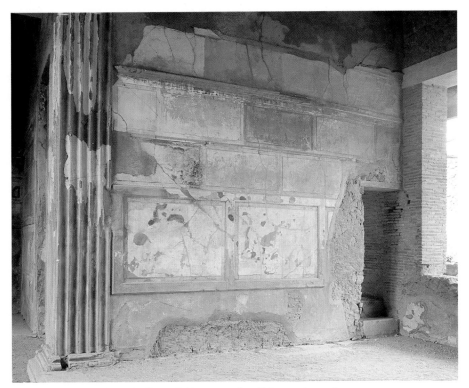

IB Pompeii VI 2, 4 (House of Sallust). *Tablinum*, north wall. Late 2nd or early 1st century B.C.

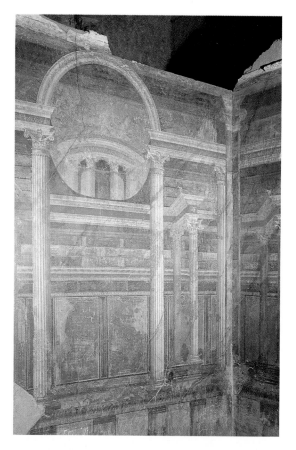

IIA Pompeii, Villa of the Mysteries. Bedroom 16, alcove B (right corner). *c.* 60–50 B.C.

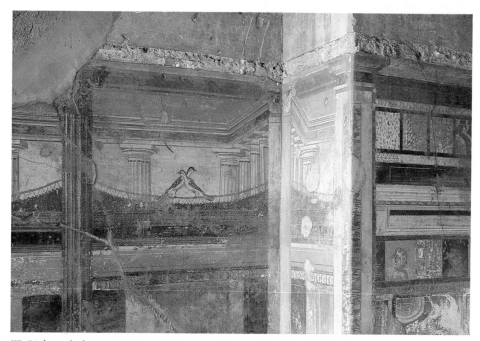

IIB Birds perched on curtain. Pompeii VI 11, 9–10 (House of the Labyrinth). Bedroom 46, west wall. Third quarter of 1st century B.C.

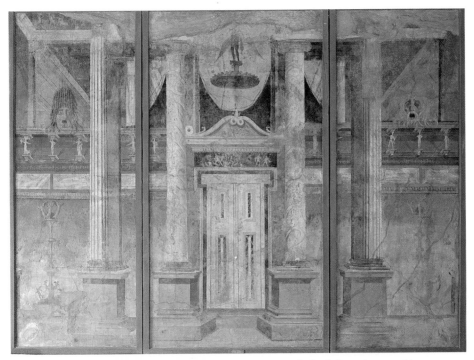

IIIA Boscoreale, Villa of P. Fannius Synistor. *Triclinium* G, west wall (divided into three panels). *c.* 50–40
B.C. Naples, Archaeological Museum. H. approx. 3.40 m.

IIIB Oplontis, Villa of the Poppaei. Room 23, north wall. *c.* 50–40 B.C.

IVA Late Second Style ornamental details. Rome, Palatine, House of Augustus. Upstairs bedroom (15), north wall. Soon after 30 B.C.

IVB Rome, House of Augustus. Ramp leading to temple of Apollo, painted ceiling (detail). Soon after 30 B.C.

VA Pompeii VII 3, 29 (House of M. Spurius Mesor). *Oecus l* (formerly *t*), north wall (colour lithograph). First quarter of 1st century A.D.

VB Pompeii IX 1, 22 (House of Epidius Sabinus). *Triclinium t'*, north wall (detail) (colour lithograph). Third or fourth decade of 1st century A.D.

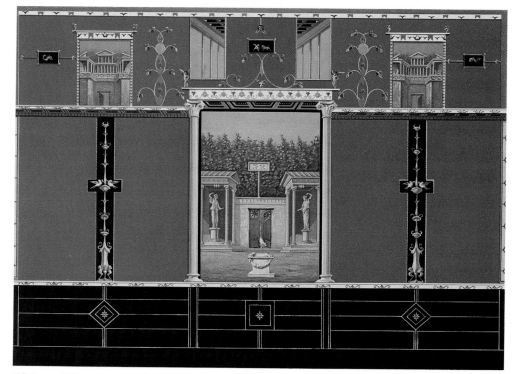

VC Pompeii IX 9, 18 (House of G. Sulpicius Rufus). *Triclinium e*, south wall (colour lithograph). Second quarter of 1st century A.D.

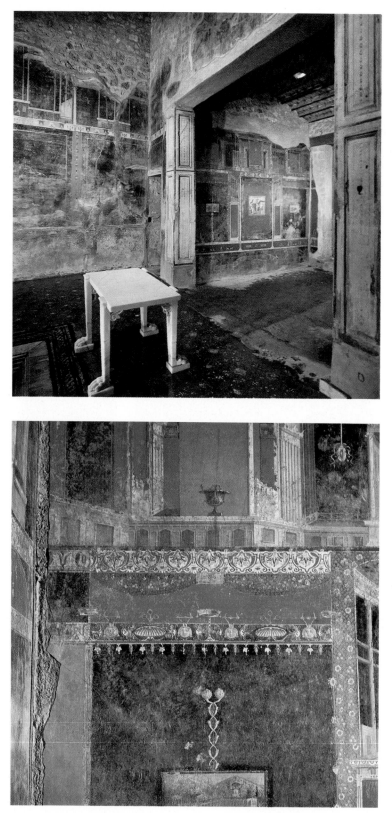

VIA Pompeii V 4, a (House of M. Lucretius Fronto). *Atrium*, north-east corner (looking into *tablinum*). *c.* A.D. 40–50.

VIB Detail of Third Style ornament. Pompeii V 4, a (House of M. Lucretius Fronto). *Tablinum*, south wall. *c.* A.D. 40–50.

VIIA Border in transitional Third/Fourth Style. Stabiae, Villa Varano, *atrium*. Mid 1st century A.D.

VIIB Fourth Style 'embroidery' border. Pompeii I 10, 4 (House of the Menander), *atrium*. Third quarter of 1st century A.D.

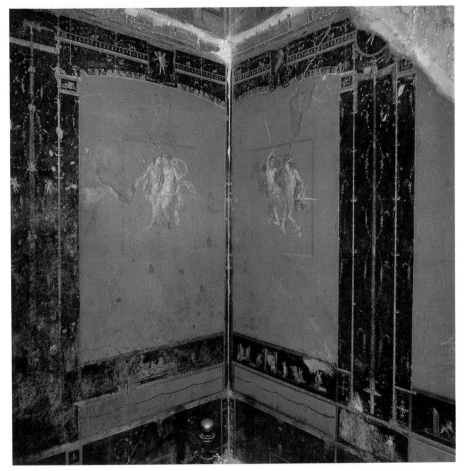

VIIC Pompeii VI 15, 1 (House of the Vettii). *Oecus q*, north-east corner. Soon after A.D. 62.

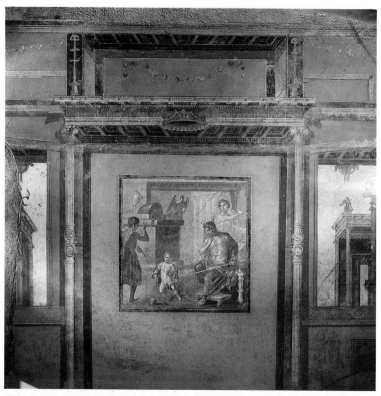

VIIIA Pompeii VI 15, 1 (House of the Vettii). *Triclinium n*, north wall (picture of infant Hercules strangling snakes, H. 1.03 m.). Soon after A.D. 62.

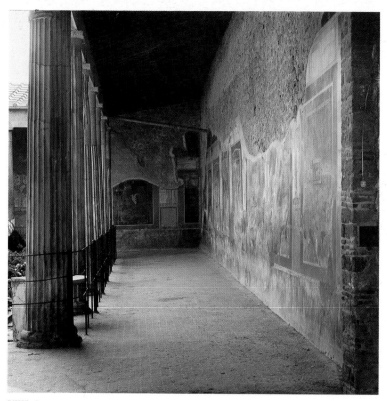

VIIIB Pompeii VI 15, 1 (House of the Vettii). Large peristyle, west wing (looking south). Soon after A.D. 62.

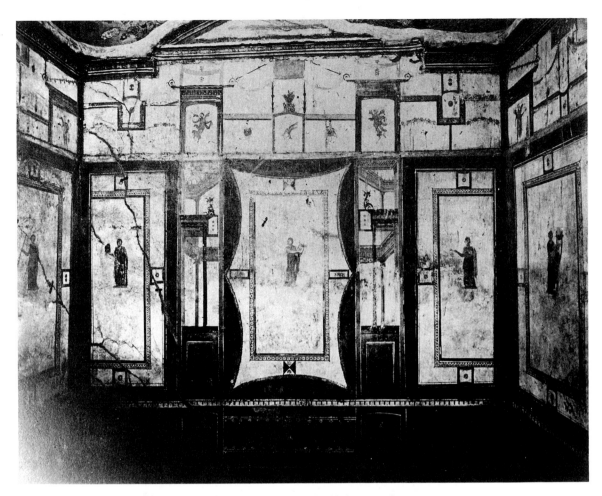

82 Pompeii IX 5, 11. Room *f*, west wall. Third quarter of 1st century A.D.

paraphernalia of birds, animals, dolphins, sea-monsters, flying Cupids, shields, drinking-horns, garlands and so forth. In the dado, in addition to imitation marble, we find panels linked by garlands and embroidery borders, shrubberies containing birds and animals or combinations of the two. Predellas and friezes are rare in the Fourth Style, but a few examples occur; particularly striking are the friezes with rich continuous scrolls which divide the main and upper zone in a number of Pompeian decorations, including that of the portico of the temple of Isis.

The colour schemes employed are also endlessly varied. While the ground colour of the dado is usually purple or black, partly to avoid showing the dirt and partly to provide a strong visual basis to the decoration, in the main and upper zones almost any combination of colours is possible. The *Durchblicke* and upper zone more often than not have a white ground, especially where an effect of receding architecture is cultivated; but the *Vorhänge* can be red, purple, black, yellow, blue or white, and often two

of these in alternation, while any parapet across the gap is almost invariably in a contrasting tone. If the *Vorhang* is white, it may be distinguished from the *Durchblick* by the addition of a brightly coloured frame; but, as in the House of the Prince of Naples [76] and in room *e* of the House of the Vettii, the white ground is frequently continuous, making it difficult at first sight to differentiate one element from the other. In a minority of decorations the *Durchblick* is coloured, generally black, while the *Vorhang* is left white, producing a kind of negative image; the most noteworthy example of this is a decoration in the House of D. Octavius Quartio (usually called the House of Loreius Tiburtinus) at Pompeii [84], where the delicate two-storeyed perspectival pavilions are given a strange ambivalence by the black surface: are they receding into the wall or projecting from it? The conventional depthless black dado leaves the issue in doubt. The upper zone may also have a coloured background, sometimes contrasting with what comes below, but more often than not picking

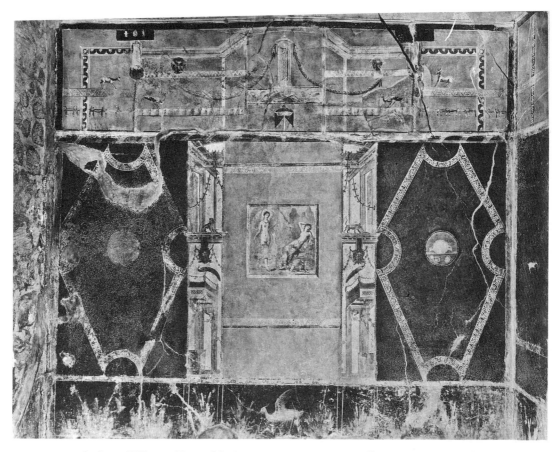

83 Pompeii VI 16, 15 (House of the Ara Maxima). Room F, west wall. Between *c.* A.D. 50 and 62.

up the dominant tone of the main fields. A not infrequent formula is a wall in a single colour, most commonly red or black, but also sometimes yellow or blue. Such schemes retain the fine perspectival pavilions of the *Durchblicke*, but the continuous colour of the background creates a conflict between their three-dimensionality and the non-spatial character of the surface. In decorations like the black scheme of the apsidal *oecus* (62, formerly 24) in the House of M. Fabius Rufus and the red one of room *b* in the House of the Red Walls [85], both at Pompeii, this tension combines with the exaggeratedly tall and slender forms of the architecture to produce a curiously effective dream-like quality. The pervasive ground colour also throws the central pictures into strong relief. Such monochrome schemes are sometimes represented with purely ornamental divisions in place of the architectural structures. A fine example, comparable to the Vettii *oecus* for the delicacy of its plant-motifs, is the white decoration of a *triclinium* in the House of the Centenary at Pompeii, in which the fields (here without pictures) are framed by vertical stalks entwined with tendrils while the intervals are occupied by leaf-encrusted candelabra [86].

Yet another variation upon the monochrome idea can be seen in the House of the Stags at Herculaneum. The background of all three zones of the decoration is black, but the main fields are distinguished by broad red borders. Whether the object of these borders was to emphasise the impenetrability of the *Vorhänge* in contrast to the illusionistic space of the *Durchblicke*, which contain the usual perspective architecture, is uncertain; but, if it was, the uniform blackness defeats the purpose. The red borders seem to stand out in isolation within an otherwise homogeneous scheme.

If there is any development discernible in the course of the Fourth Style, it is towards a less careful, less elaborate rendering of the ornament. Nowhere is this more apparent than in the treatment of the borders. In the earlier years of the style, these were fine and ornate, whether in the form of metalwork grotesques [Pl. VIIA; 74] or, as in the House of the Vettii, based on vegetal motifs: tendrils, garlands or leafy stalks and calyces repeated in series one above the other. Where the stencil-like embroidery border was used, it was almost invariably a relatively complex pattern, carefully and neatly drawn [Pl. VIIB]. In the Vespasianic period

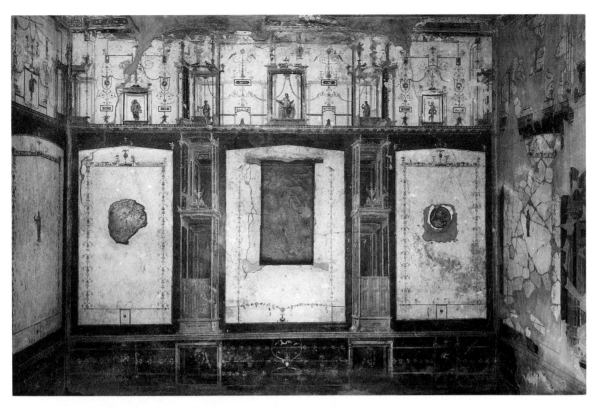

84 Pompeii II 2, 2–5 (House of D. Octavius Quartio, or of 'Loreius Tiburtinus'). Room *f*, west wall. Third quarter of 1st century A.D.

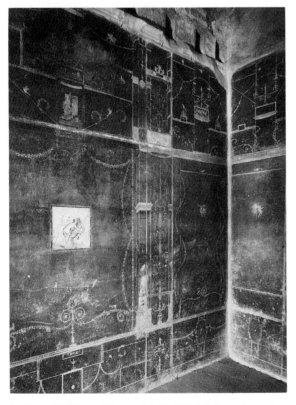

85 Pompeii VIII 5, 37 (House of the Red Walls). Room *b*, south-west angle. Third quarter of 1st century A.D.

86 Pompeii IX 8, 3/6 (House of the Centenary). *Triclinium* 7, detail of west wall. Third quarter of 1st century A.D.

(A.D. 69–79), however, there is a trend towards harder and more mechanical borders, reproduced more quickly and negligently. Grotesques and vegetal borders become less common, and embroidery borders, often of the most basic and unambitious patterns, are almost *de rigueur*. This change would have been favoured by the pressures of increased demand imposed by repairs after the earthquake of A.D. 62; for the embroidery border, single-coloured and simple to repeat, lent itself to mass production. But embroidery borders occur in northern Italy and in the provinces too; and that the simplification was part of a general stylistic trend is suggested by Domitianic (A.D. 81–96) decorations in Rome, which retained floral borders and grotesques but hardened them into simpler and more stylised forms than their Neronian predecessors.

In addition to 'scenographic' decorations and field-and-interval schemes, two more specialised kinds of decoration may be briefly mentioned: 'wallpaper' patterns and all-over subject-paintings.

'Wallpaper' patterns (German 'Tapetenmuster') are a transference to the wall of the kind of repeating schemes already familiar on ceilings (pp. 64–5). Sometimes this system trespasses only on to the upper part of a wall which is otherwise decorated in a more conventional manner; a *triclinium* in the House of Pinarius Cerialis at Pompeii has a fairly typical main zone consisting of large fields framed by simple embroidery borders and of intervals containing candelabra, but above it, in lieu of an upper zone, come tiers of rectangular panels [87]. These panels are clearly inspired ultimately by ceiling-coffers, and each contains a single decorative motif – either a whirligig-like flower seen from front or back, or a frontal head, or some kind of mythical monster (sea-panthers, fantastic birds and the like). On other occasions the pattern spreads over the whole wall except the dado and involves more varied shapes. In a small room in the Villa Varano at Stabiae, above a red dado with typical Fourth Style motifs, the decoration consists entirely of a network of diamond-shaped compartments formed by fine linear tendrils on a white ground, the compartments enlivened by flowers, birds, floating figures and little purple medallions [88]. In the House of the Gilded Cupids at Pompeii, a bedroom

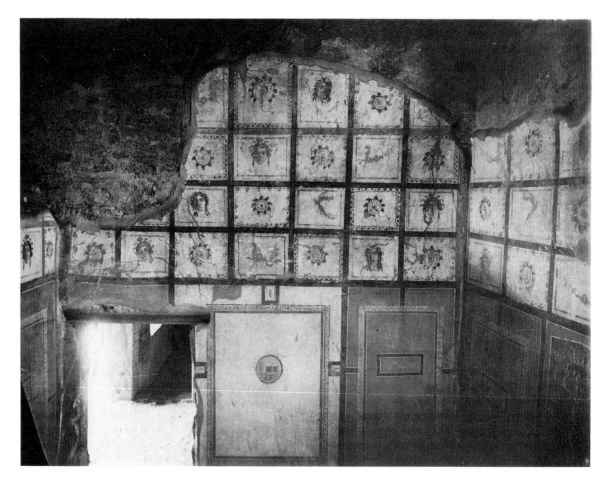

87 Pompeii III 4, 4 (House of Pinarius Cerialis). Room *c*, east wall. Third quarter of 1st century A.D.

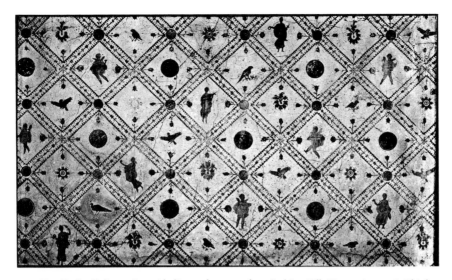

88 Detail of wall-decoration with diamond pattern, from Stabiae, Villa Varano (room 9). Third quarter of 1st century A.D. Naples, Archaeological Museum 9661.

is decorated with an all-over pattern of elongated hexagons surrounded by squares, lozenges and triangles, all carried out in brown lines on a yellow ground; the hexagons contain eight-petalled rosettes, the squares simple quatrefoils and the lozenges ivy-leaves. This relatively complicated pattern, inspired perhaps by similar schemes in mosaic pavements, has taxed the patience of the painters, for in places it has been executed in obvious haste and loses all vestiges of regularity. Some 'wallpaper' schemes graduate from a linear framework to a purely floral pattern. Thus in the House of the Coloured Capitals at Pompeii there is an all-over system of rosettes and diagonal voluted stalks, rendered in blue, yellow and green on a claret-coloured ground; this attractive décor was obviously based on a linear grid, but the geometric basis has been well concealed beneath the rich floral embellishment. Both the last-mentioned schemes were accompanied by marbled dados, and both were interrupted by figure-subjects at the centre of the wall – in the House of the Coloured Capitals by a series of mythological pictures, and in the House of the Gilded Cupids by glass discs containing the figures which have given the house its name.

All-over subject-paintings seem to have acquired popularity during the period of the Fourth Style, especially for the walls of gardens and courts. Favoured themes include landscapes, both of contemporary and Egyptianising type, and compositions of wild and exotic animals, inspired either by the game parks of Hellenistic kings and their Roman imitators or by the beast-hunts of the amphitheatre. In each case the spatial setting is designed in some sense to harmonise with, and to enlarge, the real garden – a role also performed by paintings imitating the actual trees and shrubs of the garden (cf. pp. 152–3). Sometimes the land-scape or animal composition is given a mythological formulation: the landscape, for example, is used as the setting for a story such as that of Diana (Artemis) and Actaeon, or the beasts become the enchanted audience of a lyre-playing Orpheus [160]. Frequently these outdoor scenes are enclosed within wide frames, which are in turn set behind painted shrubs and garden furnishings; and here the intention to suggest great panel-paintings or windows at the back of an ornamental garden is unmistakable. Among the best surviving examples are those in the garden of the House of the Ceii at Pompeii where scenes of predatory animals [89] and of Nilotic panoramas [157] appear above low shrubberies of myrtle and ivy containing ornamental fountain basins, and are framed by red and yellow walls adorned with shields, *paterae* (sacrificial dishes) and reliefs. The equivocal nature of the pictures is illustrated by the disparity between the frames of the upper parts, curvilinear and bordered by garlands, and those of the lower parts, which are in the form of illusionistic parapets strewn with leafy branches. The former suggest panel-paintings, the latter indicate a direct opening into an exotic world beyond the wall.

Ceiling-decorations

For this period we have a comparative abundance of evidence for ceiling-decorations, derived partly from the houses of Pompeii and Herculaneum and partly from Nero's palaces in Rome. These reveal a still wider range of designs and ornaments than in the previous period; but among the salient features are a tendency to greater richness and fantasy, consonant with the developments on walls; a much closer integration of painting and stucco-

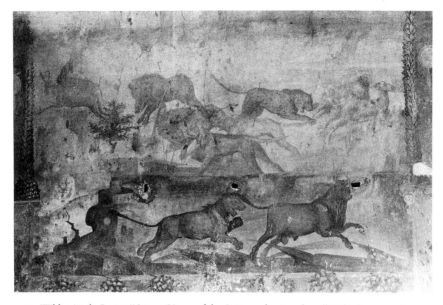

89 Wild animals. Pompeii I 6, 15 (House of the Ceii), garden (north wall). Third quarter of 1st century A.D.

work in those decorations where the two media were used in tandem; and in terms of design the triumph of centralised schemes, usually based on an underlying system of concentric zones, but with an incipient emphasis on the diagonals.

In decorations of pure stuccowork unaided by colour the dominant theme is a return to rhythmic patterns based upon coffering. Vaults from Rome and Herculaneum show a conscious imitation of stone coffering, distinguished from the earlier examples of the Second Style (pp. 42–4) primarily by the shallowness of the relief and by the richness of the frames, which frequently carry pairs of decorated mouldings, represented as if on recessed steps, one within the other. Patterns include not only grids of squares, two or more of which may be fused to form larger fields, but also networks of hexagons and of octagons alternating with small squares. The reliefs within the coffers (small figures, animals, arms, rosettes) are generally stock motifs arranged in alternating series; only the large fields created by fusing two or more units within square grids allow space for bigger figures or figure-groups. Content is once more, as in the late Republican period, subordinate to design.

Where stucco was used in concert with painting, its principal role was to create the framework for the decoration, and this framework was frequently again an all-over network. A very simple manifestation is the decoration of the segmental vault of a bedroom in the House of the Gilded Cupids at Pompeii [90], where a grid of stucco mouldings forms square fields enclosing smaller squares, roundels and polygons which were decorated with paintings of animals, still lifes and landscapes. More complex are the curvilinear systems, which now appear in Roman ceiling-decoration

for the first time; the dynamic rhythms which they introduce evidently commended them to the 'baroque' taste of the Fourth Style. We have remains of such systems executed now with painting subordinate to stuccowork, now with the roles reversed. Of the latter class a fine example is offered by rooms A2 and A5 of a *nymphaeum* (decorative fountain) complex in Nero's Domus Transitoria. Here the vaults and lunettes were decorated with a pattern of tiny medallions and concave-sided diamonds (mostly cut out in the eighteenth century) arranged in alternation within a delicate tracery of golden arabesques [91]. The medallions and diamonds were framed in relief and filled with solid colour, yellow for the former, and yellow containing blue tondi for the latter; but the overall effect was light, thanks to the white of the background. The setting of small coloured compartments against a white ground decorated with tendrils recalls some ceilings of the Third Style (cf. [66]), but the exuberance of the vegetation and its tight packing to form a network over the available spaces show the less restrained spirit of the Fourth. Also characteristic of the Fourth Style were the pairs of tiny stucco figures which were set on the coloured medallions so as to give, with their natural whiteness, the semblance of little cameos. The diamonds, many of which have found their way to Naples Museum, carried single floating figures, here painted in golden yellow on the central tondi.

The neighbouring vaults of rooms A3 and A4 displayed a similar love of arabesques and cameo-like stuccowork, but now combined with painted figure-scenes and adapted to a new decorative system. The surface was again basically white but was divided by red and blue bands into large

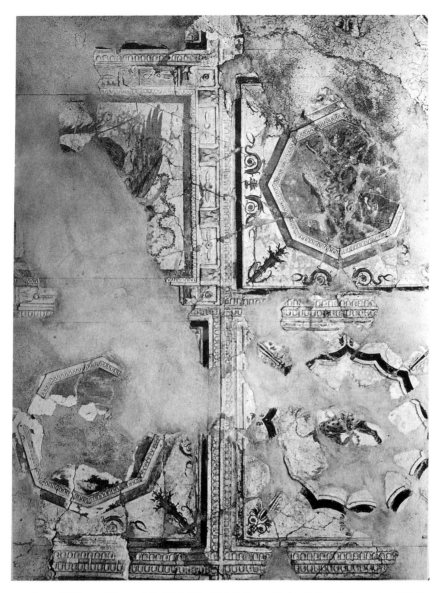

90 Pompeii VI 16, 7 (House of the Gilded Cupids). Bedroom R, detail of vault-decoration. Third quarter of 1st century A.D.

square and rectangular fields. The coloured bands were framed by stucco mouldings and carried tiny motifs in white stucco, while large stucco rosettes with gilded petals straddled them at intervals. The fields contained paintings of scenes from Homeric legend, represented as vignettes against the neutral white background [92], amid a profusion of red-gold grotesques and arabesques. This latter by-work, luxuriant yet formalised and carefully painted, is the most striking surviving feature; it includes beads of blue glass at the centres of flowers – an innovation which, together with the gilding of the stuccoes, calls to mind the Roman writer Suetonius's description of the Golden House

as 'all coated with gold and picked out with gems and mother of pearl'. Similar decorations, with rectangular fields framed by coloured bands enhanced with stucco-work, are attested for the Golden House itself by eighteenth-century drawings.

Other Fourth Style vault-decorations combining stucco-work and painting adopt the centralised principle of design. A fine example at Pompeii is the vault of the great *oecus* of the Villa Imperiale [93], where the upper parts of the Augustan Third Style scheme [56] seem to have been replaced in the new mode at some time in the 50s. Apart from a zone at either end designed to reduce the surface

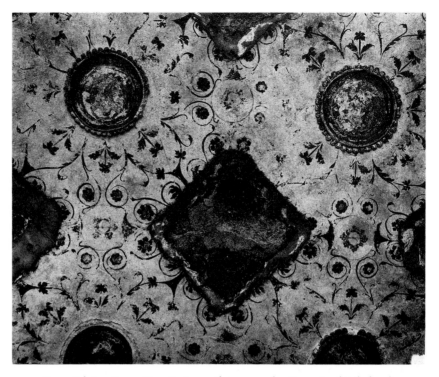

91 Rome, Palatine, Domus Transitoria *nymphaeum* complex. Room A2, detail of vault-decoration. Between *c.* A.D. 59 and 64.

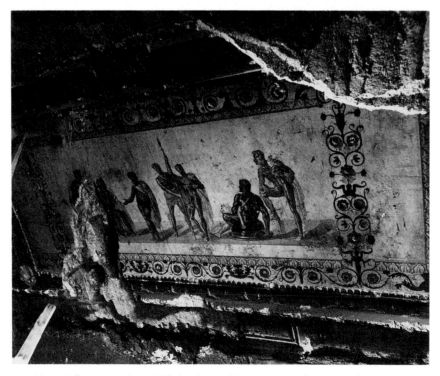

92 Homeric figure-scene. Rome, Palatine, Domus Transitoria *nymphæum* complex. Room A4, vault. Between *c.* A.D. 59 and 64. Palatine Antiquarium.

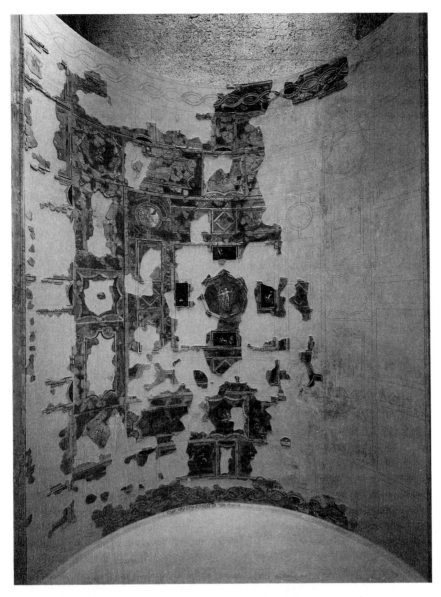

93 Pompeii, Villa Imperiale. *Oecus* (A), stucco and painted vault-decoration. Mid 1st century A.D.

to a square, the design is symmetrical on all four sides; a central octagon containing a floating couple is set in a square surrounded by three wide borders, each of which encloses a series of smaller fields of various shapes – oblongs, roundels, concave-sided polygons and so forth. Most of the fields and their surroundings are occupied by stucco reliefs on coloured grounds, but some contain painted figures and landscapes. Despite the richness of the colouring (black dominant with red, orange, purple and light blue in subsidiary roles) the overall effect is light and delicate, owing to the tiny scale of the reliefs.

Rather richer are the three vaults which use a similar hybrid technique in the Golden House. In the so-called Volta Dorata (Gilded Vault) a complicated system of rectangular and curvilinear shapes focused round a central roundel was framed throughout by gilded stucco mouldings often replete with detail and picked out in red, blue, purple and green; the grotesques and arabesques which are otherwise ubiquitous in the vaults of the Golden House are missing, but all the fields originally contained figure-paintings or stucco reliefs on coloured backgrounds, mainly red and blue. The central roundel was decorated with a suitably celestial subject, Jupiter (Zeus) and Ganymede aboard an eagle, glimpsed as if through a

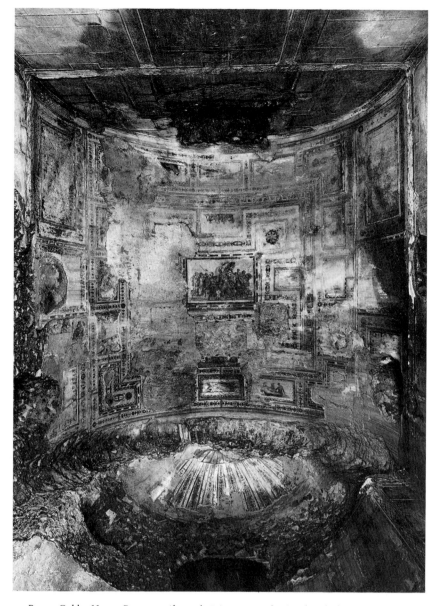

94 Rome, Golden House. Room 119 (formerly 85), stucco and painted vault-decoration. Between A.D. 64 and 68.

skylight. In the matching vaults of rooms 129 and 119 (formerly 80 and 85) [94], a scheme of concentric zones enclosing a central rectangular panel is carried out mainly in painting on a white ground, but with stucco mouldings supported by coloured channels for the frames. Delicate chains of grotesques similar to those of the Domus Transitoria are also used. The figure-paintings which survive or are known from old drawings seem, as in the Domus Transitoria, to have shown episodes from the Trojan cycle, including the meeting of Paris and Helen, the leave-taking of Hector and Andromache, and in the two central fields

Achilles on Skyros and a female figure borne across the sea, perhaps Thetis carrying Achilles' armour.

On vaults and ceilings in which painting is the sole or dominant medium centralised designs are almost obligatory. The structure is normally based upon concentric rectangular borders, but there are frequently secondary emphases on the diagonals and axes of the surface, while octagonal and circular fields sometimes play a role. For the earlier phases we can cite the ceiling of the upper peristyle in the Villa San Marco at Stabiae. Divided into separate rectangular sections focused on large square panels con-

taining celestial figure-subjects (the chariot of the sun-god, the four Seasons grouped in an armillary astrolabe), this incorporates a wealth of framing ornament: borders of double S-volutes, of goats and Cupid grotesques in heraldic opposition with wine-jars, of dolphins and palmettes, of palmettes and *bucrania* (ox-skulls), of vines and fruit-garlands. A characteristic feature is the use of supporting figures to suggest that the inner parts of the design are braced against the outer borders in a kind of architectonic structure.

The finest and most delicate of the centralised decorations are those in the Golden House. Relatively simple versions on a white ground, with light frameworks of grotesques and plant-motifs in yellow, red and green, generally resting upon lines in one of the two latter colours, appear in the eastern part of corridor 92 (formerly 70). But more ornate and carefully executed are the paintings, mostly with coloured grounds, discovered in the eighteenth century in various rooms in the west wing of the palace. The engravings published soon after their discovery show surfaces divided by bands of exquisite vegetal ornament enlivened with birds and griffins; the interspaces were occupied by picture-panels, decorative figures, hanging drapes and garlands; and at strategic points in the design there were little stucco 'cameos' with red or blue grounds. The 'Vault of the Owls' (room 29, formerly 38) [95] had round and *pelta*-shaped cameos emphasising the axes, along with painted landscapes in shuttered panels; round, onion-shaped and leaf-shaped cameos marked the diagonals. At the centre, forming the focus of the axial and diagonal thrusts, was a mythological painting, already lost in the eighteenth century (the engraving substitutes a picture from elsewhere). The red vault of room 33 (34) was less strongly centralised, being divided into a number of independent square and rectangular areas; but the treatment of these areas was almost exactly symmetrical on all four sides, and a certain emphasis was again placed on the axes, with *pelta*-shaped cameos and column-like arrangements of ornamental motifs converging on a central picture.

At Pompeii and Herculaneum the vault-paintings naturally lack the quality of those in the Golden House, but many are finely executed. Borders are normally of embroidery type or else solid bands of colour rather than grotesques or arabesques; and the designs make greater use of circular, polygonal and oblique elements than the vaults of the Golden House. A favourite device is the use of a roundel or polygon in the central position; this avoids too specific an orientation for the subject represented therein and helps to reinforce the radial nature of the design. Sometimes, as in room 8 of the House of the Lovers at Pompeii, the central field is a concave-sided octagon, giving the effect of a canopy fastened across a circular opening [96]. In other cases different shapes are set one inside the other; the so-called Taberna Attiorum at Pompeii [97] has a central octa-

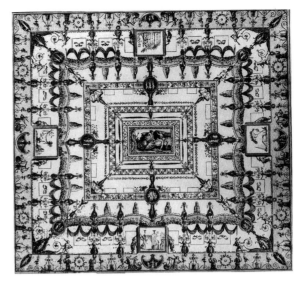

95 Rome, Golden House. Vault-decoration of room 29, formerly 38 (Vault of the Owls) (engraving, back to front). Between A.D. 64 and 68.

gon set in a square which is placed obliquely within another larger square whose angles are marked off by little quarter-circles. The result is a complex, revolving play of forms. Very frequently we find small medallions near the corners of a scheme, perhaps again a response to problems of orientation; in the House of the Lovers they support ornamental structures which serve as diagonal buttresses for one of the inner borders of a system of concentric squares. Still more frequently the axial position at each side is occupied by a small pavilion whose roof is formed by a shell or by a crown viewed in perspective from below.

All these endlessly varied schemes are colonised by the usual stock motifs of the Fourth Style: dolphins, sea-monsters, birds and animals, *gorgoneia*, wine-cups, hanging shields, baskets and horns and many others. The colouring is normally unified by the use of a single background tone, though on white grounds certain strategic panels tend to be set off in contrasting colours. White-ground ceilings, being the easiest to produce, are the most commonly found; but the buried cities, like the Golden House, yield several examples of red or black. A splendid example of a black scheme has been restored in room HH of the House of Julius Polybius at Pompeii, where a central roundel containing an eagle is set in a canopy-like frame, and successive square borders decorated with such motifs as a meander, a frieze of heraldic griffins and lyres, and a great looping ribbon, blue on one side and claret on the other, lead outwards to a border containing swans and sphinxes perched on consoles.

Of the other varieties of ceiling-decoration which occur in this period two are rare and highly specialised. The first

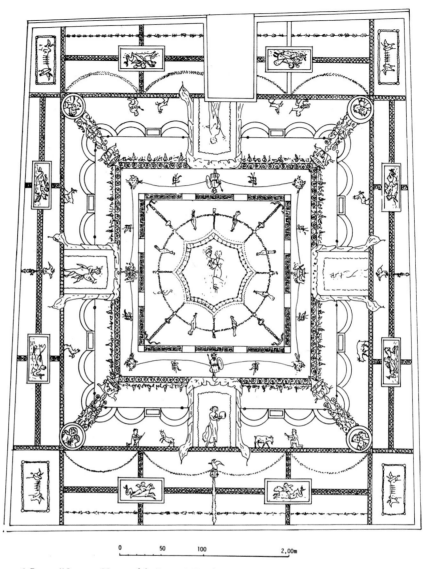

96 Pompeii I 10, 11 (House of the Lovers). *Triclinium* (8), painted vault-decoration (restored). Third quarter of 1st century A.D.

consists of evenly spaced stars, either painted in yellow, red and other colours on a white ground, as in the entrance-passage of the Forum Baths at Pompeii and the vestibule of the Palaestra (athletics ground) at Herculaneum, or in gold on a light blue ground, as in the conical dome of the *frigidarium* in the Stabian Baths at Pompeii. In the latter case there can be little doubt that the intention was to produce a stylised version of the firmament. The second is represented by a dome painted with marine fauna, including eels, mullet and an octopus struggling with a moray, on a sea-blue background in the *frigidarium* of the so-called Forum Baths at Herculaneum. Here the reflection in the pool below would have given bathers the illusion that they

were immersed in a real aquarium. Such conceits were to enjoy great favour in bath-buildings of the ensuing period.

One other occasionally found type of painted vault-decoration is the all-over pattern. Used in the Third Style for close-knit linear schemes (p. 65), this now succumbs to the all-pervasive vegetalisation of the early Fourth Style; the underlying grid is camouflaged beneath rosettes, foliate forms and volute motifs. The effect is paralleled in some 'wallpaper' murals at Pompeii (p. 85), but on vaults the only extant specimens of the period are in Rome and primarily in Nero's palaces. The decorations of rooms A2 and A5 in the Domus Transitoria *nymphaeum*, already described, belong to this genus, though with the inclusion of

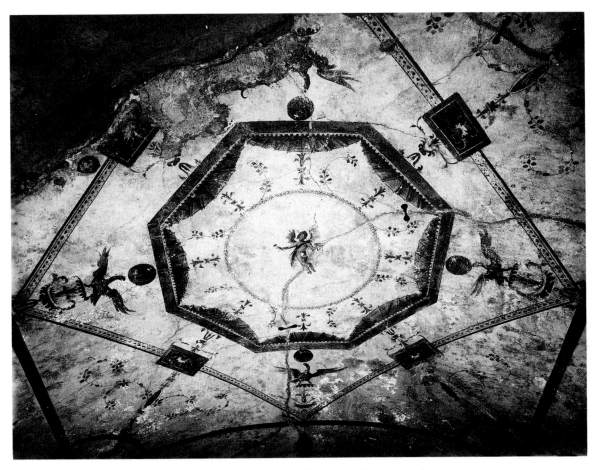

97 Pompeii IX 2, 10 (Taberna Attiorum), vault-painting. Third quarter of 1st century A.D.

stucco reliefs and with a dynamic emphasis on circular structures. More typical of the 'wallpaper' motif in their dependence on square grids are five contiguous sections of a vault in corridor 92 (formerly 70) of the Golden House. On a white ground and separated by ribs painted with scrolls or guilloches (plait-pattern), they show variations on the theme of rosettes with plant-ornaments growing from them. A typical example [98] has the pattern set parallel to the axes of the surface and the interspaces occupied by small birds, animals and mythical creatures, some painted white on red panels; in others it is set diagonally or elaborated into a tracery of looping tendrils. These patterns, which here occupy only the central part of the vault, while the lower parts are adorned with pavilions and candelabra, like the upper zone of a wall-decoration, are well suited to the needs of flat and barrel-vaulted ceilings, since they avoid hierarchical emphasis on any specific areas of the surface, and the orientation of figures and animals can be easily adjusted to the viewpoint of the spectator.

98 Rome, Golden House. Cryptoportico (70), detail of painted vault-decoration. Between A.D. 64 and 68.

Context

Among the varieties of pavement-decoration with which Fourth Style paintings were combined, the commonest remained black and white mosaics or mortar decorated with inset *tesserae* – simple types suitable to offset the polychromy of walls and ceilings. But this period also sees more examples of *opus sectile* in coloured marbles, used both for *emblemata* and in grander houses for whole floors. Such pavements accorded with the more showy side of Fourth Style taste and were clearly prized as status symbols. The materials employed included the yellow *giallo antico* from Chemtou in Tunisia, the red *rosso antico* from Taenarum in southern Greece, the green-veined *cipollino* from Carystus in Euboea (Greece), the white and purple-veined *pavonazzetto* from Phrygia, the black and red *africano* from Teos in Asia Minor and grey marbles from Proconnesus (Sea of Marmara) and elsewhere. In Nero's palaces, renowned for their luxury, there were also red porphyry from Egypt and green porphyry (serpentine) from Sparta (Greece).

As in previous periods, so in the Fourth Style decorative ensembles usually show attempts to harmonise the treatment of different surfaces within a room. The most striking gesture in this direction was the increased use of single-colour schemes. Already foreshadowed in the late Third Style, these were much favoured in the Fourth Style for the finer rooms of a house, notably dining and reception rooms. In room HH of the House of Julius Polybius at Pompeii, the black vault was accompanied by black walls; in room 48 (formerly 12) of the House of Fabius Rufus the walls and ceiling were red; and in another room in the same house the scheme was yellow. It also seems that *oecus* 11 of the House of the Menander at Pompeii, in which the prevailing colour of the wall-paintings [73] was green, had a vault-decoration in the same colour. Single-colour decorations occurred in the Golden House too; the red vault described above spans a room whose wall-paintings of 'scenographic' type were executed on a red ground; and in room 32 the unifying colour was black. Still more commonly, of course, both in the Golden House and in the Campanian cities, were rooms in which walls and ceilings were unified by the use of white [99]. In all these cases the unity was reinforced by similarities in the style of the painted ornament and in the range of decorative motifs employed. The pavements, on the other hand, sometimes deliberately established an inverse relationship with the colouring of the other surfaces; in room 49 (formerly 13) of the House of Fabius Rufus white paintings were offset by a black mosaic pavement. In room 58, however, all three surfaces – floor, walls and ceilings – are predominantly black.

With few exceptions coloured ceilings seem to have been reserved for rooms in which they picked up the predominant colour of the walls, or at least the colour of the upper zone. The vast majority of ceilings, however, were executed on a white ground, regardless of the prevailing colour of the walls. The prime object, as in earlier periods, was to avoid an excess of polychromy; thus in room 8 of the House of the Lovers at Pompeii the white of the ceiling counterbalances a rich blue and yellow scheme on the walls, and in room 9 of the Villa Varano at Stabiae it answers to a black and red one. In each case the upper zone is white, forming a transition to the ceiling, and in the House of the Lovers there are also white *Durchblicke*, so that the décor acquires a certain lightness and spaciousness which throws the brightly coloured fields into greater prominence. Such effects were no doubt very common in the Fourth Style, but it is not often that the survival of the ceiling allows us to observe them.

The Fourth Style period is especially fruitful for the study of the interaction of the different media. We find painting working in close relationship with both mosaic and stuccowork in order to produce the ornate effects which were currently in favour, and not surprisingly the close relationship resulted in a good deal of mutual influence.

Mosaic, for example, now began to appear increasingly in wall- and vault-decoration, especially in the context of baths and fountains. Its impermeability and durable colours recommended its use in damp or steamy surroundings, while the inclusion of coloured glass *tesserae*, relatively rare in floor-mosaics, produced scintillating reflections of the water. For their repertory and colouring wall-mosaics naturally turned to wall-paintings; one recently discovered specimen on the Quirinal in Rome represents a complete Fourth Style decoration with fantastic architecture and figures in niches. Elsewhere the two media are often used in close conjunction, for example in the fountain court of the House of Neptune and Amphitrite at Herculaneum, where a painted shrubbery runs up to the edges of the sections carried out in mosaic [100]. Only in the hardness and brightness of their colours, and particularly in the prominence given to dark blue and gold, do the mosaicists stand apart from painters. In depicting figures they go to great lengths to reproduce pictorial techniques such as chiaroscuro. *Opus sectile* too made occasional appearances as a medium for figure-work on walls, but the very nature of the technique precluded subtle gradations of light and shade.

Mosaic paving continued to be little influenced by painting, but it is possible that, as in the previous period (pp. 67–8), the patterns used by mosaicists may have exercised some influence on vault-design. The appearance of all-over curvilinear patterns on vaults, whether stuccoed or painted, may have been inspired by pavements, which had long featured designs of contiguous and interlaced circles. In the Domus Transitoria *nymphaeum* there are curvilinear systems on both floors and vaults, the former rendered in *opus sectile*, the latter in stucco relief and painting; but they were not, so far as we know, combined in the same

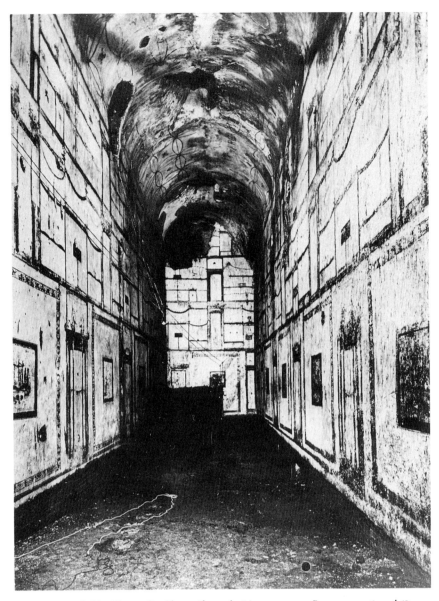

99 Rome, Golden House. Corridor 79 (formerly 61), eastern part. Between A.D. 64 and 68.

room. Generally speaking the rhythmic, all-over patterns much favoured in pavements are likely to have promoted the development of *Tapetenmuster*, of whatever form, on walls and ceilings.

A much clearer instance of painting being influenced by another medium is provided by imitations of marble wall-veneer. In the imperial palaces and similar richly appointed buildings, coloured marbles appeared not only on floors but also on the lower parts of walls [77]; and from there the practice spread to private houses. Marble dados, with compositions involving roundels, concave-sided shapes and frames in contrasting colours, had begun to appear at Pompeii by the time of the earthquake, notably in public rooms such as *tablina*, *oeci* and dining-rooms. Where a householder could not afford the real thing, he commissioned decorators to reproduce it in paintwork; thus imitation marbling appears in certain rooms in the Houses of the Vettii [81] and of the Gilded Cupids (cf. p. 85) and also at the foot of the 'scenic' decorations in the Houses of Apollo and of Pinarius Cerialis. Here, rather than a borrowing of ideas, we see a direct translation from one medium into another to suit the social requirements of the patrons.

Stuccowork, as we have seen, enjoyed a particularly

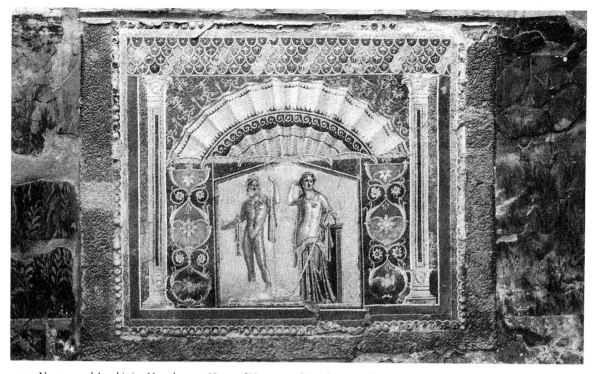

100 Neptune and Amphitrite. Herculaneum, House of Neptune and Amphitrite, wall-mosaic in fountain court. Third quarter of 1st century A.D.

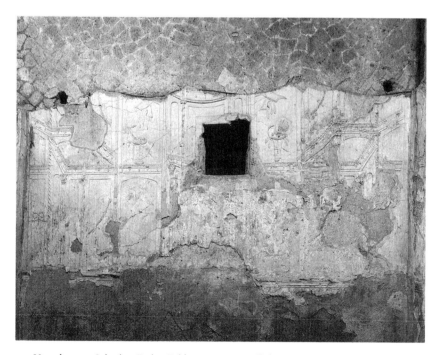

101 Herculaneum, Suburban Baths. *Caldarium*, stucco wall-decoration (west wall). Shortly before A.D. 79.

close collaboration with painting. On vaults we find decorations in which the surface was divided by stucco mouldings and the resulting fields contained either reliefs on coloured grounds or painted subjects [93–4]; decorations which consisted of paintings enclosed by stucco frames [90]; and decorations which were entirely painted apart from a few stucco cameos [95]. On walls stucco was sometimes employed to lend a little real depth to the illusion of depth which painters sought to achieve with the aid of perspective; a good example is the great wall on the west side of the *palaestra* in the Stabian Baths at Pompeii, where the entire two- or three-storeyed architectural framework was carried out in stucco relief, while the intervening spaces were filled either with stucco figures or ornaments on coloured backgrounds or with painted scenes. Still more eloquent of the integration of the two media is the occasional use of paint to suggest background details in stucco reliefs, as in the little Iliadic frieze in the House of the Iliadic Shrine at Pompeii.

Given the liaison between painting and stuccowork, it is not surprising to find each medium copying the other. Thus on walls, where all-white stucco decorations were apparently less rare than in the previous period (they were especially favoured in the steamy and comparatively gloomy conditions of baths, since they made the most of what light was available and had no colours which might be impaired by the humid atmosphere), stuccoists reproduced whole schemes and many details otherwise exclusive to the pictorial art. In the *caldarium* of the Suburban Baths at Herculaneum, decorated not long before A.D. 79 [101], the whole of the wall above a marble plinth was covered with stucco reliefs featuring typical Fourth Style perspectival architecture with spindly columns, now vertically or spirally fluted, now compounded of vegetal elements, and containing all the usual filling motifs: hanging garlands and curtains, shields and horns fastened beneath entablatures, and, within the pavilions, various lotus, volute and palmette ornaments, fruit-laden baskets with *peda* (shepherds' crooks), even sacro-idyllic landscapes. An entire painted scheme has been copied in stuccowork. Another white stucco wall-decoration, this time dated actually in 79, comes from the baths of a small villa near Stabiae; it copies an equally familiar, but altogether simpler, type of painted scheme: large rectangular fields containing concave-sided 'tapestries', 'pinned' at the corners and at the mid-points of the sides, with central pictures (Narcissus; Daedalus and Pasiphae) closely based on panel-paintings [102] (cf. [82]). Once again a pictorial composition has been translated into relief, with no assistance from colour. One final example of a stucco wall-decoration indebted to painting is that of room E in the Suburban Baths at Herculaneum, which shows warriors in high relief standing on consoles in the middle of large fields surrounded by undulating tendrils and separated by vertical fasciae containing plant-candelabra. Although the warriors

102 Stabiae, villa at Petraro, stucco wall-decoration with panel containing Daedalus and Pasiphae. A.D. 79. Castellammare di Stabia, Antiquarium 115/982.

could in theory simulate actual statuettes standing on brackets, the motif is a favourite in contemporary wall-painting (cf. [82]), and the decorative setting shows clearly that this was the source of the stuccoist's inspiration.

In vault-design, too, stuccoists may have received some inspiration from painters. The decorations of a trio of stuccoed tomb-chambers outside Puteoli (Pozzuoli), north of Naples, which are probably to be dated to the Flavian period (A.D. 68–96), echo the centralised schemes favoured by painters, and two in particular (those in Fondo Caiazzo) employ arrangements familiar in painted ceilings at Pompeii – combinations of rectilinear and curvilinear shapes focused upon a central roundel; a more or less pronounced emphasis upon the axes of the surface; and an embryonic emphasis on the diagonals. Designs of such sophistication and complication, found also in the part-relief, part-painted decoration of the Volta Dorata, are unprecedented in pure stuccowork and can only have been stimulated by comparable schemes in painting. Another pictorial feature which they employ is the illusion that fields of borders pass behind and in front of each other, suggesting that the composition is on more than one plane. This is a kind of subtle equivalent to the displays of spatial recession on Fourth Style walls.

Just as stucco copied painting, so in return painting occasionally copied stucco. Most strikingly, the centaur frieze in the green room of the House of the Menander [73], with figures painted white on a red ground and shaded to

suggest relief, seems to have been intended to reproduce a similar frieze in stucco. So too we find painters imitating little stucco cameos like those in the vaults of the Golden House (which were probably themselves inspired by work in onyx or coloured glass: one thinks again of Suetonius's 'picked out with gems'). Examples of 'false stuccoes' and 'little figures made to look like stucco cameos' are recorded for the Golden House itself in the eighteenth century; and a vault in the House of the Gilded Cupids at Pompeii contains medallions with tiny figures of swans, Cupids and griffins painted white on a red ground with exactly the same effect. Here the painter's imitation of motifs from another medium is as deliberate as the imitation of marbled dados.

There is one instance of the sharing of an idea between stucco and painting where the priority of the inspiration is less clear. A scheme of intersecting circles and straight garlands employed for a painted vault in the Golden House [99] reappears in virtually identical form in a roughly contemporary stuccoed vault in a bath-chamber at Baiae, north of Naples; the main differences, apart from the lack of colour, are the strengthening of the circles by the addition of egg-mouldings and the use of different motifs within the fields (evidently Cupids, female figures, dolphins and acanthus volutes, instead of eagles and floral ornaments). Another stuccoed vault of this period, in a bath-building at Bolsena, north of Rome, uses the same pattern, but with fuller frames for the circles and apparently without any figures or ornaments. One is tempted to argue that the pattern was created by painting and then passed to stucco, simply because the painted example is in a major metropolitan monument and the stucco versions in regional centres; but for such a basic pattern it is difficult to establish priorities, and three specimens hardly constitute evidence for firm conclusions. What is certain is that here, at least, we have a design which was interchangeable between painting and stuccowork.

To turn to the relation between painting and the architectural context. As already observed (pp. 69–70), the old rules governing the relationship between decorative schemes and the function of space were no longer much observed by the middle of the first century A.D. Admittedly the Fourth Style rooms GG and HH in the House of Julius Polybius at Pompeii incorporate strong divisions in the wall-paintings at the point of junction between a high ceiling in the front part of the room and a low segmental vault at the rear, and in room GG the division is reinforced by a change of pattern in the decorated pavement; but this pavement is probably a survivor from the previous (Third Style) phase, and the division in the wall-decoration corresponds to no pronounced change in form or colour. The hierarchy of space evidently now impinged less on the consciousness of painters. The decoration of ceilings, however, naturally continued to be conditioned by the structural arrangements; thus where one part of a room, say, had a flat ceiling, and another a low vault, each section would

receive a self-contained treatment, independent from, if stylistically related to, the other. During the Fourth Style there also seems to have been a predilection for the use of non-functional stepped and recessed areas in ceilings, and once again the decoration was adapted accordingly. If the sunken areas formed a series of separate panels, each was naturally given a self-contained decoration which balanced symmetrically with that of its opposite number or numbers within the scheme, while the intersecting ribs which divided them received some kind of continuous ornamentation. If the central part of the ceiling was recessed, then it had a centralised or symmetrical design, while the surrounding surfaces were decorated with a continuous border. Sometimes, as in room 48 of the House of Fabius Rufus at Pompeii, the whole central part was occupied by large fields recessed one within the other, a roundel within an octagon and the octagon within a square, each transition being marked by a stucco moulding; such arrangements naturally promoted, or were themselves promoted by, the popularity of vault-decorations based on concentric borders enclosing a focal panel. A favourite theme of the last years of the buried cities was a segmental vault recessed at the centre of an otherwise flat ceiling. The influence of this formula upon painting is indicated by the frequent use of incurving borders to simulate a recessed vault where none in fact existed [103].

Given that attempts were normally made to harmonise the colour schemes and decorative treatments of the different surfaces of a room, it is surprising that painters often failed to take into account the scale of their surroundings. The ornamentation of vaults in particular was often far too small. When, as frequently happened, a room was extremely high in relation to its ground area, decorators seem to have failed to make due allowance for this and applied the same patterns and motifs they might have done in a room half the height. Already in the Third Style we find such irrelation of scale in the ante-room of the Underground Basilica; but it is in the Golden House that the failing is most obvious. In the vaults of rooms 119 [94] and 129, for instance, much of the fine detail is lost on the viewer looking up from floor level. The problem afflicted the decorators of Pompeii much less, given the more intimate nature of their domestic architecture; but vaults such as that of the great *oecus* in the Villa Imperiale [93], springing at a height of over five metres but still adorned with figures and ornaments on a tiny scale (very similar to that of the stuccoes, scarcely above head-height, in the shrine which gives its name to the House of the Iliadic Shrine), demonstrate that they were not always immune to it.

A word finally about principles of design in ceiling- and vault-decoration. Repeating patterns have the advantage of being capable of limitless expansion, but often seem unsatisfactory at the edges of the surface, especially if the room is not quite rectangular; the pattern appears almost

103 Oplontis, Villa of the Poppaei. Corridor 46, detail of painted ceiling-decoration. Third quarter of 1st century A.D.

to carry on beyond the visible ceiling. Centralised schemes, and especially schemes based upon concentric rectangular friezes, were in this respect more adaptable to the needs of the surface. On the one hand the friezes could be widened or narrowed as appropriate; on the other, extra ones could be added at each end to adapt the scheme to an elongated room (thus the vault of the Villa Imperiale is extended by friezes containing interweaving ribbons). It was also possible to accommodate irregularities in the shape of the ceiling by adding narrow wedge-shaped borders along the edges. The centralised scheme was thus both self-contained and flexible. Its weakness was that it placed excessive emphasis on the central point, a circumstance which found no architectonic justification on flat ceilings or even on barrel vaults. It was better suited to the much rarer cloister or pavilion vaults, where each of the four faces rose symmetrically towards the crowning point. Indeed, it is possible that such vaults provided an important stimulus to the development of concentric schemes. The angles between the four faces would help to explain the increasing emphasis upon the diagonals in Fourth Style ceiling-

paintings; and the introduction of groined cross-vaults, in which re-entrant angles were replaced by salients, would have stimulated the process. The first groined cross-vaults known to us from Roman Italy are in the Golden House, but the type became especially popular during the second century A.D. As we shall see (pp. 178–81), this was to be the heyday of centralised and radiating ceiling-decorations, in most of which there was a more or less pronounced stress upon the diagonals.

Conclusion

As already noted, the Fourth Style began to lose its vitality and delicacy during the Vespasianic period. Decorations executed during the last years of Pompeii show tired and mechanical work, or alternatively (as in the Stabian Baths) a striving for effect which can produce a garishness and overloading of detail that pall on the senses. What little we know of Domitianic painting and stuccowork in Rome and its environs suggest that similar forces continued to operate during the post-Pompeian period. The Neronian

formulae continued to be reproduced but without the freshness and exuberance which had characterised the decorations of the Golden House.

The Fourth Style apparently died of exhaustion about the end of the first century. With it the great age of Roman wall-painting came to an end. The future was to produce some interesting and not unattractive work, but the creative thrust of the late Republic and early Empire was dissipated in a series of revivals and counter-revivals which never fully recaptured the enthusiasm of the initial period. Each of the four Pompeian Styles had offered something new and stimulating; the First had taken the Hellenistic Masonry Style of interior decoration and turned it into bright patterns of abstract blockwork; the Second had opened up the wall with grand illusions of painted architecture; the Third had closed the wall once more and put emphasis on a framed picture-panel, complemented by fine, coloristic surface-ornament; and the Fourth had reintroduced architectural illusionism but substituted lightness and fantasy for the solidity and logic of the Second Style. These developments had been spearheaded by painters working in Roman Italy, and they had turned wall-painting from the poor relation of panel-painting into the most vigorous and important branch of the pictorial arts. By the second century A.D., however, the inventiveness of Roman-Italian wall-painting was declining, and the focus of interest switches to other regions and to other media.

The painting of the second, third and fourth centuries will be surveyed in Chapter 9. In the meantime we must go back in time and examine more closely the figure-paintings and other representational subjects which featured within the decorative schemes already considered.

6

Mythological and historical paintings

By far the most important of the painted subjects which appear within Pompeian and contemporary wall-decorations are those from mythology and history. The great masterpieces of the Greek past had featured mostly such themes (Chapter 1), and the desire to incorporate reproductions or echoes of them in domestic interiors forms one of the leitmotifs of Roman wall-painting. The present chapter will be devoted to an examination of these mythological paintings, both in relation to their Greek prototypes and also as works in their own right, reflecting the changing formats and styles of the years from the mid first century B.C. to the late first century A.D.

Since there is a broad chronological division between the heyday of friezes and that of central panel-pictures, it is best to consider the two classes in turn.

Friezes

The first figure-paintings in Roman murals, apart from the isolated examples incorporated within the coloured block-work of the First Style, are those of the Villa of the Mysteries. Of these the most famous, and among the most important of all ancient paintings, is the grand frieze of an *oecus* at the south-west corner of the villa [104–5; Pl. IX]. Although the subject is not strictly mythological or historical, the inclusion of some mythical figures and the use of a strongly Hellenising style justify consideration in the present context.

The theme of the frieze is unmistakably bound up with the Dionysiac cult. Occupying a focal position at the middle of the narrow east wall, directly opposite the main entrance of the room, is a group showing Dionysus himself reclining in drunken abandon in the lap of a seated female figure [104]. To left and right of this central group, and linked to it by overlapping of the feet, are two close-knit figure-groups representing ceremonies or miracles illustrative of the god's power. At the left the actors are mythical, the woodland spirits of Dionysus's entourage. An elderly Silenus seated on a block, with a large tambourine resting beside him, holds a silver bowl or jug into which a young satyr, leaning over his left shoulder, appears to be staring;

behind them stands another young satyr, who seems to be shedding his yellow cloak from his left arm while holding a Silenus mask above the real Silenus's head with his right. At the right of the Dionysus group a half-kneeling, half-crouching woman, her hair gathered in a coif, prepares to lift the purple veil from a tall object standing in a winnowing basket; this was certainly a phallus, symbol of regeneration, whose revelation formed an important moment in the initiatory rites of the ancient 'mystery' religions. Behind the kneeling woman, against whose left shoulder leans a long torch, stands a pair of figures, one of whom holds a plate carrying what appears to be a bunch of pine-twigs.

The outermost figures of the east wall are linked by glance and gesture with the adjacent ones on the north and south walls. On the north wall a female figure starts back in alarm, her cloak billowing behind her head; the averting gesture of her left hand and the direction of her gaze shows that it is the Silenus or the activity in which he is involved that has caused her agitation. At the south-east corner the transition is effected by an additional figure on the east wall which seems to be connected both with the scene of phallus-revelation and with the first group on the south wall. This figure is the most enigmatic of the whole sequence. A tall female with huge dark wings, wearing only a short skirt and calf-length boots, she seems at one and the same moment to be turning away with a gesture of revulsion from the unveiling ritual and to be poised to bring a switch which she holds in her right hand down upon the bare back of a kneeling woman at the start of the next wall [105]. This kneeling woman, her hair loosened and her eyes shut, is held and comforted by a seated female in white, whose hair is bound, like that of the ministrant unveiling the phallus, in a kind of coif.

The next scenes on the north and south walls again involve the devotees of Dionysus, mythical and human, here apparently engaged in actions which illustrate the god's power over the emotions and over the life-giving forces of nature. Next to the woman waiting to be scourged comes a group consisting of a dancing maenad in three-quarters back view, clashing a pair of cymbals above her head, and another female figure behind her holding a *thyr-*

104 Pompeii, Villa of the Mysteries. *Oecus* 5, north and east walls. *c.* 60–50 B.C. H. of figure-frieze 1.62 m.

sus [105]. On the opposite wall, to the left of the startled female, appears an idyllic group of two young satyrs seated on rocks, a male playing the *syrinx* (Pan-pipes) and a female giving her breast to a kid, while another kid stands in the foreground. Beyond them an old Silenus leans on a column playing a lyre, an expression of rapt concentration on his face [Pl. IXB].

At this point in the room the south wall is interrupted by a large window; but the sequence of figures on the north wall continues unbroken to a small door at its left end. To the left of the lyre-playing Silenus a group of three female figures performs a ritual at a table, while a fourth approaches from the left, bearing a tray full of what seem to be cakes [Pl. IXA]. Beyond her comes a naked child reading from a scroll and a seated woman resting her right hand on its shoulder in a gesture of comfort and encouragement. The sequence is completed by a heavily draped and veiled woman standing in profile watching the ritual.

Two final scenes are fitted in the spaces between the

window and the doors. The first, which straddles the south-west corner, shows a female figure seated on a stool having her hair dressed with the assistance of a maid-servant; to the left a Cupid holds up a mirror, and to the right is another Cupid, leaning on a pillar, his face supported on his hand and uptilted in an expression of desire. The second consists of a single, majestic figure on the wall to the right of the west doorway. A woman, splendidly attired in a saffron and purple cloak over a long dress, her head veiled in an overfold of the cloak, sits on a couch with her right hand against her cheek in a pensive gesture.

The various attempts to analyse and interpret this frieze have produced an enormous bibliography, which we can barely begin to summarise. An initial problem concerns sources. Many critics have insisted that the artists have copied a Greek model more or less slavishly, crushing figures close together in some places and spreading them out in others in order to fit the room; it has also been argued that parts of this hypothetical model have been omitted,

105 Girl being beaten; maenad clashing cymbals. Pompeii, Villa of the Mysteries, *œcus* 5 (south wall). *c.* 60–50 B.C. H. 1.62 m.

that the order of the figures has been shuffled, or alternatively that at least one figure, the winged female with a switch, is an interpolation not present in the original. These various proposals seem unnecessary. Certainly there are individual figures based on Greek types: the girl with the plate of cakes for example is related to a statue-type known as the Maiden from Anzio, normally dated to the third century B.C. The figure-group of Dionysus and his female companion, too, was an established composition, versions of which are known from terracotta reliefs, a carved gem and a coin of Smyrna (Izmir). But this does not mean that the whole frieze is derivative. The various elements fit too neatly into the available spaces of this particular room, with the action spanning the angles where these are unbroken and halting where doors and windows interrupt the surface; the structure and coherence of the composition, in which figures are carefully overlapped to ensure a continuous flow, while postures and spacings are subtly varied to maintain interest, argues that the frieze was created for its present context.

For the detailed meaning of the scenes the majority of commentators concur in proposing a series of initiation rites ('mysteries') in which human protagonists freely intermingle, as often in Roman art, with characters of myth and allegory. All the human actors, with the possible exception of the child reading from a scroll, are female, and it has

therefore been argued that the specific rites portrayed are those of a Dionysiac cult whose adherents were exclusively female, possibly the cult practised in the temple of Ceres, Liber and Libera in Rome (Liber and Libera were Italian deities identified with Dionysus and Ariadne). The initiation would in this case take the form of a symbolic marriage with the god, who is portrayed with his consort Ariadne in the central group; and this 'holy marriage' would in some way relate to a real wedding, either by serving as a preparation for it, or by requiring marriage as a precondition of participation. The female figure who is having her hair dressed at the south-west angle of the room is a bride, for the hair is being parted in the characteristic six-plait bridal coiffure; and the woman seated on the couch to the left of the main entrance may again be a bride, since she wears a ring on the appropriate finger, and her head is covered with a veil.

This general theory is susceptible of variations in detail. For example, since a veil was worn in the performance of sacerdotal duties, the seated woman to the left of the door has been interpreted not as a bride but as a priestess, the mistress of the Dionysiac community shown in the ceremonies, and as the mother of the actual bride (the ring would of course be appropriate to any married woman). The female figure with Dionysus has been interpreted not as Ariadne, whose status in the cult would hardly (it is argued) justify her dominant position in relation to the god, but as his mother Semele, or as the goddess Aphrodite (Venus), who seems to have been associated with Dionysus in the cult of at least one local temple. If Semele or Aphrodite is represented, the notion of the initiation as a holy marriage loses force, and we would have to accept a less intimate link between the initiation and the bridal scene or scenes, which might refer simply to the priestess's preparation for her role in the cult.

There is also controversy as to the way in which the frieze is to be read. The general view is that the action proceeds in clockwise sequence beginning at the left end of the north wall (adjacent to the small doorway) and concluding with the bridal scene or scenes; most commentators accept, indeed, that what we have is a continuous narrative involving successive stages in the experience of the same woman, who reappears at least five, if not six or seven, times. Some, however, while retaining the same sequence of events, argue that the frescoes show several women being inducted simultaneously. That the various scenes feature different protagonists is supported by the differences in their physiognomy and dress; but taking away the continuous narrative element in the interpretation reduces the pressure on us to accept the clockwise reading. Such a reading is in fact improbable. It involves assuming that the apparition of the mythical followers of Dionysus and the epiphany of the god himself are guaranteed to the candidate or candidates during the course of her or their initiation, and before the crucial rite of the unveiling of the phallus. Much more likely

is a centralised reading, in which the divine couple, situated at the centre of the wall opposite the main entrance, just like the cult-image in a temple, constitutes a focus for the remaining scenes, which balance across the room. This is supported by the decoration of the subsidiary frieze at the top of the wall, where a pair of symmetrical vine-scrolls starts on opposite sides of the west doorway and runs along the north and south walls to converge above the divine group. It is also reflected, by and large, in the shading of the illusionistic meander between the two friezes (though this also conforms to the normal Second Style rule that shadows fall away from the principal entrance of a room). If a symmetrical reading is adopted, we find fairly neat correspondences between the two halves. On either side of Dionysus and his companion come scenes which may be interpreted as rites associated with the god's miraculous powers and his role as a bestower of fertility; at the beginning of the north and south walls we see human initiates responding to stimuli emanating from mythical figures on the east wall; next to them are groups of the god's followers, in which the music-making of a Silenus playing the lyre and an infant satyr the pipes is balanced by that of a maenad clashing cymbals; and finally, though the presence of the big south window destroys the balance across the middle of the room, the bridal toilet to the right of it can be regarded as some form of counterpart for the ceremonies depicted opposite.

The detailed interpretation of the individual scenes is, in the absence of specific information on the practices of the cult, largely a matter of conjecture. Particularly contentious are the actions of the three figures at the left end of the east wall and the function of the winged figure with the whip. For the former group it has been suggested that the satyr looking into the bowl or jug is practising 'lecanomancy' (divination from images in a vessel containing liquid) and that what he sees is the reflection of the Silenus mask held up by his companion; the alarm of the startled girl may have been caused by seeing the same image. But no satisfactory suggestion has ever been made as to the point of this exercise, and it is doubtful whether the mask could have been reflected in the bowl when the satyr's own head was in the way. It is more likely that the satyr is looking at images unrelated to the mask, or alternatively that he is watching the bowl fill miraculously with wine. The reason for the display of the mask is uncertain but it could be some kind of symbol of what is going on; another possibility is that the second satyr has removed it from the face of the real Silenus below, and that it is this unexpected revelation which has frightened the girl. Further speculation is unfruitful.

For the winged figure divergencies of interpretation have arisen because some scholars do not accept that it is engaged in scourging the kneeling girl, while others have not observed that it is shunning the revelation of the phallus. The gesture of aversion, however, is unmistakable and

is paralleled in other works of art where a figure, winged or unwinged, is shying away from the revelation of Dionysiac symbols; though the type may well (as often in Roman art) have different identities in the different works, the compositional similarities confirm the general theme. At the same time, while there is no hint of a whip or of a whipping-victim in the other representations, none the less our scene's combination of a raised rod and a kneeling girl with her eyes shut is too suggestive of flagellation to be the result of a fortuitous juxtaposition. The questions are, who is the winged figure and what is happening? Of all the numerous proposals which have been put forward the most likely is that the figure is one of the Erinyes (Furies), underworld demons whose role was to torment sinners, and that she is represented here wielding her whip as an allegory of the torments faced by the uninitiated, in this life or the next – torments which are dispelled by admission to the Dionysiac mysteries. The painting shows the precise moment at which the initiate is being freed from her tribulations by the unveiling of the god's procreative symbol.

The Mysteries frieze, whatever the details of its meaning, conveys an impressive grandeur appropriate to its religious theme. The large scale of the figures (nearly life-size and dominating the room), the sweep of the design and the brilliant but sombre backdrop of red orthostates, all contribute to the effect; and a curious sense of other-worldliness is created by the lack of cast shadows on the background and by the inconsistent fall of light on the figures themselves. Some anatomical details of some figures, such as the feet of the dancing maenad and the bodily proportions of the kneeling woman unveiling the phallus, are stiff and unconvincing, but this does not distract from the overall mastery of the design, and many of the heads are exceptionally fine [Pl. IXc]. The mural is one of the most remarkable surviving works of ancient painting and perhaps the only one to give us an idea of its more monumental qualities.

While the Mysteries frieze presents a unity of composition and conception, the other major large-scale figurefrieze of the mid first century B.C., that of the *oecus* in the villa of P. Fannius Synistor at Boscoreale, seems to have been fragmented and episodic. Appreciation and analysis are not helped by the fact that the surviving paintings are now divided between four museums in different countries and that the rest are known only from brief descriptions; but a full-scale photographic reconstruction carried out for an exhibition in 1973 enables some assessment to be made of the original ensemble. As in the Villa of the Mysteries the virtually life-size figures were depicted on a low podium, and those of the side walls appeared against a backdrop of red; but the action was broken up into independent groups by a foreground screen of columns, and the back wall, or at least its central section, was illusionistically opened so that the figures there seemed set out of doors (an effect presumably designed to correspond to the

real openings in the front wall).

The central scene of the rear wall showed Venus standing with a small Cupid perched on her raised knee. He was about to hurl a dart at Psyche, who stood in front of a temple at the right, with a couple of further Cupids fishing beside her. Of the two outer scenes on this wall we have only brief descriptions; the left was apparently a version of the central group in the Mysteries frieze, Dionysus and his female companion (Ariadne?), and the right a group of three Graces. Both 'stood out on a sky-blue background'.

On the left wall the central intercolumniation contained two female figures sitting in a rocky terrain, the one at the higher level being characterised by its Macedonian hat and distinctive round shield as a personification of Macedonia [Pl. XA], and the other by its Persian turban as a personification of Persia. In the left intercolumniation was a bearded figure leaning on a stick and wearing a thick woollen cloak, perhaps to be identified from his physiognomy and from the letter 'E' on his signet as a philosopher of the school of Epicurus. The right intercolumniation had apparently been replastered after the earthquake of A.D. 62 and so contained no figures.

On the right wall the central scene consisted of two seated figures, a heavily draped and veiled female with her hand to her cheek in a gesture similar to that of the 'mistress' in the Villa of the Mysteries, and a heroically nude male resting both hands on a sceptre [106]. His throne was richly ornamented, with a golden griffin supporting the arm-rest. In the left intercolumniation was a draped female playing a *cithara* (concert-lyre), her hair bound in what looks like a *diadema* (Hellenistic royal fillet). Behind her chair stood a small girl [107]. Finally, in the right intercolumniation, came a female figure holding an oval shield decorated with the image of a nude man.

The relation of these various figures and figure-groups to one another, and to the winged demons represented on the left and right of the main entrance, is highly problematic. Here, much more than in the Villa of the Mysteries, one gets the impression of close copying of Greek prototypes; yet at the same time there is much less sense of unity than in the Mysteries frieze, and one wonders whether the scenes have not been either put together from different sources or excerpted from a bigger composition. For the rear wall the first alternative is the more likely: the three

106 Alexander and Olympias(?), from Boscoreale, Villa of P. Fannius Synistor, *œcus* H (east wall). *c.* 50–40 B.C. New York, Metropolitan Museum of Art, Rogers Fund 1903: 03.14.13.

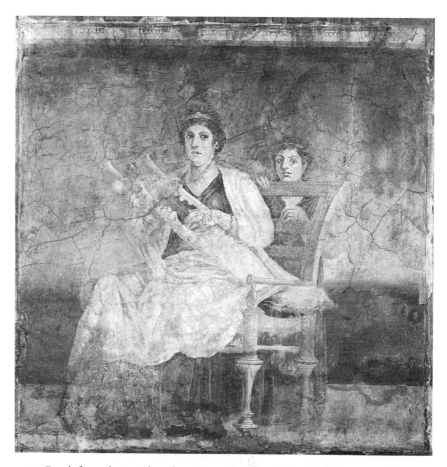

107 Female figure playing *cithara*, from Boscoreale, Villa of P. Fannius Synistor, *œcus* H (east wall). *c.* 50–40 B.C. New York, Metropolitan Museum of Art, Rogers Fund 1903: 03.13.5.

themes are but loosely connected, and at least one scene, the Dionysus and Ariadne(?), appears to have reproduced a well-known composition, while another, the three Graces, may possibly have done so; all three could therefore have been reproductions of independent pictures. For the side walls excerpting seems more plausible, since there is a certain affinity of style between the different scenes (the heavy forms and voluminous drapery point to the third century B.C.) and we get hints of a common subject-matter rooted in early Hellenistic history (the royal sceptre and *diadema*, the personifications of Macedonia and Persia, the possible Epicurean philosopher); none the less, the overall effect is disjointed, and no theory has satisfactorily accounted for every component. The seated personifications of the left wall certainly symbolised the conquest by Macedonia of Persia, and it is attractive therefore to identify the nude hero of the opposite wall as the deified Alexander the Great. His companion may be Statira, the Persian princess whom he married to symbolise the unification of the two king-

doms; a ring is prominently displayed on the third finger of her left hand. But she appears too mature to be the youthful bride, and the expression and gesture seem more appropriate to mourning than to the celebration of marriage; so another possibility is that the woman is Alexander's mother Olympias, mourning the death of her famous son. The *cithara* player and her companion could be further members of the Macedonian royal family – not necessarily of the same epoch as Alexander and Olympias if, say, the paintings from which the Boscoreale figures were selected depicted later kings and queens as well. But who is the philosopher and what is his connection with the subject? Who is the female figure holding a shield? Is the image on the shield an emblem, or a reflection conjured up by mirror-divining, an oracular technique similar to lecanomancy? The evidence is at the moment too inadequate to allow answers to these questions.

As is only to be expected in the work of copyists, there are some awkwardnesses in proportions and anatomical

details; but the powerful forms of the bodies and the bold plasticity of the drapery show greater variety and assurance than do the bodies and drapery of the Mysteries frieze. The faces, especially those of the right wall, are clearly based upon portrait-type heads of great quality, with large lustrous eyes and full lips, and forms fully modelled with hatching in light and dark colours. They seem, however, more laboured in execution than the heads of the Mysteries frieze, which are superbly economical in their brushwork. The difference between the two works is basically one between skilled copying, in which the style and features of the originals are apparently conveyed with some fidelity, and a creative composition in which the handling of some of the details fails to live up to the quality of the conception but the rendering of others displays great freshness and originality. The Boscoreale mural reproduces, in excerpts, something of the greatness of lost Hellenistic masterpieces; the Mysteries frieze forges something essentially new out of the inherited vocabulary.

In his description of the species of wall-painting introduced in Roman houses during the Second Style Vitruvius includes 'Trojan battles or the wanderings of Odysseus through landscape'. By a stroke of fortune we have surviving examples of both these themes, and they indicate a more intimate form of painting: small friezes in the upper part of the wall-decoration.

The Trojan battles are represented by a frieze originally containing upwards of eighty scenes, painted in the crypto-portico of the House of the Cryptoportico at Pompeii. Divided into separate sections by the heads of the herms which acted as structural supports in the decorative scheme [30], this frieze was set about 3 m. above the floor and measured only 34 cm. in height; it told the story of the siege and sack of Troy beginning with the events narrated in Homer's *Iliad* and concluding with some from other poems of the epic cycle. The final scene, showing the flight of Aeneas, the legendary ancestor of the Romans, illustrates how the subject was adapted to the interests of Roman patrons; one can conjecture that pattern-books of Iliadic scenes were widely circulated and copied during the late Republic. The style of the paintings is traditionally Greek, with the figures occupying most of the height of the frieze

108 Odysseus in the land of the Laestrygonians. Detail of frieze from the Esquiline, Rome (section 2). *c.* 50–40 B.C. Vatican Museums. H. 1.16 m.

109 Odysseus being attacked by the Laestrygonians. Detail of frieze from the Esquiline, Rome (section 3). *c.* 50–40 B.C. Vatican Museums. H. 1.16 m.

and indications of landscape being confined to the bare minimum. The Greek 'feel' of the paintings is reinforced by the neatly written Greek labels used to identify the various protagonists.

The 'wanderings of Odysseus through landscape' are represented by the famous Odyssey landscapes from the Esquiline in Rome, which were again broken into sections by architectural supports, in this case a series of slender piers (cf. [111]). The surviving sections all come from one wall and they represent the adventures related by Odysseus at the court of Alcinous in Books x–xii of the *Odyssey*. Their importance lies in the fact that they are the first surviving example of 'mythological landscapes': that is paintings in which figures from myth or legend were reduced to a tiny scale and set in a vast panorama of trees, rocks, sea and the like. Within this setting the story is told in the continuous narrative technique, with the principal actors reappearing from scene to scene, and even the same landscape settings being repeated where necessary – though the painter's aim is to give the impression that the landscape

of each scene passes almost imperceptibly into that of the next.

The episodes narrated in the surviving panels, which show a close relationship to Homer's text, while emphasising certain events which offer interesting artistic possibilities and omitting others which are more intractable, show no strict correspondence to the length of the spaces between the pillars. Some scenes overlap into two or more sections; at least one occupies only half a section; and the transition from one scene to the next generally falls within the picture rather than behind a pillar. The first section of the wall is lost, but flying figures at the top left of the second section must represent the Aeolian winds, the gift of King Aeolus, which had been carelessly released by Odysseus's men and had blown them away from their native land to a new phase of tribulations; the missing scene must therefore have been concerned with the visit to Aeolus or with part of the previous adventure in Book ix, the escape from the island of the Cyclopes. Section 2 [108] shows the wanderers arriving at Laestrygonia, where three scouts are met by a woman

110 Odysseus in the palace of Circe. Detail of frieze from the Esquiline, Rome (section 6). *c.* 50–40 B.C. Vatican Museums. H. 1.16 m.

with a water-jar while sheep, cattle and herds suggest a peaceful environment. In section 3 [109] this changes abruptly as dark giants tear down trees, lift rocks and seize sailors for their supper. Section 4 represents the destruction of Odysseus's ships as the giants smash them into matchwood within the harbour. In section 5 Odysseus's own ship, the only one to escape, emerges from behind a cliff and sails towards its next destination, which is announced by rocks and a group of three nymphs labelled 'Aktai' ('Promontories') at the right. The new shore is that of the island of Circe, the interior of whose palace is depicted in section 6 [110]. Here we see the sorceress herself welcoming Odysseus at the gate, and at the right, still within the same setting, the scene where Odysseus, having proved immune to Circe's magic potion, has drawn his sword on her and she falls on her knees to plead for mercy. Section 7 is too badly faded for its subject to be visible, but a tree at the top reveals that the action has shifted once more to an outdoor environment; presumably it contained the sequel to the previous scene, namely the reversion to human form of

Odysseus's followers, who had been transformed into swine. Scene 8 [111] shows the arrival of Odysseus's ship at the entrance to the Underworld, where the hero is represented meeting Tiresias while the souls of the dead cluster round in a pool of ghostly light. The Underworld scene continues in section 9, with illustrations of the punishments inflicted on various sinners; but here the sequence was broken by an opening through the wall, which reduced this particular section to half the width of the rest. Depending on whether the opening was a window or a door, there would have been space for either one or two more sections on the wall. The sole surviving remnant is the left part of a panel portraying Odysseus's ship sailing past a rock from which the Sirens perform their seductive songs. The right part of the scene must have contained at least the prelude to the adventure of Scylla and Charybdis.

These surviving sections were probably complemented by depictions of earlier and later events on the adjacent walls. But the subject-matter is almost of secondary importance; the figures could be substituted by everyday figures

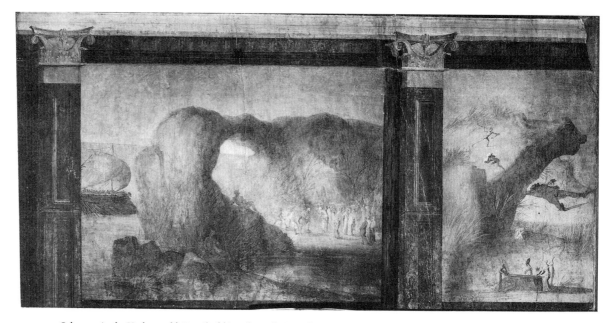

111 Odysseus in the Underworld. Detail of frieze from the Esquiline, Rome (sections 7 and 8). *c.* 50–40 B.C. Vatican Museums. H. 1.16 m.

or omitted altogether, and the landscape would still present sufficient interest to stand in its own right. Here we have a striking environment of beetling crags, twisted or wind-tossed trees, bristling clumps of reeds and expanses of sea, all rendered in a cold, rather restricted palette: the rocks in tones of purplish pink and purplish brown, the sea in bright blue, growing lighter towards the horizon, the sky in a very light blue, the male bodies in dark reddish brown and the drapery mainly in violet and yellow. (The warm golden and greenish blue tones now displayed by many of the panels are the result of nineteenth-century restoration.) The treatment of this landscape is generally realistic. The light falls consistently from the upper left, and the crags are effectively modelled with strong shading on the right; the scenery is constructed so as to lead the eye from dominant foreground elements in the lower part of the picture towards remoter features at a higher level; and the effect of distance is reinforced by reductions in scale and by the use of aerial perspective, which results in lighter colouring and less distinct forms in the background. The fact that the perspective is inconsistent (the horizon indicated by the sea is considerably higher than the eye-level implied by the figures, boats and so forth) does not cause the viewer too much disturbance because most of the elements are irregular in form and loosely grouped, so that he is more conscious of their individual relationships than of any overall lines of recession in the structure of the picture. The diminutions of scale and the introduction of hazier forms do the rest: the eye is led step by step from nearer to further subjects and receives a convincing impression of space and distance.

There can be little doubt that the frieze was copied or adapted from an earlier prototype. The very fact that Vitruvius refers to Odyssey landscapes as a standard subject demonstrates that our specimen was not unique; presumably it was one of several versions disseminated in pattern-books based upon a famous original. The use of Greek inscriptions to label the figures, as in the Trojan frieze at Pompeii, would seem to point to the same conclusion, especially as there are some spelling mistakes and at least one possible labelling error. More especially, the minute scale of the lettering and of many of the painted details, not to mention the nature of the perspective, which presupposes a high viewpoint, are remarkably ill suited to the position of the frieze at the top of a 5.50 m. wall. The high viewpoint indeed conflicts with the perspective of the pillars, which are designed to be seen from below, as they would be in reality. All this suggests that the original frieze was designed for a different context, presumably being placed at eye-level or thereabouts; the Esquiline copy was transferred to the upper part of the wall because there was no other suitable place for it in a Second Style scheme.

The dividing pillars were part of this Second Style scheme, and one can reasonably assume that the original frieze was truly continuous, with one scene flowing into the next as in the sculptured Telephus frieze at Pergamum. In fact this is how the first four surviving sections of our version were painted. The landscape matches on either side of the dividing pillars, and figures and trees are overlaid by the pillars as if the action continued behind them. This does not mean, however, that the part of the frieze depicting the Laestrygonian adventure was a literal copy of the

prototype while the remaining sections, which show no signs of similar continuity, were adapted and abridged by the copyist to fit the available spaces (as P. H. von Blanckenhagen has argued). It is scarcely credible that a faithful copy of any part of the frieze could be fitted so neatly into the Second Style scheme that only minor details were overlapped by the pillars; moreover, each of the Laestrygonian sections presents a well-balanced composition with a central focus: rocks and trees with figures in front of them in sections 2 and 3, and sea and ships framed by rocks in sections 4 and 5. Rather, we must regard the whole series of scenes as freely adapted from the model. If in one part of the wall the landscape and figures appear to run on uninterrupted behind the pillars, that is merely because the painter of this part, who may have been a different individual from the painter of the remaining sections, deliberately aimed to foster the illusion of a unified panorama beyond the wall.

The date of the prototype of the Odyssey landscapes is unknown. Some critics have assigned it to the second century, but there is no intrinsic reason why it cannot be placed rather closer in time to the existing copy. That it was created in Italy seems a reasonable assumption; the rocky coastline with steep cliffs pierced by clefts and grottoes are features found in the actual scenery of southern Italy, and two elements in the underworld scene – the Danaids engaged in their eternal task of attempting to fill a leaky vat with water and a figure apparently intended to represent a demon thwarting Sisyphus's efforts to push a boulder up a hill – are not recorded in Homer or depicted on Athenian vases but both appear in the art of Magna Graecia. The existence of a prototype in Italy, whether in one

of the Greek cities of the south or in Rome itself, would also of course help to account for the popularity of reproductions in Rome during the period of the Second Style.

In addition to the themes mentioned by Vitruvius, we have samples of other legendary and mythological subjects represented in frieze form during the later phases of the Second Style. Related to the Trojan battles are paintings of the legends of Rome found in a chamber-tomb near the Porta Maggiore in Rome. The west and south walls narrated the events of the legendary wars between the Latins and Trojans on one side and the Rutulians on the other, adapted a few years later by Virgil in the *Aeneid*; the east and north told the story of the foundation of Rome, including scenes of the seduction by Mars of Rhea Silvia and the exposure of the twins Romulus and Remus. The frieze was almost certainly an adaptation from a composition created for a major public monument in the city: the fact that the stories seem unduly condensed and the transitions unduly abrupt imply that the painter was again putting together excerpts from a fuller model. In style the neutral background and fluently modelled figures belong to the Hellenistic tradition, but the battle-scenes [112] are more varied and adventurous than their counterparts in the Homeric frieze at Pompeii, the compositions generally more close-packed, and the placing of figures more fully rendered in depth. Significantly, in view of the subject, labels are here supplied in Latin.

Mythological and legendary friezes ceased to be an important component in Roman wall-painting after the Second Style; they were evidently superseded by the new fashion for dominant panel-pictures. The only significant

112 Battle-scene. Detail of frieze from tomb on the Esquiline, Rome (south wall). Third quarter of 1st century B.C. National Museum of the Terme. H. 37 cm.

exception is the Fourth Style decoration in the principal room of the House of D. Octavius Quartio at Pompeii, where above a dado of fictive marbling came two friezes superposed: a narrow one with Iliadic scenes in the predella, and a grand sequence of episodes from the legend of Hercules, represented with figures half life-size, in the main zone. Both lack the fluidity of their Second Style predecessors. The Hercules frieze, which is divided by columns into separate scenes, has moments of vigour but the overall effect is unbalanced and disjointed. The Iliadic frieze, though rendered in continuous sequence on a unifying blue-black ground, is equally disjointed, with abrupt changes of scene and disparities of scale; the sequence of episodes is, moreover, illogically organised, since the episodes involving Achilles sulking in his tent are placed after, and not before, the death of Patroclus and the ransoming of Hector's body. The heroic compositions have clearly been reproduced without a great deal of care or conviction. Interestingly, the labels of the characters are again now written in Latin, but evidently transliterated from models in which they were inscribed in Greek, since there are examples of hybrid spellings and one instance of a lambda apparently being misread as a delta (Achilles' horse Balius becoming 'Badius').

Panel-pictures

Since the pendulum of research into Roman wall-painting swung towards the study of decorative systems rather than iconography, the examination of picture-panels in their own right has become rather unfashionable. None the less, it must be remembered that the Roman patrons themselves evidently looked upon the central pictures of the late Second and subsequent styles as the most important element in their wall-paintings. It is thus a valid exercise to study these pictures separately, provided that their context is not forgotten; we can use them not only to get some idea of the appearance of the prototypes from which they derive but also to trace the modifications in style and composition that they underwent in the hands of successive generations of copyists.

The earliest pictures in Roman painting are explicitly shown as panels (*pinakes*), framed and with folded wooden shutters. They are also painted in a sketchy, almost impressionistic style, with figures indicated by bold strokes of light and dark colour, so as to distinguish them from the carefully painted forms of the illusionistic architecture within which they were set: this architecture is supposed to be 'real', whereas the pictures are deliberately characterised as paintings within the paintings. Their position was initially on top of the screen-wall of the mid Second Style: examples in the Villa of the Mysteries and the villa at Boscoreale depict respectively religious subjects and figure-scenes of uncertain meaning, perhaps of no real meaning at all. As time went on, and the illusionistic opening in the upper part of the wall was closed, the *pinakes* regularly appeared at frieze level, resting on a fictive cornice, much as real pictures might have been displayed upon a real picture-moulding. A continuous series in the *oecus* at the south-east extremity of the cryptoportico in the House of the Cryptoportico alternated scenes of Dionysiac subjects with still lifes [Pl. XB].

In the transition to the Third Style, with the reduction of the architectural forms to little more than ornamental patterns, such panels lost much of their *raison d'être*, and the last true examples, in the *oecus* of the Villa Imperiale at Pompeii [56], are shown sitting somewhat uneasily in the white-ground frieze of a basically two-dimensional decoration. They have evolved from being simulated panels to being just another kind of painted element within the decorative scheme. Along with this conceptual change goes a change in the style of the paintings: the impressionism of the mid Second Style gradually gives way to more precise renditions, so that there is no longer a difference between these panel-pictures and the remaining elements on the wall.

In addition to shuttered panels at frieze level, the late Second Style introduced small framed pictures in the main zone, envisaged either as set directly in the wall or as resting on some form of easel. In centralised schemes such pictures occupy the side wings, playing a supporting role to the main picture in the middle: good examples are the classicising white-ground panels carried by animal-pawed Sirens in two bedrooms of the Farnesina villa. In paratactic schemes the panels might form a continuous series. The Farnesina villa again provides an example, this time in the white cryptoportico (A), where panels containing mainly Dionysiac subjects were set in the middle of the intercolumniations into which the decoration was divided; their frames were carefully shaded to suggest profiled mouldings in wood or stucco.

Whereas these smaller panels, whether equipped with shutters or enclosed in ornamental frames, were clearly envisaged as representations of pictures, the large central paintings which took over the dominant role in Roman wall-schemes of the second phase of the Second Style are more ambivalent in their function. They partake of the qualities both of pictures and of prospects. On the one hand, they usually include a representation of a real spatial environment which makes them appear like scenes glimpsed through windows in the wall, whereas the minor panels have neutral backgrounds or barely suggested settings. On the other, their settings bear no relation to the architectural vistas visible through other 'openings' in the decoration, and their perspective lacks the symmetry that their central position demands [32]. Moreover, some of them are equipped on three, if not all four, sides with borders which recall the frames of the minor panels; and, even when such borders are lacking, the columnar pavilions in which they are set tend to act as glorified frames, isolat-

ing and emphasising their contents. A few of the paintings, indeed, are clearly characterised as such by their use of conventional treatments; some of the Farnesina walls, for example, feature central subjects painted on a neutral white ground, including not only landscapes (Chapter 7) but also classicising compositions like those in the side panels [40].

In the Third Style the picture aspect of the central painting fully triumphs over the prospect: the framing pavilion loses virtually all architectural significance and becomes little more than an easel. This remains the situation in the Fourth Style. None the less, the genesis of the central painting as a kind of 'window-picture' seems for a long time to set it apart from the literal copies of panel-pictures attached to or resting on illusionistic walls of the Second Style. This is shown by the freedom with which models are interpreted. While the same iconographic formulae recur at different periods, the detailed treatment and especially the settings in which the figures are placed change from generation to generation. Only in the late Third and Fourth Styles, when the central pictures are more explicitly represented as panels applied to screens or *Vorhänge*, do more faithful reproductions of old masters seem to have become the rule.

The changing format and style of the central pictures may be reviewed with the aid of a few selected examples.

The earliest ones are big (sometimes over two metres high) and take the form of vertical oblongs, both features conditioned by their role in the Second Style scheme. A common mannerism is the treatment of the upper edge as a low arch or pediment. Within the picture a landscape is obligatory, but in most cases the figures remain comparatively dominant, their height being equivalent to nearly half that of the picture-field. The remaining space is occupied by the landscape.

A painting of Argos and Io in the House of Livia [35] heightens Nicias's group of the hapless heroine and her ever vigilant captor (cf. [133]) by the insertion of a column supporting a statue of Diana on the central axis of the composition, and by a vaguely indicated tree which spreads its branches above the figures' heads. An empty foreground contributes further height at the bottom of the panel. The other surviving picture in the same room, a representation of Polyphemus and Galatea, now legible only with the aid of early photographs and drawings [113], employs a marine setting; the nymph Galatea reclines on the back of a swimming sea-horse, while the love-struck Polyphemus stands chest-deep in the water. But this essential nucleus occupies only two-fifths of the panel; the bottom fifth becomes a shore with a rock altar on it, while the top two-fifths contain a jagged coast surmounted by a large tree. The resulting spaciousness is much more marked than in the Io painting, and is further enhanced by the placing of the figures at different levels with a pair of additional nymphs on a smaller scale in the background.

The central paintings on the rear walls of the two poly-

113 Polyphemus and Galatea. Rome, Palatine, House of Livia. Soon after 30 B.C.

chrome bedrooms (B and D) in the Farnesina villa present a similar formula of figures within a fairly realistic setting, though without the pronounced spatiality of the Polyphemus painting. That of bedroom B, with the infant Bacchus nursed by a nymph [114], shows again how landscape elements are employed to achieve a vertical development of the composition – notably on the central axis, where a rock occupies the foreground, the further pier of an arched gateway the middle ground, and a tree with spreading branches the background.

Alongside picture-paintings of this kind, in which the settings are subordinate to the figures, another class of panels picks up the 'mythological landscape' tradition first seen in the Odyssey frieze from the Esquiline. These panels introduce a number of unrealistic modes of expression which seem to have been novel in the context of mythological painting – inconsistencies of scale, incoherent perspective and, above all, the coalescence of two or more moments of time in a single, apparently self-contained setting. Continuous narrative had been a feature of friezes for at least three centuries in Greek art; the nature of a frieze, which has to be read in sequence, and the possibility which it offers for unfolding and ever changing scenery, makes movement in time seem less illogical. But the incorporation

114 Infant Dionysus nursed by a nymph, from Farnesina villa, bedroom B (back wall). *c.* 20 B.C. Rome, National Museum of the Terme 1118. H. approx. 90 cm.

of successive episodes of a story in one panel entails a certain suspension of belief. There is no true precedent known in Greek art, and the inspiration should probably be sought in the Roman Republican tradition of triumphal painting, represented by such works as Gracchus's conquest of Sardinia and Mancinus's storming of Carthage (p. 11). These, and the various genre landscapes to be discussed in the next chapter, would also have provided a precedent for perspectival anomalies such as the combination of bird's-eye and 'normal' viewpoints.

Among the first and finest of the series are the paintings of Polyphemus and Galatea and of Perseus and Andromeda from the villa at Boscotrecase. In the former [115] the nymph is shown, as in the House of Livia, riding a sea-creature, this time a dolphin, at the lower left of the picture; but Polyphemus, who is at the centre, is here seated on rocks rather than immersed in the water. Behind him, on the vertical axis of the picture, stands a column carrying a votive vase, while a steep crag rises upwards to merge in a background of rocks and trees; at the bottom right a bridge leads across to an island with a statue of Fortuna on a high cylindrical pedestal. A little temple-like building and a number of goats perched on the rocks are borrowed from the pre-existing genus of sacro-idyllic landscapes (pp. 142–4). Most noteworthy, however, is the separate scene

in the middle ground at the right: Polyphemus appears again, on a smaller scale, standing on a ledge of the central crag and raising a rock with both hands to hurl at a ship which is sailing out of the picture. This is evidently an allusion to the uncouth giant's subsequent fate: his blinding by Odysseus and his attempts to prevent the escape of the Greek hero's ship. Two successive episodes of the story are therefore combined in one landscape setting. The second is clearly subordinate to the first; its reduced scale and its higher level suggest that it is taking place in the distance, like a premonition of events to come. But there is no real change in perspective. The figures of both scenes, the pedestal and statue in the foreground, the column in the middle and the little temple at the back – all are shown from virtually the same viewpoint, irrespective of their level.

The Perseus and Andromeda picture is very similar in its composition and handling. Andromeda, chained to a towering crag, forms the centre-piece; Perseus flies in to the rescue from the left; below him the monster raises its huge and fearsome head from the sea, while at the bottom right a female figure (Andromeda's mother Cassiopeia?) sits on the rock mourning; finally, to the right of centre, is the sequel to Andromeda's rescue, the meeting between Perseus and her father Cepheus. In both pictures the absence of a visually consistent perspective is combined with an imprecision in the definition of topography: divisions between land, sea and sky are neither clearly stated nor wholly logical. Colouring adds to the effect, fusing land, sea and sky in a continuous medium of bluish green, with the shapes of the rocks emerging vaguely in dark and lighter browns; only the figures and a few other motifs stand out in brighter hues. We are presented with a magical dream-world in which time and space have no meaning.

The Boscotrecase paintings and others like them were clearly influential. Almost exact copies of both the Polyphemus and the Andromeda landscapes were created at Pompeii forty or fifty years later in the dining-room of the House of the Priest Amandus (cf. [58]); only minor details of the iconography were altered. The colouring, however, is more harsh and the forms more clearly differentiated, thus sacrificing much of the dream-like quality which gives the Boscotrecase landscapes their peculiar charm. A third painting in the Priest Amandus dining-room [116] shows Daedalus and Icarus, a favourite theme for landscape painters because of its required setting of rocks and water and of its suitability for vertical panels. The continuous narrative element is here provided by showing Icarus both tumbling from the sky at the top right and lying dead on the shore at the bottom; other elements in the picture are the chariot of the sun-god (top left), the flying Daedalus (upper centre: now missing), a walled city, presumably Cnossus (middle right), and in the lower half of the picture a stretch of sea containing two boatloads of fishermen looking upwards at the impending disaster. Two

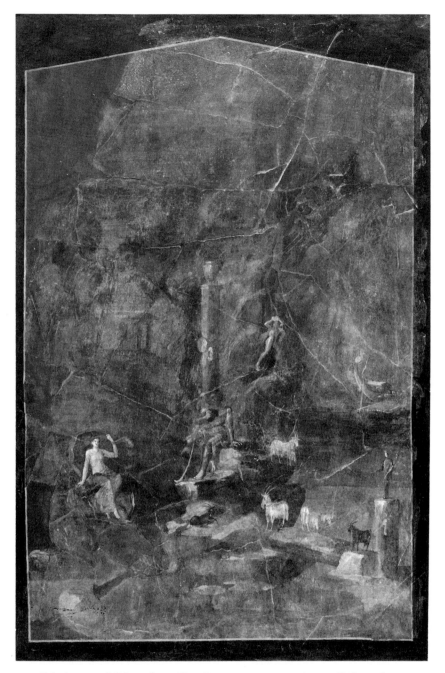

115 Polyphemus and Galatea, from villa at Boscotrecase, room 19 (west wall). Soon after 11 B.C. New York, Metropolitan Museum of Art, Rogers Fund 1920: 20.192.17. H. approx. 1.50 m.

further spectators, a pair of women, stand next to a column at the bottom left. No painting provides more eloquent testimony of the visual incoherence of Roman-style landscapes. Distributed at different levels in the picture-field, the figures show no consistency of scale: Icarus and the sun-god in the sky are much bigger than the fishermen at sea, the female spectators are bigger than the nearby body

and the fisherman who discovers it, and the figure of Daedalus was evidently the largest of all. Viewpoints change according to need: the figures are seen straight on, but the city is represented from a high level for clarity's sake. Yet, despite the anomalies or perhaps because of them, the picture is strangely effective. The consistent fall of light from the right and the pervasive blue of the back-

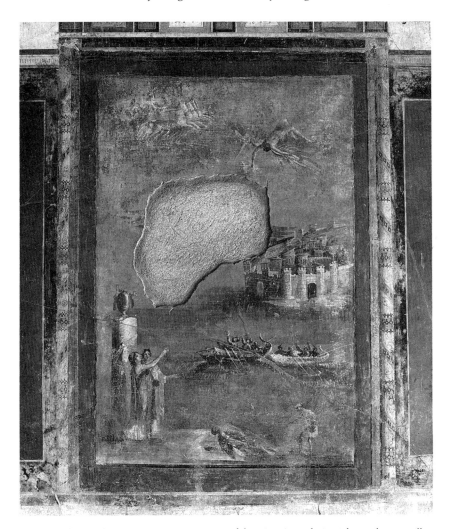

116 Daedalus and Icarus. Pompeii I 7, 7 (House of the Priest Amandus), *triclinium b*, east wall. *c.* A.D. 40–50. H. 1.35 m.

ground, shading gradually from pale at the top for the sky to deep at the bottom for the sea, succeed in unifying the disparate elements; at the same time the very inconsistencies of scale and perspective create a climate of unreality in which the paradox of Icarus's twofold appearance becomes less disconcerting.

Several other myths were accorded the continuous narrative treatment in Pompeian landscape panels of the Third Style. In the House of Julius Polybius there is a large picture showing the punishment of Dirce, who is being seized by her vengeful great-nephews Amphion and Zethus at the left and dragged to her death by a bull at the right; in the centre a double-column monument shelters a statue of Dionysus, in whose service the hapless queen had been engaged. In the black *triclinia* of the House of Epidius Sabinus (p. 58) and the House of the Orchard (pp. 61–2) the story of Diana and Actaeon, for which an outdoor setting is

obligatory, is recounted in its two main episodes: the naked goddess turning to see herself observed by the huntsman, and the same huntsman trying in vain to beat off the hounds which are exacting the goddess's retribution [117]. Sometimes as many as three phases of a myth appear in one panel. A painting from Pompeii V 2, 10 divides the story of Marsyas in this way [118]: the satyr first appears high on a cliff at the left looking down on a scene at the bottom in which a nymph shows Minerva (Athena) her reflection as she plays the flutes; then, just above the nymph, he appears again, running off with the flutes which the goddess has now discarded; finally, higher still, he advances playing his new-found instrument towards a group of Apollo and the Muses at the top right.

Not all mythological landscapes, however, employ continuous narrative. More commonly, only one episode is represented, and the treatment of the landscape and

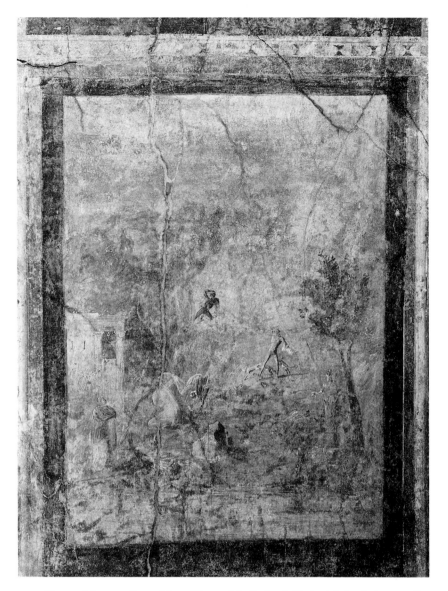

117 Diana and Actaeon. Pompeii I 9, 5 (House of the Orchard), black *triclinium* (11), east wall. *c.* A.D. 40–50. H. 1.18 m.

perspective is more or less realistic. Though figures are sometimes set at different levels, this only happens within certain limits and is always justified by the nature of the terrain or by the assumption that the observer is looking down from a slight height. Anomalies of scale (more distant figures are often not as small as they should be) are rarely so obvious as to be disturbing. For the early Third Style the paintings of two rooms in Pompeii IX 7, 16 provide good examples. The setting consists in each case of a flat foreground occupying the bottom quarter of the picture-field and a mountainous background occupying the middle two quarters; the top quarter is reserved for the sky. The figures are disposed within these surroundings as appropri-ate to the action. Thus in one picture Pegasus grazes by a stream in the foreground, while Bellerophon accom-panied by Minerva emerges from a defile between the mountains in the background; in another [119] Hylas is seized by water-nymphs in a flood-plain in the foreground, while a further nymph reclines at the foot of the mountains behind.

Mythological landscapes continue to appear in the late Third and Fourth Styles but seem to decline in popularity. At the same time their nature changes. The landscape tends to become more elaborate and heterogeneous; figures tend to grow even tinier than before (cf. [117]); and the vertical development of the setting is increasingly restricted by the

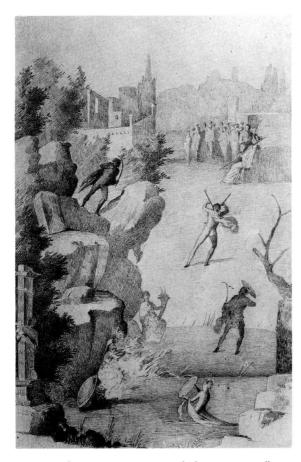

118 Story of Marsyas. Pompeii V 2, 10, bedroom *q* (east wall). First half of 1st century A.D.

119 Rape of Hylas. Pompeii IX 7, 16, bedroom *a*. Early 1st century A.D. H. 1.12 m.

shrinking height of the panel. In the Fourth Style, with a square or virtually square format almost obligatory, we find two main types of layout: either a 'single-level' scene with more or less natural perspective or a map-like arrangement which sets the actions at different levels as in earlier pictures but dispenses with the foreground and the sky. A set of three small square panels in Naples Museum, representing respectively Perseus and Andromeda, Hercules and Hesione, and Daedalus and Icarus, illustrates the more realistic 'single-level' treatment. Two panels in the British Museum (Odysseus and the Sirens, and Daedalus and Icarus) illustrate the unrealistic, map-like type of scene [120]. While the main action takes place in the bottom half of the field, in an opening framed by rocks and buildings, further landscape elements appear in the position where 'correct' perspective would place the sky.

The other main class of mythological paintings, those in which the figural element predominates over the landscape, followed a separate path of development.

The pictures in the large *oecus* of the Villa Imperiale at Pompeii are in general form the immediate successors of those in the House of Livia and the Farnesina villa. If somewhat broader in proportions, they still have to achieve a certain vertical development to suit the shape of the field. The scene on the back wall, Theseus receiving the thanks of the Athenian children after killing the Minotaur [121], has been given extra height by the inclusion of a pair of seated spectators at the left, of a pillar at the right and of a statue of Minerva looming in the background. The position of the Minotaur's body, lying in the foreground, may be a further height-gaining device, since other versions of the scene (cf. [143]) place it by the hero's feet or at the side.

But the treatment of the figures and their relation to the setting differ from that of the Second Style predecessors. Instead of being developed in depth, the composition seems relief-like with figures ranged parallel to the surface-plane and the background reduced to a more or less neutral foil. The colour and handling of form reinforce the effect of flatness. Highlights are avoided, figures and draperies being modelled by careful gradations of a single colour. There is a marked taste for clear, hard colours, sometimes juxtaposed in striking contrasts, as in the drapes of the seated

120 Odysseus and the Sirens. Provenance unknown. Third quarter of 1st century A.D. London, British Museum 1867.5–8.1354. H. 34 cm.

spectators, respectively yellow and blue next to the green of the statue. Above all, the forms stand out sharply against the pale background: there is none of the gradual softening of colour and contour which contributed to the illusion of depth in the Farnesina painting of Bacchus and the nymph [114].

In most early Third Style figured panels the layout adopts a simple, more or less standard, formula, with the figures occupying a single shallow stage about a quarter of the way up the field and virtually the whole of the action focused at this one level; the foreground is empty save for odd rocks and plants, while the background is closed by a solid barrier of landscape or buildings. This is the principle employed in a group of pictures from the rooms to the east of the middle peristyle in the House of the Cithara Player at Pompeii. Leda appears sacrificing on a low platform with an enclosure wall and a temple behind her; an oriental monarch receives a naked youth against a background of tents; Venus embraces Mars in front of a lofty mountain. A scene of the judgement of Paris is rendered with somewhat smaller figures, partly standing and partly seated,

Juno (Hera) higher than the rest; but the general principle is the same: all five protagonists are improbably spread out, with minimal overlapping, in a row parallel to the picture-plane; the bottom quarter of the picture is empty foreground; and the background is closed by precinct walls with a votive column and a tree rising above them.

A little later, the pictures from the House of Jason (or of the Fatal Loves), again at Pompeii, display a tripartite structure much favoured at this time. The meeting of Jason and Pelias [122] is a typical example of Augustan classicism, restrained and balanced, the figures elegantly drawn against an architectural backdrop so light as to be barely noticeable. Similar are the pictures of Pan and the nymphs [123] and of Europa and the bull from a neighbouring room. Each uses classicising figure-types, which stand out in strong and clear colouring against the lightly sketched landscape.

In the later years of the Third Style the taste for flatness and elegance begins to lose ground. Figure compositions make greater use of spatial and three-dimensional effects, and the actual figures become larger and less spaced out.

121 Theseus and the Minotaur. Pompeii, Villa Imperiale, *œcus* (A), east wall. End of 1st century
B.C. or beginning of 1st century A.D.

There is also a tendency to increase the number of figures in a scene, many of them playing the role purely of curious spectators. At the same time the setting becomes less obtrusive; landscapes are simplified, and perfunctory interiors become popular.

The punishment of Dirce from the House of the Grand Duke at Pompeii [124] retains the empty foreground and landscape background of the early Third Style, and some of the figures, notably Antiope at the left of the picture and Amphion at the right, are purely classical in style, imposing the sense of calm that such figures normally do; but the setting of the figures at different levels and the oblique poses of Dirce and the bull create a deeper stage for the action than heretofore, as well as introducing dynamic diagonals to disturb the calm. The landscape, moreover, is less impenetrable: we see a wooded plateau in the distance beyond the more strongly coloured crags and trees of the immediate background. A painting of Hercules, Deianira and Nessus from the House of the Centaur represents a similar phase of development, but the effect of spatial recession is stronger, with Hercules represented in three-quarters back view, and the horses of Deianira's chariot strongly foreshortened.

From an *exedra* in the House of the Gilded Cupids comes

122 Jason and Pelias, from Pompeii IX 5, 18 (House of Jason). First quarter of 1st century A.D. Naples, Archaeological Museum 111436. H. 1.90 m.

123 Pan and the nymphs, from Pompeii IX 5, 18 (House of Jason). First quarter of 1st century A.D. Naples, Archaeological Museum 111437. H. 1.20 m.

another version of the Jason and Pelias picture from the House of Jason. The basic iconography is little altered apart from the substitution of one of Pelias's daughters by a bodyguard; but the figures are much enlarged in relation to the setting, the side groups moved closer together, and the frame of the picture drawn more tightly round them. The architectural background, light and unobtrusive even before, has now been reduced to insignificance, and all emphasis is on the dramatic situation.

The latest picture-panels of the Third Style can be illustrated from the Houses of Lucretius Fronto and of the Five Skeletons. In the *tablinum* of the House of Fronto the

central picture of the left wall shows the courtship of Mars and Venus with the gods in attendance [Pl. XIA]. The shape of the panel is now approximately square, allowing the painter to concentrate on the figures, which occupy two-thirds of the height of the field; there is no longer any significant empty space in the foreground, and only sufficient space above the figures' heads to indicate a setting in the most general terms. The purity of the colouring, with pale blue and green, never common in Pompeian pictures, prominent alongside red, yellow and purple, remains typical of the Third Style; and the arrangement of the main figures is traditionally tripartite and depthless; but the spec-

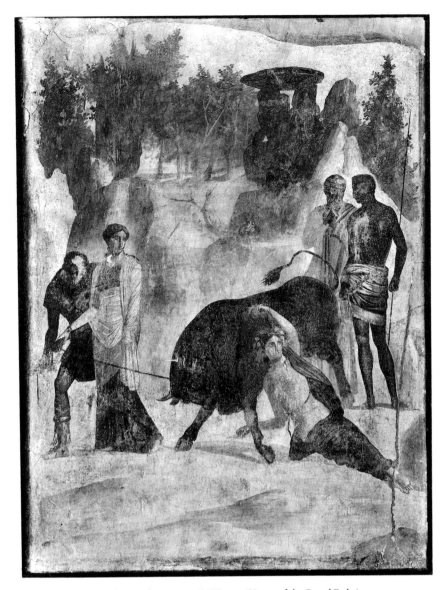

124 Punishment of Dirce, from Pompeii VII 4, 56 (House of the Grand Duke). *c.* A.D. 20–40. Naples, Archaeological Museum 9042. H. 1.46 m.

tators looking over the couch in the background are a characteristic device to enliven what might otherwise have been too arid a composition.

The paintings of the House of the Five Skeletons, all now in Naples, again incorporate supernumerary spectators. From one room come three panels (Paris and Helen, Cassandra prophesying and Odysseus and Penelope [125]) each with a backdrop similar to that of the Lucretius Fronto Mars and Venus: a broad central opening visible between a pair of columns. The lower part of this backdrop is closed, as often, by a low screen-wall, which serves the same function as the couch in the Mars and Venus scene,

separating the foreground figures (who include not only the main but also supporting actors) from spectators in the background. Another room shows the use of supernumeraries in an outdoor scene, a version of Nicias's painting of Perseus and Andromeda [135].

Many of the features found in the late Third Style point the way to those of the Fourth Style. In this period there is a greater emphasis on plasticity and spatial recession than in the Third Style: figures are more strongly modelled in light and shade, three-quarters views and overlapping are more frequently employed, and the setting becomes a real element in which the figures move rather than a mere back-

125 Odysseus and Penelope, from Pompeii VI 10, 2 (House of the Five Skeletons). Second quarter of 1st century A.D. Naples, Archaeological Museum 9107. H. 75 cm.

drop to the action. In achieving a sense of spaciousness the elimination of the non-active foreground and the disposition of the figures at subtly varied levels play an important part, while cubic and rectangular objects are now frequently shown at a true angle to the picture-plane instead of in the 'foreshortened frontal' position previously favoured. Generally speaking, architectural settings, interior or exterior, are more commonly employed than landscape settings (the landscape settings which do occur are perfunctory in the extreme); but the symmetrical, normally tripartite arrangements of the late Third Style tend to be supplanted by asymmetrical, bipartite ones. Supernumerary figures still occur but are less common than before; many paintings reduce the scene to the minimum number of essential protagonists. Finally, in colouring, the light and clear tones favoured in the Third Style are replaced by a warmer and darker palette, often with browns and purples prevailing. This provides an effective foil to the white highlights which are used to lend volume to the individual forms.

The mythological paintings of the Fourth Style include most of the finest and best-known examples of the genre.

126 Pirithous greeting the centaurs, from Pompeii VII 2, 16 (House of M. Gavius Rufus). Third quarter of 1st century A.D. Naples, Archaeological Museum 9044. H. 87 cm.

127 Admetus and Alcestis, from Pompeii VI 8, 3 (House of the Tragic Poet). Third quarter of 1st century A.D. Naples, Archaeological Museum 9026. H. 1.00 m.

doorway set obliquely. The colours are predominantly in the range pink, brown, purple and grey; only the red of Pirithous's cloak and of a couple of pomegranates in the basket of fruit at the centaur's feet add a splash of brightness. The centaurs in the doorway are rendered in fainter colours to distinguish them from the boldly painted figures in the foreground, reinforcing the effect of a crowd advancing into the picture-plane from a space beyond the immediate architectural environment.

Even where the action is confined within the interior setting, the arrangement of figures and furnishings creates a new sense of space. In a painting from the House of the Tragic Poet, conventionally identified as 'Admetus and Alcestis' [127], the different levels of the three foreground figures and the three-quarters back view of the youth sitting on a low table at the right make for a more rounded group and a deeper stage than in comparable pictures of the Third Style. In a painting of Thetis in Hephaestus's workshop from Pompeii IX 1, 7 [128] considerable depth is created by the disposition of figures at different levels, by the oblique setting of blocks, seats and Thetis's footstool, and by the strongly foreshortened shield on Hephaestus's knee.

For outdoor scenes we may cite the death of Pentheus in the House of the Vettii [Pl. XIB]. Here a strong sense of volume and space is again conveyed by the use of shadows and highlights, by the diagonal movement of the figures and by the placing of the figures at different levels. The foreshortened right leg of Pentheus and the three-quarters view of the right-hand maenad are especially effective. In contrast to the careful illusionism of the figures, the landscape setting is imprecise, consisting merely of vaguely suggested rocks which indicate the mountain-side on which the lynching took place, besides providing one of the assailants with her weapon and justifying the higher placing of the background figures. The figures are now all-important and the background totally subservient to their needs.

A corollary to the reduced importance of the background in mythological pictures is the adaptation of figure-scenes to form vignettes against a monochrome surface. This happens not in central panels but in subsidiary positions such as predellas and fields within ceiling-decorations; the background colour is the prevailing colour of the wall or ceiling. Many examples occur in Nero's palaces in Rome, for instance in the vault of one of the rooms of the Domus Transitoria *nymphaeum* complex, where Trojan scenes are represented on a white ground [92]. Only low platforms for the figures to stand on, necessary 'props' such as rock seats and occasional faintly rendered trees indicate the environment. In the great *oecus* (q) of the House of the Vettii three small panels in the predella (a fourth is missing) illustrate episodes linked with Apollo and Artemis, painted on a black ground. Pictures of Apollo after his killing of the Python [80] and of Agamemnon violating the sanctuary of Artemis show the main protagonists in animated, strid-

From the so-called Basilica at Herculaneum come pictures of Theseus after the killing of the Minotaur and Hercules discovering Telephus suckled by the hind; from the House of the Cithara Player at Pompeii pictures of Bacchus finding Ariadne on Naxos and Orestes and Pylades among the Taurians [129]; from the House of the Tragic Poet, again at Pompeii, pictures of Theseus abandoning Ariadne, Achilles' surrender of Briseis, the abduction of Helen, and the marriage of Jupiter and Juno; and from the House of the Dioscuri pictures of Achilles discovered among the daughters of King Lycomedes [137] and Medea contemplating the murder of her children [140]. In the House of the Vettii the two dining-rooms on the east of the peristyle still display their cycles of paintings in position [81; Pl. VIIIA]: in one room the punishment of Ixion, Daedalus and Pasiphae, and Bacchus finding Ariadne; in the other the death of Pentheus [Pl. XIB], the infant Hercules strangling snakes [Pl. VIIIA] and the punishment of Dirce.

A few less well-known pictures may be examined. A painting of Pirithous greeting the centaurs at his wedding-feast, from the House of Gavius Rufus, is typical in its use of an asymmetrical backdrop, its suggestion of spaciousness and its sombre colouring [126]. The backdrop is divided by a central column into two halves, the left blocked by a high wall and the right revealing an open

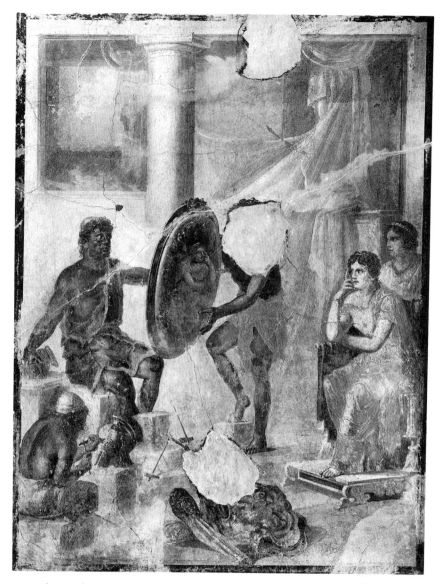

128 Thetis in the workshop of Hephaestus, from Pompeii IX 1, 7. Third quarter of 1st century
A.D. Naples, Archaeological Museum 9529. H. 1.30 m.

ing postures very similar to those of some figures in the
Domus Transitoria. But more interesting is a scene of
Orestes and Pylades, since it is clearly based on a panel-
picture known from various Pompeian houses. The fullest
version of this panel, from the House of the Cithara Player
[129], adopts the triangular structure employed in the
Third Style paintings of Jason and Pelias, though with the
more painterly handling of figures, the greater use of over-
lapping and the oblique settings of stairs and altar charac-
teristic of the Fourth Style. Orestes and Pylades, their hands
bound behind their backs, the first in three-quarters back
view, and the second behind him in front view, stand at
the left; King Thoas, accompanied by a bodyguard, sits

in profile at the right, his left arm resting on a short staff;
and above them, at the head of a flight of steps, stands Iphi-
genia, holding the sacred image of Artemis in her left hand
and gathering her skirts in the right prior to descending.
A curtain and large altar in the background designate the
goddess's sanctuary, while another altar with a lighted
torch and a jug alongside it refers to the impending sacrifice
of the two prisoners. In the Vettii vignette [130] this com-
position is dissected and its most important component
figures are put together frieze-like on the neutral ground.
The process has, however, involved certain changes. Only
Thoas is identical. Iphigenia's new position at the same
level as the king and his prisoners requires that her function

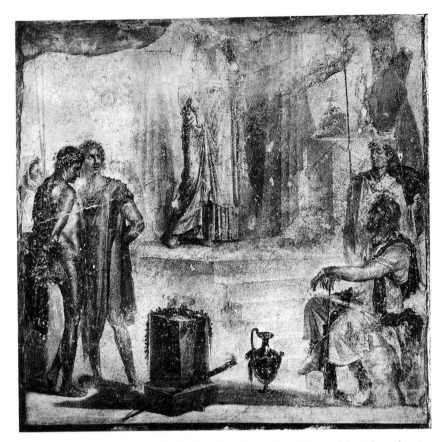

129 Orestes and Pylades among the Taurians, from Pompeii I 4, 5 (House of the Cithara Player). Third quarter of 1st century A.D. Naples, Archaeological Museum 9111. H. 1.54 m.

should be different: she is represented lighting the altar-fire. This involves her being turned in mirror-image, and since her right hand is no longer free to gather her dress a maid is introduced to do it for her. The figures of Orestes and Pylades at the left are more radically changed, the former being seated, and the latter standing with one foot resting on a block and his hand raised contemplatively to his chin. As they are no longer tied, their role in the picture makes little sense, and one must deduce that Orestes is shown seated for purely formal reasons: to provide a more effective balance to the figure of Thoas at the right.

Analogous to the adaptation of figure compositions to form little friezes is their use to people the 'scenographic' architectural schemes of Pompeii's final years (pp. 75–8). In the House of Pinarius Cerialis the Orestes and Pylades picture reproduced in the House of the Cithara Player supplied the figures for a wall in a bedroom [131]. Since the architectural setting – a central pavilion at the head of a flight of steps and a stage extending to left and right – offered very similar conditions to those in the panel, the arrangement of the figures could be repeated almost verbatim. The sole important differences (apart from the larger scale imposed by the new context) are that the two foreground groups have been transposed and their postures accordingly reproduced in mirror-image, and that Iphigenia is no longer alone but is accompanied by a pair of attendants holding plates of offerings.

One may assume that such quotations of well-known pictures were common in Pompeian 'scenographic' decorations of the Fourth Style. Another example is provided by the contest of Venus and Hesperus in the House of Apollo [132]. This is based on a panel composition known from versions in the Houses of Gavius Rufus and Fabius Rufus in which the two rivals, accompanied by their seconds, pose on either side of a regal figure of Apollo, acting as judge. The tripartite composition, similar to that of the Orestes and Pylades, again lends itself to the architectural framework; but the 'scenographic' painter removes the auxiliaries and sets the three main figures at the same level, each within a pavilion. In posture the figures are copied almost without alteration, except that Apollo seems to be stretching out his left arm to indicate Venus as the victor instead of resting it on the arm of his throne, while Venus herself is seated rather than, as in the original, standing.

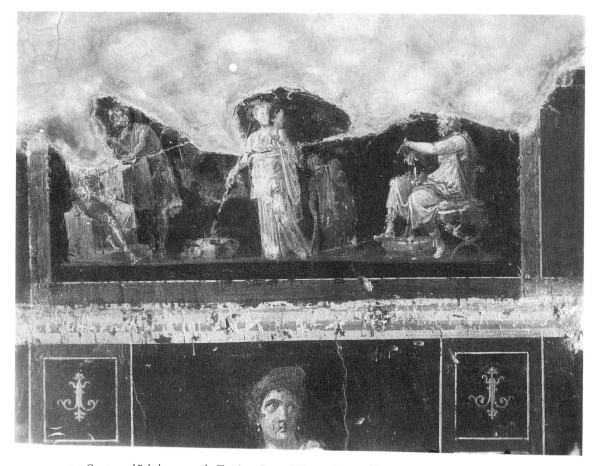

130 Orestes and Pylades among the Taurians. Pompeii VI 15, 1 (House of the Vettii), *œcus q*. Soon after A.D. 62.

The latter change is certainly due to a desire to achieve a balance with the seated Hesperus on the left: the formal setting of the architecture imposes a more rigid symmetry than the free composition within the panel.

The relation of panel-pictures to old masters

The foregoing survey has shown how the central panels of wall-decorations from the late Second to the Fourth Styles 'moved with the times'. Underlying most of the pictures were certain established iconographic formulae which were reinterpreted according to the taste of the period or to the requirements of the context. The same types could appear in both linear and painterly form. They could be represented either on a front plane before a neutral background or ranged in depth in three-dimensional space. They could be shown on a small scale in landscape or on a large scale with only the barest indications of setting. Doubtless they were derived from well-known prototypes, some of which could be the old masters recorded by Pliny and other ancient writers. Many of the subjects which we

have mentioned are, indeed, included in Pliny's lists: in addition to the Io and the Andromeda of Nicias [133, 134] there is 'the infant Hercules strangling two snakes' by Zeuxis ('in the presence of his mother Alcmena, full of alarm, and of Amphitryon', which would fit the painting in the House of the Vettii as well as two other Campanian versions), a Hercules and Deianira by Artemon, probably an early Hellenistic artist, and an 'Orestes and Iphigenia among the Taurians' by Timomachus of Byzantium, a contemporary of Julius Caesar.

The problem is to know how closely any of the Pompeian versions is related to a given original. Granted that pattern-books of some form were in circulation (see below, pp. 217–19), we can deduce that at least the basic compositions could be transmitted accurately; indeed the Alexander mosaic [1] suggests that sometimes there were highly detailed cartoons including colour and other aspects of the pictorial rendering. Most pattern-books, however, probably gave little more than the main outlines; details of colour, shadow and setting were perhaps recorded in only the most general terms or not recorded at all. This will explain

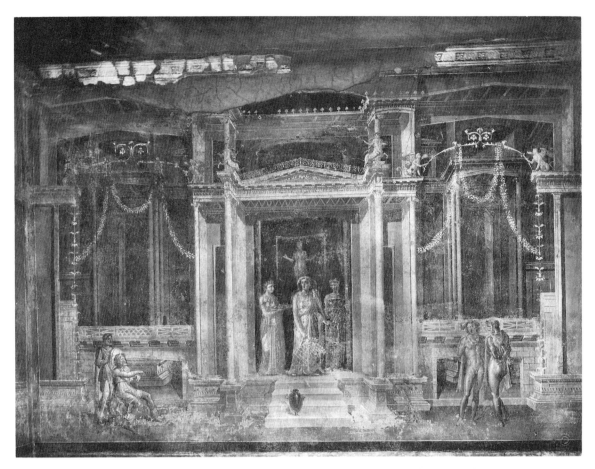

131 Orestes and Pylades among the Taurians. Pompeii III 4, 4 (House of Pinarius Cerialis), bedroom *a*, north wall. Between A.D. 62 and 79.

many of the variations which occur, such as the representation of the same scene against different backdrops. The varying capabilities of different painters will explain more: misunderstood details, for example, and awkward anatomical transitions. In some cases, however, it seems that the same workshop deliberately reproduced a scene in 'de luxe' and 'economy' versions to suit the context or the purchasing power of the patron; thus an identical composition of Ariadne handing Theseus the ball of thread at the entrance to the labyrinth recurs at Pompeii both with an architectural backdrop and without any background at all – the first time in a polychrome bedroom in the House of Lucretius Fronto [60], the second in a white bedroom in a more modest house. The decorations of the two rooms show affinities which imply that they were the product of a single workshop, so the difference in treatment is clearly not fortuitous.

For the general flavour of the lost originals it seems likely that the pictures of the Fourth Style, with their squarish format, dominant figures and simple backgrounds, are the most faithful. This can be deduced not only from ancient descriptions of the old masters, which dwell on the kind of plasticity, lighting effects and psychological aspects found in Fourth Style panels, but also from comparison with the modes of representation employed in late Classical and early Hellenistic murals, mosaics and ceramics, as well as from general stylistic links with the art of this period, for instance in the proportions, physiognomy and postures of the figures. In a few examples, such as the Argos and Io of the Macellum [133] and the Perseus and Andromeda of the House of the Dioscuri [134], based on works by Nicias, it is probable that we have relatively accurate reproductions of the prototypes.

The extensive landscape settings of the late Second and Third Styles, and the multiplication of supernumerary figures in the late Third Style, were almost certainly not features of any Greek models but rather changes conditioned by contemporary fashions in Roman wall-painting. We have seen how the Second Style version of Nicias's Io was adapted to a vertical format by the addition of a votive column and a tree [35]. In the same picture the inclusion of an extra figure, Mercury (Hermes), turns the composi-

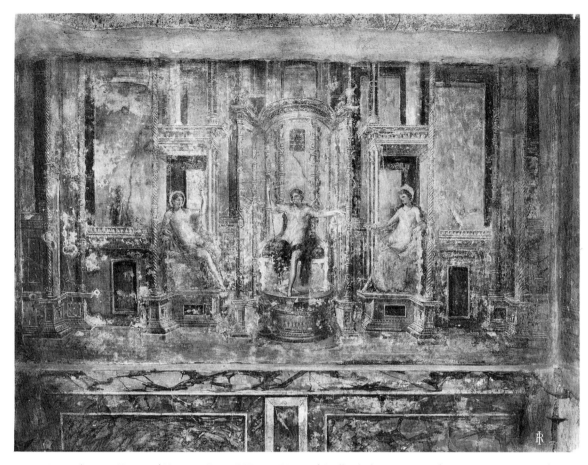

132 Contest between Venus and Hesperus. Pompeii VI 7, 23 (House of Apollo), bedroom 25, west alcove. Between A.D. 62 and 79?

tion into a three-part group, and by thrusting Io into the middle of the picture, transforms what was originally a brooding duet into the simple story of a damsel in distress. Similarly the Perseus and Andromeda was provided with a couple of watching nymphs, seated high on a rock, in two late Third Style versions (cf. [135]). The addition of spectators was the most popular of all the Roman variations upon inherited themes: the seated females of the Perseus and Andromeda are a leitmotif of the Third Style, reappearing with slight modifications but always on a rock or on a stone block in various mythological scenes to which they are scarcely appropriate; while heads looking over walls or out of windows are especially fashionable during the late Third and Fourth. Even the two-figure Odysseus and Penelope in the Pompeian Macellum [136], a pendant to the Argos and Io (and thought by some to reproduce another painting by Nicias), cannot escape this last form of intruder.

The range of variations within Roman copies extends, however, beyond the mere changing of a background or

133 Argos and Io (after Nicias). Pompeii VII 9, 7 (Macellum), ▶
north wall. Third quarter of 1st century A.D. H. 72 cm.

134 Perseus freeing Andromeda (after Nicias) from Pompeii VI 9, 6 (House of the Dioscuri). Third quarter of 1st century A.D. Naples, Archaeological Museum 8998. H. 1.22 m.

135 Perseus freeing Andromeda, from Pompeii VI 10, 2 (House of the Five Skeletons). Second quarter of 1st century A.D. Naples, Archaeological Museum 8993. H. 37 cm.

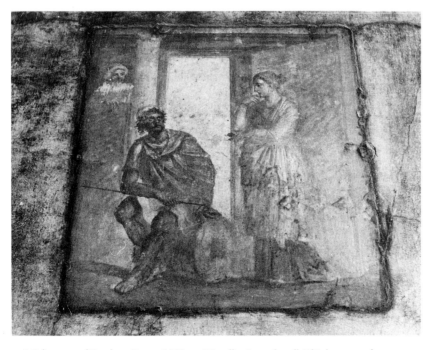

136 Odysseus and Penelope. Pompeii VII 9, 7 (Macellum), north wall. Third quarter of 1st century A.D. H. 82 cm.

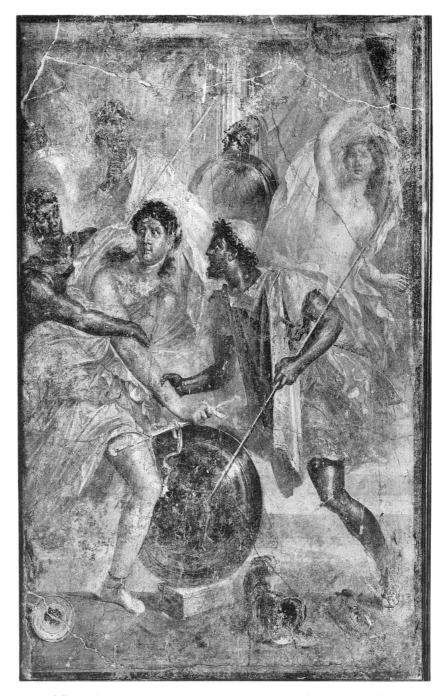

137 Achilles on Skyros (incomplete), from Pompeii VI 9, 6 (House of the Dioscuri). Third quarter of 1st century A.D. Naples, Archaeological Museum 9110. H. 1.11 m.

the insertion of extra figures. The nuclear composition itself is frequently modified. Scenes are reproduced in mirror-image; figures are omitted or deliberately altered (by being shown seated rather than standing, for instance); the places of figures within a composition are switched round. Sometimes figure-types are transferred to different actors. Thus in a painting of Io's captivity from the temple of Isis at Pompeii the type normally used for Argos is

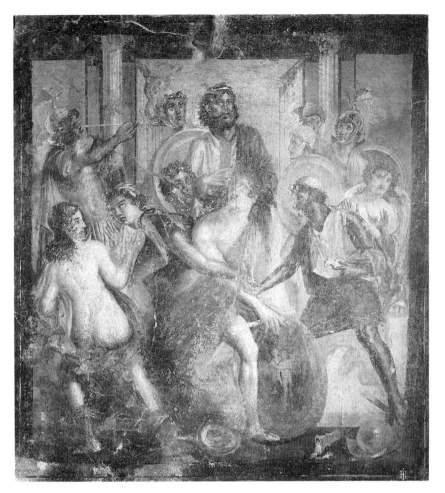

138 Achilles on Skyros, from Pompeii IX 5, 2. Third quarter of 1st century A.D. Naples, Archaeological Museum 116085. H. 1.30 m.

assigned to Mercury, albeit in mirror-image and with the extended arm adapted to hold out the pipes with which the god was to lure Io's captor into a musical contest; Argos himself is instead shown seated at the right. The scene is evidently an uncomfortable hybrid between the Nician composition and a separate iconography for the handing over of the pipes, reflected in other paintings from Pompeii and Herculaneum. A further kind of adaptation consists in turning participants into spectators: the 'Admetus and Alcestis' painting from the House of the Tragic Poet [127] does this with four figures (Apollo, a veiled woman and an elderly couple) which elsewhere play an integral part in the composition; here they are rearranged into two symmetrical pairs of onlookers behind low walls at the rear. Finally there are paintings which appear to be pastiches putting together figure-types or groups from various sources. The Pan and the nymphs from the House of Jason [123] is a case in point: Pan himself is based on a type of Marsyas playing the flutes; the lyre-player at the right is derived from a fifth-century type, probably via a classicis-

ing copy of the first century B.C.; and the seated nymphs at the left are our familiar female spectators. The Mars and Venus of the House of Lucretius Fronto [Pl. XB] combines the same female spectators, here on the opposite side of the picture, with a favourite type of the divine couple in which Mars, complete with parade helmet, leans over Venus's shoulder and seeks to lay his left hand on her breast; in the middle is a Cupid with a bow, based on a statue-type attributed to the late Classical sculptor Lysippus. The stone seat of the two nymphs looks decidedly incongruous next to the sumptuous couch of the bed-chamber, and their very presence at this intimate encounter is hard to explain.

When one adds the countless minor changes of dress, gesture, angle of the head or position of the feet to the major variations listed above, the difficulty of reconstructing the archetypes becomes obvious. Even when we can be fairly sure that we have copies which are relatively closely based upon a famous original, there are often problems with regard to detail. Take, for example, the paintings of

Achilles on Skyros from the House of the Dioscuri [137] and from a smaller Pompeian house, IX 5, 2 [138]. In both, the setting and the main group of figures are virtually identical. The action takes place in front of a colonnaded entrance. Achilles, who has been disguised as a girl among the daughters of King Lycomedes, moves precipitantly to the right, clasping a sword and a shield, his dress still flapping round his body. The two Greek warriors who have come to lure him to Troy converge on their prey, Diomedes holding him from behind and Odysseus seizing his right forearm. In the background the king emerges from his palace, a bodyguard with a shield on either side of him, to find out the cause of the commotion. The left-hand part of the two pictures cannot be compared because that of the Dioscuri version is destroyed; the other painting shows one of the daughters, probably Achilles' mistress Deidamia, starting back half-naked, her right hand raised in alarm, while another girl (or a nurse) making a similar gesture emerges from behind Diomedes, and above them a soldier blows the clarion call which has roused Achilles into revealing himself. That the latter figure at least recurred in the Dioscuri painting is indicated by the mouth of his trumpet on the surviving section.

So far so good. But the remaining elements in the composition are different. At the right there is another of Lycomedes' daughters, but in the Dioscuri picture she is a half-naked figure, visible from the hips upwards, flinging her arm above her head in consternation, and in the other she is hidden by Odysseus save for her head and shoulders, is fully clad and makes only a genteel gesture of concern. In this second painting there is the helmeted head of a further soldier in the background, whereas the first shows only a curtain hanging from the entablature of the porch. The position of the trumpet is different in the two copies, rising obliquely above the head of Lycomedes' guard in the Dioscuri, and extending horizontally in IX 5, 2. The Dioscuri copy also provides Diomedes and Odysseus with diagonal spears not present in the other copy, where Odysseus's left hand instead grasps the hilt of his sword. The various objects in the foreground take different forms and lie in different positions: a metal vase is turned into a tiny basket spilling wool, and exchanges positions with a helmet which itself becomes transformed into a different type. Achilles' shield rests now on a casket, now directly on the ground.

The handling and colouring of the two copies shows even more striking differences: as Curtius comments, in essence there is no brush stroke in the two pictures which is identical. The Dioscuri version is infinitely the finer work, with well-proportioned figures, flowing movements, convincing facial expressions and shimmering colour effects. In the other the figures are wooden and ill-proportioned (see especially the lumpish Deidamia), the action disjointed, the brushwork heavy and uninteresting. The second painter seems also to have misunderstood the setting. The entablature above the columns is carried down the sides

of the picture to give the impression that the action is taking place indoors and that the openings are to the outside; but this makes no sense of the high level of the king, his bodyguards and the trumpeter. The situation is clarified by the Dioscuri copy, where a flight of steps runs across the picture behind the Achilles group: the raised figures, including here the right-hand daughter, are standing on the palace steps, and the half-open doors behind Lycomedes lead to the interior. In colouring the Dioscuri copy is again superior. Whereas the other painter uses a scale of reds, yellows and purples with little feeling and little sense of the structure of the scene, the Dioscuri artist produces a coloristic masterpiece unified by balancing accents of reddish brown, blue-green and white. The silky texture of the drapes is brilliantly conveyed by glancing highlights; the head of Achilles, somewhat lost in the other picture, is effectively isolated and emphasised by the light tones around it; the background forms are atmospherically softened instead of standing out as starkly as those in the foreground.

The ultimate source of the paintings is probably a famous masterpiece by the late fourth-century artist Athenion of Maronea: 'Achilles disguised in a girl's clothes being detected' (or 'seized') 'by Odysseus'. The two copies fit Pliny's words much better than the alternative iconography, found both at Pompeii and in later works, where Achilles is in full cry, with the shield on his raised left arm and a spear in his right hand, and Odysseus has not yet got hold of him. But which copy is closer to the original? Not necessarily the better piece of work, since an accomplished artist might well have interpreted his model with greater freedom. The poorer copy might have transmitted some details, such as the extra soldier on the right or the objects lying in the foreground, more faithfully than the other. Even its colour scale may be truer to the original. There is in any case no way of knowing how many intermediaries intervened between Athenion and the Pompeian painters of the third quarter of the first century A.D.; perhaps both copies contain elements which were altered or introduced by earlier copyists.

It is, in short, generally a futile exercise trying to recapture great Greek paintings from their Roman copies and adaptations. In most cases we can be fairly sure that an element of the original has remained, but that generations of artistic transmission have imposed extraneous features; thus a painting of the sacrifice of Iphigenia from the House of the Tragic Poet at Pompeii [139] retains at least one feature of the famous masterpiece by the early fourth-century painter Timanthes (namely Agamemnon covering his face to hide his grief) but changes others (the figure of Menelaus is apparently missing, and the victim is not 'standing at the altar' but being carried to it). Sometimes there may have been two independent prototypes, both with the status of old masters, the one perhaps adapted from the other. Pliny frequently records different paintings of the same subject: a 'Medea', for example, appears among the works of both

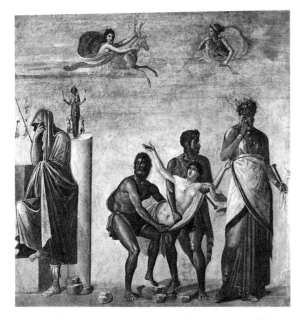

139 Sacrifice of Iphigenia, from Pompeii VI 8, 3 (House of the Tragic Poet). Third quarter of 1st century A.D. Naples, Archaeological Museum 9112. H. 1.26 m.

Themes and their organisation

In general terms the *raison d'être* of Pompeian wall-painting is clear enough. Its object was to make the environment comfortable and attractive. More specifically those rooms that received decorations in the four Pompeian Styles were transformed and enhanced. The First Style imparted an effect of monumental masonry and of Hellenistic palaces; the Second, with its porphyry and alabaster columns, its gilded detail and its exotic architectural devices, may also have been intended to evoke the grandeur of eastern courts (or indeed of the fabulous mansions of the nobility in Rome); the Third, and to a greater extent the Fourth, transported the dweller into a world of pure imagination. The perspectival forms of the Second and Fourth Styles also, of course, seemed to enlarge the physical space within a room; and in some instances, by offering a glimpse of sky above the painted architecture, or by opening windows through it on to a mythical world (the Odyssey landscapes, for example), the decoration seemed to break right through the bounds of the wall. The ultimate expression of this is provided by the garden murals from Primaporta (see below, pp. 149–50), which turned the room into an open-sided pavilion set in a magic forest. The aesthetic value of such paintings in rooms which were often cramped and badly lit is all too obvious.

Another role of interior decoration was to turn parts of the house into picture-galleries (*pinacothecae*). Rooms for the display of panel-pictures had long been a feature of Greek sanctuaries (the most famous was in the Propylaea on the Athenian Acropolis); and, with the growth of private art collections in Rome, similar rooms came to be incorporated in the luxurious villas of late Republican nobles. Something of their appearance may be gauged from those decorations of the mid Second Style in which imitation *pinakes* are represented standing on picture-mouldings, much as they might have done in reality. But the history of the picture-gallery as a theme in mural decoration begins with the introduction of the dominant central picture at the end of the Second Style. By the time of the Fourth Style well-off householders, such as the Vettii brothers and the owner of the House of the Tragic Poet at Pompeii, were collecting reproductions or adaptations of Greek old masters in much the same way as more recent generations have collected copies of the Laughing Cavalier or the Mona Lisa (with the difference that the ancient panels were fixtures within the wall). This was one means whereby the *nouveaux riches* could make a display of their culture.

At the same time, the choice of subjects within a given decoration often unmistakably reflects the function of the room. Bacchic pictures and motifs, not to mention still-life paintings of food, are frequently found in saloons and dining-rooms; myths of Venus and symbols of love are favoured in bedrooms. Even where subject-matter was less

Aristolaus in the late fourth century and Timomachus in the mid first. We learn from elsewhere that Timomachus's Medea was shown with sword in hand, agonising over the killing of her children; and a type of Medea contemplating infanticide is known in at least six Campanian paintings. But the mother's attitude varies from picture to picture: she is now standing with her hand on the hilt of her sword [140], now standing with her hands clasped in front of her in an agony of conflicting emotions [141], now seated with her head sunk on one hand and her sword resting in her lap [146]. Could one of these versions reproduce the painting of Aristolaus? The question must remain open. The different poses could represent distinct and long-standing traditions, but they could equally be variations created in local workshops at Pompeii and Herculaneum. By the same token a close relationship between Pompeian paintings of the same scene, as in certain Third Style versions of Hercules, Deianira and Nessus, does not necessarily constitute evidence for the appearance of a famous original: they could all be interdependent.

What is more important than tracing putative prototypes is observing how the Roman painter adapted his heritage. The painting of mural pictures was a living tradition and the Pompeian examples tell us more about the taste of the times and the artists' response to it than about the past. Before we turn to the other *genera* of representational painting which featured within wall-schemes, it is worth considering the factors that governed the choice and the treatment of subjects in a given room.

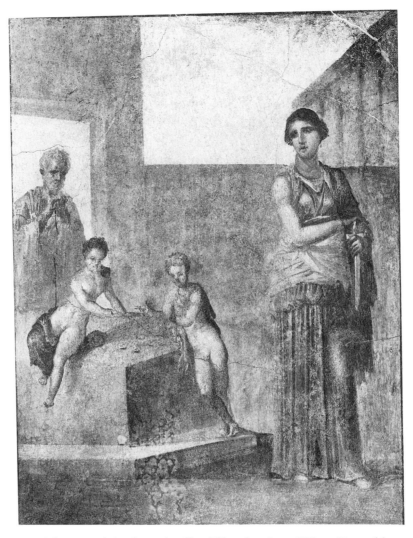

140 Medea contemplating the murder of her children, from Pompeii VI 9, 6 (House of the Dioscuri). Third quarter of 1st century A.D. Naples, Archaeological Museum 8977. H. 1.13 m.

specifically related to room function, it is a general rule that reception rooms were decorated with grand and heroic themes, bedrooms with more intimate ones. In bath-suites the most popular themes were aquatic and athletic (bathing and athletics being closely associated activities). The baths of the House of the Menander contain not only wall-paintings (from two different periods) showing athletes, women bathers and riverine scenes, but also mosaic pavements featuring dolphins and other marine fauna, sea-horses, oil-jars and strigils (athletes' body-scrapers). The 'aquarium' in the Forum Baths at Herculaneum (p. 92) is even more eloquent.

Such function-related themes are fairly straightforward. What is more controversial is whether there are deeper meanings to be discerned. An extreme position has been taken by the Swiss scholar Karl Schefold who argues from the Pompeian evidence that the subjects within a decoration were normally linked in a consistent programme embodying deep-felt moral or religious ideas. Thus one decoration will present a hymn to the great deities of love and fertility, Venus and Bacchus; another will contrast the exploits of a divinely favoured hero with the sufferings of an offender against the gods. Landscape paintings are invariably sacred, still lifes are offerings to the gods and so forth. The same idea is explored by Mary Lee Thompson, though with a more pragmatic approach: for her most of the programmes are on a relatively superficial plane, dealing with a particular hero such as Achilles, a particular locale such as Thebes, and particular combinations of concepts such as love and water.

There is doubtless some truth in all this. A religious element appears in many Roman murals – not just in explicitly

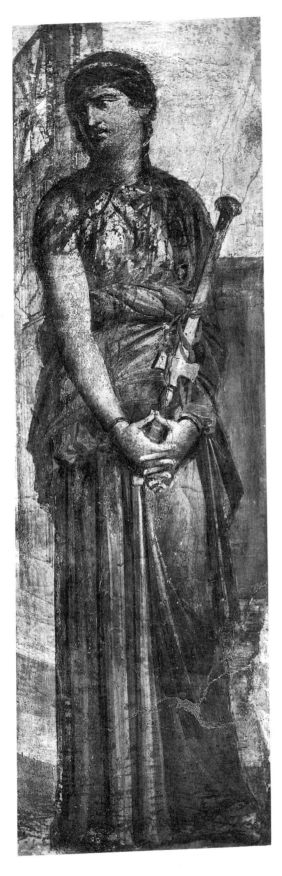

ritual celebrations like the Mysteries frieze, but also in the various 'props' and figures found scattered in the painted architecture of the Second and Fourth Styles. One can also cite the assemblages of deities, approximately one-third life size, round the walls of the *atria* in the Houses of the Dioscuri [142] and of the Ship at Pompeii; their size and prominent position exceed the requirements of purely decorative subjects. In addition, there are some undeniable instances of thematic links between companion pictures. The left *ala* of the House of the Menander at Pompeii contains a Trojan cycle in which paintings of the wooden horse and of the death of Laocoon, both allusions to warnings unheeded by the Trojans, are combined, as in a Greek tragedy, with the ruinous sequel: Priam watching grief-stricken while Menelaus seizes Helen and Ajax assaults Cassandra [Pl. XIC]. In the *tablinum* of the House of the Dioscuri the discovery of Achilles in the court of Lycomedes [137] was

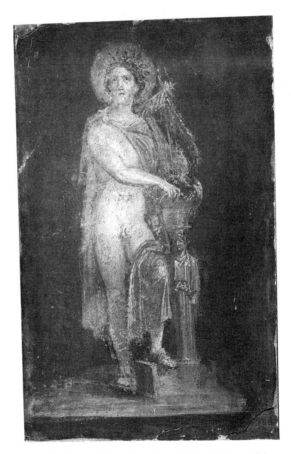

142 Apollo playing *cithara*, from Pompeii VI 9, 6 (House of the Dioscuri), *atrium*. Third quarter of 1st century A.D. London, British Museum 1857.4-15.1. H. 62 cm.

◀ **141** Medea contemplating the murder of her children (incomplete), from Herculaneum. Third quarter of 1st century A.D. Naples, Archaeological Museum 8976. H. 1.37 m.

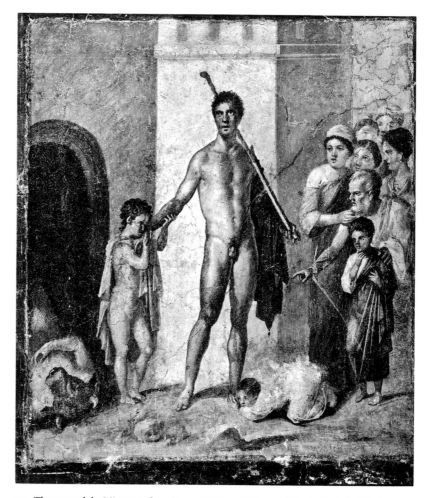

143 Theseus and the Minotaur, from Pompeii VII 2, 16 (House of Gavius Rufus). Third quarter of 1st century A.D. Naples, Archaeological Museum 9043. H. 90 cm.

depicted on the right wall, and his subsequent quarrel with Agamemnon on the left; and in Pompeii IX 5, 2 the discovery of Achilles [138] was combined with two other related episodes – his mother Thetis collecting his armour from the workshop of Hephaestus and her voyage with it across the sea. In VII 2, 25 an even more close-knit cycle showed the collection and delivery of Achilles' armour combined with a scene of its manufacture.

But such cases are the exceptions to the rule, and it is difficult to find any clear evidence for a widespread interest in connections of theme, still less a sensitivity to the moral and religious implications of the subjects represented. Indeed the great variety of combinations in which subjects occur, and the iconographic variations in their rendering, militate against all theories of consistent programmatic links. Among the known decorations of Pompeii and Herculaneum it is almost impossible to find two rooms employing precisely the same combination of subjects; and

even when subjects recur together, the changes of colouring and composition are such as to imply that simple appearances were more important than any underlying 'message'.

The chief factor which seems to have dictated the choice of pictures in a given room was the possibility of achieving a formal balance. Thus in the House of Gavius Rufus at Pompeii, the painting of Pirithous and the centaurs [126] was set opposite one of Theseus and the Minotaur [143], a suitable thematic counterpart since Theseus and Pirithous were friends and the exploits depicted both involved victories over half-human, half-bestial monsters; but it is not the links in subject-matter which were emphasised (in one scene the prelude to the struggle was represented, in the other its sequel), but rather the similarities in composition – the common scale of the figures, the central motif of the hand being kissed, the crowd of figures receding obliquely into the background at the right, and the vertical accents at the centre. The third picture in the room was a version

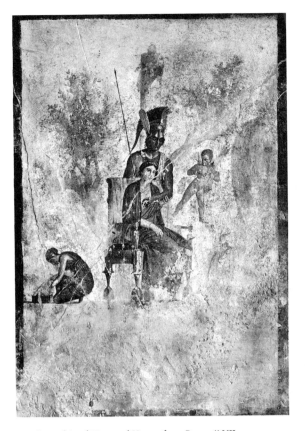

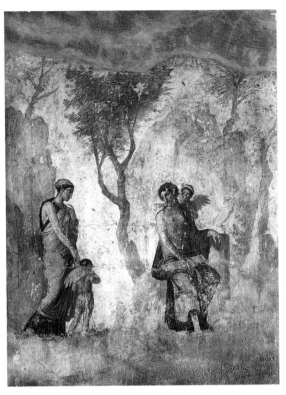

144 Courtship of Mars and Venus, from Pompeii VII 2, 23 (House of the Punished Cupid), *tablinum*. First quarter of 1st century A.D. Naples, Archaeological Museum 9249. H. 1.23 m.

145 Punished Cupid, from Pompeii VII 2, 23 (House of the Punished Cupid), *tablinum*. First quarter of 1st century A.D. Naples, Archaeological Museum 9257. H. 1.16 m.

of the dispute between Venus and Hesperus (cf. pp. 127–8), which has neither a direct thematic relationship nor an obvious compositional correspondence with the other two scenes. Its symmetrical structure is appropriate, however, to its position at the middle of the back wall.

The effort to achieve broad compositional and coloristic balance was often pursued in unpromising circumstances. A classic instance of an uneasy adaptation is a picture of the courtship of Mars and Venus from the House of the Punished Cupid at Pompeii [144]. Here the central motif of Mars, resplendent in his parade helmet, caressing the breast of a seated Venus is closely related to the similar group at the left of a painting in the House of Lucretius Fronto [Pl. XIA]; but instead of being set in a boudoir it is transferred to the open country, where Venus's throne looks distinctly incongruous. The scene properly belongs to the interior of Hephaestus's palace, as the Fronto version shows it; the painter of the Punished Cupid version has added a backdrop of trees and rocks to reflect the setting of the picture on the opposite wall, the scene of the punished Cupid which gives the house its name [145]. He has also added two further figures to fill out the composition: a flying Cupid and a maidservant crouched over a

casket. The latter is disproportionately small, and her very presence is hard to explain in functional terms. Curtius suggests drolly that she is attending to the picnic!

Examples can be multiplied. In the three paintings of 'fatal loves' – Medea and her children, Phaedra and the nurse, and Paris and Helen – from a bedroom in the House of Jason at Pompeii, the compositions and settings are closely harmonised (cf. [146], [147]). An even finer example is provided by the Pentheus Room in the House of the Vettii. Though the three pictures (the death of Pentheus, Hercules strangling the snakes and the punishment of Dirce) may have been based on originals of different date and pedigree, they have been made equal in shape and size, and closely matched in composition, style and colour scheme (cf. [Pls. VIIIA, XIB]).

It is rare that the pictures of a room are as carefully harmonised as they are here. But it is a fair generalisation that links in composition and colouring are more frequent than direct links in theme: correspondence in form was more important than correspondence in content. In other words the factors which dictated the choice of pictures were primarily aesthetic (and no doubt practical, since much would depend on the availability of compositions in the

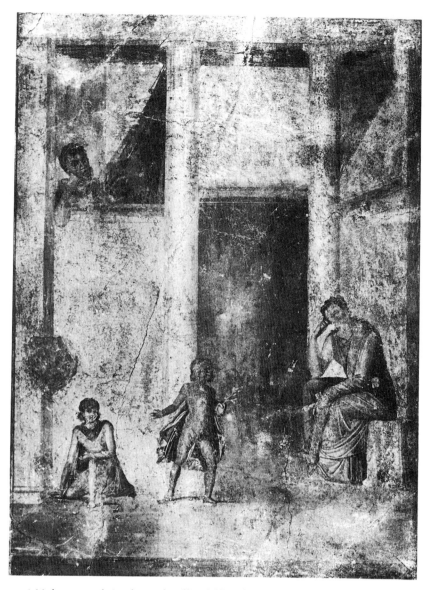

146 Medea contemplating the murder of her children, from Pompeii IX 5, 18 (House of Jason).
First quarter of 1st century A.D. Naples, Archaeological Museum 114321. H. 1.14 m.

painters' copy-books) rather than intellectual. All this sheds an interesting light on the mentality of the patron, who (we may assume: see pp. 217, 219–20) exercised the predominant voice in the selection process. He liked to have pictures on his walls in imitation of the galleries of the nobility; he may have taken pride in acquiring something that purported to be a reproduction of a Zeuxis or an Apelles; he often selected subjects which were appropriate in a bedroom rather than a dining-room and vice versa; and he no doubt frequently chose pictures because they depicted a favourite story, because they evoked an exotic or literary atmosphere (as the Yellow Frieze conjured up the romance of the East, or the Boscotrecase landscapes the bucolic images of Theocritus and Virgil: see below, pp. 142–3, 144), or simply because their appearance appealed to him. But he was primarily concerned that they could be made to look right together, even if this meant allowing or encouraging the painter to alter the number and arrangement of the figures, adjust the colours and change the settings.

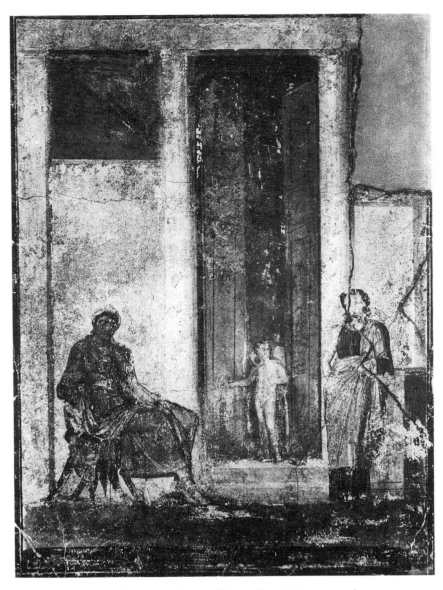

147 Paris and Helen, from Pompeii IX 5, 18 (House of Jason). First quarter of 1st century A.D. Naples, Archaeological Museum 114320. H. 1.15 m.

7

Other paintings

Landscapes

The discovery of a frieze with hunting-scenes set in a landscape of trees and rocks on the façade of one of the royal tombs at Vergina [2] has confirmed that landscape was a component of Greek painting as early as the fourth century B.C. Quite how prominent a role it came to play in Hellenistic times must remain uncertain in the absence of direct evidence. Relief sculpture employed it only sparingly; but the evidence of relief sculpture is a poor guide to what was happening in painting, a medium much better suited to the rendering of space. We may guess that painters frequently placed scenes in landscape environments and that they reduced the scale of the figures so as to give greater prominence to the setting: the Odyssey frieze [108–11] would represent the culmination of this development.

But it remains unlikely that Greek painters represented landscape in its own right. This is one of the achievements that must be credited to the Roman age. The key is provided by a crucial passage in Pliny's book on painting, in which he refers to an Augustan artist named Studius who 'first introduced the most attractive fashion of painting walls with villas, porticoes (harbours?) and landscape gardens, groves, woods, hills, fish-pools, canals, rivers, coasts – whatever one could wish, and in them various representations of people strolling about, people sailing, people travelling overland to villas on donkey-back or in carriages, and in addition people fishing, fowling, hunting or even gathering the vintage'. The important characteristics of this type of painting seem to have been that the landscape itself and the buildings within it formed the centre of interest; the figures were of secondary importance and were derived not from myth or legend but from everyday life.

The evidence from surviving wall-paintings seems to bear out Pliny's testimony that this kind of landscape became an important subject at the time of Augustus. But it was not created entirely *ex novo*; rather it emerged from a development which can be traced back at least to the end of the second century B.C. At its roots probably lies a kind of topographical painting inspired by map illustration and evidently imported from Alexandria: the Nile mosaic at Palestrina [3] represents the characteristic appearance of the genre, with snatches of landscape containing buildings, people and animals ranged at different levels to express the scenery and landmarks of the Nile valley. A painted frieze in the *atrium* of the Villa of the Mysteries shows the same subject adapted to a continuous horizontal format, with the palm-trees and building-types of Egypt set amid a broad expanse of water; as in the Palestrina mosaic, the landscape is enlivened with ordinary figures – a goatherd, worshippers, people in boats, passers-by. The colouring here remains fully naturalistic, but a series of slightly later paintings adopts a monochrome treatment, so that the landscape can be represented as a surface-decoration upon the fictive blocks of Second Style architecture. From Boscoreale come fragments of a purple frieze now in Mariemont and a yellow panel, painted as if adorning a low screen-wall, beneath the window in the back wall of the bedroom in New York. The formula consists, as in the Villa of the Mysteries, of small buildings interspersed with staffage figures; but there are no specifically Egyptian features. At Oplontis monochrome landscapes are painted on orthostates in two rooms, once in yellow and once in turquoise. The tall and narrow format imposes a pronounced vertical development, and the scenes are broken into three or four architectural vignettes placed one above the other [148].

The crowning achievement in monochrome painting is the yellow frieze of the House of Livia [149]. Painted only a decade or so later than Boscoreale and Oplontis, it presents a much more realistic treatment of space: depth is indicated not so much by the use of higher levels (though this method is still exploited within the limits of the field) as by the use of a markedly smaller scale and of a hazier, more atmospheric rendering for distant elements. For the first time in genre landscapes space is represented in visually convincing terms. Yet the unreal colouring, with buildings, trees, statues and figures sketched in strokes of maroon and flecks of creamy-white on the yellow background, produced a ghostly, dream-like effect somewhat akin to that of Japanese prints. Egyptian elements now reappear; the repertory includes a camel, a statue of Isis-Fortuna, a statue of a winged sphinx and possibly a tower tapering in the

148 Yellow monochrome landscape. Oplontis, Villa of the Poppaei, *triclinium* 14 (east wall). *c.* 50–40 B.C.

As well as romantic monochromes the third quarter of the first century B.C. saw the appearance of other types of landscape painting. Among them we may class prospects of buildings and gardens viewed through an architectural screen, the finest examples of which are in the Boscoreale bedroom [27, 28]. These may originally have been inspired by stage-sets (cf. p. 30), and as such they differ from the landscapes already described not only in their use of a much larger scale but also in the clarity of their modelling, in their non-panoramic treatment and in their lack of human figures. Particularly striking are the ivy-clad grottoes with fountains and vine-pergolas on the rear wall.

More important are the rustic sanctuaries which appear in close-up in several central panels. Typical examples occur in one of the rooms of the House of Livia and in the Room of the Masks on the Palatine [33, 150]. In each case the composition is focused on a sacred column or pillar of some form, with trees growing behind or round it, and various offerings attached to it or placed at the bottom. Human figures are lacking, but birds or grazing animals appear in the foreground. The depiction of the environment is more circumstantial and realistic in the House of Livia, where the whole picture-field is filled, and the sky is visible above the trees; in the Room of the Masks, however, the background is a neutral white and the suggestion of space accordingly less real, foreshadowing a tendency of the ensuing period. It is noteworthy that these pictures occupy the central place. Landscapes, admittedly of a religious type, have now acquired sufficient respect as a branch of painting to appear in the position normally reserved for mythological themes. At the same time the pronounced vertical emphasis lent by the cult-pillar or votive column makes them particularly well suited to the format of the field.

The development of genre landscape reached a climax at the end of the Second Style and the beginning of the Third with the paintings from the Farnesina villa and from the red and black rooms at Boscotrecase.

The Farnesina villa presents almost a compendium of the uses of landscape at this time. From bedroom E come rustic sanctuaries of the type just described, though including an isolated goatherd or worshipper in the foreground. From other rooms come landscapes of more or less panoramic type, with views of buildings and people. Those of the cryptoportico A and corridor F–G are on a white ground, the former floating in the middle of the main zone, behind the columns of the foreground plane, and the latter occupying alternate panels of a frieze [151]. Those of the *triclinium* (C) on the other hand are on a black ground, scattered in brilliantly coloured sketches all over the main fields. Finally, the taste for landscape even invades the stuccowork of the vaults: the three bedrooms (B, D and E) yielded deftly modelled scenes with similar buildings and figures to those painted on the walls. In all the scenes the repertory is broadly identical: trees, temples, country

Egyptian manner. But this is not a specifically Nilotic scenery: only two sections feature a river, while the boats, buildings, people and animals have little in common with those represented on the Palestrina mosaic. Much of the setting is formed by generalised representations of temples, porticoes, statues of Greek deities, sacred gates and columns, and country houses of a type familiar throughout the Mediterranean world; while the people (travellers, donkey-drivers, herdsmen, worshippers and fishermen) could belong to any land. Overall, one gets the impression that these are simply idealised landscapes with an exotic flavour created by contemporary painters in response to a demand from educated patrons familiar with Alexandrian poetry.

149 Rome, Palatine, House of Livia. 'Right *ala*', detail of north-east wall. Soon after 30 B.C.

houses, rustic shrines, statues, worshippers, wayfarers, fishermen, goatherds, grazing flocks and cattle, mere bystanders. The figures include a number of finely observed details: note in [151] (which closely recalls Pliny's description of the paintings of Studius) a man bending over some task on a rock at the left, an angler drawing in his line with a fish wriggling on the end, and a woman cleaning, or tying a fillet to, one of the columns of the villa's porch. The paintings are distinguished by their quick, sketchy quality, with bold juxtapositions of light and dark to suggest volume.

The Boscotrecase landscapes are closely related to those of the Farnesina and seem to pick up where the latter leave off. In the black room, instead of scattered buildings over the whole surface, there are neat vignettes at the centre [152]. Little country houses, shrines or tombs, enlivened with figures of worshippers making offerings, a shepherd with his sheep, and people reclining beneath an awning, are carried out in quick strokes of pale blue, green, yellow, red and purple. In the red room, we find white-ground land-

scapes in framed panels, again in the central position [56]. These are inspired by the earlier pictures of rustic shrines, from which they inherit a vertical accent formed by a column or similar monument set against a tree; but instead of being rendered on a large scale and at close quarters they are treated as panoramic landscapes with various subsidiary figures and motifs in the foreground and distant buildings in the background [153]. All the same, they come nowhere near to filling their fields, and float in the middle surrounded by the white of the background. As in the Farnesina white-ground landscapes, the foreground figures and objects are painted in stronger tones, mainly from the brown and purple range, and the background trees and buildings in lighter, hazier tints, among which green and yellow are prominent. But the scenes are now more compact and more isolated, and the inconsistencies of perspective, whereby the foreground is seen at eye-level while the background seems to be viewed from a height, are more pronounced.

After Boscotrecase, landscapes of this 'sacro-idyllic' type

150 Rustic shrine with sacred column. Rome, Palatine, House of Augustus, Room of the Masks (south wall). Soon after 30 B.C.

152 Landscape vignette. Boscotrecase villa, black room (15), north wall. Soon after 11 B.C. New York, Metropolitan Museum of Art, Rogers Fund 1920: 20.192.1.

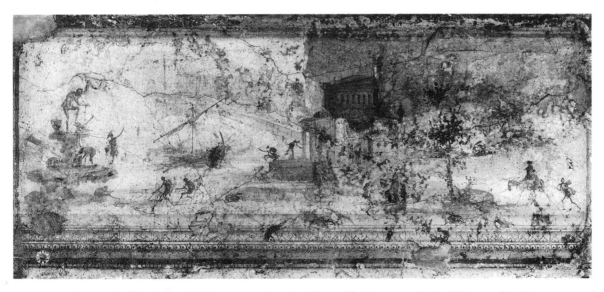

151 Landscape with villa and fishing harbour. Rome, Farnesina villa, corridor F. *c.* 20 B.C. National Museum of the Terme 1233.

153 Detail of sacro-idyllic landscape. Boscotrecase villa, red room (16), east wall. Soon after
11 B.C. Naples, Archaeological Museum.

do not seem to have enjoyed great favour in the Third Style.
One or two examples are known from old drawings, and
simple vignettes using the same vocabulary, chiefly on a
white ground, are preserved in a few modest houses; but,
by and large, genre landscapes were eclipsed by mythologi-
cal ones. In this respect the artistic strain represented by
the third ('mythological') room at Boscotrecase was more
successful than that contained in the red and black rooms.
The influence of genre landscapes is to be measured, rather,
in the extent to which their motifs – sacred pillars and other
kinds of rural shrines, herdsmen and their animals,
fishermen, wayfareres, villas and porticoes – permeated the
settings of the mythological series.

Towards the end of the Third Style, however, a new
species comes to the fore: the villa landscape. Though villas
had been one of the elements in the landscapes of the
Augustan period, they had normally shared the stage with
religious buildings and monuments and with all the varied
folk of the countryside; moreover, they had usually con-
formed to a traditional Mediterranean type of country
house, irregular in form and often equipped with a tower
and small garden. The villas of the new landscapes appear
alone, all the figures present can be identified as residents
and staff of the establishment, and the architectural types
reflect the new luxury of contemporary Italy. Typical are
grand colonnaded façades, often symmetrical in form,
overlooking gardens or waterfronts. Behind them rise
wooded parks scattered with further buildings. Two fine

examples in squarish panels have been combined in a single frame in Naples Museum (inventory number 9406) [154]. Though their provenance and function are unknown, similar examples are to be found in the side fields of surviving decorations. Such are the little villa landscapes attached to candelabra in the *tablinum* of the House of Lucretius Fronto at Pompeii (cf. [Pl. VI]). Here only one of the four panels shows a symmetrical façade fronting a formal garden [Pl. XIIA]; the rest feature irregular buildings or groups of buildings along a lakeside or a sea-front, with bystanders and boatloads of fishermen adding a human interest.

An interesting feature of all the villa landscapes is the realistic treatment of both space and colour. The perspective of the buildings is sufficiently consistent for us to reconstruct plans and elevations, while their setting in the landscape is almost wholly convincing, with a firm distinction drawn between earth and sky, the former brown and green and the latter pale blue. The spatial ambiguities of the Farnesina and Boscotrecase paintings have been replaced by a totally matter-of-fact approach; the artist leaves no doubt that these landscapes are real, not idealised. Some of the forms represented can, in fact, be closely paralleled in surviving villas of the late Republic and early Empire. One of the two villas represented in Naples 9406 is almost a carbon copy, apart from the fall in ground level in the foreground, of the north front of Oplontis, while the oblique wings of the other call to mind the great five-sided recess in the façade of Nero's Golden House.

Similar paintings continue into the Fourth Style, though

154 Villa landscapes, from Pompeii. Second quarter of 1st century A.D. Naples, Archaeological Museum 9406. H. 22 cm.

155 Lakeside or seaside villa landscape, from Stabiae. Third quarter of 1st century A.D. Naples, Archaeological Museum 9480. H. 16 cm.

rendered in a more sketchy, often impressionistic technique. The normal format is small square panels or horizontal oblongs, or occasionally tondi, set in the fields of the main zone. A couple of well-known pieces from Stabiae, now in Naples, are typical of the period. They each show lakeside or seaside villas, one a double-storeyed, three-winged structure with statues along the water's edge, the other a loosely grouped series of buildings set behind a quay which several times changes direction [155]. Figures of passers-by, including a mother and child, and a boatman with a grappling hook, are represented in quick strokes of light and dark.

Occasionally the interest of the painter extends beyond the representation of contemporary villas to the depiction of harbour towns (another subject favoured by Studius). A small square panel from Stabiae, in the same style as the two villa paintings just described, presents a fine sketch of a harbour which may well have been that of Puteoli [Pl. XIIB]. The buildings are spread out in bird's-eye perspective, but distance is suggested by reductions in scale and the use of lighter, hazier colouring. In the foreground rocks, boats, buildings and statues are vigorously conveyed by

strokes of white and brown. The water is a bright blue, and white scribbles suggest the sunlight dancing on it.

The Fourth Style sees a revival of interest in other kinds of landscape too, including sacro-idyllic and Egyptianising, for both of which romantic, dream-like colours and atmospheric effects remained appropriate. Generally speaking, landscape paintings were common in this period but tended to be confined to subsidiary roles. Small, impressionistic panels were especially favoured for secondary rooms, where they could be used to evoke a picture-display without the trouble and expense of mythological paintings. They are featured for example in corridors and service-rooms in the Golden House. The quality of the work seems often to have been a matter of indifference to artist and patron alike, and many pieces are largely meaningless daubs. Others, however, exploited the sketchy style to produce a pleasing and surprisingly modern impression of light and movement [156].

In gardens, however, we frequently find various sorts of landscape compositions enlarged to fill whole walls, or large parts of walls; and here naturally the treatment is more careful. Of the 'realistic' type is a vast villa-cum-

156 Impressionistic landscape with buildings and people. Rome, Golden House, room 114 (north wall). Between A.D. 64 and 68.

157 Egyptianising landscape. Pompeii I 6, 15 (House of the Ceii), garden (east wall). Third quarter of 1st century A.D.

harbour scene in the House of the Small Fountain at Pompeii. Of the Egyptianising type is a fine composition in the House of the Ceii [157]. Here the Egyptian flavour is provided by a pair of palm-trees, a statue of a sphinx on top of a column, an altar with horn-like projections at the corners, and a small temple and four-column pavilion with segmental roofs – buildings which have close parallels on the Palestrina mosaic. But, as in earlier paintings, the scenery is not exclusively Egyptian; the steep stack of rocks at the near right shore of the river is out of character with the geography of the Nile.

To sum up: landscape painting as an art form in its own right is one of the original contributions of the Roman age. As such, it can be regarded as the forerunner of one of the most popular of subjects in the painting of recent centuries. But there is an essential difference from much modern landscape art, especially that of northern Europe: the human element, whether in the form of figures or in that of buildings, is always an essential ingredient, even the dominant

ingredient. Trees tend to be grouped with buildings, often hidden behind them; rocks serve merely as platforms for shrines or statues; water seems to be introduced almost as an excuse for representations of boats or fishermen or people on bridges. There is no interest in representing natural features for their own sake, to show the loneliness and vastness of the wilds. Studius then is the ancestor of Claude Lorrain rather than Turner. The type of landscape which he and his contemporaries evolved, whether it was intended to invoke the magic of the East, the romance of rustic idylls or the luxury of contemporary villas, was always focused upon man and his works.

Gardens

Representations of gardens are a further area in which artists of the Roman age made important contributions. The first, and finest, example is the so-called Garden Room in the Villa of Livia at Primaporta, just north of Rome,

158 Garden paintings, from Villa of Livia at Primaporta (north wall). *c.* 20 B.C. Rome, National Museum of the Terme. H. 2.00 m

the paintings of which have been removed to the Terme Museum [158]. Built and decorated some time round 20 B.C., this partially subterranean chamber, nearly 12 m. long and nearly 6 m. wide, was turned entirely into a kind of open-sided pavilion set in a paradise forest. In flagrant contravention of the traditions of the Second Style all structural supports have been dispensed with, even at the angles; along the tops of the walls, however, runs an irregular rocky fringe, suggesting the mouth of a grotto. The occupants of what was perhaps a cool dining-room for summer use were clearly intended to feel themselves transported into the open air.

The fictive garden presents no great vistas of depth. In the foreground runs a low wicker fence, and behind it a stone balustrade recessed at intervals to accommodate an isolated bush or tree; in the forest proper there is a foreground plane of more carefully and sharply painted trees and shrubs, but beyond this the background is blotted out by an impenetrable mass of light, bluish green foliage. Only the band of sky at the top concedes a greater sense of space. What is chiefly remarkable in the paintings is the accuracy of the representation of individual species. Not only the plants, with their flowers and fruit, but also the birds which perch here and there upon the branches or on the ground, are depicted with almost scientific precision. Among the species of trees and shrubs which have been identified are spruce, oak, pine, cypress, palm, pomegranate, quince, oleander, laurel, myrtle, box and viburnum; among the flowers and small plants are roses, poppies, periwinkles,

chrysanthemums, daisies, violets, ivy, iris, ferns and acanthus; among the birds are pigeons, quails, blackbirds, thrushes, orioles, warblers, jays, magpies, nightingales, buntings and sparrows. Interestingly, the flowers and fruit of all seasons appear together. The painter, like the sculptor of the garlands carved on the enclosure walls of the slightly later Ara Pacis, was less concerned with strict fidelity to the laws of nature than with reproducing the flora and fauna of the garden in their most familiar and characteristic forms. Whether the resulting paradisiacal effect was deliberate or not is debatable; but such an effect would neatly mirror the emphasis upon the new golden age and the fertility of Italy in contemporary court poetry.

There is no clear evidence for any pre-existing tradition of garden painting. Decorations like that from Primaporta, in which all structural elements are removed, seem barely conceivable in the context of the First and early Second Styles; only with the loosening of the shackles of architectural compositions in the later years of the Second Style is it feasible for the whole wall to be surrendered to organic forms. Previously the nearest thing to a painted forest – the decoration of an *exedra* in the House of the Menander at Pompeii – was organised in terms of a typical Second Style framework, the trees being glimpsed through arched openings and a fictive colonnade. Another sequence of trees containing birds is known to have decorated an Augustan tomb in Rome, but it is difficult to be sure whether this example, for which there is a parallel in a late Hellenistic or early Imperial tomb-chamber in one of the cemeteries

at Alexandria, belongs to the mainstream tradition: the trees were depicted singly, and were intended (as an epigram makes clear) to perform a specific sepulchral function – to provide a kind of Elysian enchantment round the last resting-place of the deceased. The representations were here symbolic, whereas Livia's garden was illusionistic, designed to delight and dazzle the senses of the living.

Painted gardens enjoyed a great vogue during the Third and Fourth Styles. Two fine Third Style examples survive in the House of the Orchard at Pompeii, employed unusually for the decoration of small bedrooms. In accordance with the spirit of the new style, the representation of trees is flatter and harder than in Livia's villa, and an ornamental

framework of slender white columns imposes a conventional tripartite division upon each wall. In the more naturalistically painted garden of room 8 [Pl. XIIIA], a dense shrubbery rises above a fence, as at Primaporta, and the upper part of the wall is light blue, suggesting the sky. But there is no hint of depth: the artist concentrates on ornamental trappings, some of which introduce a note of unreality. The fence is totally two-dimensional, and the shrubs appear to grow on top of it rather than behind it; the shrubbery contains Egyptianising statues and pillars supporting small Dionysiac panel-paintings, both again seeming to rest on the fence; the flimsy architrave above the dividing columns acts as a ledge for vases, further

159 Pompeii I 9, 5 (House of the Orchard). Black bedroom (12), east wall. *c.* A.D. 40–50.

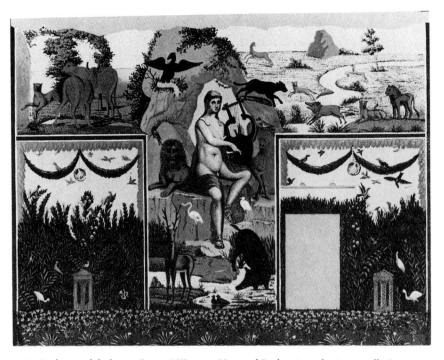

160 Orpheus and the beasts. Pompeii VI 14, 20 (House of Orpheus), garden (west wall). Between *c*. A.D. 50 and 62?

picture-panels and perching birds; and a chain of garlands and hanging ornaments is suspended from the top of the wall. In room 12 [159; Pl. XIIIB] the representation is even less realistic, because the trees and shrubs stand out in negative on a black ground, each isolated and reduced almost to an abstract pattern.

While these examples suggest, however conventionally, that the room is enclosed by the garden, another Third Style fashion takes the garden as a whole, viewed in perspective from a distance, and treats it as a movable motif to be used in various parts of the decorative scheme, generally on a black ground. It forms a kind of vignette, framed by fences and containing (if space permits) a suggestion of pathways, shrubs and pavilions. The layout is formal, no doubt reflecting the patterns of contemporary horticulture. Although the regular place for these vignettes is in the predella, examples occur also in the central panel of the main zone and in the dado. Particularly striking is the version in the dado of the *tablinum* of Lucretius Fronto [Pl. VIA]. Its comparatively large scale and perspectival recession fit ill with the miniaturism and two-dimensionality of the rest of the decoration; the motif was clearly so well established that such conflicts no longer worried the painter.

By the time of the Fourth Style the most popular role of the painted garden was as a means of enlarging space in an actual garden. Walls were painted with shrubberies and orchards which gave the illusion that the vegetation continued beyond the planted area. At the same time the furnishings and livestock represented became more numerous and exotic, reflecting both the florid taste of the period and a specific desire to make the garden appear more luxurious. Favourite items were marble fountain basins of various forms (often set in semi-circular recesses in the enclosure fence), decorative statues, herons and peacocks. The integration of the illusion and the reality is vividly demonstrated by painted fountains which seem to spill their contents into real gutters in the pavement. At times, however, the images become more confused, appearing in juxtapositon with other themes, such as the familiar animal landscapes [89]. On the back wall of the garden in the House of Orpheus at Pompeii [160] the garden scenes, overloaded with birds and other embellishments, are set in two large panels which might at first sight appear to be openings through the wall; but the spaces between and above them are filled by a big composition of Orpheus charming the wild beasts, itself suggestive of a world beyond the wall. In the House of Venus two garden pictures flank a huge panel representing Venus reclining on a shell, the whole ensemble being set behind a continuous painted fence, which passes in turn behind a statue of Mars and a magnificent marble fountain. In the House of the Amazons a wooded garden containing a shrine of Egyptian deities is surmounted by three island villas viewed in a distant sea [161]. In these cases the painted shrubbery has become just one ingredient in a grand farrago of themes with which

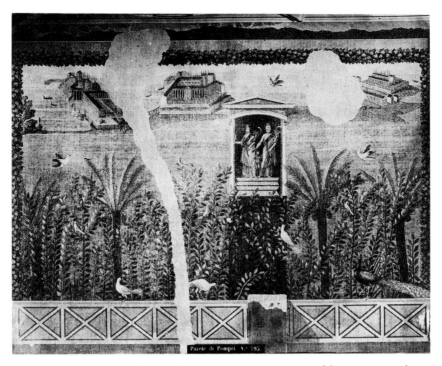

161 Garden with shrine of Egyptian deities. Pompeii VI 2, 14 (House of the Amazons), garden (east wall). Third quarter of 1st century A.D.

householders sought not just to expand their tiny *viridaria* but also to transform them into wonderful environments to enchant and impress their visitors.

Still life

The Roman paintings classed, for want of a better term, as 'still lifes' include a relatively broad range of subjects. A large number feature items of food, such as fruit, fish, trussed animals and game-birds; other themes are writing implements, religious objects, the paraphernalia of athletics, theatrical masks and so forth. There are also combinations of items of different types, such as food with silver vessels, writing equipment and materials with piles of money, animals with torches and sacrificial fillets, a calf's head with a knife. Most groupings are logical (the writing implements and money, for example, are united by the common theme of banking), but sometimes the assemblages of objects are so heterogeneous as to appear random; thus one picture contains a large leaf or plate piled with dates and figs, a little bag or purse covered with writing, a torch and a pair of sacrificial fillets – objects whose connection is far from clear. In such cases the painter was evidently more interested in achieving interesting effects of colour, texture and composition than in unity of content.

What primarily distinguishes the Roman paintings from modern still lifes is the frequent inclusion of living creatures. Some of those in food-paintings are clearly

intended for the cooking-pot, whether they are already trussed or not; but others are equally clearly scavengers (rabbits nibbling, or birds pecking, at fruit) or simple intruders (a strutting peacock with figs, dates and almonds; a goat with bundles of asparagus spears and baskets of cheese; a water-fowl with a flask of water and a pair of objects of uncertain identity, perhaps edible bivalves [162]). From here it was a small step to paintings in which living creatures are the central theme: a favourite subject, interchangeable with 'still life' proper, is a bird or birds pecking grapes, cherries or pears, sometimes from an overturned basket. In association with other kinds of objects the birds or animals have different meanings. Groups of cocks combined with palm-branches, prize-vases and other symbols of victory are presumably the victorious and vanquished contenders of cock-fights. An eagle with a globe, a sceptre and a thunderbolt betokens the world of Jupiter [163], and an owl with a pair of shields, a spear and a helmet that of Minerva. A panther with attributes of Bacchus and a goat with a further set of attributes of Minerva are equally understandable (the goat is the source of Minerva's breastplate, the *aegis*).

This wide range of subjects is doubtless a development of Roman times, but the beginnings of certain types of still life can be traced back to the Hellenistic period. Food-paintings in particular are known to have started early. Among the subjects credited by Pliny to the Greek painter Piraeicus, disparagingly nicknamed 'Rhyparographos'

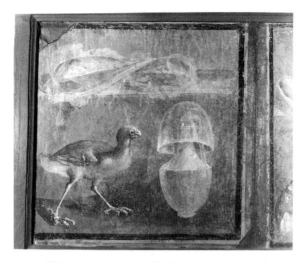

162 Still life with water-fowl and flask of water, from Herculaneum. Third quarter of 1st century A.D. Naples, Archaeological Museum 8644. H. 41 cm.

163 Attributes of Jupiter. Pompeii I 7, 10–11 (House of the Ephebe), room 9 (east wall). Third quarter of 1st century A.D.

('painter of sordid subjects'), were *obsonia*, literally 'prepared food'. Though Piraeicus's date is uncertain, the context suggests the Hellenistic age. We also hear from Vitruvius about the existence of *xenia* ('guest-gifts'), a class of paintings which depicted the provisions which Greek hosts supplied to visitors on self-catering holidays – poultry, eggs, vegetables, fruit and the like. The idea of using food as a subject for painting is an aspect of the general diversification and 'trivialisation' of art in Hellenistic times. Analogous manifestations appear in other media: representations of fish on the red-figure fish-plates produced in Athens and southern Italy during the fourth and early third centuries, and more especially the famous Pergamene mosaic pavement by Sosus (late third or second century) whose design was based on litter from the dining-

table. Surviving copies of this last show an even scattering of bones, shells, discarded fruit and other refuse, and one of them includes a live mouse gnawing a nut – perhaps, if it belonged to the original, a precursor of the scavengers in Pompeian still lifes. At the centre of the pavement was the panel with doves on a bowl (p. 7), which was also influential in the Roman period, and which may have indirectly inspired another motif sometimes found in still lifes – a bird pulling a fillet or ribbon from a basket or a box.

The foundations of still-life painting were therefore laid in the Hellenistic age. In Roman wall-paintings the new genre was adapted to a variety of decorative roles and presented in a variety of forms, though not surprisingly it never gained the popularity and importance of mythological or landscape pictures. In the Second Style its first appearance was in the shuttered panels which simulated real pictures displayed upon the cornices of the architectural scheme: of those in the House of the Cryptoportico at Pompeii the two best preserved show respectively a cock with a basket of fruit covered by a napkin [Pl. XB] and some kind of goose or wading-bird with bunches of grapes, a basket of dates and figs and an overturned basket of vegetables. Such pictures were no doubt precisely the *xenia* mentioned by Vitruvius. Second Style painters also, however, revealed their inventiveness by taking motifs out of the pictures and deploying them freely amid the architecture; thus dead game and fish are hung on the walls [32], bunches of grapes lie on the floor, and baskets or bowls of fruit rest on ledges. Particularly fine are the glass bowls containing golden quinces and blue and purple plums in the decorations of Oplontis [25] and Boscoreale. In a similar vein we find the architecture visited by occasional birds and strewn with inanimate objects, such as torches, cult-implements, bronze vases and, of course, masks [Pl. III; 25–7, 32–4].

The first independent still-life compositions to have survived (that is, the first compositions which do not purport to be imitations of displayed panels) are those of the Farnesina villa. Here in the white corridor F–G the landscape panels already mentioned (p. 143) alternate with assemblages of objects of a mainly Bacchic nature [164]. Theatrical masks of satyric type, represented both frontally and in profile or three-quarters views, are accompanied by a variety of subsidiary motifs: *peda*, tambourines, baskets of fruit (one with a bird perched on the handle), drinking-horns, torches, a *syrinx*, an ox-skull, a ritual box, a glass bowl containing a pair of perfume-bottles. Like the landscape panels, these paintings are set against a neutral white ground; but their structure is much looser, since a unified setting and perspective are lacking; instead, the objects appear scattered throughout the picture-field, with only the barest hint of blocks or shelves to explain their different levels.

In the Third Style, following the Farnesina example, the

164 Still life with Bacchic objects, from Farnesina villa, corridor G. *c.* 20 B.C. National Museum of the Terme 1231.

165 Silver vessels (athletics prizes?). Pompeii I 6, 15 (House of the Ceii), bedroom *c*, west wall. Second quarter of 1st century A.D.

166 Still life with gazelles, basket and goose. Pompeii VI 9, 6 (House of the Dioscuri), peristyle.
Third quarter of 1st century A.D. H. 46 cm.

normal position for still-life groupings was in the panels of a frieze, whether the conventional frieze at the top of the main zone, or the newly introduced predella. The composition was typical of this style, lacking all suggestion of depth and setting: the objects were drawn on a tiny scale and strung out in a well-spaced row on a fine ground line against a background of black or purple or yellow. In the *triclinium* in the House of Spurius Mesor at Pompeii [Pl. VA] the frieze proper contained a pecking goose, a basket of fruit, a *sistrum* (rattle used in the worship of Isis) and a glass unguent-jar, all on a black ground, and the predella birds and fruit on a purple ground and athletics equipment and prizes on yellow. In a bedroom of the House of the Ceii there is a frieze with birds and fruit on a black ground and silver vessels on yellow [165]. In each case the miniaturism and isolation of the elements reduces the composition almost to the status of an ornamental pattern.

Only at the end of the Third Style do single panels with irregular groupings and naturalistic settings reappear. Two specimens in the *tablinum* of the House of Lucretius Fronto [Pl. VIA], one centrally placed in the upper zone of each

wall, show varieties of fish, rendered in the characteristic firm and clear manner of the period, but now arranged at different levels and against a well-defined backdrop – a wall with a window in it. Some of the fish hang from nails in the wall, others rest on the ground, still others lie on the window-sill or tumble from a basket which has overturned there. The spacing is deliberately made inconsistent to produce the appearance of random distribution.

These principles of composition are continued in the Fourth Style, though combined with that style's more illusionistic, painterly treatment. Still-life pictures now enjoy something of a heyday, occurring in a variety of positions. Most common are panels set at the bottom of architectural *Durchblicke* or at the centre of the main coloured fields. In the House of the Vettii we see small pictures of both kinds: little flat food-paintings in the *Durchblicke* of the Ixion Room, further food-paintings and collections of attributes of gods in the black fields of the peristyle, fighting-cocks and prizes·in the yellow fields of the *alae*, and attributes of Mercury in the black fields of the vestibule. Grander panels appear in the *Durchblicke* of the

peristyle of the House of the Dioscuri. Each about 50 cm. square and represented as a *pinax* with open shutters, they contained fruit, dead game and live creatures arranged on two levels: for example birds pecking figs at the top and a dead bird and a basket of figs below. The upper level is nominally created by raising the background objects or creatures on a step, but because there are no consistent differences in scale or in clarity of rendering the result looks like a couple of separate compartments. In the best preserved panel [166] the compartmentalised effect is reinforced by the division of the face of the step into light and dark sections designed to throw the foreground items – a basket of fruit and a white goose – into sharper relief. With the trussed kids on the shelf of the background the picture acquires a total of three compartments.

The finest still-life paintings of the Fourth Style are now in Naples Museum, removed from the walls of Pompeii and Herculaneum because they particularly appealed to the taste of the eighteenth and nineteenth centuries. The use of steps or shelves to place objects at different levels is a regular expedient. One of a series of large panels from a frieze in the House of Julia Felix at Pompeii [167] shows a glass bowl containing apples, pears and raisin grapes on a step at the left and a pottery bowl full of more grapes at the right; a tilted wine-jar is visible in the background. Another panel combines pewter vessels and a plate of eggs on a step, with dead thrushes and a napkin hanging from a wall. A picture from Herculaneum contains green peaches, one cut in half, on a step at the rear and a beaker half-full of water at the front. Another favourite device, prefigured in the House of Lucretius Fronto, is the setting of objects in a window recess. In a panel from Herculaneum there is a window at the right with an apple on the sill; below it a rabbit is nibbling at a bunch of grapes, and to the left a dead partridge hangs from a ring fixed to the wall.

Each of these pictures is rendered with a loving attention to colour and texture. The gold and brown of apples and grapes, the dull bluish grey of pewter, the opaquity of objects seen through glass containers, and the shimmering highlights on fruit, metal and glass alike – all betray the artist's relish for his task, as well as his intention to appeal to the senses of the viewer. Not till the Dutch still lifes of the seventeenth and eighteenth centuries were the aesthetic qualities of food and inanimate objects so effectively recaptured in painting.

Portraits

Portraits in the round were no rare sight in well-appointed houses. The keeping of ancestral portraits in the *atrium*, whether in the form of wax masks, sculptured busts or *clipeatae imagines* (heads embossed on metal shields), is a well-documented practice connected with family religion; and busts of famous figures, whether poets, philosophers, statesmen or members of the imperial family, could be displayed in various parts of the house. But portraits in wall-paintings are unusual. *Clipeatae imagines* are sometimes represented as objects within fictive architecture [168]

167 Still life with bowls of fruit and wine-jar, from Pompeii II 4, 3 (property of Julia Felix), *triclinium* west of garden. Third quarter of 1st century A.D. Naples, Archaeological Museum 8611. H. 74 cm.

168 Third Style architecture with *clipeatae imagines*. Pompeii I 9, 1 (House of the Beautiful Impluvium), *tablinum*. Second quarter of 1st century A.D.

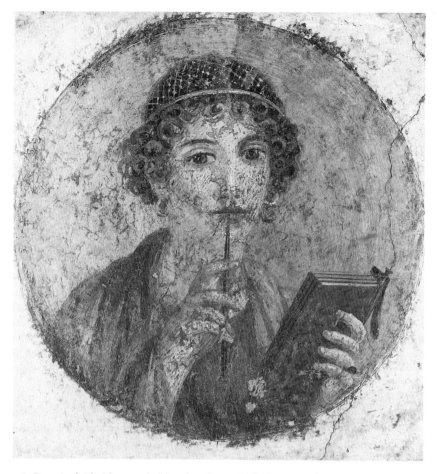

169 Portrait of girl with pen and tablets, from Pompeii. Third quarter of 1st century A.D. Naples, Archaeological Museum 9084. D. 29 cm.

(most of them significantly in the decorations of *atria*), but as such they were always very small and usually set at an oblique angle, with no real attempt being made to equip them with distinctive physiognomies: they were merely part of the general show of aristocratic luxury with which householders liked to surround themselves. For portraits in their own right there was little place in wall-decoration: mythological and allegorical subjects dominated the figured repertory.

Those portraits which do occur can be divided into two classes: contemporary and historical. Of the first category the few known examples take the form of busts, and all derive from modest decorations of the later years of Pompeii. Busts, either single or paired, are a favourite motif from the late Third Style onwards (pp. 58, 60, 80), appearing in small panels at the centre of fields of the main zone and especially in roundels in the side fields. The majority of them represent deities [Pl. XIVA], personifications or mythical characters such as satyrs and bacchantes; but some almost certainly portray contemporary

personages (busts in tondi can, indeed, be understood as a debased form of clipeate portraits). A well-known picture of a young woman holding writing tablets in her left hand and a pen to her lips [169] is a case in point: the gold hair-net that she wears and the tight curls which emerge from it are both fashions of the well-to-do ladies of the Neronian and early Flavian periods, and the pen and tablets seem to be a conventional statement of a good education. Whether the actual features were conveyed with any great realism, however, may be doubted, since the face has the same rather bland form of classicising beauty which characterises many of the portrait-statues and busts of late Republican and early Imperial ladies.

The tondo containing this portrait was balanced, in the corresponding position in the other half of its wall, by a tondo with the bust of a male figure holding a scroll. He wears an ivy-wreath and could be a poet, but his individual features and the fact that he is a pendant to the female suggest otherwise. A famous square panel from Pompeii VII 2, 6 [170] combines the types of the woman with pen and

tablets and the man with scroll in a single composition. Here the features are strongly individualised; the man, in particular, with his wispy beard and moustache, full lips and slightly shifty expression, presents a clearly defined personality. His physiognomical counterparts can be met in any modern town in southern Italy. The couple, shown in an intimate study, the man protectively behind the woman's shoulder, are certainly man and wife, and presumably members of the family which had the house decorated in the last years of the city. The scroll held by the man has been identified as the marriage-contract but, by analogy with the woman's pen and tablets, may rather be a conventional symbol of learning: scrolls held by male figures in tondi in another Pompeian house are labelled as works of Homer and Plato.

Most of the supposed tondo-portraits from Pompeii have, like the representations of *clipeatae imagines*, turned up in the *atrium* or in adjoining rooms, especially the *tablinum* and the *alae*, the traditional showplaces for ancestral portraits and masks. But their status as portraits is often uncertain. In some cases all distinctive attributes are lacking; in others unexpected attributes are present, such as a spear and a sword for the man in what appears to be a married couple; and in still others there are companion tondi which show obviously mythical figures, such as satyrs and bacchantes. Although the faces have portrait-like features, the subjects may in such cases be unidentifiable figures from mythology or perhaps no specific personages at all – merely decorative busts in the guise of portraits.

The portraits of historical personages feature mainly famous Greek writers and philosophers. The seated Menander in the Pompeian house named after it [Pl. XIVB] is the best-known example. His identity is revealed by a label painted beneath his throne and by a tag (beginning 'Menander: he was the first to write New Comedy...') on the open scroll which he holds in his left hand; he also wears an ivy-wreath, an appropriate emblem for a dramatic poet, while next to him, on the adjacent wall, is a group of three comic masks. The features of Menander are sketchily indicated and bear no strong resemblance to the authenticated portraits in bronze and stone: for patron and painter it was sufficient to give the poet's name and attributes; close adherence to the facial features as handed down in the artistic tradition was of secondary importance. The portrait is on the right side of an *exedra*, and a bearded figure on the left wall, characterised as a tragic poet by the adjacent masks, was probably Euripides; only the incised guidelines used by the painter remain to indicate the figure's general form. The central field of the back wall was perhaps occupied by a painting of Bacchus, the patron of drama, or by the Muses of Tragedy and Comedy.

All in all, portraiture remained a minor motif in wall-painting. The themes of mural decoration were predominantly those of myth or romance; where more matter-of-fact subjects such as still life or genre scenes (see below)

were admitted, they were rarely documentary in a true sense. The kind of factual recording favoured in Roman portraits, whether painted or carved, was alien to the wall-painting tradition. Similarly, the historical personages represented in the murals were Greek, not Roman, reflecting the overwhelming grip of Hellenistic culture upon contemporary taste.

Genre scenes

There are several paintings, generally from friezes or from small panels at the centre of the wall, but sometimes painted 'free-style' on the façades of shops and the like, which can be loosely grouped under the heading of genre scenes. Some, such as the anecdotal frieze in the Farnesina black *triclinium* and a number of scenes from comic drama, evidently go back to Hellenistic models. The precise subject of the Farnesina frieze is uncertain, but a plausible theory sees it as a series of famous judgements delivered by a wise king, perhaps the Egyptian pharaoh Bocchoris (720–715 B.C.); the component scenes, rendered in a lively, spontaneous style and with the same bright colours as the landscapes in the fields below, each contain from ten to fourteen figures and illustrate both the criminal act and the judgement, with the king seated on a throne amid his bodyguards. Comedy subjects are known to have been painted by Hellenistic artists (for instance a certain Calates), and an early echo of their influence in Italy is the pair of mosaic panels by Dioscurides which represented scenes from plays by Menander [235]. One of the two, showing three musicians and a child, is paralleled by a painting from Stabiae [236], which is evidently a later (Third Style) and less able copy of the same Greek original. Further, similar copies of 'comicae tabellae' appear in the late Third Style decoration of the *atrium* of the House of the Theatrical Panels at Pompeii. In one [171] an old slave is delivering an animated discourse while making the gesture of 'the horns' (to avert evil) towards a girl who clasps her hands in dismay and is comforted, or restrained, by a youth; in another a bald old man is seated and listening to the declamation of a young man. The same *atrium* contains scenes from tragedy, including one [172] which is thought to come from Euripides' *Madness of Hercules*; it shows an old man and a girl standing at the feet of a bearded figure who reclines with a shepherd's crook in his hand. A fuller version of the same scene in the *atrium* of the House of the Centenary (Fourth Style) adds the figure of Hercules at the left, thus enabling the hypothetical identification of the remaining figures as the hero's human father Amphitryon, his wife Megara and the tyrant Lycus. These and other scenes from Greek drama, datable to the Third and Fourth Styles, and found not only in Pompeii and Stabiae but also in Herculaneum (which has yielded a second copy of the painting of the slave gesturing to the young couple), testify to the existence of a repertory of such compositions avail-

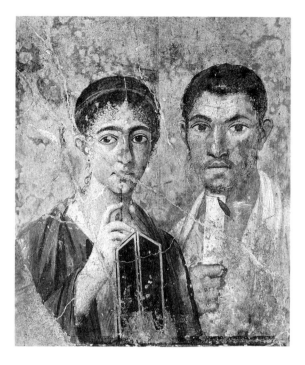

able to Campanian decorators of the first century A.D. (cf. p. 219). All are lively but simple works, with little or no indication of the stage or background, though curiously with cast shadows beside the figures. The masks worn by the actors are carefully depicted to indicate the type of characters that they play.

That there was a vigorous interest in the theatre during the period of the Third and Fourth Styles, at least among a certain educated class of citizens, is corroborated by a number of paintings which, as it were, go backstage. Such are a fine fragment with a seated poet contemplating a mask which is being held up in front of him, and a painting of an actor who has performed the role of a king and sits watching while a woman prepares to dedicate his mask to Bacchus (he has evidently won first prize at a dramatic festival). This last [173], one of a series of Third Style panels found stacked against a wall at Herculaneum pending reuse

170 Portrait of man and wife, from Pompeii VII 2, 6, *exedra* opening off *atrium*. Third quarter of 1st century A.D. Naples, Archaeological Museum 9058. H. 65 cm.

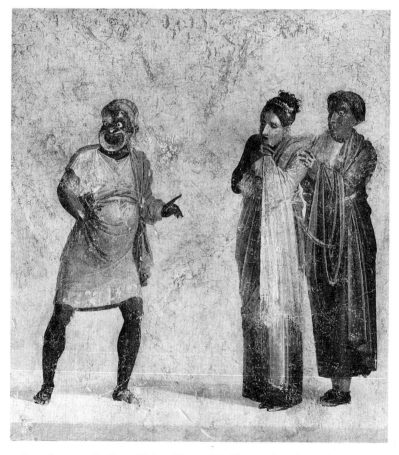

171 Scene from comedy. Pompeii I 6, 11 (House of the Theatrical Panels, or of Casca Longus), *atrium* (east wall). Second quarter of 1st century A.D. H. 52 cm.

172 Scene from Greek tragedy (*Hercules Furens* by Euripides?). Pompeii I 6, 11 (House of the Theatrical Panels, or of Casca Longus), *atrium* (east wall). Second quarter of 1st century A.D. H. 49 cm.

173 Victorious actor ('player king'), from Herculaneum. First quarter of 1st century A.D. ? Naples, Archaeological Museum 9019. H. 39 cm.

174 Ceremony of the cult of Isis, from Herculaneum. Third quarter of 1st century A.D.? Naples, Archaeological Museum 8924. H. 80 cm.

(p. 207), is a marvellously observant and assured piece of work; both the king and another actor disrobing in the background are shown with hair matted from the heat of performing with masks on. Other paintings depict actors being instructed by poets, or (rising above the everyday plane) poets in company with the Muses of Tragedy and Comedy.

A further small class of pictures represents religious ceremonies. The most impressive relate to oriental cults. A good example is a procession of devotees of Cybele on a shop-front at Pompeii, presumably painted late in the life of the city. Others are two Fourth Style panels from Herculaneum depicting ceremonies of the cult of Isis. The entrance stairway of a temple forms the setting, respectively, for a rite involving a priest with a water-vessel [174] and for a sacred dance performed by a figure in a mask. Supporting roles are played by attendants with *sistra*, flowers and further water-jugs, while throngs of worshippers line the steps or appear within the temple doorway. Sacred ibises, palm-trees and statues of sphinxes underscore the Egyptian connection. All this is rendered in a vivid, atmospheric style which bathes the foreground actors in ghostly white light and dissolves the background elements in sombre and indistinct tones, as if they are obscured by a haze of incense.

Though the last two scenes are given an Egyptian setting,

and one suspects that they were inspired by the same intellectual taste which motivated Egyptianising landscapes rather than by any intention of reproducing the ceremonies of a local Isaeum, none the less they belong to a category of documentary art which stands apart from the grand style of religious paintings embodied in the Mysteries frieze. The latter uses the language and many of the types of mythological painting, and incorporates actual deities and mythical personages alongside the human faithful; the two Isiac panels on the other hand represent their subjects in factual terms and in a style which is spontaneous and unfettered by tradition.

A non-academic and non-traditional style is characteristic of many other paintings which clearly relate to everyday life. Almost all date (where they can be dated at all) to the last years of Pompeii. Some are again religious, decorating the domestic shrines of the Lares [175]; they feature great coiling serpents (guardian spirits of the household), figures performing sacrifices, and the tutelary deities of the house and its owner, all rendered in a highly sketchy manner with limited colours and little indication of internal detail (many elements are merely outlined). Others represent craftsmen at work and may be regarded as advertisements for, or simply illustrations of, the business conducted on the premises; thus we see a potter seated at a wheel, fullers treading, brushing and bleaching cloth, and a baker selling loaves to customers in a shop [176]. A frieze of cloth-makers on the front of a Pompeian shop shows three men seated at tables combing wool, four kneading material in wooden troughs to make felt, and one (named Verecundus,

probably the proprietor) holding up a piece of finished cloth for inspection. From the walls of taverns come lively scenes of gaming and drinking. One Pompeian series, arranged in adjacent panels like a comic strip and accompanied by speech 'bubbles' in colloquial Latin, appears to tell the story of a couple of young men having a night out; they are shown first meeting, then being served by a barmaid, then tossing dice at a table, finally quarrelling and being turned out by the landlord. Similar, if a little more modishly painted, are the banqueting scenes, again labelled in Latin, from a dining-room in a house of the fifth region at Pompeii; revellers are depicted with their arms around each other, with cups or drinking-horns in their hands, and even being sick. Finally there are the erotic scenes, in which couples carry out acts of love in a variety of improbable postures. These were designed both as advertisements over the doors to the cubicles in local brothels and as titillation for the occupants of small slave bedrooms in private houses. They are generally little better than unpretentious sketches, faulty in design and crude in colouring.

A remarkable and unique series of paintings from a room in the block owned by Julia Felix apparently represents scenes of daily life in the Pompeian forum. The background is formed by a portico, with garlands slung from column to column. In the foreground we see equestrian statues (one of which is being sketched by an artist), bystanders reading a public notice, street-stalls with tradesmen selling fabrics, shoes, pots, pans and tools [177], people conducting conversations, an old beggar with a dog receiving alms from a lady with a maid, a horse-drawn cart, and a pack-animal

175 Painting from a household shrine, from Pompeii VIII 2 or 3. Third quarter of 1st century A.D.? Naples, Archaeological Museum 8905. H. 1.28 m.

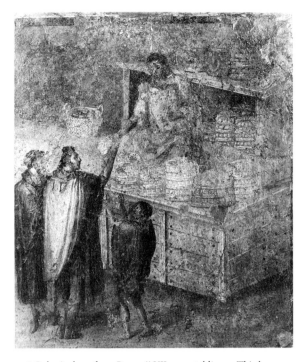

176 Baker's shop, from Pompeii VII 3, 30, *tablinum*. Third quarter of 1st century A.D. Naples, Archaeological Museum 9071. H. 56 cm.

being loaded. There is even a mobile soup-kitchen, not to mention an open-air school where a miscreant pupil is being painfully chastised. All this is rendered predominantly in tones of black, brown and orange, with bold, impressionistic brushwork more suggestive of the late nineteenth than of the first century A.D. Some of the subjects represented are among those credited to Piraeicus ('barbers' shops, and cobblers' stalls, and asses'), but it is difficult to believe that any artist of his period could have matched the freshness and immediacy of these scenes. The style springs, rather, from the sketchy technique of the Roman landscapes discussed at the beginning of the chapter. Many of the nicely observed details call to mind the humour of Studius and his contemporaries.

In sum, the everyday paintings take us almost to the opposite extreme from the traditional Greek style of most of the mythological pictures. Where the latter are often masterpieces of illusionism, fully proficient in the naturalistic rendering of human form, in the handling of light and shade, and in the disposition of figures and objects in space, the former are by comparison naïve and slapdash, with inconsistent proportions, little interest in chiaroscuro, and (at times) a deliberate rejection of spatiality. They represent the undercurrent of so-called 'popular' art which ran alongside the dominant classical style and which later began to supplant it in the rendering of certain imperial themes and

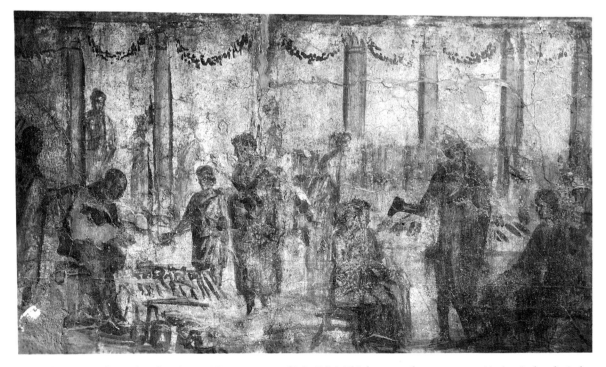

177 Scenes of market traders, from Pompeii II 4, 3 (property of Julia Felix). Third quarter of 1st century A.D. Naples, Archaeological Museum 9069. H. 64 cm.

ideas. In the Pompeian period it was clearly regarded as 'second-best', suitable only for minor subjects in modest decorations or in subsidiary parts of the grander decorations. To us, however, it often seems more attractive and more vital than the tired legacy of the old mythological tradition.

Burlesque

Alongside the vast mass of serious and romantic subjects in Roman painting it comes as a slight surprise to find a number which treat the old themes with obvious irreverence. But burlesques upon mythology are attested already in Greek times, both in works of art and in stage productions. Several vase-paintings (some evidently inspired by the theatre) show the gods and heroes with grotesque faces and in ridiculous situations, whilst in panel-painting Pliny tells us that 'Ctesilochus, a pupil of Apelles, became famous for an impudent picture which showed Jupiter in labour with Bacchus, wearing a bonnet, with the goddesses acting as midwives.'

A striking parallel to this kind of irreverence is offered by a humorous frieze dated to the late Second Style in the baths of the House of the Menander at Pompeii. Set, like the Iliadic scenes in the House of the Cryptoportico [30], between the heads of a series of painted herms, this showed scenes from Greek mythology in which the heroes and gods were represented in the form of dwarfs, with grotesquely enlarged heads and spindly legs. Theseus, round-eyed and beak-nosed like some ridiculous bird, slays the Minotaur, its mouth twisted in a howl of anguish. A hag-like Aphrodite, with the help of Eros (Cupid), promotes the love-affair between Zeus and Europa. An ape-faced Daedalus is egged on by the same love-goddess to enable Pasiphae to gratify her bestial passion. Athena, baby-faced and doll-like, presides over the musical contest between Apollo and Marsyas. The artist clearly enjoyed his task: the scenes are rendered with vivacity and freshness. That they were taken from copy-books, however, is implied by the presence of labels in Greek.

Specifically Roman is the burlesque of the well-known figure composition of Aeneas fleeing from Troy with his father Anchises on his shoulder and his son Ascanius at his heels. Derived from a statue-group set up in Augustus's Forum in Rome, a copy of which was later installed in the building of Eumachia at Pompeii, this composition appeared in a 'straight' version on the façade of the Pompeian shop IX 13, 5, together with a painting of the figure of Romulus which was evidently a companion-piece of the statues in Rome and Eumachia's building; but a less respectful painter at Stabiae gave the figures the heads and tails of dogs and long, pendulous sexual organs, reducing the heroic fugitives, ancestors of the Roman nation, to figures of fun. One senses a certain exasperation with the Virgilian cliché of the 'pious Aeneas'.

The dwarf-like caricatures of the Menander frieze may have owed their inspiration to a genus of pictures known as 'grylli', started by the Hellenistic Alexandrian painter

178 Pygmies hunting, from Pompeii VIII 5, 24 (House of the Doctor). Third quarter of 1st century A.D. Naples, Archaeological Museum 113196. H. 75 cm.

179 Cupids engaged in metal-working. Pompeii VI 15, 1 (House of the Vettii), *œcus* (*q*). Soon after A.D. 62.

Antiphilus. Related figures are used elsewhere in Roman painting for scenes of everyday life and more especially for hunting and fishing adventures in Nilotic settings, where there is evidently some confusion between pathological dwarfs and the pygmies, races of small people known to have lived near the upper reaches of the Nile. Whether this confusion goes back to Hellenistic times is unclear, but the exploits and obscene antics of the tiny tribe with enlarged heads found favour with Roman painters during the period of the late Second Style (in the decoration of a tomb in the Villa Doria Pamphili in Rome, for example) and again in the Fourth Style (numerous garden paintings at Pompeii). To take just one example, the parapet of a peristyle in the House of the Doctor at Pompeii was decorated with a series of 'pygmy' adventures including a banquet beneath an awning and encounters with the standard Nilotic wild game – crocodiles and hippopotami. In a panel from it now in Naples Museum [178] the intrepid huntsmen confront their prey on either side of an Egyptian house-platform similar to those on the Palestrina mosaic. At the left a single pygmy tackles a crocodile with

improvised weapons; on the right another pygmy is riding on a crocodile's back while three colleagues haul the creature in to the shore; and above, a warrior stands on the back of a hippopotamus, seeking to drive a spear into its hide while the monster simultaneously attacks a boatload of his companions, devouring one crewman and tipping the rest into the water. Another scene shows 'pygmies' enacting an episode similar to the biblical Judgement of Solomon. Rather than a direct burlesque upon the Jewish story, this is almost certainly a version of a comparable judgement attributed to an Egyptian king, perhaps the same wise monarch whose rulings formed the subject of the Farnesina cycle. The translation of the figures into 'cartoon characters' demonstrates the same spirit of caricature as the parodies of Greek mythology in the House of the Menander.

A gentler humour is conveyed by those paintings in which infant Cupids and Pysches carry out the business of men and women. The idea of the Cupid as a playful child goes back to the fourth century B.C., and one of its first manifestations seems to have been in pictures of the love-

affairs of martial gods and heroes, where little Cupids struggling with the discarded armour of Mars, Hercules or Alexander symbolised the conquest of great warriors by love (cf. p. 47). Subsequently Cupid–putti became a favourite decorative motif – driving chariots, riding dolphins, carrying plates, musical instruments, the attributes of various gods and so forth. But the first extensive paintings of them as genre figures belong to the Fourth Style. The finest are those in the predella of room *q* in the House of the Vettii [Pls. VIIC, XIVC; 179], where we find whole clans of Cupids and Psyches engaged in such diverse activities as metal-working, perfume-production, fulling, chariot-racing (in the colours of the contemporary circus), wine-selling, and celebrating the festival of Bacchus.

Superbly painted in miniature upon a black ground, these little tableaux achieve their success primarily from subtle parodying of human gestures and human self-importance: note, for example, how an assistant holding a piece of metal on an anvil draws his head back to avoid flying sparks from his colleague's hammer [179], or how an elegant lady uses her forearm to test a sample of perfume while the salesman stands nervously waiting for her verdict [Pl. XIVC]. Such delicate touches run through the whole series. Though similar scenes are common in Roman painting of the period, none is so detailed or finely observed as here; even if he was using schemes taken from pattern-books, the Vettii painter interprets them with freedom and with a sureness of touch which stamp him as an artist of rare ability.

8

The Pompeian Styles in the provinces

As promised in the introduction, we have inevitably concentrated on the paintings from Rome and Campania because of their abundance and good state of preservation. From the rest of Italy during the Pompeian period there are only isolated and often fragmentary remains – too few to add significant information to what can be deduced from the Roman and Campanian material, still less to determine what if any local variations existed. None the less, there is sufficient evidence to suggest that the general pattern of development visible at Pompeii applied to the whole peninsula. For the Second Style we have examples from as far apart as Centuripe and Solunto in Sicily, Sulmona and Ancona on the eastern side of Italy, Sette Finestre near Cosa on the west coast, and Brescia in the Po Valley. The Brescian material, found in excavations conducted below the city's Capitolium between 1956 and 1961, is particularly interesting and well preserved, with motifs including an illusionistic curtain painted on the dado [180], as in some Second Style decorations at Pompeii. That from Solunto, now in Palermo, includes a paratactic scheme of hanging garlands and masks analogous to certain decorations from Boscoreale. For the Third Style there are remains from Solunto again, and from various sites in central and northern Italy. To the Fourth Style may be ascribed material from Verona and Sirmione (on Lake Garda), in both cases with idiosyncratic motifs and arrangements. As in Campania, paintings classifiable in the Pompeian Styles come chiefly from private residences, though at Brescia and Sulmona the Second Style decorations were in religious buildings, and at Urbisaglia in the Marches a Third Style decoration was applied in a cryptoportico underneath a temple precinct.

Scattered remnants from other parts of the Roman Empire show that the decorative modes evolved in Italy were followed sooner or later in the provinces. This is true both of those provinces, especially in the eastern Mediterranean, which already had traditions of plasterwork and painting, and of those provinces, such as Gaul, Germany, Britain and the Danube lands, where no such traditions had ever existed. The transmission of styles was probably effected at an uneven rate, and we shall probably never fully understand the pattern, given the shortage of closely dated material from different regions; but progress would doubtless have been stimulated by public building programmes or by influxes of officials or merchants who brought with them a taste for the amenities to which they had been accustomed at home. Thus, paradoxically, the newly Romanised areas may have been quicker to adopt the latest Roman fashions, and more thoroughly permeated by them once adopted, than were many of the long-established seats

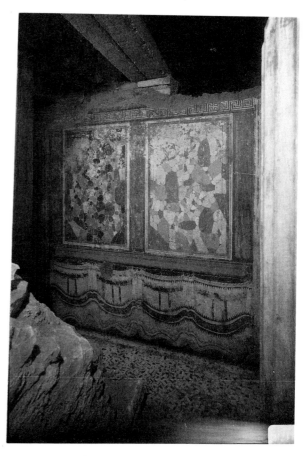

180 Brescia, Republican sanctuary underneath Flavian Capitolium. West chamber, west wall. Soon after 89 B.C.

of Hellenistic culture. Subsequently, as immigrant artists trained native apprentices, and indigenous schools came into being, there was an increasing tendency for different provinces to develop their own local characteristics. The movement of artists and ideas remained sufficiently vigorous, however, to ensure that all variations were within a common framework – that the artistic unity of Roman wall-painting far outweighed any regional diversity.

As in Italy, the bulk of the provincial material comes from the houses and villas of the well-to-do classes, though occasional examples occur in temples and other public buildings. As to the extent to which paintings were employed the limited nature of the evidence permits no firm conclusions, but we may guess that those cities which prospered under Roman rule and were most open to the influence of Roman culture could have boasted as high a concentration of frescoed rooms as Pompeii and Herculaneum. Many rooms were, to be sure, given striped and panelled schemes too simple to be categorised in the Pompeian Styles; but householders with pretensions to a 'civilised' life-style would have afforded at least one dining or reception room with a more elaborate treatment.

The Second Style, the first major phase in which the Hellenistic tradition was left behind, had reached Glanum (Saint-Rémy-de-Provence) in the south of France by the 40s B.C. Of the four houses which have yielded specimens the so-called House of Sulla is the most notable; fragments from a bedroom can be restored to produce a *trompe l'œil* architecture consisting partly of yellow orthostates surmounted by courses of blocks arranged in the regular

isodomic manner, and partly of green orthostates surmounted by an interlocking assemblage of headers, stretchers and soldier blocks (a favourite Pompeian motif); over each ran a continuous cornice carried by swan-necked brackets. The blocks were painted in imitation of *giallo antico*, various other coloured marbles and onyx alabaster.

In the East such evidence as has survived implies a greater reluctance to accept the new fashion. A house at Amphipolis in northern Greece has yielded a simple scheme of dado, orthostates and blockwork articulated by slender pillars; otherwise the only unambiguous examples are in Judaea, where Herod the Great seems to have imported Italian architects and decorators to work on his palaces at Jericho and Masada and his fortress at Herodium between 40 and 15 B.C. At Herodium one decoration, that of the *caldarium* in the baths, presents a display of columns on projecting pedestals reminiscent of the House of the Griffins [21]. At Masada [181] the painted architecture was reduced to little more than orthostates confined, as in the Greek Masonry Style, to the lower parts of the walls; but the bewildering changes of colour and the combination of plain and variegated materials betray the more ornamental spirit of Italy.

There is, however, no hint among the surviving remains in the East of the elaborate plays of projecting and receding elements found in mid to late Second Style paintings in Italy and the West. Indeed a story told by Vitruvius about a certain Apaturius of Alabanda's unsuccessful attempt to introduce them in the council-chamber at Tralles (in Caria, Asia Minor) may reflect a more widespread failure of this

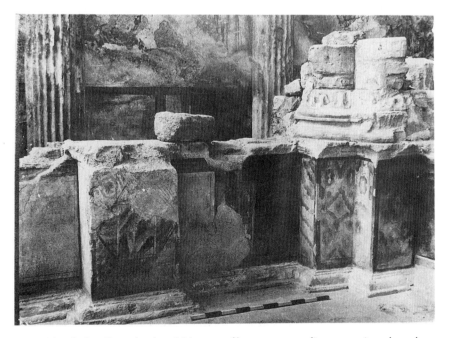

181 Masada (Israel), north palace. Main room of lower terrace, podium supporting colonnade. Between 36 and 30 B.C.

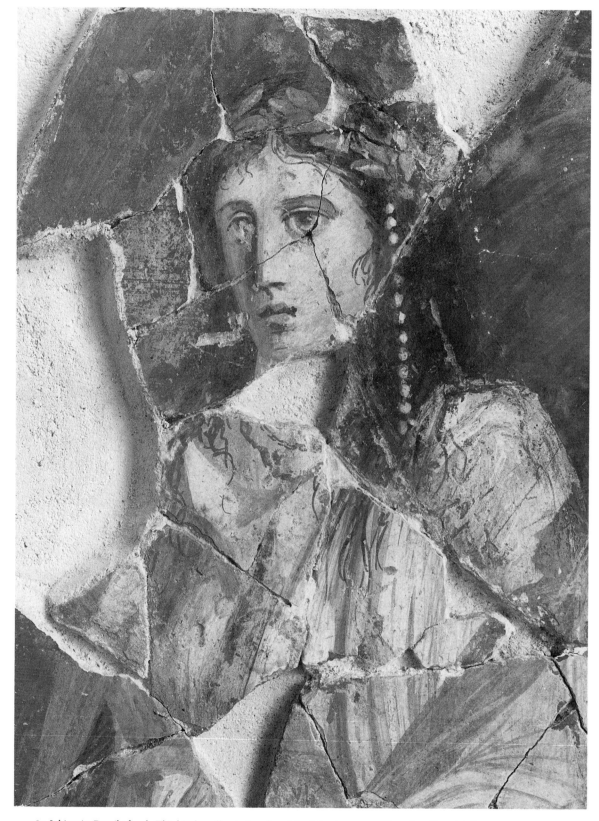

182 Iphigenia. Detail of early Third Style wall-paintings from Magdalensburg, near Klagenfurt (Austria). Late 1st century B.C. or beginning of 1st century A.D. Kärnten, Landesmuseum.

mode to take root in the Hellenistic areas of the Empire. Now, as in later periods, simple panel-schemes and imitation veneer appear to have remained in use in contexts where more elaborate decorations might have been expected; and this could be a symptom of local conservatism – the same conservatism that favoured the retention of polychrome pavement *emblemata* in Syria and the Levant long after they had passed from fashion in the West.

The Third Style too, with its ornamental miniaturism and polychrome fancies, does not seem to have exercised any great appeal in the East. Apart from remains found in a house in Jerusalem and in the sanctuary of Serapis at Alexandria (where the date may be relatively late, because many of the pieces show features of the Fourth Style) there are no known examples south of the Mediterranean or east of the Adriatic. Admittedly the lack of published and dated material makes it difficult to judge how far this situation is due merely to the accidents of survival rather than to a preference for old-established fashions; but the fact that the Third Style paintings at Jerusalem were replaced by a decoration in the manner of the Masonry Style (before the house was destroyed in A.D. 70) hints at the continuing strength of the Hellenistic tradition. In the northern and western provinces, however, there is ample evidence for the success of the new style. Of the material so far discovered in these regions the most remarkable is an early decoration from the Magdalensberg near Klagenfurt in Austria, where

a series of finely drawn figures of Dionysus and heroines from Greek legend [182; Pl. xvA] was painted in pastel colours (notably yellow, pale green and pale purple) on brilliant red grounds. Their restraint and elegance bears comparison with the best work from Rome itself. In the columnar pavilions at the centre of the walls were paintings of subjects unique among surviving Roman pictures: Theseus and Pirithous receiving a lecture from Proserpina (Persephone) in the Underworld, and a thoroughly Theocritean musical contest between two shepherds. The date is securely fixed by archaeological evidence to the middle or later years of Augustus's reign. To the mature Third Style can be ascribed fragments of several decorations in a villa at Commugny on the Lake of Geneva. They include black, red and yellow walls divided either by normal Third Style colonnettes, white with polychrome ornament, or by columns of flowers and fruit growing from wine-cups [Pl. xvB], or by columns decorated with tiny scales in imitation of palm-trunks. The floral and palm-trunk columns, often with little side-shoots at regular intervals, are favourite motifs in the northern and western provinces. Both recur in a decoration at Périgueux in southern France, occupying the black dividing strips between red fields; and the former is used in the red saloon of a house at Avenches (Switzerland), together with various ornamental dividing bands and plaited candelabra painted in white, green, yellow and pale purple [183]. Other favourite motifs

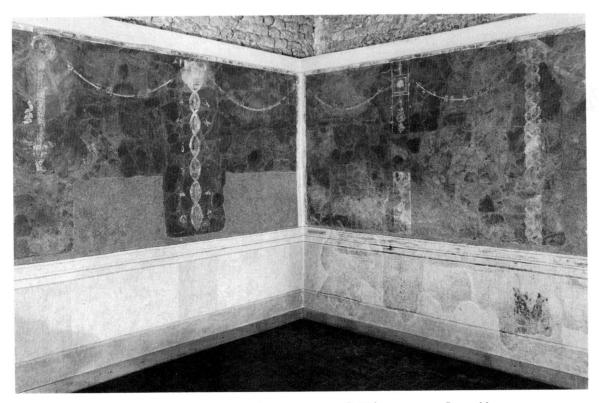

183 Avenches (Switzerland), block 18, red room (reconstructed). Mid 1st century A.D. Roman Museum.

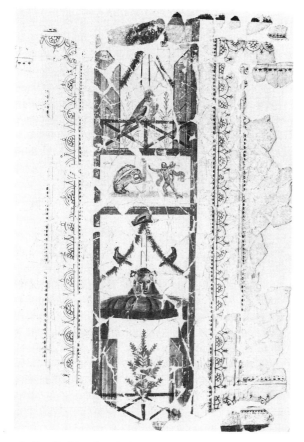

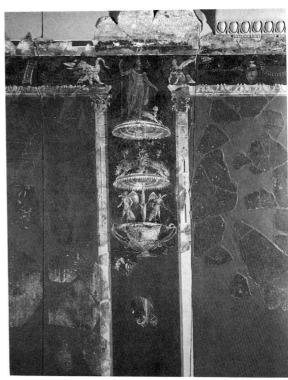

184 Detail of Fourth Style decoration. Narbonne (southern France), from House of the Porticoes, room D. Late 1st century A.D. Archaeological Museum.

186 Candelabrum carrying Sirens, leopards and Bacchus. Cologne, from house south of cathedral. First half of 2nd century A.D. Romano-German Museum.

185 Heron pecking its foot: detail of dado of red and black wall-decoration. Trier (Germany), from house under Imperial Baths. Second half of 1st century A.D. Regional Museum.

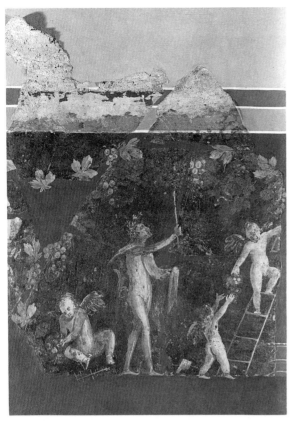

187 Satyr and Cupids conducting the vintage. Cologne, from house south of cathedral. First half of 2nd century A.D. Romano-German Museum.

188 *Petasus* (winged hat), *pelta* and globe, from Astorga (Spain). Early 2nd century A.D. Léon Museum.

of the region are light garlands, tiny white *gorgoneia* in medallions [Pl. XVC], little birds and wine-jars, and knobbly white stripes adorned with alternating hearts and spots in purple and green. All are painted with the Third Style's characteristic delicacy and precision.

The influence of the Fourth Style again seems, on present evidence, to have been stronger in the North and West than in the East. In all areas, however, it appears in diluted form. Elaborate fantasy architecture of Italian type is lacking, and identification depends largely on the presence of the tell-tale embroidery borders. From the East, apart from the Alexandrian fragments already mentioned, the only example is a wall-decoration at Ephesus [Pl. XVD] where red fields were framed by borders containing alternate yellow and white dot-rosettes; at the centre of each field was a carefully painted figure-emblem, evidently belonging to a series of philosophers and Muses (only Socrates and Urania survive). In the northern and western provinces, however, the style is attested at various sites in Gaul and Germany, in Yugoslavia and the Danube provinces, and at Mérida and other sites in Spain. Particularly widespread was a simplified version with plain stripes and bands in place of embroidery borders.

In southern France three rooms of a house at Narbonne had white-ground decorations which illustrate the especially close relationship of Provençal painting to material in Italy. In the most elaborate [184], fields containing flying Cupids were framed by embroidery borders of a standard Pompeian type (stylised palmettes in semi-circles), while the interval between them was occupied by an assortment of favourite Fourth Style motifs – open doorways, a tree viewed over a fence, a theatrical mask resting on a shell canopy, hanging garlands with a shield at the point of suspension, birds perched both on a fence and on garlands. There was also an upper zone containing light pavilions and decorative motifs – a feature otherwise rare in the North and West. Another of the three rooms had a ceiling with a central recessed area decorated, like many comparable ceilings from the last years of Pompeii and Herculaneum (p. 91), with a series of 'boxes' enclosing an octagonal panel. The frames were formed of either embroidery borders or plain stripes, and the repertory of motifs, including a floating maenad in the octagon, is analogous to that of Campania.

Further north, simplified versions of embroidery borders appeared in paintings from a temple and baths at

Ribemont-sur-Ancre (Picardy) and from houses in Trier. In a couple of cases they were incorporated in a type of decorative scheme which was universally popular in the northern and western provinces during the second half of the first century and the early years of the second. This consisted of red fields separated by black intervals containing candelabra; the candelabra varied in detail but were normally punctuated by discs or umbels and the more ornate specimens were enlivened by plant-shoots, birds, animals or mythical figures; the red fields were very frequently enclosed by green bands set between white lines. At the base of the wall there was normally a pink socle spattered with different colours to suggest a marble veneer, and above this came a black predella containing clumps of reeds, wading-birds [185] and sometimes wild animals. Many elements in this formula can be paralleled in the Campanian Fourth Style: several Pompeian dados, for instance, were decorated with plants and birds (cf. [83]), candelabra were often used in dividing strips, and there are examples of schemes of red fields separated by black intervals (notably in the great *oecus* of the House of the Vettii [Pl. VIIC]). But none of the elements enjoyed wide currency in Campania, and they never appeared together, whereas in Gaul, Germany, Spain and the Danube provinces they were almost staple components of all the more pretentious decorations of the period. Only in Britain, to judge from the available evidence, was the formula simplified by the use of austerer candelabra and by the omission of the predella with plants and animals.

The red and black candelabrum scheme occasionally admitted elaboration of detail. From Mercin-et-Vaux (near Soissons, north-east of Paris) and Cologne come decorations in which the red fields were framed by slender columns; and in the former case the architectural frame was developed by the addition of an entablature, a pediment and projecting wings. Particularly fine subsidiary detail was employed in the Cologne paintings [186–7], where the candelabra were populated with heraldic pairs of Sirens, leopards and seated women, while swans, sphinxes, griffins, lyres and vases appeared in a horizontal frieze above the main fields, together with a little panel painted with theatrical masks; in addition, at the top of one candelabrum stood a nude Bacchus with a leopard at his feet, and at the top of another a female figure dressed in pink and white holding a tray of fruit; in the corresponding position at the middle of the wall, still on a black ground, was a scene of a satyr and three Cupids harvesting grapes. Elsewhere in the northern and western provinces the candelabra were transformed or adapted in inventive ways. In the baths at Virunum in Austria they seem to have been replaced by naturalistic foliage bearing flowers and fruits and containing birds and inanimate objects (a *syrinx*, a silver vessel, a mask, a spiralling ribbon). In a villa at Balácapuszta in Hungary they were vegetalised in a different manner, being turned into heavy, formal compositions of balancing pairs of leaves and volutes, all rendered in pale green and white with touches of red. At Astorga (near Léon in northern Spain), besides more or less stylised floral and vegetal forms, we get divine emblems and other objects (Mercury's winged hat, a *pelta*, a vase, Apollo's lyre) stacked on top of one another [188]. This last decoration also presents a unique treatment of the dado, with a frieze of red and blue panels framed by lines of spots and little diagonal plant-sprigs and tenanted by Cupids riding seamonsters. Between each panel was another stylised plant-motif on a black ground. The overloading of detail, the bizarre use of the motifs and the richness of the colouring all bear witness to the anomalies which could be introduced by painters in outlying parts of the Empire.

One area which is at the moment largely blank for the early part of the Imperial age is North Africa. This may be due partly to a lack of excavation and publication of dated material; but one suspects that the prosperity of Africa in the third and fourth centuries and the intensive rebuilding which took place throughout the region at that time must have destroyed much of the earlier evidence. At all events the first paintings which can be examined in any detail, those of Tripolitania, are to be dated no earlier than the beginning of the third century. They will be mentioned in the course of the next chapter (pp. 179, 181).

9

Painting after Pompeii

The Middle Empire

During the second and early third centuries the processes of change which had begun to affect the Roman world during the previous century gained momentum. The old economic pre-eminence of Italy gave way before the development of production in the provinces, and wealth was dispersed more evenly through the Empire. In these circumstances we might expect to find provincial sites showing an increasing richness in painted and other forms of interior decoration, both in public and private buildings. At the same time, with the continuing decline of the old Italian landed aristocracy, the quality and elaboration of the wall-painting seen in the expansive villas and town houses of late Republican and early Imperial Italy might be expected to give place to simpler and less careful work – a process which had already been announced in the last years of Pompeii (pp. 82–4, 99–100).

Developments of this sort can in fact be detected, but the imbalance of the evidence makes generalisations difficult. For the painting of the period the bulk of the evidence comes from Rome and Ostia, neither of which were typical centres. Rome, of course, remained the dominant city of the Empire with a vast cosmopolitan population ranging across every social stratum; its surviving buildings with wall-decorations include the imperial palaces on the Palatine, odd rooms of well-appointed houses in various parts of the city, and numerous chamber-tombs on the outskirts, many of which were constructed by affluent freedmen (the *nouveaux riches* who had already begun to make their mark in the first century). Ostia, the port of Rome, was extensively rebuilt in the early second century after the opening of a major new harbour by Trajan, and its architecture and decorations presumably reflect the contemporary styles of the capital, from which the workmen involved in the programme must have come. Here much of the city has survived as a result of the abandonment of the site in late antiquity and its subsequent burial by sand-dunes. The typical residential building was a four- or five-storey tenement block in which a well-off family occupied the ground floor while the upper floors were divided into a number of small apartments rented out to the 'working'

classes (dockers, warehousemen, clerks and so on). Only the ground-floor units tended to contain paintings or mosaics, and these were often concentrated (or at least the more elaborate decorations were concentrated) in one or two important rooms. Outside Rome and Ostia there are remains of paintings from the imperial villas in the periphery of the capital (Castel Gandolfo and Tivoli). Otherwise, apart from a certain amount of material at Ephesus, where houses built on terraces in the eastern part of the city were buried and preserved by an accumulation of earth, the whole of the Empire has produced only scattered examples, many of them fragmentary; a combination of climatic factors, medieval stone-robbing, modern building development and agricultural activity has destroyed the rest. As in the previous period, the bulk of the surviving evidence is from domestic accommodation, but there are also a number of painted tombs, mainly in the eastern provinces.

To make analysis more difficult, dating is often extremely uncertain, especially in the provinces, where buildings phases frequently have to be dated by pottery or coins found in archaeological deposits. In Rome and Ostia some assistance is provided by the use of dated brick-stamps and (in tombs) by the nomenclature of the deceased; but this evidence usually applies to the initial construction of a building, whereas many decorations are secondary. Even in Rome it remains difficult to establish a detailed chronological frame of reference, and many paintings cannot be placed with security.

As already stated (p. 100), the Fourth Style petered out round the end of the first century, and with its death the great creative surge of Roman wall-painting was largely exhausted; from now on painters tended to be backward-looking and eclectic, ringing the changes on motifs and ideas explored in earlier times. There was thus no fifth or sixth style, merely pastiches incorporating elements of the Second, Third and Fourth, but generally without the clarity and coherence of those earlier manners. An associated trend was the decline of the central picture, especially in Italy; figured subjects on walls were increasingly confined

to single-figure emblems or vignettes at the middle of col- oured fields, while panels containing groups of figures were more often found on vaults and ceilings. At the same time decorative and figurative emphasis passed increasingly to pavements, where some of the more inventive and interest- ing developments of interior decoration are to be observed.

In the second century, as in the first, the more pretentious wall-decorations were based on painted architecture. But there was a general tendency, at least during the second and third quarters of the century, for the architecture to become less clearly structured and for three-dimensional effects to be lost in a play of colours. This may be illustrated by a few selected examples.

In Hadrianic times (117–38) we see decorations which are not too far removed from the Pompeian tradition. For instance the paintings from a house in the Villa Negroni in Rome, known from eighteenth-century water-colours and colour engravings [189], used perspectival effects for the framework of a central pavilion and even allowed visual openings with a white ground in the upper part of the wall; central pictures were present, rather larger in scale than those of the Fourth Style. Only at the sides was there some hardening and flattening, with architectural forms being replaced by plain fields and ornamental panels. A late Hadrianic date is indicated by a brick-stamp of 134.

By the Antonine period (138–92) things seem to have begun to change. The decorations from a house in Via Merulana in Rome [190] contain relatively solid and realis- tic architectural forms, but the emphasis is upon the harmonic combination of coloured surfaces (red, maroon and yellow), while some of the figure-motifs within the schemes (a dove and the Egyptian sacred bull Apis) are set illogically at the bottoms of panels, appearing neither as decorative emblems in the field nor as living fauna standing on the architectural surfaces. The result is a lack of any real effect of depth. Twenty or thirty years after these paint- ings, which may belong to the middle of the century, some of the more ambitious decorations had exchanged coherent structures for compositions so complicated as to be per- plexing or positively jarring. The late Antonine *tablinum* of the House of Jupiter and Ganymede at Ostia [191] is a case in point, superficially reminiscent of the Fourth Style but coloristically much heavier and structurally much less comprehensible. The scheme is focused not on a central pavilion but on a kind of large window revealing vistas of receding architecture; yet depth is denied by the use of a red background, and suspended improbably between the architectural structures is a panel-picture. The decoration of the upper zone, despite its use of the same basic red and yellow colour scheme, has no organic relationship with the painted structures below.

In the Severan age (193–235) some decorations retain the polychromy but dispense with an architectural framework altogether. Such are rooms VI and IX in the Inn of the Pea-

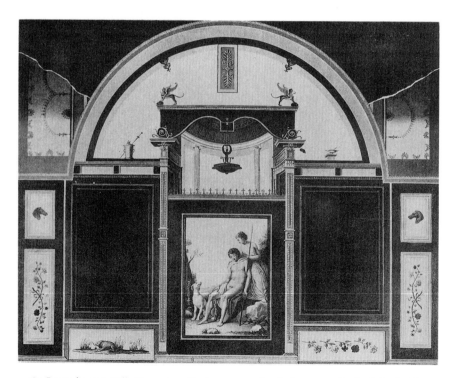

189 Rome, house in Villa Negroni: wall paintings, now lost (colour engraving by C. Buti). After A.D. 134.

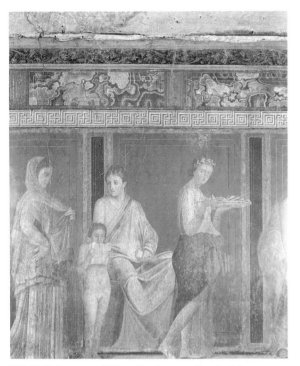

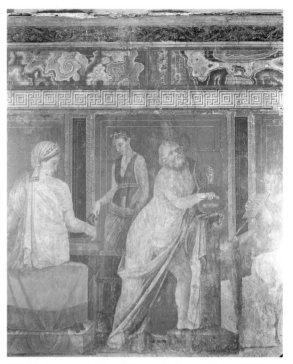

IXA Veiled woman, child reading from scroll and ministrant with plate. Pompeii, Villa of the Mysteries. *Oecus* 5, north wall. *c.* 60–50 B.C.

IXB Ministrant at table and Silenus playing lyre. Pompeii, Villa of the Mysteries. *Oecus* 5, north wall. *c.* 60–50 B.C.

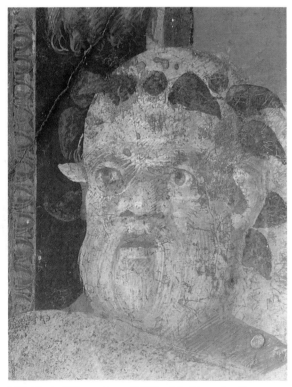

IXC Head of Silenus. Pompeii, Villa of the Mysteries. *Oecus* 5, east wall. *c.* 60–50 B.C.

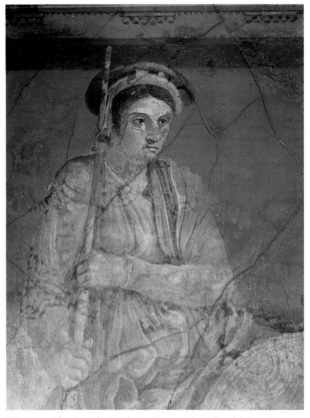

XA Personification of Macedonia. Boscoreale, Villa of P. Fannius Synistor. *Oecus* H, west wall. *c.* 50–40 B.C. Naples, Archaeological Museum.

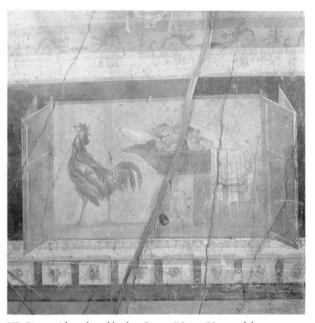

XB *Pinax* with cock and basket. Pompeii I 6, 2 (House of the Cryptoportico), *œcus* at south-east end of cryptoportico. *c.* 40–30 B.C. H. 34 cm.

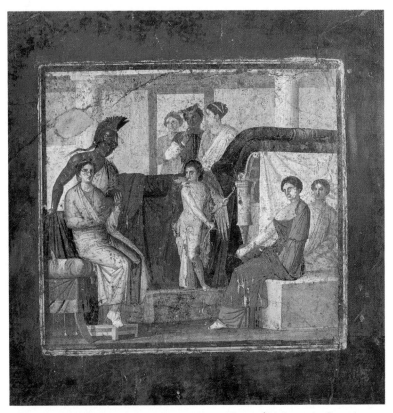

XIA Courtship of Mars and Venus. Pompeii V 4, a (House of M. Luctretius Fronto). *Tablinum*, north wall. *c.* A.D. 40–50.

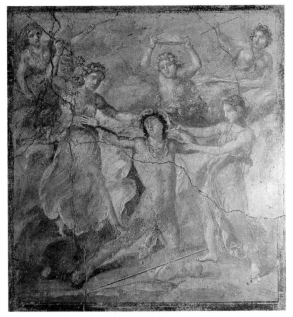

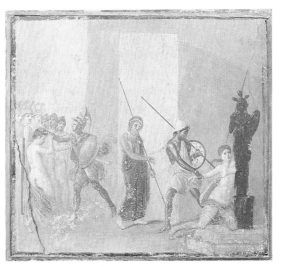

XIC Sack of Troy. Pompeii I, 10, 4 (House of the Menander). *Ala* 4, left wall. Third quarter of 1st century A.D. H. 60 cm.

XIB Death of Pentheus. Pompeii VI 15, 1 (House of the Vettii). *Triclinium n*, east wall. Soon after A.D. 62. H. 1.05 m.

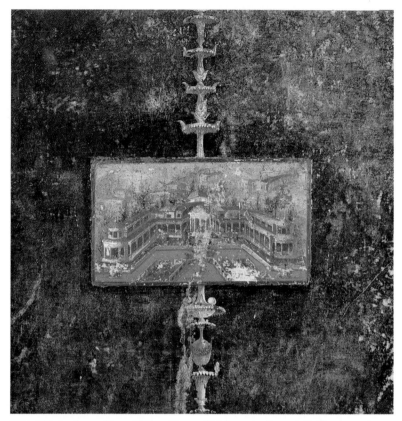

XIIA Villa landscape. Pompeii V 4, a (House of M. Lucretius Fronto). *Tablinum*, north wall (left). *c.* A.D. 40–50.

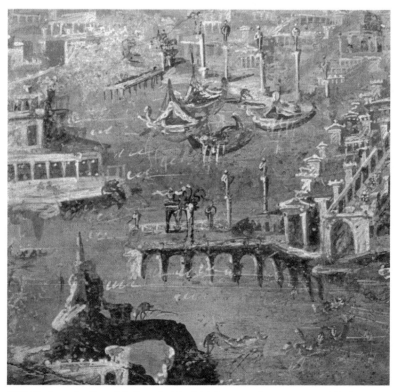

XIIB Harbour city (Puteoli?). From Stabiae. Third quarter of 1st century A.D. Naples, Archaeological Museum.

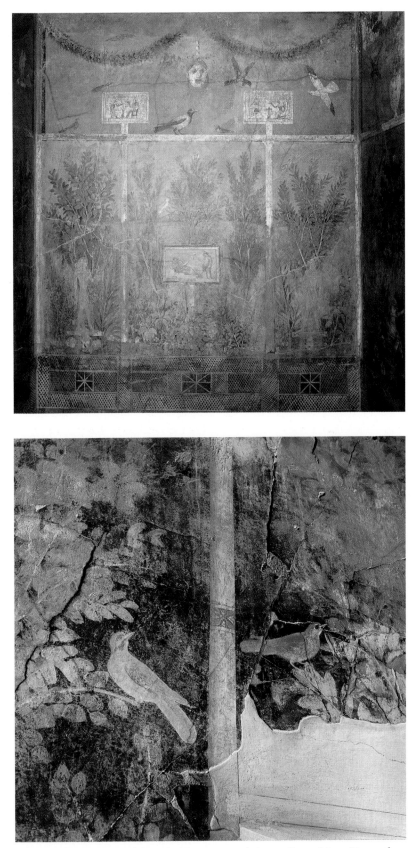

XIIIA Garden paintings with Egyptianising statues and pictures. Pompeii I 9, 5 (House of the Orchard). Bedroom 8, east wall. *c.* A.D. 40–50.

XIIIB Birds perched on fruit trees. Pompeii I 9, 5 (House of the Orchard). Bedroom 12, south wall. *c.* A.D. 40–50.

XIVA Bust of Mercury. Pompeii V 4, a (House of M. Lucretius Fronto). Bedroom 6, west wall (right). *c.* A.D. 40–50. Diam. 22 cm.

XIVB Portrait of Menander. Pompeii I 10, 4 (House of the Menander). *Exedra* 23, left wall. Third quarter of 1st century A.D. H. 1.08 m.

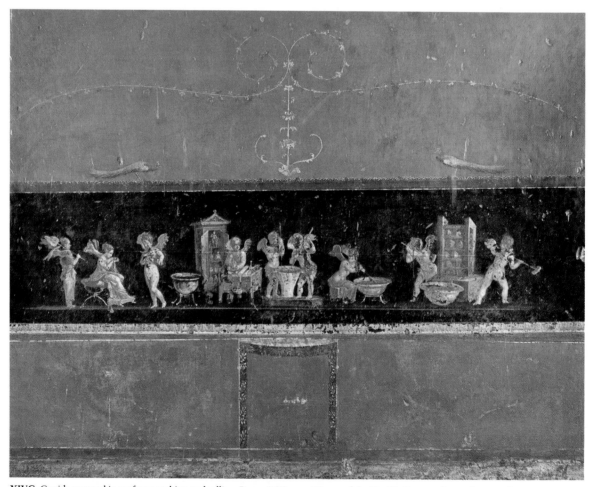

XIVC Cupids engaged in perfume-making and selling. Pompeii VI 15, 1 (House of the Vettii). *Oecus q.* Soon after A.D. 62.

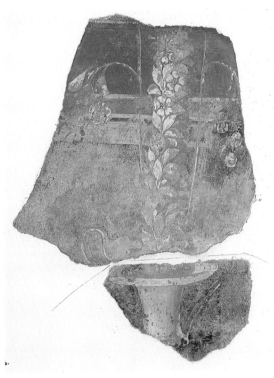

XVA Heroine from Greek legend (Agave?). Detail of wall-decoration from Magdalensburg, near Klagenfurt, Austria. Late 1st century B.C. or beginning of 1st century A.D. Kärnten, Landesmuseum.

XVB Vegetal 'column' growing from a wine-cup. Fragments of plaster from villa at Commugny, Switzerland. First half of 1st century A.D. Nyon, Roman Museum. H. approx. 32 cm.

XVC White *gorgoneion*. Avenches (Switzerland), from *insula* 18, red *œcus*. Mid 1st century A.D. Roman Museum.

XVD Panel containing portrait of Socrates. Ephesus H 2/7 and 14a (Room of the Muses). Second half of 1st century A.D.

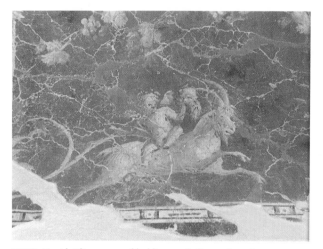

XVIA Cupid riding goat and holding mask. Rome, from house underneath Baths of Caracalla. Detail of ceiling-paintings. *c*. A.D. 130–40. Palatine Antiquarium.

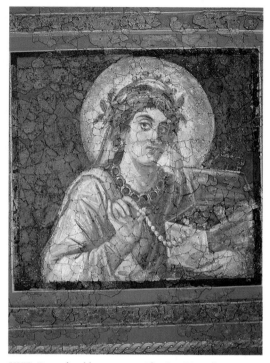

XVIB Bust of goddess or personification. Trier, from house underneath cathedral. Detail of ceiling-paintings. Second or third decade of 4th century A.D. Episcopal Museum.

XVIC Philosopher (?) with scroll. Trier, from house underneath cathedral. Detail of ceiling-paintings. Second or third decade of 4th century A.D. Episcopal Museum.

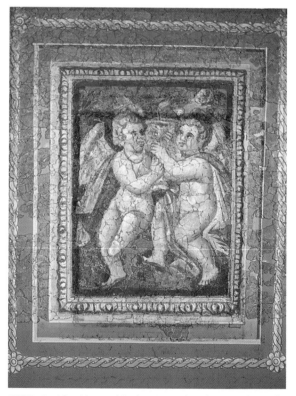

XVID Cupids with portable altar. Trier, from house underneath cathedral. Detail of ceiling-paintings. Second or third decade of 4th century A.D. Episcopal Museum.

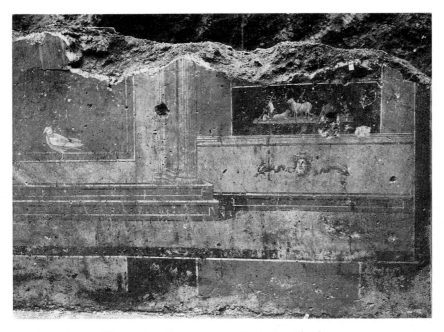

190 Rome, house in Via Merulana. Room A, west wall (detail). Mid 2nd century A.D. Antiquarium Comunale.

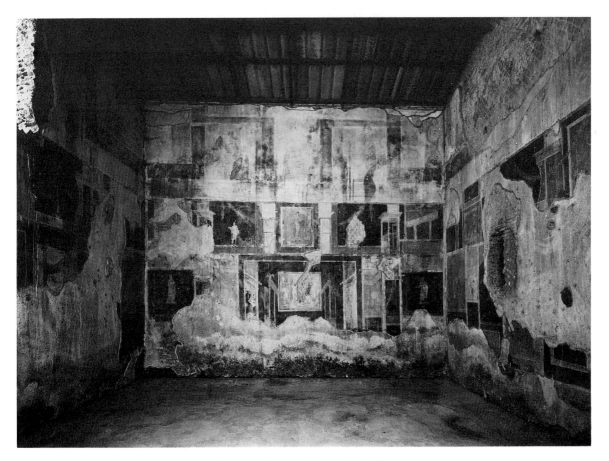

191 Ostia, House of Jupiter and Ganymede, so-called '*tablinum*' . *c.* A.D. 180–90.

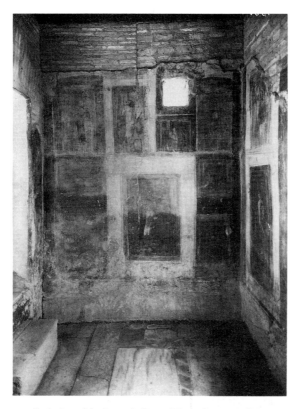

192 Ostia, Inn of the Peacock. Room IX, north-west wall. First quarter of 3rd century A.D.

193 Ephesus, H2/SR6 (Theatre Room), north wall. Last quarter of 2nd century A.D.

cock at Ostia [192], which present simple collages of coloured fields, devoid of all hints of plasticity and recession. The arrangement and size of the fields seem to be virtually random, and the colours are constantly varied; one field is red with a white frame, another yellow with a green frame and so on. Each contains a large figure or decorative motif. Elsewhere, however, architectural supports are set between coloured fields to produce schemes more logical and rhythmic than at any time since the Fourth Style. A good example appeared in a lunette in the *exedra* of the so-called Stadium in the imperial palace on the Palatine, where structural and epigraphic evidence gives a date soon after 195. An early photograph of this decoration, which is now destroyed, reveals a double-storeyed framework in which the middle field and also the side fields were framed by columns and the little outer fields represented pavilions with figures standing in open doorways; furthermore, the field at the top of the lunette disclosed a colonnaded courtyard with hangings above it – a traditional form of visual opening into a world beyond the wall. The architectural style has thus turned back the clock to produce something like the perspectival schemes of the Pompeian period. The major difference is that the intervening fields remain preeminently framed panels, even when they contain glimpses

of further planes of architecture; they form a continuous plane, with just the columns in front of them and the simplest of architectural elements visible in the openings. There is nothing approaching the complicated layers of recession and luminous spatiality of the true Fourth Style.

From the provinces come various decorations which reflect late Antonine and Severan work in the capital. A monumental scheme of large fields articulated by columns which appears in the so-called Theatre Room (H2/SR6) at Ephesus [193] can best be dated by stylistic parallels at Ostia to the end of the Antonine period or the beginning of the Severan; the red and yellow colour scheme, the schematic rendering of the architectural elements, and the lack of liaison between colour and perspective in the upper zone, all find analogies in the 'tablinum' of the House of Jupiter and Ganymede. Moreover, the central position in the upper zone is occupied by a mythological picture which, like the central panel in the Ostian decoration, is imposed upon the architectural scheme with scant regard to its compatibility with the context. In the main zone alternate fields are substituted by large framed panels containing single standing figures on a white ground, perhaps symbolic of the various pleasures of life; the remaining fields are red and carry vignettes of theatrical scenes, the comedies of Menander alternating with the tragedies of Euripides.

While this Ephesian decoration lacks structural clarity, paintings from other sites are simpler and more consistent. A room in the House of the Consul Attalus at Pergamum shows one of a number of garden paintings of the mid Imperial period, with a low parapet wall painted in

perspective beneath a shrubbery. In a house at Dover in Britain three rooms were painted with a scheme of white panels framed by short spur-walls, each terminating in a semi-column. To the same time may perhaps be attributed the decorations of the House of the Tragic Actor at Sabratha in Libya, which include 'scenographic' compositions with projecting wings and receding colonnades.

Ceiling- and vault-decoration during the mid Imperial epoch saw a number of interesting developments, stimulated by the variety of forms of vaulting now in use: cross-vaults, and new kinds of dome and semi-dome. The evidence from houses, generally reconstructed from fragments, is supplemented by better preserved examples in tombs, whose subterranean location and solid concrete vaulting favoured their survival (while their function put the decorative emphasis on the ceiling rather than on the walls, where the presence of cremation-niches and inhumation-recesses generally reduced the scope for painting to little more than illusionistic columns or other framing elements).

The most important trend was the emergence of schemes which, reflecting the increasing preponderance of groined vaults in concrete construction, placed emphasis on the dia-gonals. Already in the time of Hadrian we find the beginnings of such schemes in two of the earliest tombs (B and C) of the Roman cemetery under the Vatican Basilica. In tomb B [194], for example, the groins are decorated with chains of interweaving garlands and blue almonds which converge on a central roundel containing a representation of the sun-god.

Not all cross-vaults, however, placed emphasis on the diagonals. In tomb G of the Vatican necropolis, a delicate linear decoration patently produced by the same workshop as the paintings of tomb B imposes a four-sided symmetrical design which takes no account of the groins; and in other cases decorators used four-sided designs which met along the groins in kite-shaped fields. This often happened in panel-schemes in stucco relief, such as the all-white decoration in the *apodyterium* of the Large Baths in Hadrian's Villa at Tivoli, and the stucco and polychrome vaults of Vatican tomb F (the tomb of the Caetennii: early Antonine) and of the so-called Tomb of the Pancratii, or 'Coloured Tomb', on the Via Latina south of Rome (late Antonine).

Conversely, designs with a strong diagonal emphasis now began to appear on simple barrel vaults or segmental

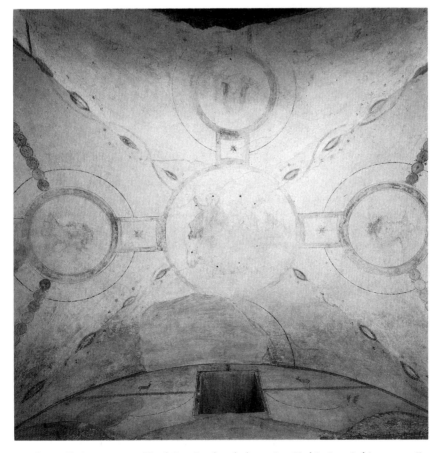

194 Rome, Vatican cemetery. Tomb B, painted vault-decoration. Hadrianic period (A.D. 117–38).

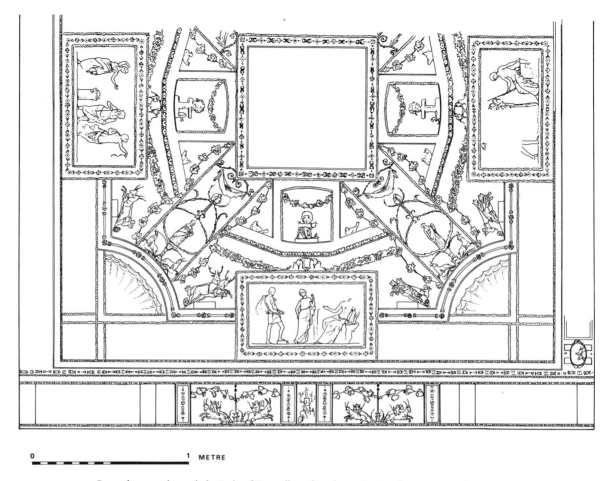

195 Rome, house underneath the Baths of Caracalla, ceiling-decoration (partly reconstructed). *c.* A.D. 130–40.

vaults where there was no structural impetus thereto. A finely painted example in a house buried beneath the Baths of Caracalla in Rome is dated, with the aid of brick-stamps, to the late Hadrianic period. Reconstructed from fragments [195], it consists of diagonal fasciae radiating out from a central square panel (contents lost) to a corner quadrant containing a shell; rectangular panels are set at the sides, and friezes of panels are added at either end to fill the residual space. The whole scheme is bound together by two borders, the inner polygonal and the outer square. The backgrounds are coloured (vermilion, dark and light blue, purple, yellow), and in addition to delicate vegetal ornament there is a variety of decorative subjects in the minor fields: Cupids driving chariots drawn by deer or felines, Cupids sitting on the backs of goats [Pl. XVIA], birds, vases, theatrical masks and so forth. One panel in the end frieze shows a little rustic sanctuary of the type found on walls in the Room of the Masks and other Augustan decorations [33, 150]. In the side panels, very imperfectly preserved, there were evidently three-figure scenes of Bacchic subjects.

Several further vault-decorations of the second century confirm the popularity of designs with diagonal emphases, whether applied to cross-vaults or to barrel and segmental vaults. Away from the Rome area we find a white-ground example, probably datable to the late Hadrianic period, in a tomb at Caivano near Naples; here the diagonal elements are vegetal, with straight garlands serving as frames for chains of interweaving tendrils enclosing palmettes. Outside Italy a tomb in Alexandria (Rue Tigrane Pasha) [200] received a decoration in which the ribs of a low cross-vault were adorned with slender tree-trunks which 'grew' from the corners of the room and sent tendrils winding across the four faces of the vault. Amid the foliage appeared livestock: eagles straddling the ribs, and springing leopards and gazelles at the sides.

Little remains of the decoration of the more elaborate multi-faceted vaults and domes created by second-century architects, of which the 'umbrella' and 'pumpkin' domes and semi-domes of Hadrian's Villa are among the best known. But that these configurations, too, influenced vault-

painters is clear from a Severan decoration in the House of the Painted Vaults at Ostia [196]. Its novelty lies in its conversion of a cross-vault into the semblance of an eight-faceted umbrella dome supported by pendentives. At the centre is a red medallion surrounded by a border in the form of a broad white band, externally octagonal; from the eight angles, like the spokes of a giant wheel, further white bands radiate towards an outer circle, red with white daisy-chains. The eight wedge-shaped spaces between the spokes are divided by curving borders into white lunettes at the base and red spandrels at the apex. The effect of the lunettes, in particular, is to suggest that the surfaces between the radiating bands are arched upwards like the facets of a scalloped dome. There can be little doubt that this decoration, which replaced a more traditional four-sided design, was in part a studied illusion inspired by structures like the vestibule of the Piazza d'Oro at Tivoli.

Alongside the more adventurous and *avant garde* vault-decorations there were many which stuck to simpler modes, for example painted imitations of stone or stucco coffering (in Hadrian's Villa and in a villa at Gadebridge, near Hemel Hempstead, in Britain), and systems of square and rectangular panels framed by broad bands of colour and ornament (the Serapeum and large cryptoportico of Hadrian's Villa). In a seaside villa at Dar Buc Amméra near Zliten in Tripolitania the paintings from part of the vault of a cryptoportico have been restored to show a delicate white-ground decoration in which some of the borders and floral patterns recall the paintings of Neronian and Flavian times; but the spaciousness of the treatment contrasts with work of that time, and the style of the heads from the cryptoportico is very close to that of the heads of the four Seasons in one of the villa's mosaic pavements, the most plausible date for which is the Severan age. The figure-subjects, including a composition of Bacchus seated on a springing leopard and a landscape with pairs of figures and village houses scattered at different levels [197], are deftly modelled in strokes of deep shadow and white highlights. The facility of the painting and attractiveness of the overall effect provide a salutary glimpse of the standards which were being attained even in those provinces for which the record is most defective.

With regard to iconography in paintings of the second and early third centuries, the most striking feature is the

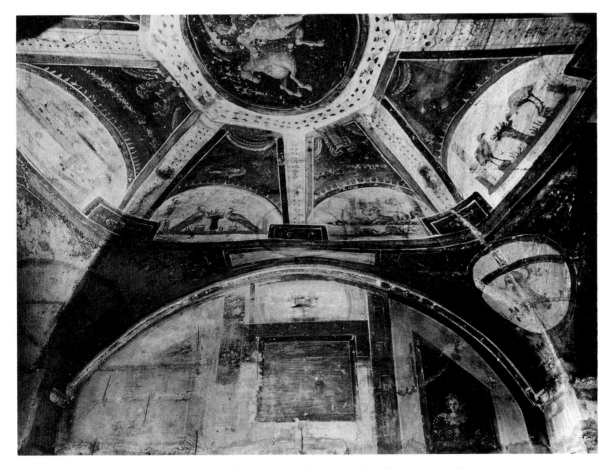

196 Ostia, House of the Painted Vaults. Room IV, painted vault and lunette. Early 3rd century A.D.

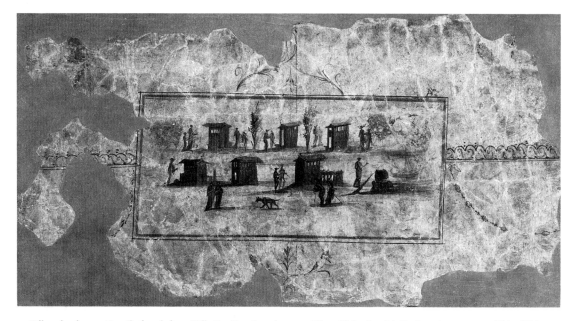

197 Village landscape. Detail of vault from Villa Bar Duc Amméra near Zliten (Tripolitania). Early 3rd century A.D. Tripoli Museum.

rarity of mythological panel-pictures in house-decoration. Exceptions are pictures in the house of Villa Negroni [189] and in the main rooms of one or two houses at Ostia, including the Houses of the Child Bacchus and of Jupiter and Ganymede [191], each named after its best preserved panel. From Germany there are examples in two Antonine decorations – the so-called 'green wall' at Trier, which features Jason and Medea stealing the golden fleece [198] and, in a little shuttered *pinax* in the upper zone, a scene of sacrifice; and a rich marbled mural from the frontier fort of Echzell (north-east of Frankfurt) in which two Cretan scenes, Daedalus fashioning wings for Icarus, and Theseus killing the Minotaur, are displayed one on either side of a picture of Hercules receiving a cornucopia from the hands of Fortuna. In the East, the sole survivor of the mythological paintings in the upper zone of the Theatre Room at Ephesus [193] shows a scene best interpreted as Proteus being subdued by Menelaus and his companions, an episode recounted in the fourth book of the *Odyssey*.

Otherwise, apart from isolated figures of Muses and the like, and from figure-scenes on ceilings and vaults, normally rendered on a neutral coloured ground, the majority of mythological compositions come from tombs. Several examples survive in the Levant. A rock-cut tomb found near Tyre, reconstructed in the Beirut Museum, contains a frieze of pictures appropriately drawn from the tales of the Underworld, including on the back wall the rape of Persephone [199], painted in accordance with an iconographic format which can be traced all the way back to the late Classical period. Another rock-cut tomb, this time

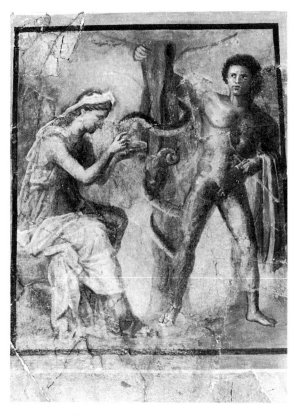

198 Jason and Medea stealing the golden fleece, from Trier, Palastplatz (central panel of 'green wall'). Mid 2nd century A.D. Regional Museum.

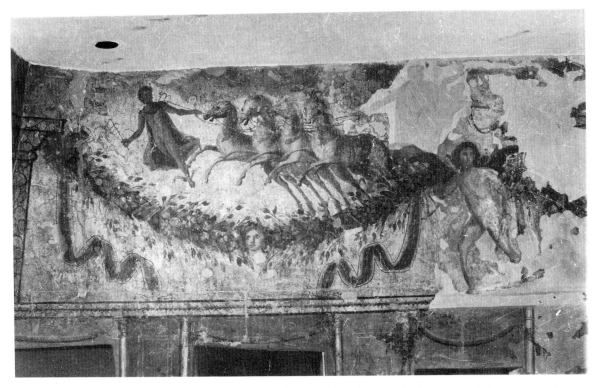

199 Hermes leading the chariot of Pluto, from tomb near Tyre (back wall). Third quarter of 2nd century A.D. Beirut, National Museum.

near Masyaf in Syria, contained a further rape of Persephone, as well as Hermes the guide of souls, a group of children playing, Narcissus at the spring, and Jason and Medea. In Egypt the two-storeyed tombs of Hermopolis (modern El Ashmûnein) include some with Greek mythological subjects, such as the rape of Persephone again, the wooden horse at Troy, Electra at Agamemnon's tomb, and episodes from the story of Oedipus in which allegorical figures of Search and Ignorance are portrayed. Other paintings at Hermopolis, like those of many Roman-age cemeteries in the Nile valley, remain purely Egyptian in style and content; and even in Alexandria the wall-decorations of the tomb in Rue Tigrane Pasha [200] show Egyptian subjects – a vivid illustration of the continuance of local traditions in this part of the Empire. An interesting detail of all the Greek mythological paintings in the Levant and Egypt is their use of inscriptions to label the figures; it seems almost as if the artists felt that the subjects were unfamiliar to their clients.

Among the non-mythological subjects, some of the favourites of first-century painting lost ground or changed character, while new ones took their place. Still lifes virtually disappeared, except for isolated items such as bowls of fruit used as decorative motifs. Of landscapes there are still at first a few relatively accomplished examples, as well as little panels with impressionistic daubs employed (as for-

merly in the Golden House [156]) as centre-pieces in simple decorations; but the magic, unreal quality of earlier works is now lost, and by the Severan period the traditional landscape types have disappeared, giving way to different sorts of rural subjects, all with landscape subordinate to the figures: agricultural labours, hunting scenes, or animals in their natural setting. Generally speaking, realistic and everyday subjects gained favour at the expense of mythology and romance: good examples are the hunting-scenes and circus-charioteers [201] in the late Antonine decorations of the Caseggiato degli Aurighi (Tenement of the Charioteers) at Ostia. Such scenes had hitherto been more the stuff of street 'posters' than of interior decoration. Painted aquaria remained popular, especially in the decoration of bath-chambers, and came to be associated with genre and idyllic (later also mythological) subjects, for example fishermen. Portraits remained rare, apart from occasional historical subjects (the seven sages complete with verse inscriptions giving patent cures for constipation in a wine-shop at Ostia). Exceptions occur in the far East, where there are portraits of the owners and occupants of tombs at Palmyra.

Though the technical quality of painting remained good during the second and early third centuries, it is clear that artistic standards were declining. When painters sought to improvise upon the architectural repertoire they often

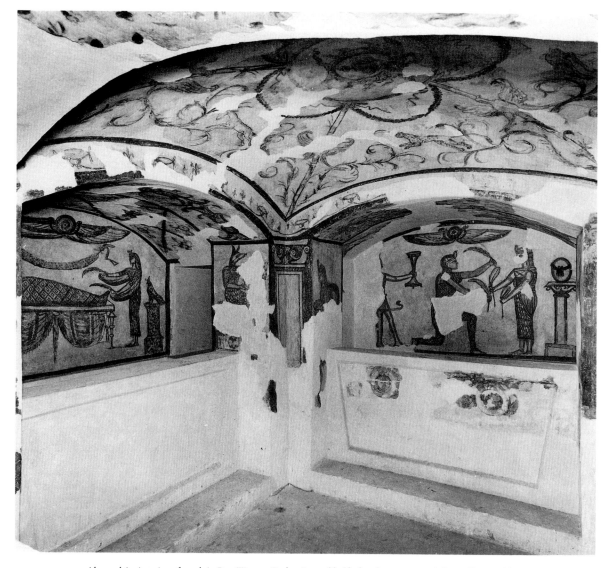

200 Alexandria, interior of tomb in Rue Tigrane Pasha. Second half of 2nd century A.D.? Greco-Roman Museum.

created mere gaudiness and confusion; when they clung to it more closely, they were often heavy-handed and unoriginal. It is against this gradual decline of painting (at least on walls) that we must see the success of the other media. Stuccowork, though destined to pass almost completely out of fashion during the third century, obtained successful effects in vault-decoration, precisely because it accepted its limitations and did not attempt anything too ambitious. Mosaicists in particular showed a greater sense of purpose than painters, and, in the West at least, a better control over the aesthetic possibilities and limitations of their medium. The *emblema* tradition continued in the eastern Mediterranean, where it is best represented by the long series of pavements in and near Antioch (Antakya in southeast Turkey), but in Italy and the western provinces, including Greece, decorators favoured representational styles which played down the three-dimensional factor and above all tried to spread the visual interest more evenly over the pavement, with the orientation of subjects varied according to their position within the room. The characteristic Italian (or rather central-Italian) fashion, known principally from the pavements of Ostia, was a free composition of figures in black silhouette on a white ground, a style which had the virtue of respecting the inviolability of the surface and at the same time provided a perfect foil to the bright colouring of Antonine wall-paintings. In north Africa and the north-western provinces, however, mosaicists moved over to polychrome styles, to which they remained faithful till the end of the Roman period. Some relied largely or wholly upon geometric patterns and motifs. Where figures were

201 Charioteer. Ostia III, x, 1 (Tenement of the Charioteers), corridor north of court. *c.* A.D. 170–90.

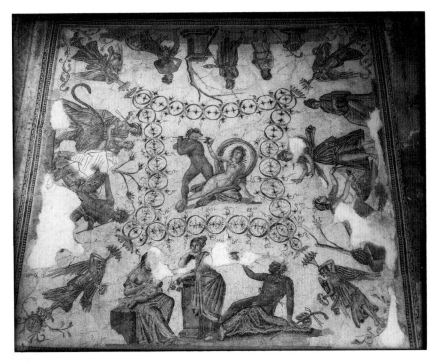

202 Djemila (Cuicul, Algeria), House of Bacchus. Dionysiac mosaic. Second or third quarter of 2nd century A.D.

employed, they tended to be distributed in a number of more or less equally important panels within the design. A striking feature of one or two pavements, including a famous Bacchic mosaic at Djemila (Algeria) [202], is their emphasis upon the diagonals, which are occupied by caryatids or similar supporting figures; the motif, more explicitly stated later, when such figures seem to strain against the weight of the central panel-frame, implies the influence of decorated cross-vaults and domes in which such figures were represented on the groins or pendentives.

The Late Empire

The fall of the Severan dynasty in 235 signalled the start of a period of political and economic confusion which lasted for half a century. A combination of civil wars and unstable governments, pressures from marauding tribes beyond the frontiers (Italy itself was invaded for the first time in four centuries), epidemics and financial collapse produced a crisis which discouraged investment in property and in all expensive forms of interior decoration. The situation was particularly difficult in Italy and the European provinces; Africa, now the Empire's leading producer of pottery and oil, was less seriously affected, and the eastern provinces, too, escaped the worst effects. The main consequence for wall-painting, in Italy and the northern provinces at least, was the decline of the middle-class patronage which had been the staple source of commissions since Republican times. This meant not only a curtailment in

the amount of decoration carried out but also a lowering of ambition. The care bestowed on wall-painting is much reduced; and, though occasional architectural and figural paintings still occur, there is an overwhelming tendency to cheaper and more economical systems of decoration, many of which break away completely from the illusionist tradition into patterns of abstraction. Stuccowork, a more costly technique, and one which had always been reserved for the grander rooms of a house or the finer tombs in a necropolis, disappears almost completely. Mosaics too are relatively few in number before the economic revival in the later part of the third century.

Strong government returned with the accession of Diocletian in 284 and his establishment of the Tetrarchy (college of four emperors). In this period and in the reign of Constantine (312–37) there is a revival of good quality wall-painting, particularly associated with the emergence of a wealthy senatorial élite which required expensive decorations for its luxury villas. At the same time the establishment of imperial courts in regional capitals such as Trier and Thessaloniki promoted building and decoration in those cities and offered the conditions for the dissemination of a court style to the provinces. Under these circumstances Roman wall-painting enjoyed something of an Indian summer before the collapse of the western Empire and the transition to Christian themes and iconographies brought an effective end to its history.

Bound up with the third-century decline in carefulness is a change in styles of representation. Like the other arts,

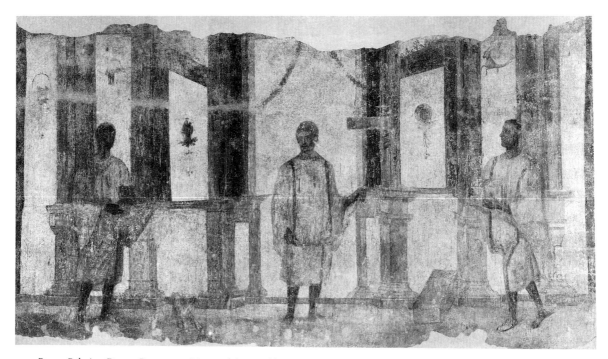

203 Rome, Palatine. Domus Praeconum (House of the Heralds), wall-painting. Second quarter of 3rd century A.D.? Palatine Antiquarium.

painting from Severan times onwards shows a marked divergence from the illusionistic tradition which had prevailed since the golden age of Greek art; where figures are depicted their forms are now increasingly simplified and emphasis is laid on the contours rather than the volumes. Apart from the classical revival during the first half of the fourth century (see below) this trend continued unabated into the early Christian era. One of its corollaries was the growing popularity of work in mosaic and *opus sectile*, which now became pre-eminent in the decoration of major public buildings, not only on floors but also on walls and vaults. These cut-stone techniques were ideally suited to the two-dimensional quality of late antique art, whereas the paint-brush lent itself more readily to an illusionistic style which was less frequently in demand. It may have been partly because of a reaction against plastic effects and subtle modulations in interior decoration that stuccowork passed out of fashion.

The lack of paintings in well-dated contexts, and the simplicity of the schemes in fashion, makes any analysis of work in this period still more difficult than for its predecessor. This is true even of Rome and Ostia, where brick-stamps and inscriptions now desert us. For the third century in particular the chronological fabric remains completely uncertain and only the most generalised statements can be offered. Unfortunately the evidence from Africa and the East is as exiguous as elsewhere and far less well known. Here the continuance of a flourishing tradition of polychrome and pictorial mosaics bears witness to the continuing prosperity of the regions, and we must suspect that good quality paintings existed but have not been recovered (or, if recovered, have not been published).

Architectural paintings continued to be produced during the period of anarchy, though becoming heavier and harder in style. The paintings from the so-called Domus Praeconum (House of the Heralds) on the Palatine [203] are a case in point, with a large-scale 'scenographic' composition serving as a backdrop for a series of figures of imperial attendants and officials: the painting relies on broad effects rather than refinement of detail, and some of the figures, large-bodied and short-legged like the soldiers in the reliefs of Septimius Severus's triumphal arch in the Forum, are awkward and unconvincing.

The most popular style of the period, however, at least

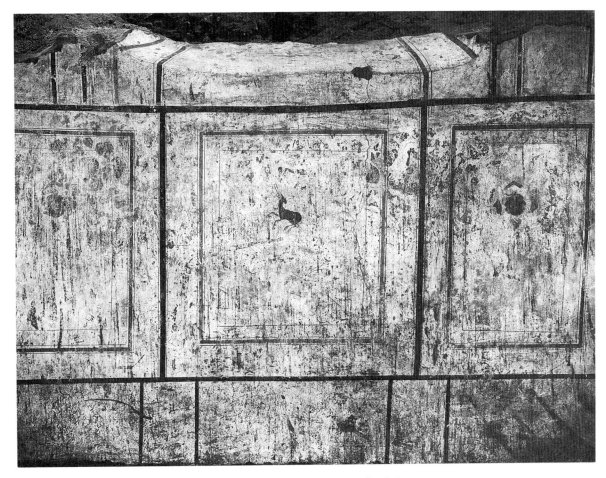

204 Rome, house under S. Giovanni in Laterano, wall-painting. *c.* A.D. 10–90.

in Rome and its surroundings, was the so-called 'red and green linear style'. The origins of this can be traced back to subsidiary rooms in the Fourth Style, where white-ground decorations with panels formed by simple banding provided a quicker and cheaper version of the polychrome schemes applied in more important rooms. During the Antonine age such schemes became more common; fields were marked out by broad bands of colour, often supported by fine accompanying lines, and sketchy vignettes or decorative motifs were set within them (the Caseggiato degli Aurighi at Ostia: cf. [201]). Good examples, dated *c.* 180–90, appear in a building underneath the Lateran Basilica [204], where the main decorative divisions are carried out in red, while internal frames consist of yellow or green bands between purple lines; within the fields are masks, gazelles, goats, lionesses, eagles and rosettes. By the Severan period the bands were in many cases being replaced by simple lines, colour scales were being reduced (yellow and purple being eliminated), and systems based on the traditional syntax of dado, main zone and upper zone were changing into purely abstract patterns, often with curving lines [205]. The result was what has been aptly described

as a kind of 'spider's web'. The spaces in the patterns were occupied by figures and animals, generally painted as isolated motifs with only the barest hint of an environment.

The linear style became particularly associated with the catacombs, whose paintings are formally indistinguishable from those of contemporary pagan monuments; only the iconography sets them apart. In the catacomb of Peter and Marcellinus the vault of chamber 69 [206] has a pattern which is typical of the style: a central medallion is surrounded by four semicircles, all embraced within a large circle. But the subjects are now unequivocally Christian. In the central medallion stands the Good Shepherd, shown as always with a lamb on his shoulders and further sheep at his feet; in the semicircles are episodes from the story of Jonah; and in the interstices are characteristic Christian *orantes*, their hands raised in prayer. Both the Good Shepherd and the *orans* motifs were taken over from pagan art; but their peculiar appropriateness to Christian ideology ensured that they would enjoy far greater popularity in Christian contexts than they had enjoyed before.

While the red and green linear style marks the culmination of an anti-structural trend in Rome and Ostia, a similar

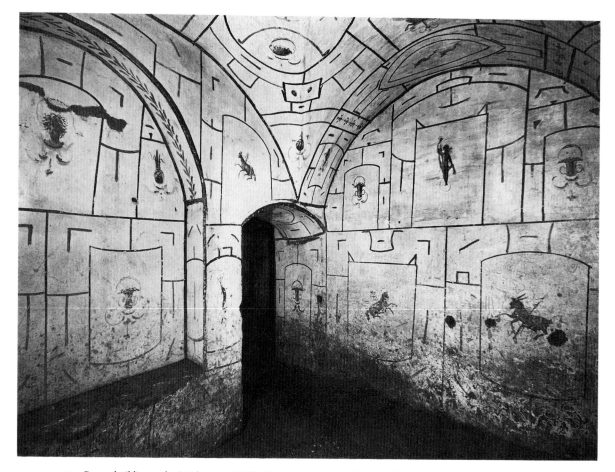

205 Rome, building under S. Sebastiano ('Villa Piccola'), paintings in linear style. Second quarter of 3rd century A.D.

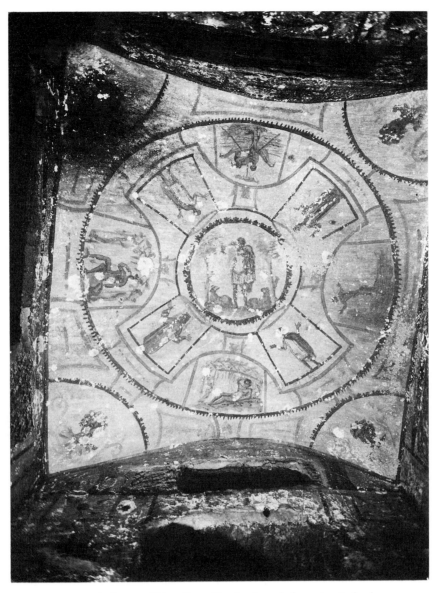

206 Rome, catacomb of Peter and Marcellinus. Chamber 69, vault-decoration. Early 4th century A.D.

role was played in the provinces by 'wallpaper patterns' (*Tapetenmuster*). Already occasionally found on vaults and walls in Italy during the time of the Fourth Style (pp. 84–5), these enjoyed enormous success throughout the Empire from the second to the fourth centuries. They are to be distinguished from the coffer-based schemes, with their heavy frames, often illusionistically shaded and accompanied by illusionistic enrichments, which are confined to vaults and ceilings and recur at all periods in the history of Roman painting where pseudo-architectural effects are required. The true 'wallpaper pattern', whether applied to the wall or to the ceiling, is a lighter kind of decoration, based either upon vegetal and floral forms or (less frequently) upon linear networks – that is systems of squares, hexagons, roundels and the like in which the frames are relatively unobtrusive and the pattern all-important.

It seems that certain patterns were chosen for specific surfaces. Curvilinear schemes were preferred for ceilings. Intersecting circles, for example, a scheme already used on a vault in the Golden House [99], are attested at Hölstein and Bösingen in Switzerland; in each case the circles took the form of garlands, small coloured discs masked the points of intersection, and straight elements bisected the

207 Fragments of ceiling-plaster, from Bösingen, villa (Fribourg, Switzerland). End of 2nd or beginning of 3rd century A.D.

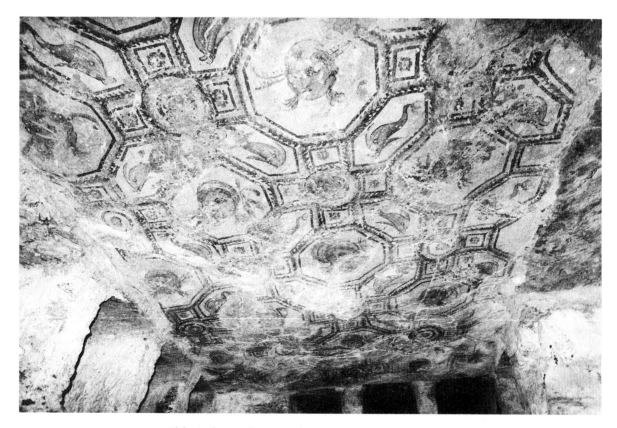

208 Abila (Jordan), tomb Q, painted ceiling. Third or early 4th century A.D. ?

almond shapes created where the circles overlapped. The Bösingen ceiling [207] seems to have been particularly delicate and attractive, with peacock-feathers in the almonds and small square panels containing flowers at the centres of the circles; the whole scheme was rendered in pale green and shades of pink and reddish brown on a white ground.

Schemes involving polygons were also, it seems, applied chiefly on ceilings. In addition to the ubiquitous pattern of contiguous octagons, inspired by vault coffering, at least one design based upon intersecting octagons derives from a ceiling: the barley-stalk decoration from house XXI, 2 at Verulamium (Britain), dated to the last years of the second century. More complex designs involving polygonal figures, with the frames featuring painted garlands, and with rosettes and figural motifs in the fields, occur in the necropolis of Abila (north Jordan). One ceiling [208], in which large octagons containing masks and Bacchic attributes alternate with elongated hexagons containing dolphins, is very reminiscent in both pattern and general effect of late Imperial mosaic pavements. A similar pattern, but with simpler frames and without the figure-motifs, appears in Rome in the mid fourth century on vaults in

the mausoleum of Constantia (S. Costanza) and in the Via Latina catacomb.

In contrast to curvilinear and polygonal patterns, a simple lattice formed by intersecting diagonal garlands or chains of leaves was employed primarily on walls. This is true of examples in north Africa and Ephesus, probably datable to the third or fourth centuries; unusually two African decorations, from Sabratha and Cyrenaica respectively, have central figure-paintings superimposed on the lattice [209]. On the other hand, a series of decorations in which the lattice is supplemented by small discs at the points of intersection and by large roundels in the interstices is attested on both walls and ceilings. Several examples come from sites in the Alps and Gaul, where they have been dated between the mid second century and the end of the third. In a house at Avenches in Switzerland one such pattern, with rosettes inside the larger roundels and petals growing from the small discs [210], was used for the ceiling and upper parts of the walls in a series of corridors; the measured economy of the ornament, and the delicacy of the colouring, reddish brown, grey-green, pale blue and yellow on a white ground, shows just how attractive this

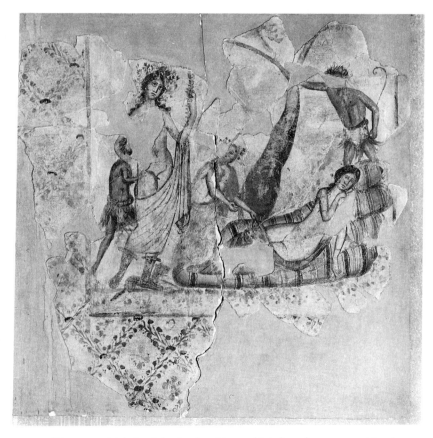

209 Dionysus and Ariadne. Sabratha, from House of Ariadne. 4th century A.D. Museum. H. 1.02 m.

kind of repeating design could be.

One of the concomitants of the new phase of stable government introduced by Diocletian in the late third century was the increased use of painting to simulate marble veneer. This 'pseudo-veneer', obviously a cheap substitute for the real thing, had always been a popular motif, particularly in the dado ([81]; cf. pp. 85, 95), but also occasionally in the main zone (for example in an Antonine house at Verulamium, where illusionistic columns alternated with panels of fictive alabaster and breccia); from the time of the Tetrarchy, however, it enjoyed a heyday, with whole walls (as in certain rooms of the house under the church of SS. Giovanni e Paolo in Rome) divided into brightly col-

oured panels, rectangular, diamond-shaped and circular, painted in imitation of various marbles and breccias. The intention no doubt was to reproduce the sumptuous environment created in the mansions of the new senatorial aristocracy. It is indicative of the decline in painting standards, however, that the required effects were often now achieved by broad strokes and scribbles and by the ubiquitous 'fried eggs' (blobs of one colour surrounded by wavy lines in another) in place of the meticulous realism of earlier times. A relatively good quality example is the decoration of the so-called Cenatorium (H1/b) at Ephesus (c. 300) [211], in which a series of Corinthian columns or pilasters frames fields of imitation inlay in white (marble), dark grey (granite) and dark red (porphyry). The hard black contours of all the elements, notably the columns, produces a schematised, two-dimensional effect which contrasts with similar decorations in earlier centuries.

More important artistically is another fashion which flourishes in the late third and fourth centuries: large-scale figured murals which occupy much of the wall-surface. The all-over format, previously used primarily for peopled landscapes [157], animals in the wild [89], or seascapes populated with fishermen and marine fauna (p. 183), becomes more common in the third century for mythological compositions. One of the best known is a problematical sea-scene on the wall of a fountain court in the house under SS. Giovanni e Paolo in Rome [212]. At the centre, on an island, are two reclining female figures, one clothed and the other largely naked, with a male in attendance; while all around are anecdotal groups of Cupids in the water or in boats. Of the many interpretations suggested for the central group the most widely accepted names the figures

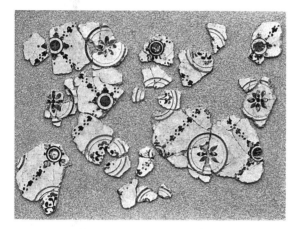

210 Fragments of wall- or ceiling-plaster. Avenches, from house in block 7. Beginning of 3rd century A.D. Roman Museum.

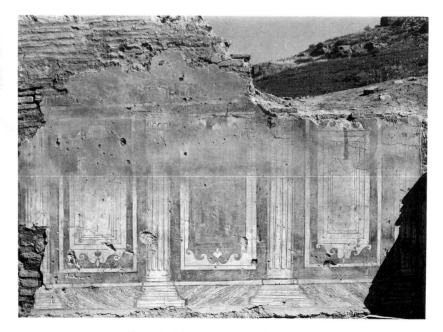

211 Ephesus H1/b (Cenatorium), north wall. c. A.D. 300.

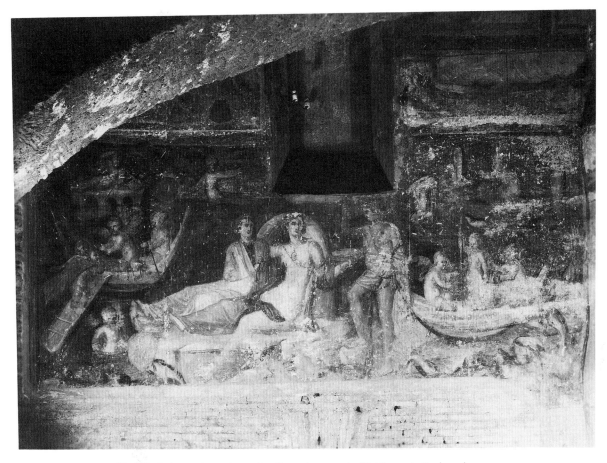

212 Mythological scene in marine setting. Rome, house under SS. Giovanni e Paolo. 3rd century A.D.

as Ceres (Demeter), Proserpina (Persephone) and Bacchus; but a more recent theory sees them as inspired by a work of art in a sanctuary of Venus in her role as a protectress of sailors: the female figures would then be Venus herself and a companion deity or local personification.

A number of fourth-century murals, similarly large in scale, represent ceremonial and documentary subjects. Most important is the chamber of the imperial cult in the fortress planted by Diocletian about 300 in the old Egyptian temple at Luxor. This showed processions of soldiers with horses moving along the side walls and figures of the Tetrarchs seated in state, two at the left and two at the right, amid tiers of soldiers and officials on the back wall. At the centre of the same back wall, opposite the entrance, was an apsidal recess decorated with further paintings of the Tetrarchs, here standing with the bust of a deity or personification between them and with an eagle holding a wreath, symbol of Roman power, in the semi-dome above. This decoration embodied many of the characteristic features of late Imperial official art. While the processional friezes of the side walls retained much of the variety and freedom of the old classical style, the scenes on the back

wall employed centralised compositions and totally conventional perspective, with the seated emperors above the heads of their troops and the troops themselves arranged at different levels. The emperors were depicted, as normal at this time, in hieratic frontality, directly addressing and demanding respect from the spectator. All the figures, including the soldiers, were over life-size, and the emperors were nearly double life-size, the two senior partners (Augusti) being fractionally taller than the juniors (Caesars). To this hierarchy of scale was added careful delineation of rank by means of the dress and insignia of those present; the supreme status of the emperors was confirmed by giving them not only the imperial purple but also the bearings and attributes of gods, most notably the nimbus derived from the sun-god and other deities of the heavens. The significance of these paintings as precursors of the art of early churches is clear to see. The use of nimbi foretokens the Christian convention for depicting Christ and the saints; the wreath-bearing eagle prefigures the dove in the apses of Christian basilicas; and the decoration of the apse with painted images in place of a cult-statue also points ahead to Christian practice. More generally, the

combination of animated and spatially conceived figure-scenes on the side walls with hieratic images in the apse is a formal principle destined to be repeated in Christian basilicas.

The popularity of standing figures in ceremonial dress or uniform extended also to the paintings of aristocratic villas of the period, where they perhaps represent a new kind of self-advertisement on the part of the wealthy owners. Where the nobles of the late Republic had displayed their culture with exhibitions of Greek-style paintings, the new governing classes glorified their public service and achievements. In the grand villa at Piazza Armerina in Sicily, datable to the first quarter of the fourth century, nearly life-size figures of soldiers, officials and the like decorated important areas of passage and circulation, namely the vestibule, peristyle and ovoid courtyard (most of the major reception rooms were faced with marble veneer). Particularly interesting are robed figures on the walls adjacent to the main entrance, which may have represented male members of the owner's family; they were accompanied by military standards, possible allusions to careers in the army. That portraits of this type appeared in fourth-century villas is confirmed by a letter of Symmachus, the distinguished orator and politician, which reveals that one of his villas contained paintings of a previous owner, Septimius Acindynus, the consul of 340, and of his father

and father-in-law; the father-in-law, who had held priestly office in Athens, was depicted in a Greek mantle, the father, a Roman magistrate, in a ceremonial toga, and Acindynus himself, a former praetorian prefect for the eastern provinces, in a military cloak.

Some of the figure-paintings described above offer hints of a new classicising phase which reaches its climax in the reign of Constantine. Already at Luxor many of the individual figures can be seen to have been fully modelled in terms of light and shade, and in the side friezes at least a sense of spaciousness is invoked by the use of back views, overlapping, cast shadows and a rudimentary suggestion of hills in the background. Under Constantine we meet with paintings in which plastic forms and spatial settings are combined with the characteristic restful contours and dignified restraint of classical art. Constantine sought to legitimise his rule by associating himself with the great emperors of the past (thus his triumphal arch in Rome incorporates reliefs taken from monuments of Trajan, Hadrian and Marcus Aurelius, in some of which the heads are reworked to create portraits of Constantine and his circle); and it would be fully consonant with this ideological stance if contemporary official painting echoed the style of earlier centuries. Of prime importance is a frieze of almost life-size figures in a corridor, perhaps part of an official building, excavated near the Lateran Basilica in Rome.

213 Dea Barberini. Rome, precise provenance unknown. Third or fourth decade of 4th century A.D. National Museum of the Terme.

214 Perseus and Andromeda. Rome, from Capitoline, painted lunette of niche. Second half of 4th century A.D. Antiquarium Comunale. H. 1.32 m.

Probably representations of deities, these figures are carefully rounded with a subtle use of shadows and highlights, yet at the same time stand out in grand isolation against a featureless white ground. Very similar is the so-called Dea Barberini (also from Rome but without a precise provenance), a painting of a majestic seated goddess dressed in gold and purple [213]. With a little winged figure of Victory supported on her right hand, a spear or sceptre in her left and a shield at her side, she is a distant descendant of Phidias's great statue of Athena Parthenos set up in Athens some 700 years earlier. The subject is here, however, probably Venus (the helmet is an eighteenth-century restoration). It has been suggested that the figure reproduces the cult-statue of the temple of Venus and Rome, restored between 307 and 314.

Similarly traditional in style are the paintings of a room excavated underneath the cathedral at Trier in Germany. Trier was the capital of the north-west provinces in the period of the Tetrarchy, and the room in question may have formed part of the imperial palace, or at least of a residence associated with the imperial court; its decoration is thought to have been completed not many years before its destruction to make way for the cathedral, begun in the late 320s. Here, as invariably in the history of Roman painting, the use of chiaroscuro and foreshortening in the rendering of the figures was accompanied by a revival of illusionistic

framing devices. The wall-paintings, still to be restored, showed single standing figures between *trompe l'œil* pilasters. The ceiling, which has been reassembled from thousands of fragments, was decorated with a series of busts and with pairs of Cupids (or in one case Cupid and Psyche) set in coffers framed by *trompe l'œil* mouldings. The subject-matter of the ceiling has provoked extensive discussion, in which the crucial problem is the identity of the busts. These fall into two main categories: bearded men of the stamp of philosophers or poets (one holds a scroll) [Pl. XVIB], and nimbed, veiled females, one drawing a necklace from a jewel-box [Pl. XVIC], another holding a wine-cup, and a third admiring her reflection in a mirror. Another nimbed bust, less completely preserved, was evidently equipped with a lyre. Among the suggested identifications are portraits of personages of the imperial family and court, personifications of the pleasures and intellectual pursuits appropriate to the cultured classes of the period, and a combination of historical portraits and abstract ideas bound together in an elaborate programme focused on an ideal portrait of Constantine's empress Fausta in the guise of Health (Salus) and Youth (Iuventus). None of these ideas is completely satisfying, because we lack the comparative material to arrive at secure conclusions; the busts in fact give the impression of being quotations from fuller paintings where the context (or labels) would have made the

meaning clear. Perhaps these prototypes, like many of the reliefs on Constantine's arch in Rome, go back to the second century. At all events the style of the figures fully accords with the classicising taste which prevailed in good quality paintings of the Constantinian period; not only are the forms and draperies competently modelled in terms of light and shadow, but the varied movement and three-quarters views of the pairs of Cupids [Pl. xvid] recall many similar groups in the painting of earlier centuries. The neutral blue background of all the panels is, however, very much a contemporary feature; and the general predominance of blue and red in the ceiling reflects a favourite late antique colour combination, paralleled in many of the surviving paintings at Piazza Armerina.

These Constantinian paintings represent the swan-song of the Graeco-Roman illusionistic style in its pure form; by the second half of the fourth century the tendencies which were to lead to Byzantine and medieval painting had gained the upper hand. Illusionistic architecture was dissolved into pattern-like forms in bright and contrasting colours (decorations from Lullingstone and Caerwent in Britain); figures became hard and linear with shadows used to reinforce contours rather than to express form. At the same time the peace of the Church and the triumph of Christianity presaged the phasing out of pagan iconography in favour of Christian subjects, such as the *orantes* of Lullingstone and the Old Testament legends painted in the catacombs. As a final example of the Roman tradition we may take a large-figure version of the old Nician composition of Perseus and Andromeda found in a niche on the slope of the Capitoline hill in Rome [214]. For all its classical pedigree, this picture, dated to the second half of the fourth century, demonstrates the stiffening and simplification characteristic of late antique art, with the figures turned uncomfortably into almost frontal postures (that of Perseus, who seems to be seated, is evidently misunderstood), and with strong emphasis being placed on the outlines. The colour scale is simplified, the changing surface-tints of earlier periods being abandoned in favour of homogeneous tones, mainly browns, purples and greens.

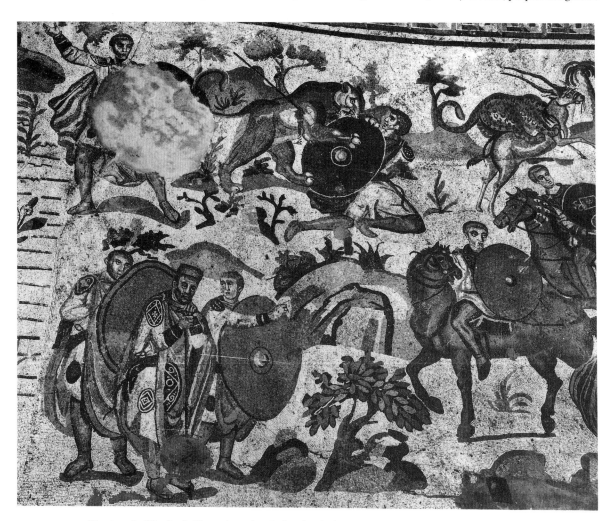

215 Hunting of wild animals. Piazza Armerina (Sicily), detail of mosaic pavement. First quarter of 4th century A.D.

The features are conventionally drawn, with eyes framed in black, noses and mouths indicated with a few dark strokes, and the hairline straight across the forehead. As the last known pagan mythological painting in the old metropolis (now replaced by Constantine's new capital at Byzantium), this work provides an interesting comment on the tenacity of the old iconographic formulae while at the same time illustrating the victory of the new artistic grammar.

Artistic leadership had now passed definitively to the other media of interior decoration. In floor-mosaics the late third and fourth centuries saw vigorous developments in various parts of the empire. In Italy, for example, a preference for polychrome mosaics began to overtake the black and white style, leading eventually to the brightly coloured 'carpet'-style pavements of the early Christian churches in Aquileia and Grado. No region was more influential, however, than north Africa, and no development more important than that of the large-scale compositions depicting scenes from hunting, the amphitheatre, the circus and rural life which became popular there during the third century. These were laid out in a series of polychrome figures and groups distributed at different levels on a white ground (cf. [215]). The African style enjoyed a wide success during the fourth and fifth centuries, influencing mosaics in Spain and Italy and ultimately spreading, in modified form, even to Syria and Palestine, traditional strongholds of the *emblema*-type panel.

More directly prejudicial to the future of painting was the other main branch of the mosaic art: wall- and vault-mosaic. This had appeared first in the late Republic and early Empire, and its early manifestations included the brightly coloured fountain niches in the gardens of Pompeii and Herculaneum [100]; but during the mid Imperial period its most important role was on the soaring vaults and domes of the great public baths of Rome. Almost no trace of these has survived, and the best preserved vault-mosaics of the third and fourth centuries are on a very small scale or untypical of their kind. That of tomb M in the Vatican cemetery (first half of the third century), though providing an interesting foretaste of the art of Byzantium in its Christian themes and its use of a gold background, is a tiny piece of work which gives little inkling of the effect of large-scale compositions. That of the anular ambulatory in S. Costanza (mid fourth century) employs a white background, and the patterns and subjects seem to be those of contemporary pavements rather than of vaults – amongst them African-style all-over designs with vintaging Cupids and a miscellany of birds, vases and sprigs of fruit derived ultimately from Hellenistic prototypes. Rather more typical of vault-mosaics was the lost decoration of S. Costanza's dome, known from old drawings. This, like the roughly contemporary mosaics of a domed mausoleum at Centcelles, near Tarragona in Spain, incorporated numerous features alien to floor-mosaics, including a degree of illusionistic recession, the use of imitation supports (caryatids in S. Costanza, columns at Centcelles), and coloured backgrounds for parts of the design.

It was the tradition of vault- and wall-mosaics which was to have the greatest artistic importance in early Christian and Byzantine decoration. The marvellous series of mosaics, generally with backgrounds of dark blue and gold, which are the crowning glory of the fifth- and sixth-century churches of Ravenna, Rome, Milan and Thessaloniki are the inheritors of the techniques of 'painting in stone' devised during the Roman period. Their permanence, the brilliance of their colours, their shimmering effect, their suitability for producing the hard unmodulated style favoured in late antiquity – all commended them, rather than frescoes, to the early church-builders. Not that fresco-painting went out of fashion: it probably continued as the standard form of mural decoration in the less opulent and ambitious buildings (even if there is little surviving evidence before the sixth and seventh centuries). But much of the technical competence and artistic virtuosity of the best Roman work was lost, not to be recovered till the great classical revival of the late fifteenth and early sixteenth centuries.

IO

Technique

The technique of Roman wall-painting naturally varied according to the quality of the decoration; generally speaking more careful and elaborate techniques prevailed in the more finely decorated rooms of a house, especially those with a coloured ground, and in the period from the second century B.C. to the third century A.D., after which a decline in quality became general. The finest technical quality of all is found in the First, Second and early Third Styles.

For our information on the actual processes employed we can refer partly to literary evidence, and partly to the surviving remains. By far the most important literary evidence is a passage in Vitruvius's book on interior decoration, in which he describes the preparation of the plaster, the manner of its application, and the pigments and dyes used by painters. As a practising architect familiar with the craftwork of the early Augustan period, Vitruvius is an invaluable witness, even if he tends to assume a certain basic knowledge in his readers and does not spell out in detail, for example, what tools were used and how painters carried out the different stages of their task. Next to him Pliny, who was no expert and refers to technical matters incidentally to his comprehensive survey of minerals, is of marginal value, though he adds a few interesting details about pigments. The surviving remains include not only the paintings of Rome and Pompeii, where we have the advantage of being able to see technical features on intact or nearly intact decorations, as well as upon decorations which remained unfinished, but also the often fragmentary material from archaeological sites in the provinces. Less embarrassed by riches, provincial archaeologists have been more zealous in subjecting their miserable fragments to scientific analysis; so we are often better informed about materials and techniques here than for the well-preserved decorations of Roman Italy.

The technical procedures can be divided into two main stages: the application of the plaster and the application of the paint.

Plastering

In plastering the first step was to ensure good adhesion to the underlying surface. Where this surface was rough or absorbent, as was the case with brickwork, most types of stonework, the reeds normally fastened to the underside of suspended ceilings, and the occasional surface of interwoven slats, there was no need to take special measures; but on smooth surfaces some form of key had to be prepared. The main evidence comes from daub or cob walls, which were scored or imprinted, while still soft, with crisscross or herring-bone patterns [216]. A similar preparation was also sometimes carried out on a render coat. Where an underlying surface was hard or dry, however, and particularly when a new coat of plaster was to be applied over a pre-existing decoration, a key was prepared by pecking the surface with a pick-hammer or similar implement [217]. The signs of this process, as of the more common herring-bone keying, are frequently visible in relief on the reverse of plaster fragments even when the wall itself has perished.

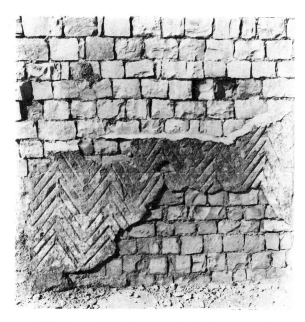

216 Wall-plaster with keying pattern for final coat. Vaison-la-Romaine (France), House of the Messii.

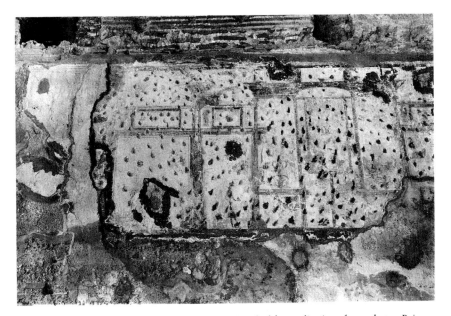

217 Wall-paintings (beginning of 1st century A.D.) pecked for application of new plaster. Baiae, Baths of Sosandra.

The plaster was built up, as it is today, in a number of coats. These were based on slaked lime (calcium hydroxide) which, when mixed with water to produce a creamy suspension or putty, gradually 'sets' by taking up carbon dioxide from the air and drying out to form calcium carbonate, chemically the same thing as limestone and marble. The lime putty was invariably mixed with some form of gritty material to give it body and to allow the ingress of air for the setting process. In the undercoats this was normally sand and fine gravel, incorporated in the ratio of two or three to one (as in mortar used for bonding purposes); in the finishing coat or coats, where a fine white appearance was desired, it was frequently some form of powdered limestone or (ideally) marble dust, incorporated in the ratio of one or two to one. Another material occasionally added was crushed brick or powdered pottery; Vitruvius recommends it for damp places, and indeed a pinkish plaster containing fired clay particles is often seen on exposed walls or on the lowest metre or so of internal walls. As in modern cement, the alumina, and particularly reactive silica, content of the fired clay confers hydraulic properties, that is the ability to set in an entirely different way, by hydration, which allows it to harden in damp conditions and subsequently to be waterproof.

The number of coats of plaster varied according to the period and the circumstances. Vitruvius, ever the perfectionist, and writing at a time when technical standards had achieved their highest level of excellence, recommends, in addition to a render coat, no less than six coats of wall-plaster, three incorporating sand and three marble-dust. For his vault, which had a suspended ceiling, with reeds attached to a wooden framework, he naturally lightens the weight, but still prescribes three coats: first a render coat, then a plaster containing sand, and finally a plaster containing marble-dust or '*creta*' (here probably chalk). One or two good quality decorations actually measured up to Vitruvius's ideal. In the House of Livia and the Farnesina villa in Rome, both perhaps properties of the writer's imperial patrons and decorated about the time that he was writing, conservators have been able to recognise examples of the six-layer technique, with three undercoats composed of a mixture of lime, sand and *pozzolana*, and three coats of lime, sand and either marble-dust (the Farnesina villa) or alabaster-dust (the House of Livia). Even at Pompeii multi-layer techniques are not unknown during the First and Second Styles. One example of the First Style is precisely comparable to Vitruvius's description, with a render coat in a kind of cob (clay mixed with sand and lime), three coats of plaster containing sand, and three coats of plaster containing marble-dust. But the vast majority of wall-plasters, both at Pompeii and elsewhere, are simpler. A reasonable norm would be two undercoats containing sand, and a finishing coat containing limestone or the like. But sometimes this would be reduced to a single undercoat and top coat, or even, in inferior work, to an undercoat with a simple whitewash. Vitruvius himself admits that there was a gap between his ideal and what happened in practice, for he specifically warns of the faults that may arise 'when only one coat with sand and one with powdered marble are applied'.

The object of multiple layers was partly to smooth out irregularities in the wall-fabric (for the first coats Vitruvius

insists on careful checking with rule and line, plumb-bob and set-square) but mainly to create a well-compacted and homogeneous mass which would present the optimum conditions for painting. Each new coat was applied before its predecessor was quite dry, and the later coats were made progressively thinner. These measures ensured that the moisture in the plaster was initially drawn inwards by capillary action, thus helping to bond the coats together, while the lower ones were thick enough to prevent the porosity of the wall-fabric, especially in masonry walls, from drying out the material too rapidly. By the time the last coats were going on the whole was firm enough to withstand the pressure which had to be exerted to achieve a smooth and durable finish. Eventually, when the plastering was completed, the moisture within the wall would be drawn back to the surface, providing the ideal conditions for the frescoist.

The main implements used by plasterers were very similar to those used by their modern counterparts: the mason's trowel (*trulla*) for applying the material and the float (*liaculum*) for smoothing and polishing it. Many examples of iron trowel-blades, rhomboidal or leaf-shaped with an offset tang for insertion in a wooden handle, have been found in Pompeii and at other Roman sites [218]; and

the tool is also represented on funerary reliefs in France and Germany, along with other masons' tools. Floats were depicted on a Pompeian painting, now lost [219], and on a Gallo-Roman relief at Sens [234], both showing decorators at work, while an actual wooden example was recovered from a well in the Saalburg Roman fort in Germany [218].

Painting

As soon as the surface was ready the painter began his work. There is little doubt that the basic technique of Roman wall-painting was fresco: in other words the pigments were applied while the plaster was still damp and were subsequently fixed by the chemical reaction as the evaporating water brought the setting lime to the surface, forming a transparent grid of calcium carbonate crystals over them. This is clearly the process that Vitruvius describes, even if he did not understand how it worked: 'When the colours are carefully laid upon the damp plaster, they do not fail but are permanently durable, because the lime has its moisture removed in the kilns, and becoming porous and feeble, is compelled by its dryness to absorb whatever happens to present itself ... So well-made plaster never wears out from old age, nor loses its colours when they are wiped, unless they were applied carelessly and on a dry surface.'

218 Plasterers' tools (wooden float and trowel blades). Saalburg (Germany), fort.

219 Painting of plasterer at work (now lost). Pompeii IX 5, 9.

The modern writers who have postulated other techniques do not take sufficient account of Vitruvius's testimony. E. Schiavi's idea that wall-painters used an 'encaustic' technique, involving the pigments being 'burnt in' with a hot iron, is certainly excluded. Although Vitruvius (followed by Pliny) describes a method of heating the wall as part of a process of spreading melted wax over surfaces painted with cinnabar, this was evidently an abnormal measure necessitated by the peculiar needs of a specific pigment, which otherwise tended to turn black on exposure to light (see below, p. 209). The very fact that it is recorded in this context shows that it was not universal. Pliny actually states that the encaustic method was 'alien to walls', though common for painting on ships: in other words it was used on wood (and, as he tells us elsewhere, on ivory) rather than on plaster. S. Augusti's theory that the painters worked in a pure tempera technique, that is a process whereby colours are applied to a dry surface with the aid of an organic binding medium, is seen to founder on both literary and archaeological evidence. He argues, from analyses of samples from Pompeii, that the pigments were mixed with a calcium soap to which hot wax was added; they were applied, in addition, over a priming coat which consisted of a similar mixture, containing chalk in suspension. Vitruvius, it is true, tells us that black pigments and certain organic dyes had to be mixed with a medium to make them suitable for wall-painting (see below, p. 209); but these were clearly exceptions to the rule: for the majority of pigments in standard use he mentions no such preparation, and the obvious inference is that none was necessary. Furthermore, if tempera had been widely used, one might have expected greater signs of deterioration or discoloration of the pictorial surface due to the action of micro-organisms under the various conditions of burial. Most telling of all, where wall-paintings have been exposed to intense heat, one would expect any medium to have been charred. At Pompeii and Herculaneum, although the standard yellow pigment has frequently turned red as a result of dehydration, a chemical reaction which requires a heat of at least 300° Centigrade (see below, p. 208), none of the other colours seems to have been affected.

There is, by contrast, unequivocal evidence of the use of true fresco not only at Pompeii and Herculaneum but also at innumerable other sites. On a plain white background in particular one can frequently see how the painter's brush strokes have created slight furrows in the surface or have smoothed out irregularities in the soft plaster. On a well-burnished or coloured background slight indentations and a greater intensity of colouring round decorative details reveal how the craftsman worked the surface with some kind of blunt tool after the initial painting, in order to squeeze out extra lime-water for the fixing of the pigments. In some cases, especially beneath figure-motifs and other areas which required careful brushwork, there are also tiny oblique indentations left by the artist's finger-nails as he used his free hand to support the hand that held the brush. If the surface had been dry, it would not have been necessary to take such elaborate precautions to avoid resting the brush hand directly on the wall. The most characteristic hallmarks of fresco-painting, however, are the tell-tale seams which separate the so-called *giornate di lavoro* – areas of plaster applied on different days to delimit the amount of painting to be completed in each session. These are everywhere to be found in Roman murals. Sometimes, as in the House of Livia [220], it has been shown that the different work-areas were executed in different grades of plaster – relatively coarse for the plainer parts, finer for decorative features and figured panels. In one house at Pompeii, the House of the Iliadic Shrine, there are decorations in which work has been left uncompleted; and in each case only the part of the wall that was actually

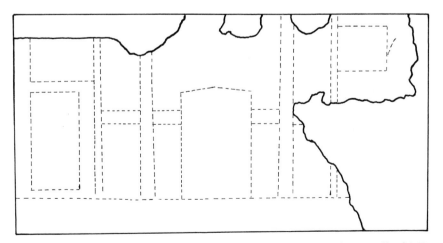

220 Diagram of 'giornate di lavoro'. Rome, House of Livia, *'tablinum'* (south-west wall) (cf. [35]). Soon after 30 B.C.

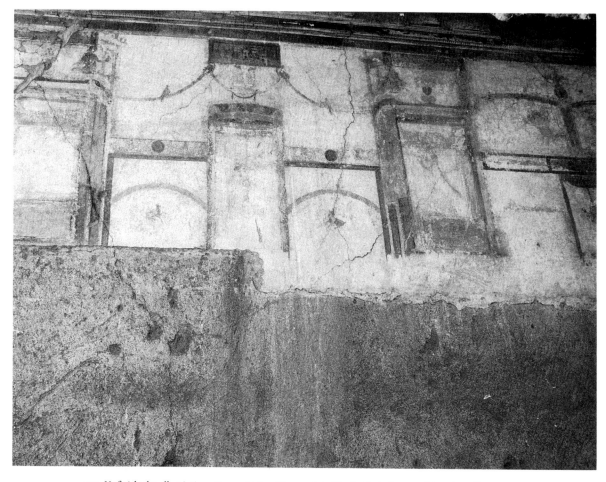

221 Unfinished wall-paintings. Pompeii I 6, 4 (House of the Iliadic Shrine), room *h* (south wall). A.D. 62?

being painted had received the final layer of plaster. The process is clearest in a bedroom to the left of the *atrium*, where the upper zone of the wall has been plastered and painted but the rest remains bare [221]; the decorator had begun to trim the lower edge along a line in readiness for the application of the next stage of plastering, but was interrupted before he could complete his task. How closely the painter had to follow on the heels of the plasterer is implied by the above-mentioned Gallo-Roman relief, which shows a plasterer and painter working simultaneously on the same scaffolding [234].

All this does not preclude the occasional use of tempera, especially where for one reason or another the plaster had become too dry for the operation of true fresco. At Cologne chromatographic analysis of a sample from the Roman buildings beneath the cathedral has revealed traces of amino-acids, which would be consistent with the use of pigments mixed with animal-size. Paintings from the fort at Echzell in Germany were adjudged to have been executed on dry plaster with a medium of lime and casein. Two sam-

ples from Stanton Low (Buckinghamshire, England), both of a thick purple-red paint, contained a small amount of extractable, glue-like protein, which presumably again derived from a binding medium. Beeswax has been identified in samples from Thistleton (Leicestershire, England). Such discoveries, together with the testimony of Pliny that size made from the ears and genitals of bulls was used 'by painters and physicians', confirm that a medium was sometimes employed. The fact that tests for organic media have often proved negative could clearly be due to decay. On the other hand, even the presence of a medium does not necessarily rule out a fresco technique. A very dilute size solution will merely retard the normal setting process of the lime; so it is possible by painting colours in such a solution to secure a binding with both lime and size. That pigments mixed with size could be applied in the fresco technique is illustrated by Vitruvius's account of the production of black (p. 209).

Fresco-painting was naturally carried out from the top of the wall to the bottom. Normally, in rooms of manage-

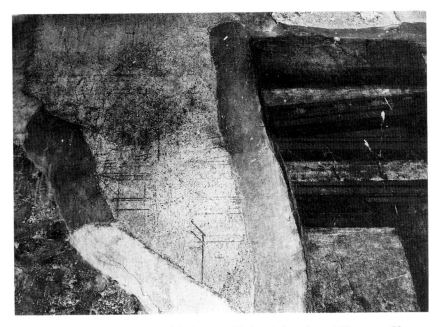

222 Ochre 'sinopia' on undercoat (left) for Second Style paintings. Pompeii VI 11, 9–10 (House of the Labyrinth), *œcus* 43 (east wall). Third quarter of 1st century B.C.

able size, the surface was divided into three horizontal stages which corresponded to the three characteristic zones of the decoration; indeed the emergence of the trizonal system may have been partly promoted by the technical demands of fresco. Vertical divisions are less common, because Roman plaster was thick enough and well enough compacted to retain its moisture for long periods; but in large and elaborately decorated walls like those of the *oecus* (A) in the Villa Imperiale at Pompeii and of the '*tablinum*' in the House of Livia, they were found necessary in order to break down the surface-area into smaller units. Like the horizontal joints, vertical joints were for obvious reasons made to coincide with lines in the decorative scheme.

In mapping out his decoration the painter would frequently have drawn guide-lines in the plaster. Especially in the period of the Second Style these were applied in red ochre, like the Renaissance *sinopia*; and in one instance at least, a fragment preserved in the Corinthian *oecus* of the House of the Labyrinth at Pompeii, the ancient artist has actually anticipated his Renaissance counterpart by putting his 'sinopia' on the coarse undercoat rather than the final surface [222]. In later times the more usual practice was to score guide-lines with a pointed implement on the final surface. This was particularly necessary for geometric patterns where a high degree of precision was desired (though the painter did not always follow the lines with adequate care), but it was also employed to sketch out figures and figure-groups [223]. For long straight lines, however, it was sometimes found easier to use the tech-

223 Incised preliminary sketch for painting of a griffin. Pompeii VI 8, 23–4 (House of the Small Fountain).

nique called 'line-snapping', that is stretching a line taut across the damp plaster then drawing it back and letting it recoil on to the surface, so as to leave an imprint. The advantage of scoring and line-snapping was that they left no distracting traces of colour; once the painting had been completed they were virtually invisible, except to close inspection.

One of the characteristics which distinguish the better quality Roman wall-paintings, particularly those with coloured backgrounds, from their Renaissance and post-Renaissance successors is the brilliant sheen of the surface. Various writers have suggested different means by which this could have been achieved. Augusti attributes it to the wax in his medium, but it seems likely that wax would produce a dull gloss rather than a brilliant lustre. P. Mora believes that *boli*, or argillaceous earths like kaolin, were added to the pigments so as to make them susceptible of receiving a polish; but this theory rests partly on a mistranslation of Vitruvius, and in Cologne at least no kaolin could be detected in analyses. W. Klinkert suggests that a mixture of size and marble-dust was rubbed over the paintings. What is clear is that the surface was burnished with floats or similar implements after the ground colours had been applied: the relevant sentence of Vitruvius is best translated, 'But when the plaster has been rendered solid by working over with floats and smoothed till it has the firm whiteness of marble the walls will have a brilliant lustre when the colours are laid on and polished.' Microscopical examination of the paintings from the House of Livia revealed that the grains of alabaster grit in the plaster surface were rounded by friction, and Roman paintings frequently show tiny parallel scratches identical to those left on fresh plaster by the passage of a hard stone or metal object. It is possible that a lime-plaster containing powdered marble or other crystalline varieties of calcium carbonate will take a polish from simple burnishing. A related, if slightly different, effect has been observed by analysts at Cologne. They found that the red paint in their samples was full of calcite crystals, which they concluded had been deliberately mixed with the pigment to produce a glinting quality; working of the plaster by the craftsman would force the tiny mirror-like faces of the crystal fragments to align themselves in the plane of the surface and thus reflect the light.

For ornaments and figures painted over coloured grounds, whether or not they were prepared with preliminary sketches, adhesion was secured by one of the methods already adumbrated. If the plaster was still sufficiently damp, pressure was exerted with a rubbing stone or the like to bring more lime-water to the surface so that the motifs could be painted in *buon fresco*. If it was already dry, the colours might be applied either in *fresco secco*, that is mixed in a specially prepared solution of lime-water, or with an organic medium which would 'glue' them to the surface (the tempera technique). Where parts of the figures or ornaments have fallen away since antiquity, this was presumably either because insufficient lime had been present for the fresco technique to work properly or because the binding medium that had been chosen proved ineffectual. Sometimes, to ensure better adhesion, the motifs seem to have been burnished into the background after painting. This could only work if the plaster was still soft, and it would inevitably result in a loss of sharpness. It was more usual, therefore, to leave the paint unburnished, so that it has a matt appearance and stands slightly proud of the glossy background.

For more complex painting, and especially for panel-pictures, where the artist needed plenty of time, fresh plaster would often be applied, even at the expense of chipping away a surface which had already been laid. A clear illustration was provided during the 1940s conservation of the paintings from the House of Livia, which showed that each of the main mythological panels, as well as the architectural vistas, had been treated as separate *giornate* [220] (cf. [35]). A similar observation has been made on plaster from the Farnesina villa. In most ateliers these elements were certainly painted by a different artist or artists from those who did the background (the *pictor imaginarius* as opposed to the *pictor parietarius*: see below, pp. 213, 215–17) and there is even evidence of some panels being painted in a workshop and installed in the wall after completion. This latter practice, similar to the production of mosaic *emblemata* for insertion in pavements, would account for the original presence of wooden frames and backings attested by imprints round certain panel-pictures; they would be the remains of trays, like the stone or terracotta trays in which mosaic *emblemata* were set for ease of transport. In an example at Herculaneum the charred remains of a wooden frame were found in position surrounding a painting of Cupids playing with the attributes of Apollo. At Pompeii there are several straight-edged voids which may have held such 'studio'-prepared panels; one or two of them retain the imprints of backing timbers used to reinforce the trays and the remnants of nails used to secure them to the wall.

Repairs to worn or damaged frescoes are a familiar feature at Pompeii and elsewhere. They could either affect the whole surface of a wall or ceiling, in which case more often than not a new layer of plaster was simply spread over the old; or they could be confined to one part of the decoration, such as a dado which had been scuffed by feet or chipped by furniture. A peculiar form of repair at Pompeii was the patching of cracks and the like created by the earthquake of A.D. 62. In such cases, as in the preparation of panel-paintings described above, the surface surrounding the area which was to be made good was chipped away, generally as far as some convenient decorative division which would help to make the reworking less conspicuous. Then new plaster was added and painted in the normal way. There are countless examples of Pompeian repairs which have

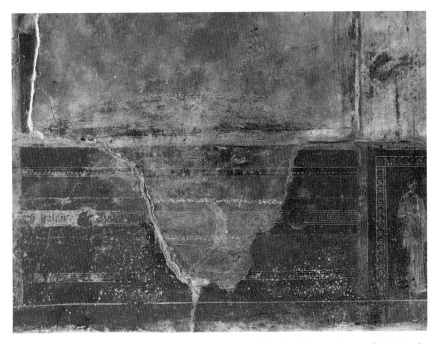

224 Repair in painted dado. Pompeii VII 2, 45 (House of the Bear), *fauces* (west wall). Original painting between *c.* A.D. 50 and 62; repair between 62 and 79.

been toned in with the surrounding decorations so that they are scarcely distinguishable from *giornate di lavoro*, except by their better preservation or by subtle stylistic variations. Good examples appear in two of the three walls of an open-fronted *oecus* in the House of the Menander, where a vertical swathe incorporating the central picture-panels has been replaced from ceiling to floor, no doubt as a result of earthquake fissures; visually the repainting can only be detected from the greater freshness and better preservation of the colours, from slight changes of the decorative motifs on either side of the seams, and from the differences in style, theme and composition between the two newly painted mythological panels and their counterpart on the third, unrepaired wall. Here the original decoration and the repair both date to the period of the Fourth Style, and the differences in style, in so far as they are not simply the result of a change of workshops, represent no more than the differences between the early and late versions of that style; but elsewhere repairs were made to considerably earlier decorations, dating back as far as the Third, Second or even First Styles. In such circumstances attempts were usually made to reproduce the earlier manner, sometimes with great fidelity to the original detail, at other times in an altogether rough and ready fashion [224]. Sometimes no real attempt was made to harmonise styles. A main zone in the Second Style, for example, may be combined with a dado or ceiling in the Fourth; and even within a single zone there may be an abrupt change from one period to another. A

striking example can be seen in the west wall of the *atrium* of the House of the Theatrical Panels, where a fine Third Style decoration has been crudely patched with Fourth Style paintings which not only substitute the delicate polychrome ornament of the original by characteristic monochrome embroidery borders but also change the colour of the main fields from sky-blue to yellow [225].

An interesting corollary to repairs in older styles is the possibility of reuse of earlier panels or emblems. In the context of public art and the art 'trade' we hear about the cutting of plaster from old walls to display as framed panels, a practice which was clearly an aspect of the same antiquarianism that led to the collecting of Greek sculptures or of 'old-master' pictures. Vitruvius and Pliny tell us how paintings cut from walls in Sparta were set in wooden frames and brought to be exhibited in the Comitium in Rome in 68 B.C.; and Pliny, quoting Varro, reports that plaster panels were cut from the walls of the ancient temple of Ceres in Rome at the time of a restoration, again to be set in framed panels. Elsewhere, in a passage praising the quality of plaster made by the Greeks, Vitruvius hints that the practice was fairly common. Some of the panels acquired in this way were no doubt reset in walls, like the prefabricated paintings of contemporary decorators (or, in a different medium, the paintings on marble plaques found at Herculaneum and elsewhere). On a more mundane level we find fragments of earlier paintings at Pompeii and Herculaneum being salvaged for reuse in later schemes.

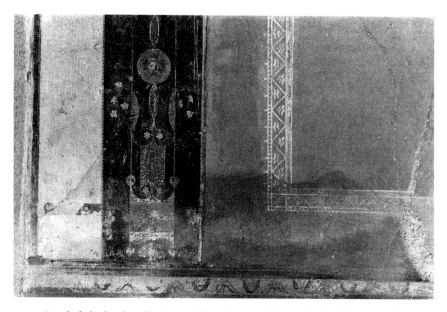

225 Detail of Third Style wall-paintings (left) with repair in Fourth Style (right). Pompeii I 6, 11 (House of the Theatrical Panels, or of Casca Longus), *atrium*. Original paintings second quarter of 1st century A.D.; repair between 62 and 79.

226 Theatrical masks: fragment of Second Style painting inserted in decoration of Fourth Style. Pompeii VII 16, 17 (House of Ma. Castricius), *triclinium* 25 (formerly House of M. Fabius Rufus, third level, room 12), north wall. Third quarter of 1st century B.C. H. 35 cm.

227 Theatrical masks (Fourth Style). Pompeii VII 16, 17 (House of Ma. Castricius), *triclinium* 25 (formerly House of M. Fabius Rufus, third level, room 12), south wall. Third quarter of 1st century A.D. H. 32 cm.

The most spectacular evidence was afforded by the discovery in 1761 of seven figured panels of the Third Style stacked at the foot of a wall in Herculaneum; they had evidently been cut from damaged decorations and were waiting for a new home. Other examples can actually be recognised in completed schemes, such as that of a room in the House of Ma. Castricius at Pompeii where a group of theatrical masks from a Second Style decoration [226] has been inserted into a wall of the Fourth Style; here the later decorator has painted a companion-piece with a similar group of masks in a contemporary style whose harshness in comparison to the fluency of the earlier group is painfully obvious [227]. In the peristyle of the house VI 15, 23 two figure-panels of the Third Style were reused in an otherwise undecorated surface of coarse plaster perhaps dating to the post-earthquake period. Elsewhere, as in certain rooms of the Villa Imperiale and in room 11 of the House of Augustus in Rome, holes mark the former positions of panels and emblems which were evidently removed in antiquity at the time that the house was abandoned [228].

Even more interesting is a decoration in the House of the Four Styles at Pompeii, where a figure excerpted from a Third Style wall has been set in a decoration of the Second Style [229]. The householder's attachment to past fashions here extended to salvaging a piece from one old scheme and inserting it in an even older one.

For the pigments used by wall-painters we have the results of analyses carried out on samples from Pompeii, Cologne, York and other sites, as well as the accounts given by Pliny and Vitruvius. In commonest use were the naturally occurring earth pigments. The standard red is anhydrous ferric oxide, which occurs both in crystalline form (haematite) and in earthy form (red ochre); its most famous ancient source was Sinope on the Black Sea, but Vitruvius mentions also Egypt, the Balearic Isles and the North Aegean island of Lemnos, while Pliny adds north Africa and Cappadocia (in eastern Turkey). Yellow is hydrated ferric oxide, derived from crystalline goethite or found in earthy form (yellow ochre); the most famous ancient variety, from Attica, had been exhausted by

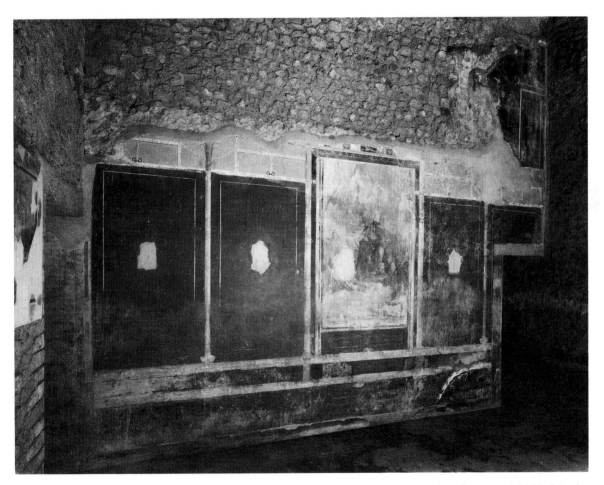

228 Wall-painting with emblems cut out in antiquity. Pompeii, Villa Imperiale, *triclinium* (C). Dado and main zone Third Style (end of 1st century B.C. or beginning of 1st century A.D.); upper zone Fourth Style (mid 1st century A.D.).

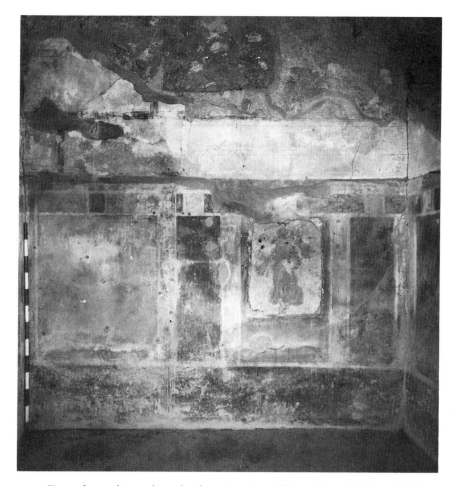

229 Figure of maenad inserted in earlier decoration. Pompeii I 8, 17 (House of the Four Styles), bedroom 4 (west wall). Original decoration Second Style (1st century B.C.); inserted panel first half of 1st century A.D.

Vitruvius's time, but there were many other sources, including some in Italy. When heated, this pigment loses water and becomes anhydrous ferric oxide, thus turning red – a phenomenon frequently observed on Pompeian plaster which was in contact with burning timbers at the time of the eruption. The standard green is green earth (*terre verte*), a pigment containing the minerals glauconite or celadonite, hydrosilicates of potassium, aluminium, iron and magnesium; Vitruvius tells us that it occurred in many places, but that the best variety was from Smyrna (Izmir, Turkey). A green pigment analysed at Cologne is said to have been identical in structure to celadonite mined at Verona and in Cyprus. White is usually some form of calcium carbonate, obtained from chalk or the like. A sample tested at Cologne consisted of dolomite, aragonite and calcite; the analysts suggest that it was derived from a chalk or a dolomitic limestone. A white named after Paraetonium on the coast of Egypt, but also found in Cyrene and in

Crete, was singled out by both Vitruvius and Pliny, the latter of whom refers to its richness and permanence. Another form of white listed by the ancient writers is white lead (basic lead carbonate) which was prepared by steeping lead in vinegar fumes; but this has not yet been identified in wall-paintings.

The normal blue is blue frit, or Egyptian blue, an artificially produced pigment consisting of copper calcium silicate in a glassy matrix. This is more or less coarse-grained (paler shades were obtained by finer grinding) and is sometimes mixed with or applied over white, perhaps to ensure its adherence. The production process, which was pioneered in Egypt and refined during the first century B.C. at Puteoli by the wealthy businessman G. Vestorius, consisted in rolling a mixture of sand, flowers of soda and copper filings into small pellets, which were then baked in an oven. The pigment was evidently marketed in the form of these pellets, because specimens are frequently discovered on

archaeological sites. Some have even turned up in the wreck of a ship which was carrying cargo from Italy to the south of France.

Black is carbon, obtained from soot or charcoal. Vitruvius describes various methods of manufacture, primarily a technique for obtaining soot from burnt resin; if this could not be managed, the alternatives were burning brushwood, pine-chips or wine-lees to get charcoal. In every case the resulting material had to be mixed with size, presumably in order to counteract the oily nature of the pigment, which would cause it to shed water. The addition of a medium was thus a matter of necessity; that black was none the less applied, like the water-dispersible pigments, in a fresco technique is indicated by decorations in Pompeii which have clearly been worked over after the application of a black surface-paint in order to bring up lime-water for overpainting. Samples of black submitted for scientific examination have been identified as deriving from charcoal (Downton, in Wiltshire, England) and bone-black (Verulamium); the black pigment at Cologne was mostly amorphous carbon, probably obtained from soot. As for media, a sample from the villa of Müngersdorf in the suburbs of Cologne is reported to have contained an 'organic substance', while Verulamium gave a positive test for protein (though this may have come from incompletely combusted animal matter rather than from a medium).

All the pigments so far mentioned fall into the category which Pliny defines as 'plain'. Certain more costly pigments were classed as 'florid'. Foremost among these was cinnabar (ancient *minium*), the native form of mercuric sulphide, which yields a sumptuous red – a red, however, which had the disadvantage of turning black on exposure to bright light and which was therefore unsuitable for use in peristyles, *exedrae* and other open spaces. To guard against this defect it was necessary to employ an elaborate technique which involved coating the finished surface with wax and oil, heating it, then rubbing it over with candles and linen cloths. Cinnabar is not commonly found, except in the richest decorations, including the Mysteries room in the Villa of the Mysteries, the large *oecus* (*q*) in the House of the Vettii, and at least three rooms in the House of Augustus; one of the reasons for its rarity was doubtless the trouble involved in protecting it. In some surviving decorations indeed, such as those of the *atrium* in the Villa of the Mysteries and of *oecus* A in the Villa Imperiale, the pigment has suffered the very discoloration which Vitruvius and Pliny warn against. Originally extracted from ore mined near Ephesus, cinnabar was by Augustan times being mined in Spain and brought to Rome for working under the supervision of public contractors.

Other 'florid' pigments in Pliny's list are 'armenium' (azurite), 'chrysocolla' (a green copper mineral, probably malachite), indigo and purple. The last two are not strictly pigments but organic dyes and, like a number of 'artificial' colours named by Vitruvius in his concluding chapter – a purple obtained from madder and oak-gall, a yellow from 'violae' (possibly in this context wall-flowers), etc. – are not known to have been applied directly to plaster in the normal way, but were impregnated in some other material such as chalk. In addition, we are told, true purple 'because of its saltness' must be mixed with honey to prevent it from becoming 'dry'. Although by their very nature more vulnerable than pigments, organic dyes when on mineral substrates and not exposed to the light can be quite stable, and analysts have detected both purple and indigo in paintings from Pompeii.

For all the variety of exotic possibilities available, the average wall-painter worked with a limited range of basic pigments. Any uncommon or pastel shades he could usually obtain by mixing; thus red and yellow would produce orange, red and white would produce pink, and so forth; or indeed impurities in the pigments themselves might provide him with the desired tone. Prices given by Pliny shed interesting light on the economic factors which would in practice have limited the palette. To take a few examples, the various types of yellow ochre cost from 6 *asses* ($1\frac{1}{2}$ sesterces) to 2 *denarii* (8 sesterces) per pound, red ochre from 8 *asses* (2 sesterces) to 2 *denarii* (8 sesterces), and blue frit from 8 *denarii* (32 sesterces: for Egyptian blue) to 11 *denarii* (44 sesterces: for Vestorian blue). The best quality of Paraetonium white cost $8\frac{1}{3}$ *denarii*. Against this may be set the prices of some of the 'florid' colours: up to 20 *denarii* per pound for indigo, up to 30 *denarii* for purple, and up to 75 *denarii* for *armenium* (though competition from Spain had subsequently brought this down to 6 *denarii*). For cinnabar it was necessary to impose a ceiling of 70 *denarii* by law to keep the price from rising beyond bounds. When one considers that this was nearly nine times the cost of the best red ochre, that from Sinope, it is small wonder that cinnabar was restricted to a relatively small number of particularly luxurious decorations.

Another colouring agent which was even more expensive, yet which was employed occasionally to enhance selected details in painting, as well as stuccowork, is gold leaf. It was too rare to be cited in Vitruvius's or Pliny's lists of pigments, but at least a dozen occurrences have now been recognised by scientific examination. Most, if not all, seem to have derived from ceilings or vaults, where the gold was out of harm's way. They extend from Colchester and London in Britain to Tel Anafa in Israel and Petra in Jordan, and chronologically from the second half of the first century B.C. at least to the middle of the second century A.D. From analyses that have been carried out it seems that the gold was normally applied over an undercoat of white or yellow with the aid of an organic medium such as size or casein.

The chief tool used by wall-painters was, of course, a brush (*penicillus*). Pliny reveals that plasterers' brushes were made of pigs' bristles, and the same probably applied to most paint-brushes, although finer hair may have been

230 Painters' equipment from tomb near Fontenay-le-Comte (Vendée, France).

231 Grave-goods including pigment-pots (front left), from tomb at Nida-Heddernheim. Frankfurt, Museum for Prehistory and Early History.

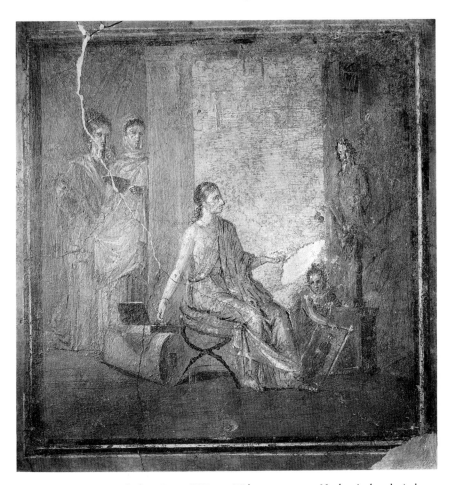

232 Paintress at work, from Pompeii VI 1, 10 Mid 1st century A.D. Naples, Archaeological Museum 9018. H. 32 cm.

used for finer work (in late medieval and Renaissance times, in addition to pigs' bristles, we hear of brushes made of squirrels' tails, badgers' hair and miniver). No doubt the brushes came in different sizes; a broad one would be used for large coloured surfaces, and narrower ones for more detailed work. No brushes complete with bristles have turned up in archaeological deposits; but brush handles of bone have been recognised, for instance, among the effects of a Roman tomb at St-Médard-des-Prés near Fontenay-le-Comte in France. The same tomb, while containing implements which were obviously used by a painter of wooden panels rather than of walls, gives a glimpse of the remaining apparatus which a wall-painter would have needed [230]: glass bottles containing pigments, palettes, a paint-box, a mortar and rubbing-stones for grinding colours, knives, bronze scoops and so forth. Other tombs, at Herne-St-

Hubert near Tongres, Belgium, and at Nida-Heddernheim in the suburbs of Frankfurt, Germany, have yielded sets of cylindrical paint-pots [231], while artistic representations of easel-painters from Pompeii and elsewhere show further examples of paint-boxes [232]. From archaeological sites where decoration was in progress we have examples of the rather more rough and ready containers pressed into service by wall-painters 'on the job'. These include standard drinking-beakers, the broken-off bases of cooking-pots, and potsherds or oyster-shells used as palettes. In addition to all these items associated with the application of the paint we must not forget the implements that would have been needed to lay out the decorative scheme, such as a chalk-line, plumb-bob, rules and compasses, and the pointed implements employed to score guidelines and to incise preliminary sketches in the plaster.

II

Painters and patrons

Whereas no mosaicist of the Roman age is recorded by name in the ancient sources, several painters are mentioned in the pages of Pliny and other writers. Going back to the mid Republican period, we hear that wall-painting was an activity not beneath the dignity of Romans of good birth. In 304 B.C. Fabius Pictor, a member of the distinguished aristocratic family of the Fabii, won fame as a painter by decorating the walls of the temple of Health in Rome. During the second century the dramatic poet Pacuvius (c. 220–c. 130 B.C.) attained scarcely less celebrity for his painting in the temple of Hercules at the Forum Boarium; Pliny tells us that 'he added distinction to the art of painting at Rome by reason of his fame as a playwright'.

Such instances were, however, certainly exceptions to the rule. Drawing (like music) was a part of the Greek educational curriculum which seems to have been rejected by the Roman upper classes. So painting was not usually regarded as an appropriate profession for men of standing, and most practitioners were of humbler rank, even if their work sometimes brought them honour and prestige.

During the second and first centuries B.C., the mania among the Roman nobility for collecting Greek pictures reached its height, and several of the panel-painters known to have worked in Rome were Graeco-oriental immigrants, or at least had Greek names. The Athenian painter Metrodorus was engaged by L. Aemilius Paullus to do the pictures for his triumphal procession in 167 B.C.; the Alexandrian Demetrius, the 'topographus' (painter of illustrated maps?), was living in Rome in 164 B.C.; Iaia of Cyzicus, one of a number of woman painters known from the Classical and Hellenistic ages, painted at Rome during the youth of the scholar Varro, i.e. about 100 B.C.; and a certain Sopolis, who figures in Pliny's catalogue of Greek painters, was active in Rome in 54 B.C. This does not necessarily mean, as some have assumed, that Greek artists enjoyed a virtual monopoly in picture-painting at this time. Pliny refers also to three or four panel-painters who were native Romans or Italians; and, though they are mentioned primarily for their social or anecdotal interest, he implies that at least two of them enjoyed some success. It is clear that, while Greek artists were especially esteemed, rather

like French chefs or hairdressers in modern times, they must have had many imitators of Italian or other non-Greek stock.

As in panel-painting, so in wall-painting it would be rash to assume that artists of Greek extraction played a dominant role. Some wall-painters of Republican times were certainly Greeks or had Greek names. From the late third century B.C. we hear of a painter with the Greek name of Theodotus working in a Roman context; and perhaps around 200 an artist from Asia named M. Plautius was honoured by the city of Ardea, south of Rome, for painting the local temple of Juno; he was undoubtedly of Greek blood, although a grant of citizenship had provided him with a Roman name. During the early Augustan period the Egyptianising elements which appeared in Second Style painting after the battle of Actium (pp. 38–9) may imply the arrival of Alexandrian artists in Rome. It has been suggested specifically that an Alexandrian painter was responsible for some of the decorations in the House of Augustus. But none of the other evidence which has been adduced in support of Greek nationality is conclusive. The occasional presence of Greek labels and quotations on wall-paintings of the Second and early Third Styles at both Rome and Pompeii – at Rome on the Odyssey landscapes and on the Argos and Io picture in the House of Livia, and at Pompeii on the Iliadic frieze in the House of the Crypto-portico, the frieze of caricatures of Greek myths in the House of the Menander, the central paintings of the Room of the Epigrams in the house of the same name, and a picture of Daedalus and Icarus in the Villa Imperiale – need mean no more than that the painters were copying the captions from pattern-books. This they would have done partly to satisfy their patrons' demand for Greek pictures, partly perhaps to establish their own professional credentials. Some of the spelling, for instance on the Odyssey landscapes, suggests an unfamiliarity with the Greek language. The inscriptions on the frieze of Roman legends from near the Porta Maggiore (p. 111) are actually in Latin. Another piece of evidence, the signature in Greek of a certain Seleucus on the Farnesina paintings, is highly dubious; it takes the form of a graffito on one of the painted

columns of the decoration – an unlikely way for the artist to sign his work. We have, in short, no means of establishing the ethnic origins of the anonymous wall-painters of late Rupublican and Augustan Italy. Many were doubtless Greeks or schooled in Greek ateliers, but just as many were probably natives.

From Augustus onwards the Greek connection becomes clearly less important. Studius the landscape painter (p. 142), probably active during the last thirty years B.C., has a name suggestive of a central-Italian origin; and during the third quarter of the first century A.D. three mural painters with impeccable Italian or Roman names were employed on major imperial programmes in the capital: Famulus or Fabullus, who painted in Nero's Golden House, and Cornelius Pinus and Attius Priscus, who painted the temple of Honour and Virtue in Vespasian's restoration of it. At Pompeii the only known signature, 'Lucius painted this', in the House of D. Octavius Quartio, is of uncertain value, since it is not clear whether it refers to the nearby pictures, to the bench on which the name appears, or even simply to the name itself ('Lucius his mark'); in any case the Latin *praenomen* Lucius could easily conceal a freedman of Greek or other racial stock. More significant is the use of Latin captions on the Homeric frieze in the same house. These were evidently transliterated from a pattern-book with the labels in Greek (p. 112); whether they were the work of a Latin-speaking artist, or were carried out by a Greek-speaker for the benefit of the patron, they indicate a growing degree of Italianisation in the craft of painting.

During the course of the Imperial period the old ethnic distinctions would have become increasingly meaningless. In Italy, even where families of artists were ultimately of Greek extraction, their members would have lost any sense of being culturally apart from their clients, while more and more of them would have acquired the Roman franchise and nomenclature. Epitaphs of painters from the Rome area, for what they are worth (the term 'pictor' includes a range of statuses and specialisations), suggest a marked diminution of Greek names and a marked increase of Roman ones during the first three centuries A.D. In the provinces most of the work would have been in the hands of local painters, for there would have been abundant commissions at most times to keep them in business (whereas mosaicists and sculptors often had to travel widely to find clients for their more expensive and time-consuming art forms). The eastern provinces had acquired a tradition of wall-painting during Hellenistic times, and this must have been continued by local workshops into the Roman period, though with an increasing flow of artistic ideas from Italy (cf. Chapters 8, 9). In the newly conquered provinces of the West there were periods of initial influence from the Mediterranean which imply the arrival of immigrant painters to meet the demands of Roman merchants and officials and of Romanised natives (pp. 168–9); but within a genera-

tion or two, once the craft was well established, independent local schools would have sprung up and taken over.

The social standing of painters obviously varied according to the nature of their work. We have already seen that, in the Republican period at least, the decoration of public buildings was occasionally undertaken by men of some standing. Though this was unusual, the artists who carried out important commissions evidently continued, like M. Plautius at Ardea, to win social advancement. Thus at Cyrene in the second century A.D. L. Sossius Euthycles, who carried out figure-paintings in major local buildings, was admitted to the city-council. (At Perinthus on the Black Sea a similar honour was accorded to a mosaicist, P. Aelius Proclus.) Naturally enough the painter of figures would have been a cut above the painter of backgrounds and subordinate decoration. This is clearly acknowledged in the table of wage-limits laid down in the Edict of Diocletian (A.D. 301), where the figure-painter (*pictor imaginarius*) is allowed to earn 150 *denarii* per day, plus subsistence, while the wall-painter (*pictor parietarius*) is allowed only 75. The term *pictor imaginarius* certainly embraces both the painter of wooden panels and the painter of the main figure-scenes in murals, because their talents and qualifications must have been very similar (indeed, like a certain Theophilus known from Ptolemaic Egypt, they may frequently have been the same person) and it is impossible to believe that one was paid twice as much as the other. How highly the figure-painter was regarded can be demonstrated by comparing his wage with that of other craftsmen; he earned three times as much, for example, as a builder, a joiner, a baker and a blacksmith, and six times as much as a farmworker. What is slightly more surprising is the relatively high status of even the more humble wall-painter, who still earned half as much again as a builder and a joiner. He was also ranked above both wall- and floor-mosaicists (60 and 50 *denarii* respectively), though it must be remembered that the time taken to carry out a mosaic, and thus the overall cost of the work, would have been far greater. Among decorative artists only the modeller in clay or stucco (*plastes imaginarius*) was paid the same rate as the wall-painter. Further evidence of the demand for painters, and possibly of the respect in which they were held, comes from later in the fourth century, when an edict of Valentinian I and his co-emperors (A.D. 374) granted teachers of painting special exemptions from taxes both for themselves and for their dependants, provided them with studios or workshops in public places free of rent, and allowed them to live in whatever municipality they liked.

Many painters must have been freedmen or slaves, especially those employed by the great nobles of the late Republic and by the emperors; they may have acquired their skill in their homeland before enslavement or may have been trained in their master's household. The same must have been true of many of the small independent workshops in the cities of Roman Italy. The *pictores* named

on epitaphs are frequently specified as freedmen or slaves or can be deduced to be such from the context or from their nomenclature; indeed many of the artists of Greek origin or speech referred to above may well have belonged to these classes. As time went on, however, there was inevitably a greater freeborn element within the craft, if only because in painting, as in sculpture and mosaic, many workshops were based upon a family, with the skill being passed from father to son; even if new slaves or freedmen were brought in from time to time, the descendents of the firm's founders would have been *ingenui* of several generations' standing. In the provinces, however, there were probably always more freeborn painters in the various local workshops. Much of the demand for wall-painting must have been met by native craftsmen, whether citizen or non-citizen (*peregrini*): the only inscription which records status is an early Christian epitaph from Szombathely in Pannonia (modern Hungary), which refers to two painters as 'pelegrini' (*sic*).

This leads to the question of how the craft was organised. Leaving aside the great Republican families and the imperial household, which would have been able to call upon the services of their own slaves or freedmen, we can concentrate on the independent workshops of the Imperial age. It has already been suggested that painters had less need to travel in search of commissions than either sculptors or mosaicists. Whereas we have clear epigraphic evidence for travelling sculptors and mosaicists, one of whom boasted in his epitaph of having practised his craft 'in many' (or 'all'?) 'cities', there is only one unequivocal instance of an expatriate painter, Annaeus Atticus from Aquitania who was buried at Isola Sacra, the cemetery for the imperial port near Ostia. Once a taste for wall-painting was established, there was hardly a well-appointed house in the Empire, even in peripheral provinces such as Britain, that did not have at least one, if not several, rooms decorated with wall-paintings, often of high quality; it is a reasonable conjecture, therefore, that every fair-sized town may have been able to sustain one or more painters' workshops. These would have serviced the villas of the surrounding countryside too, or if they acquired a wider reputation might occasionally have been summoned for commissions further afield. Obviously the great cities will have sent artists far and wide, especially when a city patron owned property in distant parts. That this happened in an earlier period is attested by papyrus evidence from

233 Detail of red decoration. Herculaneum V 1–2 (Samnite House), room behind *atrium* (north wall). Third quarter of 1st century A.D.

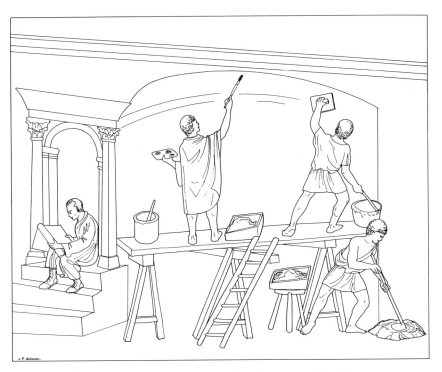

234 Funerary relief of decorators at work. 2nd century A.D. Sens Museum.

Ptolemaic Egypt, where we learn of a painter from Alexandria being brought to Philadelphia in the Fayoum, a distance of some 250 km., to decorate the villa of a royal official; and there is no reason to doubt that the precedent holds good for Roman times. It has been suggested, for instance, that metropolitan workshops were responsible for some painted wall-decorations in the Pompeii area; and where this involves villas which belonged to Roman notables or to the imperial family it is not at all implausible. For the better quality paintings within the actual city of Pompeii we need not look so far afield; but the occasional presence of artists from, say, Naples or Puteoli may well be suspected.

In a situation dominated by local workshops we should expect to find the emergence of distinctive local variations within the general styles. This in fact seems to have been the case. In the First Style, for example, in addition to the broader differences of syntax between the east Mediterranean and Italian versions, there may have been differences within Italy between the First Style at Pompeii, which dispenses with figured friezes but puts figures on the blockwork, and the First Style at Cosa, where at least one decoration put richly painted zones above the orthostates and included a frieze with Cupids among tendrils similar to those of Delos (p. 13). In the Fourth Style it is possible to discern differences of emphasis between Herculaneum and Pompeii. At Herculaneum single-colour walls are much more popular than at Pompeii, mythological picture-panels tend to be smaller in size, and more emphasis is placed upon the architectural elements, which are often extraordinarily rich, with miniaturistic detail, or include statue-like figures of a scale and importance analogous to that of the central panels. Sometimes indeed the architectural framework becomes the be-all and end-all of the decoration, owing to the omission of all figured panels and emblems in the main fields. Another popular motif is a hanging curtain [233]. Such tendencies betoken the existence of a local workshop or workshops at Herculaneum which preferred to combine the elements of the decorative repertory in a different way from the workshops of Pompeii. In the provinces too one can find broad differences of approach which are conditioned by the independent taste of local workshops. Thus the red and black candelabrum schemes popular throughout the north-western provinces during the late first and second centuries A.D. seem to have received a simpler treatment in Britain than in Gaul and Germany (p. 174). Further regional differences, characterised by local idiosyncracies, can be recognised within each province.

How were the workshops constituted? For a quality decoration at least three specialists would be needed: the figure-painter (*pictor imaginarius*), the background and ornament painter (*pictor parietarius*) and a plasterer, who could of course have been a trainee painter. To these may be added an assistant or two. A typical nuclear working-unit would be represented by the Sens relief [234], which

Painters and patrons

shows a plasterer and painter at work, an assistant preparing materials, and a seated figure consulting a scroll – possibly the patron but more probably the master-artist, who might in that case be the figure-painter while the painter at work is the *parietarius*. A very similar unit is attested by the one piece of epigraphic evidence that may refer to a team of decorators, a graffito in the fourth-century Platonia under the church of San Sebastiano outside Rome, which reads 'Musicus cum suis laburantibus Ursus Fortunio Maximus Eusebius' ('Musicus with his workmen Ursus, Fortunio, Maximus and Eusebius'). These were possibly the stuccoists and painters who carried out the actual decoration in which their names are cut. It is clear, however, that workshops could consist of much larger groups of artists. This is implied by the decorations of houses like the villa at Oplontis, the Farnesina villa and the House of the Vettii, where large numbers of rooms with elaborate and highly detailed murals were evidently painted under one contract; unless the patron was prepared to wait for several months while a small band of men proceeded from room to room, we must conclude that the rooms were painted simultaneously by different working-units. That this was indeed the case is vividly demonstrated by the unfinished decorations in the House of the Iliadic Shrine at Pompeii (pp. 201–2); here work was in progress simultaneously on at least six separate rooms, and had reached varying stages of completion; in one room only the upper zone had been completed [221], in two others only the dado remained to be done, in another two only the central figure-panels were missing, and in the shrine which gives the house its name the vault was stuccoed and painted but the walls awaited the final plastering. In addition, the *atrium* and *tablinum* had received rough coats of under-plaster so were presumably about to be painted. It is inconceivable that one small unit could have been doing all this at once; we must rather imagine some kind of working arrangement in which different plasterers and *parietarii* were engaged in different rooms at once, while the skilled figure-painters were ready to move into action wherever required.

There have been a number of attempts in the last thirty-five years to isolate the output of individual workshops and more specifically to identify the hands of individual painters; and, though the results of researchers have often been contradictory, the potential value of this line of enquiry has been amply demonstrated.

Ascriptions to workshops can be made on the basis of favoured designs and motifs, compositions and colour schemes. Thus in the late Second Style it has been argued that the paintings and stuccowork of the House of Livia, the Aula Isiaca and the House of Augustus on the Palatine, as well as the Farnesina villa, and some fragments of unknown provenance in the Louvre, are the work of one main workshop which was charged with commissions by Augustus and Agrippa; its hallmarks included friezes with lotus or other floral patterns, vegetalised columns, pedi-

ments and candelabra, Egyptianising elements, a fondness for figures and animals growing from or perched among tendrils, a taste for 'scenographic' compositions with a mythological or landscape picture at the centre, a bold and inventive use of colour and a very delicate and linear style of draftsmanship. In the Fourth Style at Pompeii there is scope for identifying a number of workshops. Beyen listed ten, which he promised to analyse in detail in the fourth volume of his history of Pompeian wall-decoration; unfortunately this was never written, and only two of the workshops were briefly characterised in a preliminary article – the 'Workshop of the Casa dei Vettii' and the 'Workshop of the Hermaphrodites'. How far Beyen's attributions are reliable is difficult to assess, because he does not rehearse his arguments in detail; but he apparently relies heavily on style and brushwork, and thus includes even isolated figures and panels whose original context is unknown – a policy which may lead to oversimplification, since it tends to equate individuals with workshops, and makes allowance neither for a variety of styles and aptitudes within one workshop nor for the possible movement of artists from one workshop to another. Methodologically more sound is Mariette de Vos's analysis of a workshop which carried out a number of modest decorations in Regions I and II of the city; her results are based upon complete walls and take into account the general syntax, the colour schemes (restricted mainly to red, yellow and white), the subjects (panels containing groupings of birds or fish, tondi with portraits, *gorgoneia* or still lifes, vignettes with peacocks, and emblems in the form of free-floating griffins and sphinxes), and the decorative ornaments (embroidery borders with floral and ivy-leaf motifs set against a colour distinct from that of their fields, S-shaped or interweaving tendrils, and twisted or floral candelabra). It is difficult to apply this approach in the area of the older excavations, where so many decorations have been destroyed or dismembered; but one suspects that Beyen's workshops are too many and too narrowly defined. An example of the danger of adopting too rigid an interpretation of stylistic divergences is his chronological division of the post-earthquake decorations of the House of the Vettii; while accepting that everything was done by one workshop, he asserts that the *atrium* and large *oecus* (*q*) were painted soon after A.D. 62, and the rest ten years later. W. J. T. Peters has now argued, more convincingly, that the differences perceived by Beyen are less significant than he believed and therefore that the bulk of the decorations could belong to a single operation; the differences may be explained partly by a deliberate variation of the repertory in accordance with the function and relative importance of the rooms, partly by the distribution of the work among painters of varying skills and specialities.

To identify the hands of individual artists it is necessary to use the technique developed by the nineteenth-century Italian art historian Giovanni Morelli. This depends on the

premise that the artist, even when copying or adapting an earlier prototype, will betray himself by the details which he does without thinking: the lips, the eyes, the fingers, the proportions of a figure, his handling of light and shade, etc. He may vary these details in the course of his career, but there will be sufficient overlapping to enable the range of his vocabulary to be charted, even if some dispute may arise about early or late works, or about the borderline between his *œuvre* and that of a pupil or imitator. By using these techniques Beazley was able to identify hundreds of personalities in the history of Athenian vase-painting; and there is every possibility that a similar exercise could be carried out on Pompeian painting, all due allowance being made for the more limited corpus of material and its uneven state of preservation. The results might then be used to corroborate inferences about workshop relationships drawn from decorative schemes. Of the experiments undertaken so far the most thorough is that of Lawrence Richardson. In his study of the House of the Dioscuri he identifies seven figure-painters who were involved in the post-earthquake redecoration of the house; for each of them, using the stylistic mannerisms detectable in the Dioscuri as a starting-point, he tries to compile a corpus of works which takes in other houses, even other cities. The results are interesting, but not entirely convincing. We get an impression of artists acting freelance and hired specifically for every job; they are found working in different combinations, now doing both the major and the minor figure-paintings in a room, now concentrating on the central figure-panels while another artist or artists did the rest. It is possible, however, that some of Richardson's distinctions are over-subtle; for example, a number of the paintings which he attributes to his artists the Dioscuri Painter, the Io Painter and the Achilles Painter look very much like the work of one hand. Moreover, in the Romano-Campanian context, it is more plausible to think of the workshop as a team combining every skill from plain plasterer to image-painter. Within this workshop there would have been a good deal of fluidity, with every painter going through a career-cycle; he might have started by mixing plaster or painting coloured backgrounds, proceeded to borders and subsidiary motifs, and then advanced through various stages of skill improvement till he ended up as a leading figure-painter. Richardson's artists were probably, therefore, at the head of the workshop or workshops, with various apprentices and assistants under their control. We should not think of them as freelance virtuosi operating independently from the humbler craftsmen.

What, then, of the relation between patron and painter? One may guess that the patron normally put out the job to the painter or painters under a contract of *locatio operis faciendi* ('hire of work to be carried out'), the normal arrangement for craftwork which required an element of skill or responsibility. Under the early Empire at least this meant that a price was fixed in advance, to be paid in a lump sum or in instalments as each part of the assignment was completed; a time-limit would be agreed, and the contractor (*conductor* or *redemptor*) might face penalties for failing to meet the deadline; finally the payment would be conditional upon the workmanship meeting the hirer's (*locator*'s) approval. Under such contracts materials could be provided by either the hirer or the contractor. In the field of wall-painting we learn from both Vitruvius and Pliny that the craftsman was expected to supply only the basic materials, i.e. the standard ('plain') pigments; it was the patron's responsibility to supply the 'florid' pigments. Vitruvius tells us that the reason for this was the cost of such materials (see above, p. 209); presumably it was not a viable proposition for painters to hold them in stock or to get involved in transactions for the purchase of small quantities as required. One may suspect, however, that in practice the arrangements for supplying materials could often be varied by agreeement. From an earlier period, in a Graeco-Egyptian papyrus of about 255 B.C., we have a wall-painter's estimate which offers the client alternative prices depending on who provides the materials; if the client supplies them, the cost of the job will be reduced from 53 *drachmae* to 30. Similar flexibility appears in documents concerning the painting of woodwork in the same house, where the decorators had agreed to furnish materials themselves but had subsequently received supplies from the client; the value of these was as a consequence deducted from their fees. If we had similar documents from the Roman period, we might well discover the same sort of *ad hoc* adjustments.

One thing that seems fairly clear is that the patron exercised the final choice as to how a room was decorated, even though he might be guided by patterns offered to him by the painter. This is the situation implied by the quotation of 255 B.C. mentioned above, in which the painter gives verbal specifications of decorative elements to be carried out in four rooms, and at one point refers to a 'model' (*paradeigma*) of a vault-decoration which the client has seen and approved. A more cut and dried situation appears in another papyrus of similar date, this time concerning mosaic pavements; for these, to be laid in a bath-house belonging to a rich, perhaps even royal, villa at Philadelphia, the artist is obliged to work to detailed specifications, including a model which had been sent from the royal palace; only one of the decorative elements referred to in the surviving lines is left to his discretion ('a band of suitable type'). In other words he is given virtually no say in the pattern of the mosaic which he is laying. Although this evidence belongs to an earlier period and to the peculiar circumstances of Ptolemaic Egypt, there is every reason to believe that the two basic principles of the patron having the decisive voice and the decorative details being set out in models and specifications were standard practice also in Roman times.

The existence of artists' pattern-books has often been

questioned, but the evidence for them is almost overwhelming. Much of this evidence relates to figure-scenes. Already in Classical Greek times we hear of drawings by Parrhasius, both on panels and on sheets of parchment, being used as exemplars by other artists; and from this kind of art-school copying to the compilation of copy-books was a small progression. It would have received a strong impetus from the demands of Roman art collectors in the late Republic: indeed it is difficult to conceive how the trade in reproductions of old-master paintings could have functioned without the circulation of models of some kind, just as the reproduction of statues depended on the dissemination of plaster casts. Admittedly many of the pictures in Roman wall-decorations were freely adapted and varied (pp. 127–40), but there are enough instances of fairly close replication, often over considerable distances, to suggest that models were circulating; in any case it was in the production of portable panels that the copying could and would be most careful. In the related field of mosaic we can point

to instances of figure compositions appearing in almost identical form as far apart, for example, as Amphipolis in Macedonia and Volubilis in Morocco, a phenomenon hardly explicable in terms of the movement of actual artists; that it was due to the circulation of pattern-books seems the logical inference. A similar explanation has been offered for the close coincidence between the compositions of certain north African pavements and the iconography of sculptured sarcophagi made in Rome; here the success of the sarcophagus workshops may have led to the publication of patterns which then circulated to Africa, where they were taken up by mosaicists.

The forms taken by the models must have varied, but for ease of transport and consultation they must almost invariably have been smaller than the originals. It may be to their production that the rhetorician Quintilian refers when he comments scathingly on painters whose 'sole aim is to be able to make drawings of pictures with measures and lines'; this sounds like reduced drawings with inscribed

235 Scene from New Comedy (street-musicians): mosaic from Pompeii, Villa of Cicero. Late 2nd century or beginning of 1st century B.C. Naples, Archaeological Museum 9985. H. 44 cm.

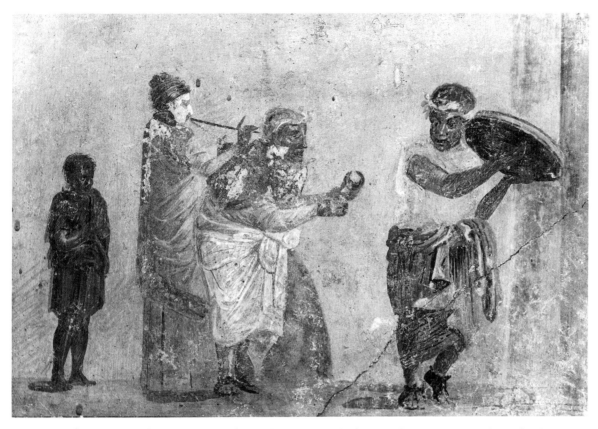

236 Scene from New Comedy (street-muscians), from Stabiae. Second or third quarter of 1st century A.D. Naples, Archaeological Museum 9034. H. 29 cm.

measurements, similar to the drawings of building-plans which have survived on stone; the 'lines' may in that case be reference-lines to enable the copyist to fix the position within the panel of specific details. There is no word of colouring, and one may suspect that colours were often indicated in the vaguest of fashions or merely annotated. Many copy-books in circulation may have consisted of little more than sketches, which would of course have been one factor militating against accuracy of reproduction, especially where the reproduction was being carried out on a wall in the more or less spontaneous conditions imposed by the fresco technique. Another medium through which figure-types and compositions could have been spread was the illustrated text. We know from Pliny that Varro's books about famous Greeks and Romans were illustrated with seven hundred portraits and that as a result he immortalised these people 'in all lands'; and the possibility that theatrical pictures were used to illustrate the texts of dramas is implied by a third-century A.D. mosaic at Mytilene in the eastern Aegean which shows labelled scenes from comedies by Menander. Since at least one of the Mytilene scenes recurs in identical form in a mosaic panel found at Pompeii, and further close correspondences

exist between mosaics and paintings of other theatrical scenes in Pompeii, Herculaneum and Stabiae [235–6], it is clear that a series of fixed compositional types was in circulation; these may have featured first in artists' copy-books (as suggested by the fine detail of the versions at Pompeii) before being adapted for use as text-illustrations (as suggested by the Mytilene mosaic).

All these examples relate to individual figure compositions. But we may also assume the existence of more general patterns giving whole decorative schemes, with the details to be inserted within them. Such must have been the *paradeigmata* of the two Egyptian papyri. And such, no doubt, was the scroll being consulted by the master-artist at the left of the Sens relief.

It was from these patterns that the customer would have selected the schemes to be applied in different rooms of his house. Here recent research has suggested a clear grading of paintings according to the function and importance of the rooms, and it has been argued that the type of decoration and the care taken over it would be regulated by price; thus the most elaborate paintings, with polychrome colour schemes and mythological panels, were reserved for reception rooms and the most important bedrooms, and would

command the highest price; slightly less elaborate paintings, which would appear in rooms of secondary rank, for example bathrooms and the bedrooms of the householder's children or important slaves, would be rather less expensive; and relatively simple paintings, for the bedrooms of ordinary slaves, would be cheaper still. The patron would obviously fix the position of each room on the hierarchical scale and select from the appropriate price-range.

This is understandable enough. What is more remarkable is the degree of freedom with which the basic schemes were interpreted. Despite the use of pattern-books and the striking similarities between decorative motifs and figure compositions in far-flung regions of the Empire, hardly any two decorations are identical. Even among the hundreds of wall-paintings known from Pompeii the degree of repetition is extraordinarily small, being confined in most cases to the odd figure-subject or a handful of ornamental motifs; only two or three schemes reveal more wholesale duplication (cf. pp. 61–2). Moreover, when repetition does occur, the motif or motifs in question are often used in a different way or in a different position, or the basic colour scheme is changed. Part of this must have been due to the client's freedom of choice: he was offered a variety of colour schemes, a variety of figure-scenes, a variety of architectural formulae, even a variety of borders and a variety of minor emblems and motifs. But, unless we suppose that he decided every last detail, a large share of the credit must also go to the painters, whether because they deliberately set out to ring the changes in each new decoration or because the spontaneity with which they operated naturally produced this result.

This spontaneity is a crucial element in the production of Roman wall-paintings. Many of the stock motifs (candelabra, birds, animals, Cupids, maenads, shields, drinking-horns and so forth) would have been carried round in the artist's head, to be called forth whenever there was an appropriate space to be filled. The use of such a repertory of motifs naturally speeded execution, an important requisite for the fresco technique; and, as a result of

the way in which the types were memorised and no doubt passed from father to son, from master to apprentice and from one workshop to another, the repertory would gradually change and evolve, helping to produce the sequence of 'styles' with which we are familiar. At the same time speed of execution would also have assisted painters to cope with the enormous demand for their services. This is particularly apparent at Pompeii in the period of the Fourth Style, where quickly sketched figures and ornaments succeeded the precise and carefully laid out figures and ornaments of the Third Style: most notable of all is the replacement of bands of miniaturist polychrome ornament by the ubiquitous embroidery borders, painted in one colour and always painted freehand. Such changes were partly a response to the pressure of increased demand, imposed initially by social changes and then (after A.D. 62) by the peculiar circumstances of the post-earthquake recovery programme.

Ultimately all these elements – grading of decorations, variety of composition, speed and spontaneity of production – were determined by social conditions. And the most important conclusion of all is that wall-painting was socially necessary. Any householder with aspirations to a degree of respectability felt obliged to commission murals in at least the most important rooms of his house; and the social advancement of freedmen and the small commerical classes during the early Imperial period meant that there were more and more people with such aspirations. The wall-painting industry expanded to meet their needs. The result was that the extraordinary technical and artistic skills of the frescoist were brought to the living quarters of tens of thousands of private houses, whether grand or comparatively modest – in the context where today's householder would be content with a plain coat of paint or with a mass-produced wallpaper. It is this universal availability and the close interdependence of artistic form and social environment which give Roman wall-painting much of its exceptional interest.

EPILOGUE

By way of conclusion some words may be said about the importance of Roman painting.

Measured in terms of certain other branches of classical art, such as the statuary and panel-painting of the Greeks, or even the relief sculpture of Roman times, Roman painting was not regarded in antiquity as a major art form. Certainly it overtook contemporary panel-painting in popularity and prestige, as Pliny makes clear (p. 1); and certainly it played a major role in the decoration of many imperial residences, such as Nero's palaces or Hadrian's Villa. But it remained essentially a private art, an art of interiors, and particularly of domestic interiors. Pliny's complaint that the switch in fashion from panels to murals had robbed the general public of the opportunity to share in the best paintings of his time has a certain validity.

None the less, the achievements of the wall-painters of the Roman age, so far as we can judge from the surviving examples, were considerable. In the Second Style, the first truly Roman system of decoration, they used the attainments of their Greek predecessors in the fields of perspective, shading and foreshortening to create the first convincing spatial compositions in the history of mural art; in the Third Style they welded rich colours and a repertory of part-organic, part-abstract ornaments into a new mode of space-denying pattern; in the Fourth Style they created a world of light and fantasy which anticipates by sixteen centuries the effects of baroque and rococo. The novelty and imagination of all this earns the anonymous authors a distinguished place in the annals of ancient art.

Their achievements have also exercised considerable influence on the painting of recent centuries. The event which opened the eyes of the modern world to Roman painting was the discovery of the Golden House about 1480. Buried underneath the Baths of Trajan and full of debris to within a few feet of the vaults, the rooms gave the semblance of caves, and thus the painted ornaments which decorated them came to be called 'grottesche' (from the Italian 'grotte'). The leading artists of the time spent whole days underground sketching these ornaments, and their sketchbooks served as a source for contemporary decorations: Pinturicchio, for example, painted a couple

of vaults at Siena based on the Volta Dorata. The influence of Nero's palace was especially strong on the artists of Raphael's school, whose decorations in the Vatican Loggias, the Villa Madama and Castel Sant' Angelo in Rome are heavily indebted in repertory and style to the Golden House. One of the most successful imitators was Giovanni da Udine, who devised a technique for imitating ancient stuccowork.

The Golden House continued to be influential in the eighteenth century, when the new excavations and drawings commissioned and subsequently published by Luigi Mirri in the 1770s brought the paintings to the attention of an even wider public. At this time the grotesques inspired British architects and decorators such as the Adam brothers and Cameron, who studied the remains and their Renaissance derivatives in Rome. But the second, and even more dramatic, event which stimulated modern admiration and imitation of antique painting was the discovery of the cities buried by Vesuvius – first Herculaneum in 1709, then Pompeii in 1748. Visited by the foremost artists and intellectuals of the day, they had the same kind of influence in the eighteenth and nineteenth centuries as the Golden House in the previous two and a half centuries. Contemporary potentates commissioned buildings and decorations of Pompeian type. Ludwig I of Bavaria built an imitation of the House of the Dioscuri, with all its paintings, as a kind of museum at Aschaffenburg on the Main (1840–8), while his Villa Ludwigshöhe in Rheinpfalz (1846–51) is decorated throughout in the Pompeian manner. Prince Jérôme Napoleon had a Pompeian house constructed in the Avenue Montaigne in Paris (1854–9). Knowledge of the paintings was disseminated by the magnificent collections of engravings and coloured lithographs which were published in this period, and by the reports of visitors who were allowed to see the collections of Pompeian pictures in the palaces of the Bourbon kings at Portici and Naples (from where several pieces went as gifts to the royal families and dignitaries of other European countries). The fame of Pompeian pictures led to the production of replicas and pastiches, just as the Pompeian painters themselves had copied and adapted the pictures of the Greeks. Thus the

whimsical picture of a woman selling Cupids, discovered at Stabiae in the mid eighteenth century, is reproduced in works of art as varied as a painting by J.-M. Vien (now in Fontainebleau), a grisaille by Tischbein, a group of figurines in Meissen porcelain, an ivory fan, a relief by Thorwaldsen and gem-engravings. A different kind of anti-quarianism is demonstrated by A. R. Mengs's picture of Jupiter and Ganymede (1758–9: now in Naples), which was painted to look like an ancient fresco, complete with cracks, and which actually deceived an observer as prac-tised as Winckelmann.

The influence of Roman painting continues to appear, albeit less prominently, in the art of the present century. A drawing by Picasso (like a portrait by Ingres a century earlier) reproduces the gesture of Demeter, two fingers to her cheek, in the painting of the discovery of Telephus from the so-called Basilica at Herculaneum. On a more mundane level, more truly analogous to the social and intellectual milieu of Pompeian art, a set of adaptations of the paintings of four heroines and goddesses from the Villa Varano at Stabiae was recently commissioned for a *pizzeria* in central Manchester; interestingly, as in many Pompeian paintings, the figure-types were appropriated for new subjects, in this case the four Seasons. The far-reaching and catholic appeal of the paintings is even more vividly attested by the decora-tion (by a Chinese painter) of a house in Sydney, Australia, with adaptations of well-known Pompeian frescoes includ-ing specimens from the Villa of the Mysteries and the House of the Vettii. Unfortunately, owing to the absence of the patron at a crucial juncture, the wrong set of murals was executed in the main hall – a cautionary tale, perhaps, for those who look for carefully planned intellectual pro-grammes in all the decorations of Pompeii!

Roman painting has thus enjoyed a good deal of prestige in the modern world, inspiring both leading painters and workaday craftsmen. Its popularity has been further dif-fused in recent years by the travelling exhibitions on Pompeii which have been staged in various cities in Europe, America, the Far East and Australia. The study of the sub-ject flourishes, especially in Italy, France, Germany and the Netherlands; the emphasis of research, which since Mau has concentrated largely on the formal evolution and chronology of decorative systems, is now beginning to shift towards questions of patronage and social function. At the same time important new discoveries, such as that of the villa at Oplontis, have emerged to arouse the public's inter-est and to add to the sum of our knowledge. Roman paint-ing, in short, is very much alive; and there is every prospect that its appeal will continue to captivate generations to come.

ABBREVIATIONS

AbhMainz = Akademie der Wissenschaften und der Literatur [in Mainz]. *Abhandlungen der geistes- und sozialwissenschaftlichen Klasse*

AJA = *American Journal of Archaeology*

ANRW = *Aufstieg und Niedergang der römischen Welt*

ArchAnz = *Archäologischer Anzeiger. Beiblatt zum Jahrbuch des Deutschen Archäologischen Instituts*

AthMitt = *Mitteilungen des Deutschen Archäologischen Instituts, Athenische Abteilung*

BABesch = *Bulletin van de Vereeniging tot Bevordering der Kennis van de Antike Beschaving*

BAR = *British Archaeological Reports*

BdA = *Bollettino dell'arte*

BICS = University of London, Institute of Classical Studies, Bulletin

BullComm = *Bullettino della Commissione Archeologica Comunale di Roma*

BullInst = *Bullettino dell'Instituto di Corrispondenza Archeologica*

CRAI = *Comptes rendus de l'Académie des Inscriptions et Belles Lettres*

Dial. di arch. = *Dialoghi di archeologia*

DissPontAcc = *Atti della Pontificia Accademia Romana di Archeologia. Dissertazioni*

EAA = *Enciclopedia dell'arte antica, classica e orientale*

JdI = *Jahrbuch des Deutschen Archäologischen Instituts*

JHS = *Journal of Hellenic Studies*

JRS = *Journal of Roman Studies*

MAAR = *Memoirs of the American Academy in Rome*

MededRome = *Mededelingen van het Nederlands Instituut te Rome*

MEFRA = *Mélanges de l'École Française de Rome. Antiquité*

MemLinc = *Atti della Accademia Nazionale dei Lincei. Memorie. Classe di scienze morali, storiche e filologiche*

MemPontAcc = *Atti della Pontificia Accademia Romana di Archeologia* 3rd ser. *Memorie*

MonAnt = *Monumenti antichi pubblicati per cura della Accademia Nazionale dei Lincei*

MonPiot = *Fondation Eugène Piot. Monuments et mémoires publiés par l'Académie des Inscriptions et Belles Lettres*

Mon. Pitt. Ant. = *Monumenti della pittura antica scoperti in Italia*

NotScav = *Atti della Accademia dei Lincei. Notizie degli scavi di antichità*

ÖJh = *Jahreshefte des Österreichischen Archäologischen Instituts*

PBSR = *Papers of the British School at Rome*

Pliny, *NH* = Pliny, *Naturalis Historia*

RendLinc = *Atti della Accademia Nazionale dei Lincei. Rendiconti. Classe di scienze morali, storiche e filologiche*

RendPontAcc = *Atti della Pontificia Accademia Romana di Archeologia* 3rd ser. *Rendiconti*

RevArch = *Revue archéologique*

Ric. Pitt. Ell. = *Ricerche di pittura ellenistica* (Rome 1985)

RömMitt = *Mitteilungen des Deutschen Archäologischen Instituts, Römische Abteilung*

Vitr. = Vitruvius, *De Architectura*

BIBLIOGRAPHY

GENERAL BIBLIOGRAPHY

Abad Casal, L., *La pintura romana en España* (Alicante and Seville 1982)

Andreae, B., 'Römische Malerei' and 'Römische Stuckdekoration', in T. Kraus (ed.), *Das römische Weltreich* (Propyläen–Kunstgeschichte II) (Berlin 1967)

Andreae, B., and Kyrieleis, H., *Neue Forschungen in Pompeji* (Recklinghausen 1975)

Aurigemma, S., *L'Italia in Africa. Le scoperte archeologiche (a.1911–a.1943). Tripolitania* I: *I monumenti d'arte decorativa* II. *Le pitture d'età romana* (Rome 1962)

Barbet, A. (ed.), *La peinture murale romaine dans les provinces de l'Empire: journées des études de Paris 23–25 septembre 1982* (BAR International Series 165) (Oxford 1983)
La peinture murale romaine: les styles décoratifs pompéiens (Paris 1985)

Bastet, F. L., and De Vos, M., *Proposta per una classificazione del terzo stile pompeiano* (The Hague 1979)

Beyen, H. G., *Die pompejanische Wanddekoration vom zweiten bis zum vierten Stil* I and II.1 (The Hague 1938 and 1960)
'Pompeiani stili', *EAA* 6 (1965) 356–66

Blanckenhagen, P. H. von, and Alexander, C., *The Paintings from Boscotrecase* (*RömMitt* Ergänzungsheft 6) (Heidelberg 1962)

Borda, M., *La pittura romana* (Milan 1958)

Bragantini, I., and De Vos, M., *Museo Nazionale Romano. Le pitture* II.1. *Le decorazioni della villa romana della Farnesina* (Rome 1982)

Bragantini, I., De Vos, M., Parise Badoni, F., and Sampaolo, V., *Pitture e pavimenti di Pompei* (Repertorio delle fotografie del Gabinetto Fotografico Nazionale) I–III (Rome 1981–6)

Bragantini, I., and Parise Badoni, F., 'Il quadro pompeiano nel contesto decorativo', *Dial. di arch.* 3rd ser. 2 (1984) 119–29 (= *Ric. Pitt. Ell.*, 257–67)

Croisille, J.-M., *Poésie et art figuré de Néron aux Flaviens* (Brussels 1982)

Curtius, L., *Die Wandmalerei Pompejis* (Leipzig 1929; reprint Hildesheim 1972)

Davey, N., and Ling, R., *Wall Painting in Roman Britain* (*Britannia* Monograph Series 3) (London 1982)

Dorigo, W., *Late Roman Painting* (London 1971)

Drack, W., *Die römische Wandmalerei der Schweiz* (Monographien zur Ur- und Frühgeschichte der Schweiz VIII) (Basel 1950)
'Neuentdeckte römische Wandmalereien in der Schweiz', *Antike Welt* 11 (1980), part 3, pp. 3–14; part 4, pp. 17–24; 12 (1981), part 1, pp. 17–32

Römische Wandmalerei aus der Schweiz (Feldmeilen 1986)

Ehrhardt, W., *Stilgeschichtliche Untersuchungen an römischen Wandmalereien von der späten Republik bis zur Zeit Neros* (Mainz 1987)

Engemann, J., *Architekturdarstellungen des frühen zweiten Stils* (*RömMitt* Ergänzungsheft 12) (Heidelberg 1967)

Ippel, A., *Der dritte pompejanische Stil* (Berlin 1910)

Kraus, T., and Matt, L. von, *Lebendiges Pompeji* (Cologne 1973) (translated into English: *Pompeii and Herculaneum: the Living Cities of the Dead* (New York 1975))

Laidlaw, A., *The First Style in Pompeii: Painting and Architecture* (Rome 1985)

Lauter-Bufe, H., *Zur Stilgeschichte der figürlichen pompejanischen Fresken* (Erlangen 1969)

Lehmann, P. Williams, *Roman Wall Paintings from Boscoreale in the Metropolitan Museum of Art* (Cambridge, Mass., 1953)

Ling, R., 'Stucco decoration in pre-Augustan Italy', *PBSR* 40 (1973) 11–57

Liversidge, J. (ed.), *Roman Provincial Wall Painting of the Western Empire* (BAR International Series 140) (Oxford 1982)

Maiuri, A., *La Villa dei Misteri* (Rome 1931; reprint 1947)
La Casa del Menandro e il suo tesoro di argenteria (Rome 1933)

Mau, A., *Geschichte der decorativen Wandmalerei in Pompeji* (Berlin 1882)

Mielsch, H., *Römische Stuckreliefs* (*RömMitt* Ergänzungsheft 21) (Heidelberg 1975) (= Mielsch 1975a)
'Verlorene römische Wandmalereien', *RömMitt* 82 (1975) 117–33 (= Mielsch 1975b)
'Zur stadtrömischen Malerei des 4. Jahrhunderts n. Chr.', *RömMitt* 85 (1978) 151–207
'Funde und Forschungen zum Wandmalerei der Prinzipatszeit vom 1945 bis 1975, mit einem Nachtrag 1980', *ANRW* 2.12.2 (1981) 157–264

La peinture romaine (Les dossiers: histoire et archéologie 89) (Dijon 1984)

Pictores per provincias (Cahiers d'archéologie romande 43) (Avenches 1987)

Pompei 1748–1980: i tempi della documentazione (exhibition catalogue, Rome 1981)

Le regione sotterrata dal Vesuvio: studi e prospettive (Atti del convegno internazionale 11–15 novembre 1979) (Naples 1982)

Rizzo, G. E., *La pittura ellenistico-romana* (Milan 1929)

Schefold, K., *Pompejanische Malerei. Sinn und Ideengeschichte* (Basel 1952); translated into French as *La peinture pompéienne. Essai sur l'évolution de sa signification* (Brussels 1972)
Die Wände Pompejis (Berlin 1957)

Vergessenes Pompeji (Bern and Munich 1962)

Sear, F. B., *Roman Wall and Vault Mosaics* (RömMitt Ergänzung-sheft 23) (Heidelberg 1977)

Spinazzola, V., *Pompei alla luce degli scavi nuovi di Via dell'Abbondanza (anni 1910–23)* (Rome 1953)

Strocka, V. M., *Forschungen in Ephesos* VIII.1. *Die Wandmalerei der Hanghäuser in Ephesos* (Vienna 1977)

'Ein missverstandener Terminus des vierten Stils: die Casa del Sacello Iliaco in Pompeji (I 6, 4)', *RömMitt* 91 (1984) 125–40 (= Strocka 1984a)

Casa del Principe di Napoli (VI 15, 7.8) (Häuser in Pompeji I) (Tübingen 1984) (= Strocka 1984b)

'Die römische Wandmalerei von Tiberius bis Nero', in *Pictores per provincias* (Avenches 1987), 29–44

Wadsworth, E. L., 'Stucco reliefs of the first and second centuries still extant in Rome', *MAAR* 4 (1924) 1–102

Ward-Perkins, J. B., and Claridge, A., *Pompeii A.D. 79* (exhibition catalogue, London 1976)

Wirth, F., 'Römische Wandmalerei vom Untergang Pompejis bis Hadrian', *RömMitt* 44 (1929) 91–166

Römische Wandmalerei vom Untergang Pompejis bis ans Ende des dritten Jahrhunderts (Berlin 1934; reprint Darmstadt 1968)

Zevi, F., *La Casa Reg. IX 5, 18–21 a Pompei e le sue pitture* (Studi miscellanei 5) (Rome 1964)

(ed.), *Pompei 79. Raccolta di studi per il decimonono centenario dell'eruzione vesuviana* (Naples 1979)

BIBLIOGRAPHY FOR INDIVIDUAL CHAPTERS

References are arranged in the order in which topics are discussed. For items expressed by author or short title alone, or by author plus date, see the General Bibliography above.

Chapter 1 The antecedents

1. **Greek painting (general):** E. Pfuhl, *Malerei und Zeichnung der Griechen* (Munich 1923); idem, *Masterpieces of Greek Drawing and Painting* (1926); A. Rumpf, 'Classical and post-Classical Greek painting', *JHS* 67 (1947) 10–21; idem, *Malerei und Zeichnung der klassischen Antike* (Handbuch der Archäologie IV) (Munich 1953); C. M. Robertson, *Greek Painting* (Geneva 1959); idem, *A History of Greek Art* (Cambridge 1975); V. J. Bruno, *Form and Colour in Greek Painting* (London 1977); P. H. von Blanckenhagen, 'Painting in the time of Alexander and later', in B. Barr-Sharrar and E. N. Borza (eds.), *Macedonia and Greece in Late Classical and Early Hellenistic Times* (National Gallery of Art, Washington 1982), 251–60

2. **Ancient sources for Greek painting:** J. Overbeck, *Die antiken Schriftquellen zur Geschichte der bildenden Künste bei den Griechen* (Leipzig 1868; reprint Hildesheim 1959); K. Jex-Blake and E. Sellers, *The Elder Pliny's Chapters on the History of Art* (London 1896); J. J. Pollitt, *The Art of Greece 1400–31 B.C.: Sources and Documents* (Englewood Cliffs, N.J., 1965)

3. **Alexander mosaic:** B. Andreae, *Das Alexandermosaik* (Opus Nobile 14) (Bremen 1959); A. Rumpf, 'Zum Alexandermosaik', *AthMitt* 77 (1962) 229–41; T. Hölscher, *Griechische Historienbilder des 5. und 4. Jahrhunderts v. Chr.* (Würzburg 1973), 122–69; B. Andreae, *Das Alexandermosaik aus Pompeji* (Recklinghausen 1977)

4. **Vergina frieze:** M. Andronicos, *Vergina: the Royal Tombs and the Ancient City* (Athens 1984), 106–19, figs. 58–71

5. **Gravestones:** A. S. Arvanitopoulos, *Graptai stelai Demetriados-Pagason* (Athens 1928); V. von Graeve, 'Le stele di Demetrias', *Dial. di arch.* 3rd ser. 2 (1984) 59 (= *Ric. Pitt. Ell.*, 197)

6. **Hellenistic mosaics:**
a. **General:** J. J. Pollitt, *Art in the Hellenistic Age* (Cambridge 1986)
b. **Dioscurides panels:** M. Bieber and G. Rodenwaldt, 'Die Mosaiken des Dioskurides von Samos', *JdI* 26 (1911) 1–22
c. **Doves by Sosus:** K. Parlasca, 'Das pergamenische Taubenmosaik und der sogenannte Nestor-Becher', *JdI* 78 (1963) 256–93; M. Donderer, 'The Capitoline dove mosaic: a Sosos original?', in E. P. Johnson (ed.), *5th International Colloquium on Ancient Mosaics, Bath, 5th–12th September 1987. Abstracts*, p. 17
d. **Palestrina mosaics:** G. Gullini, *I mosaici di Palestrina* (Rome 1956); H. Whitehouse, *The Dal Pozzo Copies of the Palestrina Mosaic* (BAR Supplementary Series 12) (Oxford 1976); A. Steinmeyer-Schareika, *Das Nilmosaik von Palestrina und eine ptolemäische Expedition nach Äthiopien* (Bonn 1978)

7. **Early painting in Italy:**
a. **Etruscan:** F. Weege, *Etruskische Malerei* (Halle 1921); M. Pallottino, *La peinture étrusque* (Geneva 1952)
b. **Paestan:** M. Napoli, *La Tomba del Tuffatore* (Bari 1970); A. Rouveret and A. Greco Pontandolfo, 'Pittura funeraria in Lucania e Campania. Puntualizzazioni cronologiche e proposte di lettura', *Dial. di arch.* 3rd ser. 1 (1983), part 2, pp. 91–130 (= *Ric. Pitt. Ell.*, 91–130)
c. **François Tomb:** F. Coarelli, 'Le pitture della tomba François a Vulci: una proposta di lettura', and A. Maggiani, 'Nuovi dati per la riconstruzione del ciclo pittorico della tomba François', *Dial. di arch.* 3rd ser. 1 (1983), part 2, pp. 43–78 (= *Ric. Pitt. Ell.*, 43–78)
d. **Biographical paintings at Tarquinia:** M. Moretti, *Pittura etrusca in Tarquinia* (Milan 1974), 143–4, pls. 98–100; G. Koeppel, in *ANRW* 2.12.1 (1982), 524f.

8. **Early painting in Rome:**
a. **Tombs on Esquiline:** F. Coarelli, in *Roma medio repubblicana* (exhibition catalogue, Rome 1963), 200–8, no. 283, pls. XLVI–XLVIII (= *Affreschi romani dalle raccolte dell'Antiquarium Comunale* (exhibition catalogue, Rome 1976), 13–28, pls. A, I–V); E. La Rocca, 'Fabio o Fannio. L'affresco medio repubblicano dell'Esquilino ...', *Dial. di arch.* 3rd ser. 2 (1984) 31–53 (= *Ric. Pitt. Ell.*, 169–91)
b. **Literary evidence:** O. Vessberg, *Studien zur Kunstgeschichte der römischen Republik* (Acta Instituti Romani Regni Sueciae VIII) (Lund and Leipzig 1941), 25f., 36–40, 69–71; J. J. Pollitt, *The Art of Rome c. 753 B.C.–337 A.D.: Sources and Documents* (Englewood Cliffs, N.J., 1966; reprint Cambridge 1983), 26f., 51–2; T. Hölscher, in *Tainia. Festschrift für R. Hampe* (Mainz 1980), 352–5

Chapters 2–5 The Four Pompeian Styles

1. **General:** Mau 1882; Curtius 1929; H. G. Beyen, 'Das chronologische Verhältnis der letzten drei pompejanischen Stile', in *Bericht über den VI. Internationalen Kongress für Archäologie Berlin 21.–26. August 1939* (Berlin 1940), 504–5; idem, 'Das stilistische und chronologische Verhältnis der letzten drei pompejanischen Stile', *Antiquity and Survival* 2 (1957–8) 349–72; Schefold 1962; Beyen, 'Pompeiani stili', in *EAA* 6 (1965) 356–66; Barbet 1985

2. **Mosaic and other pavements:** M. E. Blake, 'The pavements of the Roman buildings of the Republic and early Empire', *MAAR* 8 (1930); E. Pernice, *Pavimente und figürliche Mosaiken* (Die hellenistische Kunst in Pompeji VI) (Berlin 1938); M. De Vos, 'Pavimenti e mosaici', in Zevi 1979, pp. 161–76

3. **Stuccowork:** Mielsch 1975a; R. J. Ling, 'Gli stucchi', in Zevi 1979, pp. 145–60

4. **Wall-paintings in context**: see Barbet 1985, pp. 57–77, 123–39. Also: D. Corlaità Scagliarini, 'Spazio e decorazione nella pittura pompeiana', *Palladio. Rivista di storia dell'architettura* 23–5 (1974–6) 3–44; A. Barbet, 'Quelques rapports entre mosaïques et peintures murales à l'époque romaine', in R. Ginouvès (ed.), *Mosaïque. Recueil d'hommages à Henri Stern* (Paris 1983), 43–53

Chapter 2 The First Style
1. **General**: Laidlaw 1985; see also Ling 1973. To the bibliography cited there add: Abad Casal 1982, p. 255, fig. 419
2. **Beginnings**: V. J. Bruno, 'Antecedents of the Pompeian First Style', *AJA* 73 (1969) 305–17
3. **Aegean sites**:
a. **Delos**: M. Bulard, *Peintures murales et mosaïques de Délos* (*MonPiot* 14((Paris 1908); *Exploration archéologique de Délos* VIII. J. Chamonard, *Le quartier du théâtre* (Paris 1922–4), part 2, pp. 358–91; U. T. Bezerra de Meneses, in P. Bruneau and J. Ducat (eds.), *Guide de Délos* (Paris 1965), 56–8; *Exploration archéologique de Délos* XXVIII. P. Bruneau and others, *L'Îlot de la Maison des Comédiens* (Paris 1970), 151–93
b. **Athens**: F. Wirth, 'Wanddekoration ersten Stils in Athen', *AthMitt* 56 (1931) 33–58
4. **Decorative motifs**:
a. **Cubic pattern**: E. M. Moormann and L. J. F. Swinkels, 'Lozenges in perspective', in Barbet 1983, pp. 239–62
b. **Subjects painted on orthostates and blockwork**: M. De Vos, in *MededRome* 39 (1977) 34–6; eadem and A. Martin, 'La pittura ellenistica a Pompei in decorazioni scomparse documentate da uno studio dell'architetto russo A. A. Parland', *Dial. di arch.* 3rd ser. 2 (1984) 131–40 (= *Ric. Pitt. Ell.*, 269–78); Laidlaw, 33f., 340–1
5. **Harbingers of Second Style**:
a. **Tomb of Lefkadia**: C. I. Makaronas and S. G. Miller, 'The tomb of Lyson and Kallikles', *Archaeology* 27 (1974) 248–59; P. W. Lehmann, 'Lefkadia and the Second Style', in G. Kopcke and M. B. Moore (eds.), *Studies in Classical Art and Archaeology: a Tribute to P. H. von Blanckenhagen* (Locust Valley, N.Y., 1979), 225–9
b. **Delos**: Bulard, *op. cit.* (see no. 3a above), pp. 152, 178, pls. VIA a, VIIIA k
c. **Athens**: Wirth, *art. cit.* (see no. 3b above), pp. 34, 45f., 52f., no. 6, Beilage XV, XVII (1), XXIV

Chapter 3 The Second Style
1. **General**: Beyen 1938, 1960; R. Winkes, 'Zum Illusionismus römischer Wandmalerei der Republik', in *ANRW* I.4 (1975) 927–44
2. **Eastern origins**: K. Fittschen, 'Zur Herkunft und Entstehungen des 2. Stils – Probleme und Argumente', in P. Zanker (ed.), *Hellenismus in Mittelitalien* (Göttingen 1976), 539–63; Lehmann, *art. cit.* (see Chap. 2, no. 5a above); against: F. G. Andersen, 'Intorno alle origini del secondo stile', *Analecta Romana Instituti Danici* 8 (1977) 71–8; B. Wesenberg, 'Wanddekoration des zweiten pompejanischen Stils in Griechenland', *Resümees: XIII. Internationaler Kongress für klassische Archäologie Berlin 24.–30. Juli 1988*, p. 328
3. **First phase**:
a. **Capitolium at Pompeii**: F. Mazois, *Les ruines de Pompéi* III (Paris 1829), 50, pl. 36; Beyen 1938, pp. 41–4, fig. 5
b. **House of the Griffins**: G. E. Rizzo, *Le pitture della Case dei Grifi* (*Mon. pitt. ant.* III, Roma I) (Rome 1936)
c. **Villa of the Mysteries**: Maiuri 1931
d. **Villa at Oplontis**: A. De Franciscis, 'La villa romana di Oplontis', in Andreae and Kyrieleis 1975, pp. 9–38
e. **Villa at Boscoreale**: F. Barnabei, *La villa pompeiana di P.*

Fannio Sinistore scoperta presso Boscoreale (Rome 1901); Lehmann 1953; B. F. Cook, 'The Boscoreale cubiculum. A new installation', *Metropolitan Museum of Art Bulletin* 22 (1963–4) 166–83
4. **Theories about sources of inspiration**:
a. **Theatrical sets**: H. G. Beyen, 'The wall-decoration of the cubiculum of the Villa of P. Fannius Synistor near Boscoreale in its relation to ancient stage-painting', *Mnemosyne* 4th ser. 10 (1957) 147–53; A. M. G. Little, *Roman Perspective Painting and the Ancient Stage* (Kennebunk, Maine, 1971)
b. **Hellenistic architecture**: K. Schefold, 'Der zweite Stil als Zeugnis alexandrinischer Architektur', in Andreae and Kyrieleis 1975, pp. 53–9
c. **Architecture of contemporary Italy**: Lehmann 1953, pp. 82–131; Engemann 1967
d. **Other**: G. C. Picard, 'Origine et signification des fresques architectoniques romano-campaniennes dites de Second Style', *RevArch* (1977) 231–52
5. **Second phase**:
a. **House of the Cryptoportico**: Spinazzola 1953, pp. 435–593
b. **Other decorations of phase 2A**: Beyen 1960
c. **Odyssey landscapes**: see Chap. 6, no. 4
d. **House of Augustus**: G. Carettoni, 'Due nuovi ambienti dipinti sul Palatino', *BdA* 46 (1961) 188–99; idem, 'La decorazione pittorica della Casa di Augusto sul Palatino', *RömMitt* 90 (1983) 373–419 (translated into German: G. Carettoni, *Das Haus des Augustus auf dem Palatin* (Mainz 1983)); identification: idem, 'I problemi della Zona Augustea del Palatino alla luce dei recenti scavi', *RendPontAcc* 39 (1966–7) 55–75
e. **House of Livia**: G. E. Rizzo, *Le pitture della Casa di Livia* (*Mon. Pitt. Ant.* III, Roma III) (Rome 1936)
f. **Ausa Isiaca**: G. E. Rizzo, *Le pitture dell' Aula Isiaca di Caligola* (*Mon. Pitt. Ant.* III, Roma II) (Rome 1936)
g. **Decoration from villa near Herculaneum**: Bastet and De Vos, 1979, pp. 24f., pl. I (1)
h. **House of Obellius Firmus**: Spinazzola 1953, pp. 335–65
i. **Farnesina villa**: Bragantini and De Vos 1982
6. **Ceiling decoration**:
a. **General**: Barbet 1985, pp. 77–89
b. **Stucco coffer-schemes**: Ling 1973
c. **Montefiore**: A. Laidlaw, 'The tomb of Montefiore. A new Roman tomb painted in the Second Style', *Archaeology* 17 (1964) 33–42
d. **House of Augustus**: Carettoni, *Haus des Augustus* (see no. 5d above), 50f., 81–5, figs. 6, 7, 15–17, pls. 22, colour plates Y, Z
e. **Livia's Villa at Primaporta**: Wadsworth 1924, p. 35, pl. X (1); Mielsch 1975a, pp. 23, 114, pl. 6 (1)
f. **Farnesina stuccoes**: Wadsworth 1924, pp. 23–34, pls. I–IX; Mielsch 1975a, pp. 20–3, 111–14; Bragantini and De Vos 1982, *passim*
g. **Aula Isiaca**: Rizzo, *Pitture dell'Aula Isiaca* (see no. 5f above), 22–5; Barbet 1985, pp. 162–4
7. **Lunettes**: Ling 1973, pp. 28f., pl. VI; Mielsch 1975a, pp. 16–19, 109f.; Maiuri 1933, pp. 92f., 140–2, figs. 44, 45, 65, pl. X; Laidlaw, *art. cit.* (see no. 6c above)
8. **Context**: Ling 1973, pp. 46–55; Barbet 1985, pp. 57–77; B. Wesenberg, 'Zur asymmetrischen Perspektive in der Wanddekoration des zweiten pompejanischen Stils', *Marburger Winckelmannsprogramm* (1968) 102–9

Chapter 4 The Third Style
1. **General**: Bastet and De Vos 1979; Ehrhardt 1987; Strocka 1987, pp. 29–44

2. Chronology: Bastet and De Vos, 8–16; Ehrhardt, 1–12

3. First phase:

a. House of Paquius Proculus: Bastet and De Vos, 33; Ehrhardt, 24–7

b. Pyramid of Cestius: Bastet and De Vos, 28; Ehrhardt, 53f.

c. Caserma dei Gladiatori: Bastet and De Vos, 31f., Ehrhardt, 27f.

d. Decoration in Pompeii V 1, 14: Mau 1882, pp. 206–9, pl. VIII; Bastet and De Vos, 29f.; Ehrhardt, 51

e. Boscotrecase: Blanckenhagen and Alexander 1962; Bastet and De Vos, 45–7; Ehrhardt, 54–7

f. Villa Imperiale: Bastet and De Vos, 37–9; U. Pappalardo, 'Die "Villa Imperiale" in Pompeji', *Antike Welt* 16 (1985), part 4, pp. 3–15; Ehrhardt, 47–9

g. House of Spurius Mesor: Mau 1882, pp. 394–6, pl. XII; Bastet and De Vos, 42f.; Ehrhardt, 72f.

4. Second phase:

a. House of Epidius Sabinus: Mau 1882, pp. 352f., 440, pls. XV, XVI; Bastet and De Vos, 59f.; Ehrhardt, 76–8

b. House of Sulpicius Rufus: Bastet and De Vos, 89f.; Ehrhardt, 106–8

c. House of the Priest Amandus: A. Maiuri, *Le pitture delle case di 'M. Fabius Amandio', del 'Sacerdos Amandus' e di 'P. Cornelius Teges'* (*Mon. Pitt. Ant.* III, Pompei II) (Rome 1938), pp. 3–13; Bastet and De Vos, 81–3; Ehrhardt, 139–42

d. House of Caecilius Jucundus: Mau 1882, p. 414, pls. XIII, XIV; Bastet and De Vos, 76–9; Ehrhardt, 101–4; cf. (Egyptian palm-columns) Athenaeus, *Deipnosophistae* 5.196b–c

e. House of Lucretius Fronto: Bastet and De Vos, 64–7; Ehrhardt, 96–101

f. House of the Orchard: Bastet and De Vos, 74–6; Ehrhardt, 135–8

5. Ceiling-decorations:

a. General: Barbet 1985, pp. 140–74

b. Underground Basilica: G. Bendinelli, 'Il monumento sotterraneo di Porta Maggiore in Rome', *MonAnt* 31 (1926) 601–856; Mielsch 1975a, pp. 29–33, 118–21

c. Tomb of the Arruntii: G. B. Piranesi, *Le antichità romane* II (Rome 1756), pls. XII–XV; Wadsworth 1924, pp. 36f.; Mielsch 1975a, p. 184

d. Pyramid of Cestius: Barbet 1985, pp. 104f., 162

e. House of Julius Polybius: Barbet 1985, pp. 158–62

f. House of the Wooden Partition: Barbet 1985, pp. 156–8

g. All-over patterns: M. De Vos, in *RömMitt* 89 (1982), 331–5; Barbet 1985, pp. 140–6

h. Tomb of Pomponius Hylas: T. Ashby and F. G. Newton, 'The columbarium of Pomponius Hylas', *PBSR* 5 (1910) 463–71, pls. XXXVII–XLVII; Ehrhardt, 69

i. House of the Orchard: Barbet 1985, p. 164; cf. (Bacchic caves) Athenaeus, *Deipnosophistae* 4.148b–c

j. House of the Theatrical Panels: Barbet 1985, pp. 147–52

6. Context: Barbet 1985, pp. 123–40; cf. Bastet and De Vos, 107–17 (pavements)

Chapter 5 The Fourth Style

1. General: there is no monograph; see the general books on Roman and Pompeian painting: also W. J. T. Peters, 'La composizione delle pitture parietali di IV stile a Roma e in Campania', in *La regione sotterrata*, 635–59

2. Chronology: Strocka 1984a; Strocka 1984b, pp. 36–9 (with references to earlier bibliography) (see review by R. J. Ling, *Gnomon* 59 (1987) 429–33); Strocka 1987

3. Transitional and early decorations:

a. General: I. Bragantini, 'Tra il III e il IV stile: ipotesi per l'identificazione di una fase della pittura pompeiana', in *Pompei 1748–1980*, pp. 106–18; cf. references under no. 2 above

b. Menander green *oecus*: Maiuri 1933, pp. 57–74, pl. VIII; H. G. Beyen, 'Die grüne Dekoration des Oecus am Peristyl der Casa del Menandro', *Nederlands Kunsthistorisch Jaarboek* 5 (1954) 199–210

c. Villa San Marco: O. Elia, *Pitture di Stabia* (Naples 1957), 20, drawing A

d. Vettii *alae*: W. J. T. Peters, in *MededRome* 39 (1977), 97–8

e. House of the Prince of Naples: Strocka 1984b

4. Mature period:

a. Golden House: L. Mirri and G. Carletti, *Le antiche camere delle Terme di Tito e le loro pitture* (Rome 1776) (cf. N. Ponce, *Description des Bains de Titus* (Paris 1786): plates reprinted in a different order and back to front); W. J. T. Peters and P. G. P. Meyboom, 'The roots of provincial Roman painting: results of current research in Nero's Domus Aurea', in Liversidge 1982, pp. 33–74

b. Scenographic decorations at Pompeii: E. Moormann, 'Rappresentazioni teatrali su scaenae frontes di quarto stile a Pompei', *Pompeii Herculaneum Stabiae* 1 (1983) 73–117

c. House of the Vettii: W. J. T. Peters, 'La composizione delle pareti dipinte nella Casa dei Vettii a Pompei', *MededRome* 39 (1977) 95–128

d. Single-colour walls: Schefold 1962, pp. 128–32

e. House of the Stags *triclinium*: A. De Franciscis, *The Buried Cities: Pompeii and Herculaneum* (London 1978), figs. 146–7

f. Borders: A. Barbet, 'Les bordures ajourées dans le IVe style de Pompéi', *MEFRA* 93 (1981) 917–98

g. *Tapetenmuster*: K. Schefold, in *RömMitt* 60–1 (1953–4), 113; A. Barbet and C. Allag, in *MEFRA* 84 (1972), 1000–6

h. All-over picture-paintings: Schefold 1962, pp. 146–52; see also under Chap. 7, no. 2a below

5. Ceiling-decorations:

a. General: Barbet 1985, pp. 215–69

b. Domus Transitoria *nymphaeum*: F. L. Bastet, 'Domus Transitoria I', *BABesch* 46 (1971) 144–72; 'Domus Transitoria II', *BABesch* 47 (1972) 61–87; A. Allroggen-Bedel, 'Malerei-Fragmente aus der Domus Transitoria in Neapel', *BABesch* 48 (1973) 194

c. Villa Imperiale: Mielsch 1975a, pp. 34–6, 122f., pls. 20, 21 (1)

d. Golden House: see under no. 4a above; also F. Weege, 'Das Goldene Haus des Nero (Neue Funde und Forschungen)', *JdI* 28 (1913) 127–244; N. Dacos, 'Fabullus et l'autre peintre de la Domus Aurea', *Dial. di arch.* 2 (1968) 210–26; eadem, *La découverte de la Domus Aurea et la formation des grotesques à la Renaissance* (London and Leiden 1969); Mielsch 1975a, pp. 40f., 126f.

e. Villa San Marco: Elia, *op. cit.* (see no. 3c above), pp. 21–38, pls. I–X, drawings B, C; Barbet 1985, pp. 247f.

f. Centralised vaults at Pompeii and Herculaneum: Barbet 1985, pp. 225–47

g. Vaults decorated with stars: Barbet and Allag, *art. cit.* (see no. 4g above), 997–9; Davey and Ling 1982, p. 116; Barbet 1985, pp. 262f.

h. Forum Baths at Herculaneum: A. Maiuri, *Ercolano, i nuovi scavi* I (Rome 1958), 97, figs. 73–4

i. All-over patterns: see under 5d above (Golden House)

6. Context:

a. General: Barbet 1985, pp. 266–9 and *passim*

b. Wall-mosaic and *opus sectile*: Sear 1977; T. Dohrn, 'Crustae', *RömMitt* 72 (1965) 127–41; P. Coarelli, *Roma sepolta* (Rome 1984), 146–55 (Quirinal)

c. Marble veneer and painted imitations: M. De Vos, in H. Eschebach, *Die Stabianer Thermen in Pompeji* (Berlin 1979), 87, notes 21–7; H. Eristov, 'Corpus des faux-marbres à Pompei', *MEFRA* 91 (1979) 693–771

d. Fourth Style stuccowork: see generally Mielsch 1975a, pp. 39–72; add: Mielsch, in Eschebach, *op. cit.*, pp. 74–80 (Stabian Baths)

e. Stuccoed vault at Baiae: R. J. Ling, in *PBSR* 45 (1977), 45–7, pls. XV, XVI

f. Split-level ceilings: Barbet 1985, pp. 253–62

Chapter 6 Mythological and historical paintings

1. **Mysteries frieze:** Basic publication: Maiuri 1931, pp. 121–74, pls. G–U, colour pls. I–XV; other important discussions: M. Bieber, 'Der Mysteriensaal der Villa Item', *JdI* 43 (1928) 298–330; J. M. C. Toynbee, 'The Villa Item and a bride's ordeal', *JRS* 19 (1929) 67–87; Curtius 1929, pp. 343–72; R. Herbig, *Neue Beobachtungen am Fries der Mysterien-Villa in Pompeji* (Baden Baden 1958); K. Lehmann, 'Ignorance and search in the Villa of the Mysteries', *JRS* 52 (1962) 62–8; J. Houtzager, *De grote wandschildering in de Villa dei Misteri bij Pompeii en haar verhouding tot de monumenten der vroegere kunst* (The Hague 1963); G. Zuntz, 'On the Dionysiac fresco in the Villa dei Misteri at Pompeii', *Proceedings of the British Academy* 49 (1963) 177–201; F. Matz, *Dionysiake Telete. Archäologische Untersuchungen zum Dionysoskult in hellenistischer und römischer Zeit (AbhMainz 1963, no. 15)* (Mainz 1964); P. Boyancé, 'Dionysos et Sémélé', *RendPontAcc* 38 (1965–6) 79–104; O. J. Brendel, 'Der grosse Fries in der Villa dei Misteri', *JdI* 81 (1966) 206–60 (translated into English: *The Visible Idea* (Washington 1980), 90–138); R. Turcan, 'La démone ailée de la Villa Item', in J. Bibauw (ed.), *Hommages à Marcel Renard* (Brussels 1969) III, pp. 586–609; F. L. Bastet, 'Fabularum dispositas explicationes', *BABesch* 49 (1974) 206–40; R. A. S. Seaford, 'The Mysteries of Dionysus at Pompeii', in H. W. Stubbs (ed.), *Pegasus: Classical Essays from the University of Exeter* (Exeter 1981), 52–68; R. Turcan, 'Pour en finir avec la femme fouettée', *RevArch* (1982) 291–302; U. Pappalardo, 'Nuove osservazioni sul fregio della "Villa dei Misteri" a Pompei', *La regione sotterrata*, 599–634; idem, 'Beobachtungen am Fries der Mysterien-Villa in Pompeji', *Antike Welt* 13 (1982), part 3, pp. 10–20; G. Sauron, 'Nature et signification de la mégalographie dionysiaque de Pompéi', *CRAI* (1984) 151–76

2. **Boscoreale frieze:** Lehmann 1953, pp. 23–81; C. M. Robertson, 'The Boscoreale figure-paintings', *JRS* 45 (1955) 58–67; M. Bieber and D. von Bothmer, 'Notes on the mural paintings from Boscoreale', *AJA* 60 (1956) 171–2; 'Another note on the murals from Boscoreale', *ibid.*, 283–4; B. Andreae, 'Rekonstruktion des grossen Oecus der Villa des P. Fannius Synistor in Boscoreale', in Andreae and Kyrieleis 1975, pp. 71–92; K. Fittschen, 'Zum Figurenfries der Villa von Boscoreale', *ibid.*, 93–100

3. **Trojan frieze:** Spinazzola 1953, pp. 903–70 (F. Aurigemma)

4. **Odyssey landscapes:** B. Andreae, 'Der Zyklus der Odyssee-fresken im Vatikan', *RömMitt* 69 (1962) 106–17; P. H. von Blanckenhagen, 'The Odyssey frieze', *RömMitt* 70 (1963) 100–46; A. Gallina, *Le pitture con paesaggi dell'Odissea dall'Esquilino (Studi miscellanei 6)* (Rome 1964); Engemann 1967, pp. 141–6

5. **Foundation frieze:** M. Borda, 'Il fregio pittorico delle origini di Roma', *Capitolium* 34.5 (May 1959) 3–10; E. Nash, *Pictorial Dictionary of Ancient Rome* (London 1962) II, pp. 359–63, figs. 1139–48

6. **Octavius Quartio friezes:** Spinazzola 1953, pp. 971–1008 (F. Aurigemma)

7. **Panel-pictures (general):** W. Helbig, *Wandgemälde der vom Vesuv verschütterten Städte* (Leipzig 1868); A. Sogliano, *Le pitture murali campane scoverte negli anni 1867–1879* (Naples 1880); P. Herrmann and F. Bruckmann, *Denkmäler des Malerei des Altertums* (Munich 1904–50); see also general books on Pompeian painting, esp. Curtius 1929, Rizzo 1929

8. **Shuttered panels:** A. W. Van Buren, 'Pinacothecae', *MAAR* 15 (1938) 70–81; see publications cited under Chap. 3, nos. 3 and 5; also A. Allroggen Bedel, 'Die Malereien aus dem Haus Insula Occidentalis, 10', *Cronache pompeiane* 2 (1976) 144–83 (esp. 162)

9. **Central pictures:**

a. Stylistic development: H. Diepolder, 'Untersuchungen zur Komposition der römisch-campanischen Wandgemälde', *RömMitt* 41 (1926) 1–78; F. Wirth, 'Der Stil der kampanischen Wandgemälde im Verhältnis zur Wanddekoration', *RömMitt* 42 (1927) 1–83; Lauter-Bufe 1969; Bragantini and Parise Badoni 1984

b. House of Livia and Farnesina villa: see publications cited under Chap. 3, nos. 5e, 5i

c. Mythological landscapes: C. M. Dawson, *Romano-Campanian Mythological Landscape Painting (Yale Classical Studies 9)* (New Haven 1944); P. H. von Blanckenhagen, 'Narration in Hellenistic and Roman art', *AJA* 61 (1957) 78–83. Individual groups of pictures: W. Klein, 'Pompejanische Bilderstudien II', *ÖJh* 19–20 (1919) 268–95 (Pompeii IX 7, 16 and V 2, 10); Blanckenhagen and Alexander 1962, 38–51; H. Sichtermann, 'Zu den Malereien des Tricliniums der Casa del Frutteto in Pompeii', in F. Krinzinger, B. Otto and E. Walde-Psenner (eds.), *Forschungen und Funde. Festschrift Bernhard Neutsch* (Innsbruck 1980), 457–61. Individual subjects: P. H. von Blanckenhagen, 'Vom Ursprung Roms', *Prähistorische Zeitschrift* 34–5 (1949–50), part 2, pp. 245–9; K. M. Phillips, 'Perseus and Andromeda', *AJA* 72 (1968) 1–23; P. H. von Blanckenhagen, 'Daedalus and Icarus on Pompeian walls', *RömMitt* 75 (1968) 106–43; R. J. Ling, 'Hylas in Pompeian art', *MEFRA* 91 (1979) 773–816; E. Winsor Leach, 'Metamorphoses of the Actaeon myth in Campanian painting', *RömMitt* 88 (1981) 307–32; eadem, 'The punishment of Dirce: a newly discovered painting in the Casa di Giulio Polibio and its significance within the visual tradition', *RömMitt* 93 (1986) 157–82

d. House of the Cithara Player: O. Elia, *Le pitture della Casa del Citarista (Mon. Pitt. Ant. III, Pompeii I)* (Rome 1937)

e. House of Jason: Zevi 1964

f. Other Third and Fourth Style pictures: see works under no. 7 above

g. Scenographic compositions: see under Chap. 5, no. 4b

10. **Relation of panel-pictures to old masters:**

a. General: W. Helbig, *Untersuchungen über die campanische Wandmalerei* (Leipzig 1873); G. Lippold, *Antike Gemäldekopien (Abhandlungen der Bayerischen Akademie der Wissenschaften, Philosophisch-historische Klasse new ser. 33)* (Munich 1951); Lauter-Bufe 1969

b. De luxe and economy versions: Bragantini and Parise Badoni 1984, pp. 123–9

c. Supernumerary figures: W. Klein, 'Pompejanische Bilderstudien', *ÖJh* 15 (1912) 143–67; D. Michel, 'Bemerkungen über Zuschauerfiguren in pompejanischen sogenannten Tafelbildern', in *La regione sotterrata*, 537–98

d. Pan and the nymphs: W. Kraiker, 'Aus dem Musterbuch eines pompejanischen Wandmalers', in G. E. Mylonas (ed.), *Studies Presented to D. M. Robinson* I (St Louis 1951), 801–7; Zevi 1964, pp. 44–6

e. Achilles on Skyros: Curtius 1929, pp. 206–13; cf. *Lexicon Iconographicum Mythologiae Classicae* I (1981), 58f., no. 108

f. Medea and Nessus pictures: Zevi 1964, pp. 40f., 47f.; Lauter-Bufe, 1969, pp. 59–61

11. **Themes and their organisation:**
 a. Picture galleries: Van Buren, *art. cit.* (see no. 8 above); cf. K. Lehmann, 'The Imagines of the Elder Philostratus', *Art Bulletin* 23 (1941) 16–44

 b. Programmatic theories: Schefold 1952; M. L. Thompson, 'The monumental and literary evidence for programmatic painting in antiquity', *Marsyas* 9 (1960–1) 36–77; cf. R. Brilliant, *Visual Narratives. Storytelling in Etruscan and Roman Art* (Ithaca and London 1984), 65–83

 c. Harmonisation of pictures: G. Rodenwaldt, *Die Komposition der pompejanischen Wandgemälde* (Berlin 1909); cf. Helbig, *op. cit.* (see no. 10a above), 339f.; Zevi 1964, pp. 52–5 (House of Jason); Lauter-Bufe 1969, p. 106 (Pentheus Room)

Chapter 7 Other paintings
 1. **Landscape painting:**
 a. General: K. Schefold, 'Vorbilder römischer Landschaftsmalerei', *AthMitt* 71 (1956) 211–31; idem, 'Origins of Roman landscape painting', *Art Bulletin* 42 (1960) 87–96; Blanckenhagen and Alexander 1962; W. J. T. Peters, *Landscape in Romano-Campanian Mural Painting* (Assen 1963) (see review by P. H. von Blanckenhagen, *Gnomon* 39 (1967) 175–85)

 b. Sacro-idyllic and villa landscapes: M. I. Rostovtzeff, 'Die hellenistisch-römische Architekturlandschaft', *RömMitt* 26 (1911) 1–186; R. J. Ling, 'Studius and the beginnings of Roman landscape painting', *JRS* 67 (1977) 1–16; E. Winsor Leach, 'Sacral-idyllic landscape painting and the poems of Tibullus's first book', *Latomus* 39 (1980) 47–69; S. R. Silberberg, *A Corpus of the Sacral-Idyllic Landscape Paintings in Roman Art* (dissertation, Los Angeles 1980)

 2. **Garden paintings:**
 a. General: P. Grimal, *Les jardins romains à la fin de la République et aux premiers siècles de l'Empire* (Bibliothèque des Écoles Françaises d'Athènes et de Rome 155) (Paris 1943; reprint 1969); W. Jashemski, *The Gardens of Pompeii, Herculaneum and the Villas Destroyed by Vesuvius* (New York 1979), 55–87; D. Michel, 'Pompejanische Gartenmalereien', in H. A. Cahn and E. Simon (eds.), *Tainia. Festschrift für Roland Hampe* (Mainz 1980), 373–404

 b. Primaporta: M. M. Gabriel, *Livia's Garden Room at Prima Porta* (New York 1955)

 c. Tomb in Rome: V. Tran Tam Tinh, *Catalogue des peintures romaines (Latium et Campania) du musée du Louvre* (Paris 1974), 72–7

 d. House of the Orchard: A. Maiuri, 'Nuove pitture di giardino a Pompei', *BdA* 37 (1952) 5–12; H. Sichtermann, 'Gemalte Gärten in pompejanischen Zimmern', *Antike Welt* 5 (1974), part 3, pp. 41–51

 e. Social implications of painted gardens: P. Zanker, in *JdI* 94 (1979), 504–13

 3. **Still life:** H. G. Beyen, *Über Stilleben aus Pompeji und Herculaneum* (The Hague 1928); G. E. Rizzo, *Le pitture di natura morta* (*Mon. Pitt. Ant.* specimen) (Rome 1935); F. Eckstein, *Untersuchungen über die Stilleben aus Pompeji und Herculaneum* (Berlin 1957); J.-M. Croisille, *Les natures mortes campaniennes* (Brussels 1965)

 4. **Portraits:** Curtius 1929, pp. 376–84; Rizzo 1929, pp. 83f., pls. 191–3; Schefold 1962, pp. 136–8; D. L. Thompson, 'Painted portraiture at Pompeii', in *Pompeii and the Vesuvian Landscape* (Papers of a Symposium sponsored by the Archaeological Institute of America, Washington Society and the Smithsonian Institution) (Washington 1979), 78–92

5. **Genre scenes:**
 a. Farnesina frieze: Bragantini and De Vos 1982, pp. 234–83; cf. E. Loewy, 'Aneddoti giudiziari dipinti in un fregio antico', *RendLinc* 5th ser. 6 (1897) 27–44

 b. Theatrical pictures: M. Bieber, *Die Denkmäler zum Theaterwesen im Altertum* (Berlin and Leipzig 1920), 112–17, 158–61; Rizzo 1929, pp. 67–9, pls. 144–8, 150; A. Maiuri, in *NotScav* (1929), 407–12, pls. XXII–XXIV; T. B. L. Webster, *Monuments Illustrating New Comedy* (*BICS* suppl. 11) (London 1961), 184–92, 211; idem, *Monuments Illustrating Tragedy and Satyr Play* (*BICS* suppl. 20) (London 1967), 85–91, 95f.; Bieber, *The History of the Greek and Roman Theater*, 2nd edn (Princeton 1961), *passim*; cf. Bragantini and De Vos 1982, p. 130, pls. 41 (back to front), 42; U. Pappalardo, in *Antike Welt* 16 (1985), part 4, p. 9, fig. 15

 c. Religious ceremonies: Spinazzola 1953, pp. 161–242; V. Tran Tam Tinh, *Essai sur le culte d'Isis à Pompéi* (Paris 1964), 123–53; idem, *Le culte des divinités orientales à Herculaneum* (Leiden 1971), 29–49, 83–6

 d. *Lararium* paintings: G. K. Boyce, *Corpus of the Lararia of Pompeii* (*MAAR* 14) (Rome 1937)

 e. Craftsmen at work: Spinazzola 1953, pp. 181–95, 207f.; B. J. Mayeske, *Bakeries, Bakers and Bread at Pompeii* (dissertation, Maryland 1972), 47f., pl. VIII (1); Kraus and von Matt 1973, figs. 196, 200, 235; G. Zimmer, *Römische Berufsdarstellungen* (Berlin 1982), 128 (no. 42), 130 (no. 45), 199 (no. 143); Croisille 1982, pls. 113, 116–17, 121

 f. Drinking and revelling: Kraus and von Matt, figs. 216, 222–6; Ward-Perkins and Claridge 1976, nos. 227, 259–62; Croisille 1982, pls. 126–9

 g. Erotic scenes: M. Grant and A. Mulas, *Eros a Pompei*, 2nd edn (Milan 1975); Kraus and von Matt, figs. 217, 218; Croisille 1982, pls. 130–5

 h. Forum scenes: Croisille 1982, pls. 118–20, 122–5

 6. **Burlesque:**
 a. Menander frieze: Maiuri 1933, pp. 128–39

 b. Aeneas and Anchises: A. Maiuri, 'La parodia di Enea', *BdA* 35 (1950) 108–12; O. Brendel, 'Der Affen-Aeneas', *RömMitt* 60–1 (1953–4) 153–9

 c. *Grylli* and pygmy paintings: W. Binsfeld, *Grylloi* (dissertation, Cologne 1956), 27–35; Rizzo 1929, pp. 69f., pl. 151; A. Maiuri, 'Una nuova pittura nilotica a Pompei', *MemLinc* 8th ser. 7 (1955) 65–80; Ward-Perkins and Claridge 1976, no. 99

 d. Cupids: R. Stuveras, *Le putto dans l'art romain* (Brussels 1969); cf. A. Sogliano, in *MonAnt* 8 (1898), 348–64, figs. 47–56; A. Mau, *Pompeji in Leben und Kunst*, 2nd edn (Leipzig 1908), 350–5; Rizzo 1929, pp. 65–7, pls. 139–40

Chapter 8 The Pompeian Styles in the provinces
 1. **Italy outside Rome and Campania:**
 a. General: Mielsch 1981, pp. 170f.; A. Frova, 'Pittura romana nella Venetia et Histria', in *Aquileia nella 'Venetia et Histria'* (*Antichità altoadriatiche* 28) (Udine 1986), 203–28 (with references)

 b. Second Style: G. Libertini, *Centuripe* (Catania 1926), 52–64, pls. II–V; Beyen 1938, pp. 44–6, fig. 6 (Solunto); M. De Vos, 'Pitture e mosaico a Solunto', *BABesch* 50 (1975) 195–224; B. Andreae, in *ArchAnz* (1959), 175f., fig. 47 (Ancona); *EAA* suppl. (1970), colour pl. opp. p. 56 (Ancona); F. Van Wonterghem, *Superaequum, Corfinium, Sulmo* (Forma Italiae, Reg. IV, vol. I) (Florence 1984), 247–50, figs. 347–8 (Sulmona); A. Carandini and S. Settis, *Schiavi e padroni nell'Etruria romana* (Bari 1979), panels 47–50 (Sette Finestre); various authors, *Brescia romana. Materiali per un museo* II.1 (Brescia 1979), 34–42; cf. also *Fouilles de l'École*

Française de Rome à Bolsena (Poggio Moscini) II. A. Balland, A. Barbet, P. Gros and G. Hallier, *Les architectures (1962–1967)* (*MEFRA* suppl. 6) (Paris 1971), 318–88

c. **Third Style**: references in Bastet and De Vos 1979, pp. 140–1; add: C. Delplace, 'Le pitture murali del criptoportico di Urbisaglia – I', *BdA* 6th ser. 11 (July–September 1981) 25–48

2. **Roman painting in the provinces (general)**: A. Linfert, *Römische Wandmalerei der nordwestlichen Provinzen* (Cologne 1975); Liversidge 1982; Barbet 1983; *La peinture romaine 1984*; *Pictores per provincias 1987*

e. **Individual provinces**:

a. **Switzerland**: Drack 1950, 1980, 1981, 1986

b. **Gaul**: *Peinture murale en Gaule. Actes des séminaires 1979* (Dijon 1980); A. Barbet and Y. Burnand (eds.), *Peinture murale en Gaule. Actes des séminaires de Limoges (1980) et Sarrebourg (1981)* (Nancy 1984); A. Barbet (ed.), *Peinture murale en Gaule. Actes des séminaires AFPMA 1982–1983 1er et 2 mai 1982 à Lisieux, 21 et 22 mai 1983 à Bordeaux* (BAR International Series 240) (Oxford 1985); A. Barbet (ed.), *La peinture murale antique. Restitution et iconographie. Actes du IXe séminaire de l'AFPMA Paris, 27–28 avril 1985* (Documents d'archéologie française 10) (Paris 1987)

c. **Hungary**: L. Nagy, 'Die römisch-pannonische dekorative Malerei', *RömMitt* 41 (1926) 79–131; E. B. Thomas, *Römische Villen in Pannonien* (Budapest 1964); M. Frizot, 'Les peintures murales romaines de Hongrie', *RevArch* (1981) 261–76

d. **Asia Minor**: Strocka 1977

e. **Israel**: A. Ovadiah and T. Michaeli, 'Roman wall-paintings in Israel', in *Pictores per provincias*, 243–8

f. **Spain**: Abad Casal 1982

g. **Britain**: Davey and Ling 1982

4. **Second Style**:

a. **Glanum**: A. Barbet, *Recueil général des peintures murales de la Gaule* I. *Narbonnaise* 1. *Glanum* (Paris 1974)

b. **Amphipolis**: *To Ergon tes Archaiologikes Hetaireias* (1982), 16f., figs. 17, 18

c. **Judaea**: Y. Yadin, *Masada: Herod's Fortress and the Zealots' Last Stand* (London 1966); V. Corbo, 'L'Herodion di Gebal Fureidis', *Studii Biblici Franciscani Liber Annuus* 13 (1962–3) 219–77

d. **Apaturius of Alabanda**: Vitr. 7.5–7; cf. Engemann 1967, pp. 115–16

e. **Retention of simple schemes in the East**: C. H. Kraeling, *Ptolemais. City of the Libyan Pentapolis* (Chicago 1962), 225–36; cf. Mielsch 1981, pp. 244, 262

5. **Third Style**:

a. **Jerusalem**: N. Avigad, *Discovering Jerusalem* (Oxford 1984), 99–103, figs. 103–6

b. **Alexandria**: R. Pagenstecher, *Nekropolis* (Leipzig 1919), 186–203

c. **North and West (general)**: A. Barbet, 'La diffusion du IIIe style pompéien en Gaule', *Gallia* 40 (1982) 54–82; 41 (1983) 111–65; cf. *Pictores per provincias*, 13–26

d. **Magdalensberg**: H. Kenner, *Die römischen Wandmalereien des Magdalensberges* (Archäologische Forschungen zu den Grabungen auf dem Magdalensberg 8) (Klagenfurt 1985), 22–62, pls. 10–24 (with earlier dating)

e. **Commugny**: Drack 1950, pp. 66–75, pls. I–VI, Beilage 1; Drack 1986, p. 17, pl. 1 a–d

6. **Fourth Style**:

a. **Ephesus**: Strocka 1977, pp. 93–6, 103f., figs. 191–7

b. **Sites in Yugoslavia**: L. Plesnicar-Gec, in *Pictores per provincias*, p. 220, pl. IX

c. **Sites in Spain**: Abad Casal 1982, pp. 48–54, 113, 156, 160, 185–90, figs. 31–8, 161, 227, 257, 286–97; G. Guiral Pelegrin and A. Mostalac Carrillo, 'Avance sobre la difusión de los cuatro estilos pompeyanos en Aragón (España)', in *Pictores per provincias*, 233–41

d. **North-west (general)**: H. Eristov, 'Les peintures murales provinciales d'époque flavienne', in *Pictores per provincias*, 45–55

e. **Narbonne**: M. and R. Sabrié, 'Style et datation des peintures de la Maison à Portiques à Narbonne', in *Pictores per provincias*, 161–6; M. and R. Sabrié and Y. Solier, *La Maison à Portiques du Clos de la Lombarde à Narbonne et sa décoration murale* (*Revue archéologique de Narbonnaise* suppl. 16) (Paris 1987)

f. **Ribemont-sur-Ancre**: A. Quillet, *Latomus* 37 (1978) 361–3; C. Allag, 'Enduits peints de Ribemont-sur-Ancre', *Gallia* 40 (1982) 107–22

g. **Trier**: P. Steiner, 'Römische Wandmalerei in Trier', *Trierer Zeitschrift* 2 (1927) 59–68; W. Reusch, 'Wandmalereien und Mosaikboden eines Peristylhauses im Bereich der Trierer Kaiserthermen', *Trierer Zeitschrift* 29 (1966) 187–235

h. **Mercin-et-Vaux**: A. Barbet, 'Peintures murales de Mercin-et-Vaux (Aisne): étude comparée', *Gallia* 32 (1974) 107–35; 33 (1975) 95–115

i. **Cologne**: A. Linfert, 'Römische Wandmalereien aus der Grabung am Kölner Dom', *Kölner Jahrbuch für Vor- und Frühgeschichte* 13 (1972–3) 65–76

j. **Virunum**: C. Praschniker and H. Kenner, *Der Bäderbezirk von Virunum* (Vienna 1947), 196f., pls. II–IV

k. **Balácapuszta**: Thomas, *op. cit.* (see no. 3c above), 97–104, pls. XXIX–LVII

l. **Astorga**: Abad Casal, 138–40, figs. 206–11

Chapter 9 Painting after Pompeii

1. **General**: Wirth 1934; Borda 1958; Mielsch 1981; M. De Vos, 'La peinture italienne du IIe au IVe siècle', in *La peinture romaine 1984*, pp. 18–28

2. **The Middle Empire**:

a. **General**: Wirth 1929; Mielsch 1975b; H. Joyce, *The Decoration of Walls, Ceilings and Floors in Italy in the Second and Third Centuries A.D.* (Rome 1981)

b. **Ostia**: C. C. Van Essen, 'Studio cronologico sulle pitture parietali di Ostia', *BullComm* 76 (1956–8) 155–81; B. M. Felletti-Maj, *Le pitture delle Case delle Volte Dipinte e delle Pareti Gialle* (*Mon. Pitt. Ant.* III, Ostia I/II) (Rome 1961); eadem, 'Problemi cronologici e stilistici della pittura ostiense', *Colloqui del sodalizio* 2nd ser. I (1966–8) 27–41; B. M. Felletti-Maj and P. Moreno, *Le pitture della Casa delle Muse* (*Mon. Pitt. Ant.* III, Ostia III) (Rome 1967); C. Gasparri, *Le pitture della Caupona del Pavone* (*Mon. Pitt. Ant.* III, Ostia IV) (Rome 1970); M. L. Veloccia Rinaldi, 'Nuove pitture ostiensi: la Casa delle Ierodule', *RendPontAcc* 43 (1970–1) 165–85

3. **Wall-decorations**:

a. **House in Villa Negroni**: H. Krieger, 'Dekorative Wandgemälde aus dem II. Jahrhundert nach Christus', *RömMitt* 34 (1919) 24–52; H. Joyce, 'The ancient frescoes from the Villa Negroni and their influence in the eighteenth and nineteenth centuries', *Art Bulletin* 55 (1983) 423–40

b. **House in Via Merulana**: M. De Vos, 'Due monumenti di pittura post-pompeiana', *BullComm* 81 (1968–9) 149–72; H. Mielsch, in *Affreschi romani dalle raccolte dell'Antiquarium Comunale* (Rome 1976) 38–41, pls. XI–XV

c. **House of Jupiter and Ganymede**: G. Calza, 'Gli scavi recenti nell'abitato di Ostia', *MonAnt* 26 (1920) 321–430; Strocka 1977, p. 50; Mielsch 1981, p. 223 (with earlier dating)

d. Inn of the Peacock: Gasparri, *op. cit.* (see no. **2b** above); Mielsch 1981, p. 217

e. Palatine Stadium: Wirth 1934, pp. 129–31, pl. 32; Mielsch 1975b, pp. 122–4, pls. 19–20

f. Theatre Room at Ephesus: Strocka 1977, pp. 46–56, pls. 54–78

g. House of the Consul Attalus: *Altertümer von Pergamon* I. A. Conze and others, *Stadt und Landschaft* (Berlin 1912–13), 287f., fig. 88, Beil. 53, pl. XXI; Strocka 1977, p. 100 (dated to third quarter of 2nd century)

h. House at Dover: B. J. Philp, *The Roman Painted House at Dover* (Dover, n.d.); Davey and Ling 1982, pp. 111–14

i. House of the Tragic Actor: Aurigemma 1962, pp. 100–11, pls. 93–118; dating: Mielsch 1981, p. 243

4. Vaults and ceilings:

a. Vatican tombs: J. M. C. Toynbee and J. B. Ward-Perkins, *The Shrine of St Peter and the Vatican Excavations* (London 1956); H. Mielsch, 'Hadrianische Malereien der Vatikannekropole "ad Circum"', *RendPontAcc* 46 (1973–4) 79–87; idem and H. von Hesberg, *Die heidnische Nekropole unter St Peter in Rom: die Mausoleen A–D* (*MemPontAcc* 16.1) (Rome 1986)

b. Large Baths at Tivoli: Wadsworth 1924, pp. 62f., pl. XVII (2); Wirth 1934, pp. 70–2, fig. 31; Andreae 1967, p. 217, pl. 166

c. Tomb of the Pancratii: Wadsworth 1924, pp. 73–8, pls. XXV–XXXV; Wirth 1934, pp. 83–6, figs. 41–2, pl. 16; Andreae 1967, pp. 217f., pls. 170–1

d. House under Baths of Caracalla: I. Jacopi, 'Soffitto dipinto nella casa romana di "Vigna Guidi" sotto le Terme di Caracalla', *RömMitt* 79 (1972) 89–110

e. Tomb at Caivano: O. Elia, 'L'ipogeo di Caivano', *MonAnt* 34 (1931–2) 421–92; Wirth 1934, pp. 87–9, fig. 43, pl. 18

f. Tomb in Alexandria: A. Adriani, 'Ipogeo dipinto della Via Tigrane Pascià', *Bulletin de la Société Archéologique d'Alexandrie* 41 (1956) 63–86; idem, *Repertorio d'arte dell'Egitto greco-romano*, ser. C. (Palermo 1966), 145f., pls. 66, 67 (226–7), 72 (239); G. Grimm, *Die römischen Mumienmasken aus Ägypten* (Wiesbaden 1974), 115f., pls. 126–8; dating: Mielsch 1981, pp. 246, 262

g. House of the Painted Vaults: Felletti-Maj 1961 (see no. **2b** above), 11–17, figs. 6–7, pl. III; Mielsch 1981, pp. 215f.

h. Hadrian's Villa: Wirth 1929, pp. 134–40; Wirth 1934, pp. 64–77

i. Villa at Gadebridge: Davey and Ling 1982, pp. 117–19

j. Zliten villa: Aurigemma 1962, pp. 7–77; dating: Mielsch 1981, pp. 243f.; D. Parrish, 'The date of the mosaics from Zliten', *Antiquités africaines* 21 (1985) 137–58

5. Mythological subjects:

a. Houses of the Child Bacchus and of Jupiter and Ganymede: Calza, *art. cit.* (see no. **3c** above), 375–402

b. Green wall at Trier: *Trierer Zeitschrift* 18 (1949) 317f., pl. 4; R. Schindler, *Landesmuseum Trier: Führer durch die vorgeschichtliche und römische Abteilung* (Trier 1970), 76f., figs. 231–2

c. Echzell: D. Baatz, 'Wandmalereien aus einem Limeskastell', *Gymnasium* 75 (1968) 262–9; idem. 'Römische Wandmalereien aus dem Limeskastell Echzell Kr. Büdingen (Hessen)', *Germania* 46 (1968) 40–52

d. Proteus and Menelaus: H. Mielsch, 'Proteus und Menelaos. Ein antoninisches Gemälde in Ephesos', *ArchAnz* (1980), 550–3

e. Tomb at Tyre: M. Dunand and J. P. Rey-Coquais, 'Tombe peinte dans la campagne de Tyr', *Bulletin du musée de Beyrouth* 18 (1965) 5–51

f. Tomb at Masyaf: F. Chapouthier, 'Les peintures murales d'un hypogée funéraire près de Massyaf', *Syria* 31 (1954) 172–211

g. Tombs at Hermopolis: S. Gabra and É. Drioton, *Peintures à fresques et scènes peintes à Hermoupolis Ouest (Touna el-Gebel)* (Cairo 1954)

6. Non-mythological subjects:

a. Caseggiato degli Aurighi: J. E. Packer, *The Insulae of Imperial Ostia* (*MAAR* 31) (Rome 1971), 177–82, figs. 172–4, 184–5, 191; Mielsch 1981, p. 218, pl. XXI

b. Aquaria with fishermen: G. Jacopi, 'Scavi in prossimità del porto fluviale di S. Paolo, località Pietra Papa', *MonAnt* 39 (1943) 1–178

c. Seven sages: G. Calza, 'Die Taverne der sieben Weisen in Ostia', *Die Antike* 15 (1939) 99–115

d. Tombs at Palmyra: H. Ingholt, 'Quelques fresques récemment découvertes à Palmyre', *Acta archaeologica* 3 (1932) 1–20; C. H. Kraeling, 'Color photographs of the paintings in the Tomb of the Three Brothers at Palmyra', *Annales archéologiques de Syrie* 11–12 (1961–2) 13–18; M. A. R. Colledge, *The Art of Palmyra* (London 1976), 84–7, figs. 114–18

7. Stuccowork: Wadsworth 1924; Mielsch 1975a

8. Mosaics:

a. Antioch: D. Levi, *Antioch Mosaic Pavements* (Princeton 1947)

b. Italy: M. E. Blake, 'Roman mosaics of the second century in Italy', *MAAR* 13 (1936) 67–214; G. Becatti, *Mosaici e pavimenti marmorei* (*Scavi di Ostia* IV) (Rome 1961); J. R. Clarke, *Roman Black-and-White Figural Mosaics* (New York 1979); M. Donderer, *Die Chronologie der römischen Mosaiken in Venetien und Istrien bis zur Zeit der Antonine* (Berlin 1986)

c. Greece: G. Hellenkemper Salies, 'Römische Mosaiken in Griechenland', *Bonner Jahrbücher* 186 (1986) 241–84

d. Western provinces: *Recueil général des mosaïques de la Gaule* (Paris 1957–); K. Parlasca, *Die römischen Mosaiken in Deutschland* (Berlin 1959); V. von Gonzenbach, *Die römischen Mosaiken der Schweiz* (Basel 1961); *Corpus de mosaicos de España* (Madrid 1978–); D. S. Neal, *Roman Mosaics in Britain* (*Britannia* Monograph Series I) (London 1981); D. J. Smith, 'Roman mosaics in Britain: a synthesis', in R. Farioli Campanati (ed.), *III Colloquio internazionale sul mosaico antico Ravenna 6–10 settembre 1980* (Ravenna 1984), 357–80

e. North Africa: *Corpus des mosaïques de Tunisie* (Tunis 1973–); K. M. D. Dunbabin, *The Mosaics of Roman North Africa* (Oxford 1978)

f. Mosaics with supporting figures on the diagonals: L. Leschi, 'Mosaïque à scènes dionysiaques de Djemila-Cuicul (Algérie)', *MonPiot* 35 (1935–6) 139–72; Becatti, *op. cit.* (see no. **8b** above), 42–4 (no. 64), pls. CVII, CVIII (Ostia); Von Gonzenbach, *op. cit.* (see no. **8d** above), 43f., pl. 79 (Avenches); Parlasca, *op. cit.* (see no. **8d** above), 55f., pl. 53 (Trier); Dunbabin, *op. cit.* (see no. **8e** above), 139f., 264, pl. 138 (Lambiridi in Algeria); D. J. Smith, *The Roman Mosaics from Rudston, Brantingham and Horkstow* (Kingston upon Hull 1976), 25, pl. X (Horkstow in Britain)

9. The Late Empire (general): Dorigo 1971; J. Kollwitz, 'Die Malerei der konstantinischen Zeit', in *Akten des VII. Internationalen Kongresses für christliche Archäologie Trier 1965* (Vatican City and Berlin 1969), 29–158; Mielsch 1978; W. Tronzo, *The Via Latina Catacomb: Imitation and Discontinuity in Fourth-Century Roman Painting* (Pennsylvania and London 1986)

10. Domus Praeconum: Wirth 1934, pp. 125–9, pls. 29–31; M. Cagiano de Azevedo, 'Osservazioni sulle pitture di un edificio romano di Via dei Cerchi', *RendPontAcc* 23–4 (1947–9) 253–8; dating: Mielsch 1981, p. 228

11. Red and green linear style and its antecedents:

a. General: Wirth 1934, pp. 134–42, 166–83; L. De Bruyne,

'L'importanza degli scavi lateranensi per la cronologia delle prime pitture catacombali', *Rivista di archeologia cristiana* 44 (1968) 81–113; Mielsch 1975b, pp. 127–9; Mielsch 1981, pp. 225, 227, 229–31

b. Buildings under Lateran Basilica: De Bruyne, *art. cit.*, 81–92, figs. 1–7

c. Catacomb of Petrus and Marcellinus, chamber 69: J. G. Deckers, H. R. Seeliger and G. Mietke, *Die Katakombe 'Santi Marcellino e Pietro': Repertorium der Malerei* (Roma sotterranea cristiana VI) (Vatican City and Münster 1987), 324–9, pls. 49, 50

12. Tapetenmuster:

a. General: W. J. T. Peters, in *Berichten van de Rijksdienst voor het Oudheidkundig Bodemonderzoek* 15–16 (1965–6), 140–2; J. H. F. Bloemers, in J. S. Boersma, W. A. van Es, C. E. s'Jacob-Visser and others (eds.), *Festoen, opgedragen aan A. N. Zadoks Josephus Jitta* (Groningen 1976), 100–4; C. Allag, in *Gallia* 41 (1983), 193–200; R. J. Ling, in *Antiquaries Journal* 64 (1984), 293–5

b. Hölstein: B. Kapossy, *Römische Wandmalereien aus Münsingen und Hölstein* (Acta Bernensia IV) (Bern 1966), 30–1, 34–7, 41, fig. 10; Drack 1981, pp. 19f., figs. 4, 8, 11–12; Drack 1986, pp. 58f., figs. 43–5, pl. 12a

c. Bösingen: Drack 1986, pp. 59f., figs. 46–7, pl. 14b–c

d. Verulamium: Davey and Ling 1982, pp. 175–8, fig. 43, pl. LXXXVIII

e. Abila: C. Vibert-Guigue and A. Barbet, 'Tombeaux peints du nord de la Jordanie à l'époque romaine', *The Hashemite Kingdom of Jordan: Annual of the Department of Antiquities* (1982) 67–83

f. Vaults in S. Costanza and the Via Latina catacomb: Tronzo, *op. cit.* (see no. 9 above), p. 16, figs. 27, 28

g. Sabratha and Cyrenaica: G. Pesce, in *BdA* 36 (1951), 162–3, figs. 8–10

h. Ephesus: Strocka 1977, pp. 119, 120, figs. 280, 282, 285

i. Avenches: Drack 1981, p. 28, figs. 16, 21; M. Fuchs, 'Peintures murales romaines d'Avenches', in Barbet 1983, pp. 27–75; Drack 1986, pp. 60–2, figs. 48–9, pl. 14a

13. Imitation marbling:

a. General: Borda 1958, pp. 135–42; Mielsch 1978, pp. 163f., 201–3 (with bibl.)

b. Verulamium: Davey and Ling 1982, pp. 184–6, fig. 47, pl. XCII

c. House under Ss. Giovanni e Paolo: Mielsch 1978, pp. 158–64, pls. 81–3

d. Cenatorium at Ephesus: Strocka 1977, pp. 31–4, 36–8, pls. 2–17

14. Large-figure murals:

a. Sea-scene under SS. Giovanni e Paolo: Wirth 1934, pp. 80–2, pls. 13, 15; Borda 1958, p. 320; B. Andreae, *Studien zur römischen Grabkunst* (*RömMitt* Ergänzungsheft 9) (Heidelberg 1963), pp. 140–3, pls. 74, 76–7; interpretation: Mielsch 1975b, pp. 129–32

b. Chamber of the imperial cult at Luxor: J. G. Deckers, 'Die Wandmalerei des tetrarchischen Lagerheiligtums im Ammon-Tempel von Luxor', *Römische Quartalschrift* 68 (1973) 1–34; idem, 'Die Wandmalerei im Kaiserkultraum von Luxor', *JdI* 94 (1979) 600–52

c. Piazza Armerina: A. Carandini, A. Ricci and M. De Vos, *Filosofiana, the Villa of Piazza Armerina* (Palermo 1982); De Vos, in *La peinture romaine 1984*, pp. 27f.

15. Constantinian classicising phase:

a. General: Mielsch 1978, pp. 173–9

b. Frieze near Lateran Basilica: V. Santa Maria Scrinari, 'Per la storia e la topografia del Laterano', *BdA* 50 (1965) 38–44

c. Dea Barberini: M. Cagiano de Azevedo, 'La dea Barberini',

Rivista dell'Istituto Nazionale d'Archeologia e Storia dell'Arte new ser. 3 (1954) 108–46

d. Room under cathedral at Trier: W. Weber, *Constantinische Deckengemälde aus dem römischen Palast unter dem Dom* (Bischöfliches Dom- und Diözesanmuseum Trier Museumsführer 1) (Trier 1984); H. Brandenburg, 'Zur Deutung der Deckenbilder aus der Trierer Domgrabung', *Boreas* (Münstersche Beiträge zur Archäologie) 8 (1985) 143–89; E. Simon, *Die konstantinische Deckengemälde in Trier* (Mainz 1986)

16. Anti-classical tendencies in second half of 4th century:

a. General: Mielsch 1978, pp. 191–201

b. Lullingstone and Caerwent: Davey and Ling 1982, pp. 138–45, 211–12; J. E. A. Liversidge and F. Weatherhead, in G. W. Meates, *The Roman Villa at Lullingstone, Kent* II: *The Wall Paintings and Finds* (Maidstone 1987), 11–46

c. Perseus and Andromeda from Capitoline: H. Mielsch, in *Affreschi romani* (see no. 3b above), 53–7, pl. XXXIII

17. Third- and fourth-century floor-mosaics:

a. General: see no. 8 above

b. Piazza Armerina: Carandini, Ricci and De Vos, *op. cit.* (see no. 14c above); R. J. A. Wilson, 'Roman mosaics in Sicily: the African connection', *AJA* 86 (1982) 413–28

18. Wall- and vault-mosaics:

a. General: Sear 1977

b. Vatican tomb M: O. Perler, *Die Mosaiken der Juliergruft im Vatikan* (Freiburger Universitätsreden n.s. 16) (Freiburg 1953); Toynbee and Ward-Perkins, *op. cit.* (see no. 4a above), pp. 72–4, pl. 32

c. S. Costanza: H. Stern, 'Les mosaïques de l'église de Sainte-Constance à Rome', *Dumbarton Oaks Papers* 12 (1958) 157–218

d. Mausoleum at Centcelles: T. Hauschild and H. Schlunk, 'Vorbericht über die Arbeiten in Centcelles', *Madrider Mitteilungen* 2 (1961) 119–82

Chapter 10 Technique

1. General: P. Pratt, 'Wall painting', in D. Strong and D. Brown (eds.), *Roman Crafts* (London 1976), 223–9; Davey and Ling 1982, pp. 51–62; C. Allag, 'Les techniques de la peinture murale romaine', in *La peinture murale romaine de la Picardie à la Normandie* (exhibition catalogue, 1982–3), 17–30; P. Mora, L. Mora and P. Philippot, *Conservation of Wall Paintings* (London 1984), 89–101, pls. 50–67

2. Literary sources: Vitr. 7.2–4, 6–14; Pliny, *NH* 35.29–49; 36.176–7

3. Plastering:

a. General: R. Ling, 'Stuccowork', in Strong and Brown, *op. cit.*, 209–21

b. Preparation of wall: A. Barbet and C. Allag, 'Techniques de préparation des parois dans la peinture murale romaine', *MEFRA* 84 (1972) 935–1069

c. Coats of plaster: M. Cagiano de Azevedo, 'Il restauro degli affreschi della Casa di Livia', *BdA* 34 (1949) 145–9; idem, 'Affresco', *EAA* I (1958) 101; W. Klinkert, 'Bemerkungen zur Technik der pompejanischen Wanddekoration', *RömMitt* 64 (1957) 111–48 (reprinted in Curtius 1972, pp. 435–72)

d. Tools: Davey and Ling 1982, pp. 55f. (with references)

4. Painting techniques:

a. Encaustic: E. Schiavi, *Il sale della terra* (Verona 1961), 150–3

b. Tempera: S. Augusti, 'La tecnica dell'antica pittura parietale pompeiana', in A. Maiuri (ed.), *Pompeiana. Raccolta di studi per il secondo centenario degli scavi di Pompei* (Naples 1950), 313–54

c. Fresco: P. Mora, 'Proposte sulla tecnica della pittura murale romana', *Bollettino dell'Istituto Centrale del Restauro* (1967) 63–

84; cf. Cagiano de Azevedo 1949 (see no. **3c** above); U. Pappalardo, in *Antike Welt* 13 (1982), part 3, pp. 11–18

d. Combination of fresco and tempera: Klinkert, *art. cit.* (see no. **3c** above); cf. Davey and Ling 1982, pp. 57f.

e. Analyses: J. Plesters, 'Examination of Roman painted wall-plaster', *Wiltshire Archaeological Magazine* 58 (1961–3) 337–41 (Downton, Verulamium, Stanton Low); D. Baatz, in *Germania* 46 (1968), 42f. (Echzell); W. Noll, L. Born and R. Holm, 'Chemie, Phasenbestand und Fertigungstechnik von Wandmalereien des römischen Köln', *Kölner Jahrbuch für Vor- und Frühgeschichte* 13 (1972–3) 77–88; Drack 1986, pp. 82–6

5. Guidelines: Barbet and Allag, *art. cit.* (see no. **3b** above); cf. M. De Vos, in *MededRome* 39 (1977), 40, 42, figs. 55, 58

6. Sheen: Augusti, Mora, Klinkert, *artt. citt.* (see no. **4** above)

7. Inserted panels: A. Maiuri, 'Note su di un nuovo dipinto ercolanese', *BdA* 31 (1937–8) 481–9; idem, 'Picturae ligneis formis inclusae; note sulla tecnica della pittura campana', *RendLinc* 7th ser. 1 (1939) 138–60

8. Repairs and reuse: Barbet 1985, pp. 116–22; cf. M. Ruggiero, *Storia degli scavi di Ercolano* (Naples 1885), 340f.; A. Allroggen Bedel, in *Cronache ercolanesi* 13 (1983), 144f., fig. 6 (Herculaneum panels); M. and A. De Vos, *Pompei, Ercolano, Stabia* (Guide archeologiche Laterza) (Bari 1982), 116 (House of the Four Styles); Strocka 1984b, p. 39 note 77 (with references); E. M. Moormann, in *BABesch* 62 (1987), 158

9. Pigments: M. Frizot, 'L'analyse des pigments de peintures murales antiques. État de la question et bibliographie', *Revue d'archéometrie* 6 (1982) 47–59; cf. S. Augusti, *I colori pompeiani* (Rome 1967); Plesters and Noll *et al.*, *artt. citt.* (see no. **4e** above); Drack 1986, *loc. cit.* (see no. **4e** above); K. Würth, 'Zur Technik der Wandmalereien', in F. Fremersdorf, *Der römische Gutshof Köln-Müngersdorf* (Berlin and Leipzig 1933), 61–4; Davey and Ling 1982, pp. 61–2, 220–2; F. Delamare and others, 'Étude physico-chimique des couches picturales des peintures murales romaines de l'acropole de Léro', *Revue d'archéometrie* 6 (1982) 71–86

10. Gold leaf: A. Barbet and C. Lahanier, 'L'emploi de la feuille d'or dans la peinture murale romaine', in *Les méthodes physico-chimiques d'analyse des œuvres d'art (tableaux, icônes, peintures murales) (Journées d'études de l'Association Francohellénique pour la Coopération Scientifique et Technique)* (Athens 1983), 260–76

11. Painters' equipment: Davey and Ling 1982, pp. 6of.

Chapter 11 Painters and patrons

1. Painters:

a. General: J. M. C. Toynbee, *Some Notes on Artists in the Roman World* (Brussels 1951), 35–50; A. Burford, *Craftsmen in Greek and Roman Society* (London 1972)

b. Literary sources: Overbeck, *op. cit.* (see Chap. 1, no. 2 above), 460–6, nos. 2372–99; cf. Vessberg and Pollitt, *opp. citt.* (see Chap. 1, no. **8b** above); H. Eristov, 'Peinture romaine et textes antiques: informations et ambiguités. A propos du "Recueil Milliet"', *RevArch* (1987) 109–23

c. Greek labels: B. Neutsch, 'Das Epigrammenzimmer in der "Casa degli Epigrammi" zu Pompeji und sein Wandbild "Eros im Ringkampf mit Pan"', *JdI* 70 (1955) 155–84; Gallina, *op. cit.* (see Chap. 6, no. **4** above), 22–8; cf. F. Matz, in *BullInst* (1869), 240

d. Signatures: Spinazzola 1953, p. 404, fig. 60 (Lucius); Bragantini and De Vos 1982, 22, fig. 1 (Seleukos); H. Eristov, *art. cit.* (see no. **1b** above), 112f.; add: A. Mau, in *BullInst* 49 (1877), 30 (? A. Syncletus); L. Correra, in *BullComm* (1894), 256 (no. 150), 257 (no. 155) (Zozzo, Fortunatus Afer); R. Egger, in *Carinthia*

I 153 (1963), 111, no. 110, figs. 45, 61 (Cosmus)

e. Epitaphs: A. Giuliano, 'Iscrizioni romane di pittori', *Archeologia classica* 5 (1953) 263–70

2. Social status and payments:

a. General: G. Becatti, *Arte e gusto negli scrittori romani* (Florence 1951), 31–41; I. Calabi-Limentani, *Studi sulla società romana: il lavoro artistico* (Milan 1958); Burford, *op. cit.* (see no. **1a** above)

b. Diocletian's Edict: H. Blümner, *Der Maximaltarif des Diokletians* (Berlin 1893); T. Frank, *An Economic Survey of Ancient Rome* v (Baltimore 1940), 305–421

c. Theophilos: M. Nowicka, 'Théophilos, peintre alexandrin, et son activité', in N. Bonacasa and A. Di Vita (eds.), *Alessandria e il mondo ellenistico-romano: studi in onore di Achille Adriani* (Rome 1984), 256–9

3. Travelling artists:

a. General: see Toynbee, *op. cit.* (see no. **1a** above); cf. C. Roueché and K. Erim, 'Sculptors from Aphrodisias; some new inscriptions', *PBSR* 50 (1982) 102–15

b. Painters: G. Calza, *La necropoli del porto di Roma nell'Isola Sacra* (Rome 1940), 268, 285f. (Annaeus Atticus); Nowicka, *art. cit.* (see no. **2c** above) (painter from Alexandria)

c. Metropolitan artists in the Pompeii area: suggested by Blanckenhagen and Alexander 1962, pp. 52–61; A. Allroggen Bedel, *Maskendarstellungen in der römisch-kampanischen Wandmalerei* (Munich 1974), 18–23

4. Workshops:

a. General: F. G. Andersen, 'Pompeian painting. Some practical aspects of creation', *Analecta Romana Instituti Danici* 14 (1985) 113–28

b. Local styles: A. Allroggen Bedel, 'Zur Eigenart der herkulanischen Wandmalerei', paper given to XI International Congress of Classical Archaeology, London, 3–9 September 1978

c. Sens relief: E. Espérandieu, *Recueil général des bas-reliefs, statues et bustes de la Gaule romaine* iv (Paris 1911), 1of., no. 2767; A. M. Uffler, 'Fresquistes gallo-romains, le bas-relief du Musée de Sens', *Revue archéologique de l'Est et du Centre-Est* 22 (1971) 393–401

d. Platonia graffito: A. De Waal, in *DissPontAcc* 2nd ser. 4 (1892), 150f.; O. Marucchi, in *NotScav* (1892), 93f.

e. House of the Iliadic Shrine: Strocka 1984a, pp. 125–40

f. Palatine and Farnesina workshop: Bragantini and De Vos 1982, pp. 3of.

g. Pompeian workshops: H. G. Beyen, 'The workshops of the Fourth Style at Pompeii and in its neighbourhood', *Mnemosyne* 4th ser. 4 (1951) 235–57 (reprinted in *Studia archaeologica Gerardo van Hoorn oblata* (Leiden 1951), 43–65); W. J. T. Peters, 'La composizione delle pareti dipinte nella Casa dei Vetti a Pompei', *MededRome* 39 (1977) 95–128; M. De Vos, 'Le bottega di pittori di via di Castricio', in *Pompei 1748–1980*, pp. 119–30

h. Individual hands: L. Richardson, *Pompeii: the Casa dei Dioscuri and its Painters* (MAAR 23) (Rome 1955); cf. Lehmann 1953, pp. 166–72

5. Patron–painter relationships:

a. Contracts: W. W. Buckland, *A Textbook of Roman Law* (3rd edn, 1963), 503–6

b. Provision of pigments: Vitr. 7.5.8; Pliny, *NH* 35.30

c. Estimates: C. C. Edgar, *Zenon Papyri* (Catalogue général des antiquités égyptiennes du musée du Caire) III (Cairo 1928), 170–2, no. 59,445; IV (Cairo 1931), 191–3, no. 59,763; cf. É. Vanderborght, 'La maison de Diotimos, à Philadelphie', *Chronique d'Égypte* 17 (1942) 117–26; Nowicka, *art. cit.* (see no. **2c** above)

d. Specifications for mosaic: Edgar, *op. cit.* IV, pp. 102–4, no.

59,665; cf. W. A. Daszewski, 'Some problems of early mosaics from Egypt', in H. Machler and V. M. Strocka (eds.), *Das ptolemäische Ägypten* (Mainz 1978), 123–36; idem, *Corpus of Mosaics from Egypt* 1: *Hellenistic and Early Roman Period* (Mainz 1985), 6–14

e. **Pattern-books**: Robertson, *History of Greek Art* (see Chap. 1, no. 1 above), 574f.; Pliny, *NH* 35.68 (Parrhasius); K. M. D. Dunbabin, 'The triumph of Dionysus on mosaics in North Africa', *PBSR* 39 (1971) 52–65 (North African mosaics); Quintilian, *Institutio Oratoria* 10.2.6 (drawings of pictures); Pliny, *NH* 35.11 (Varro's book-illustrations); S. Charitonidis, L. Kahil and R. Ginouvès, *Les mosaïques de la Maison du Ménandre à Mytilène* (*Antike Kunst* suppl. 6) (Bern 1970); Andersen, *art. cit.* (see no. **4a** above), 119–26. Against: P. Bruneau, 'Les mosaïstes antiques: avaient-ils des cahiers de modèles?', *RevArch* (1984) 241–72

f. **Effects of patronage upon form and content**: V. M. Strocka, 'Pompejanische Nebenzimmer', in Andreae and Kyrieleis 1975, pp. 101–14; E. Winsor Leach, 'Patrons, painters, and patterns: the anonymity of Romano-Campanian painting and the transition from the Second to the Third Style', in B.K. Gold (ed.), *Literary and Artistic Patronage in Ancient Rome* (Austin 1982), 135–73; Bragantini and Parise Badoni 1984; Strocka 1984b, pp. 45–50; A. F. Wallace-Hadrill, 'The social structure of the Roman house', *PBSR* 56 (1988) 43–97; idem, 'Houses, wealth and culture in Pompeii', forthcoming

g. **Copying and repetition**: Engemann 1967, pp. 134–8; Ehrhardt 1987, pp. 133–48

Epilogue

1. **Influence on the Renaissance**: J. Schulz, 'Pinturicchio and the revival of antiquity', *Journal of the Warburg and Courtauld Institutes* 25 (1962) 35–55; Dacos, *La découverte de la Domus Aurea* (see Chap. 5, no. **5d** above); eadem, *Le logge di Raffaello: maestro e bottega di fronte all'antico* (Rome 1977)

2. **Influence of Pompeii**:

a. **General**: E. C. Corti, *The Destruction and Resurrection of Pompeii and Herculaneum* (London 1951); P. Werner, *Pompeji und die Wanddekoration der Goethe-Zeit* (Munich 1970); P. Grimal, 'Herculaneum und Pompeji und das Nachleben der antiken Kultur im 18. Jahrhundert', in *Pompeji: Leben und Kunst in den Vesuvstädten* (exhibition catalogue, Essen 1973), 218–23; W. Vollrath, 'Pompeji und die Deutschen', *ibid.*, pp. 224–64

b. **Individual works**: M.-C. Dejean de la Batie, 'La maison pompéienne du Prince Napoléon Avenue Montaigne', *Gazette des beaux arts* 87 (1976) 127–34; H. Wille, 'Wer kauft Leibesgötter?', *Niederdeutsche Beiträge zur Kunstgeschichte* 11 (1972) 157–90 (Seller of Cupids); D. Honisch, *Anton Rafael Mengs* (Recklinghausen 1965), 89, no. 86 (Jupiter and Ganymede); G. Wildenstein, *Ingres*, (2nd edn, London 1956), 222, no. 280, pl. 112 (portrait); A. Blunt, 'Picasso's classical period (1917–25)', *Burlington Magazine* 110 (1968) 187–91; S. Munn, 'Up Pompeii', *Australian Mode* (September 1988) 109–13 (house in Sydney).

SOURCES OF ILLUSTRATIONS

DAI = Deutsches Archäologisches Institut DAIR = Deutsches Archäologisches Institut, Römische Abteilung
ICCD = Istituto Centrale per il Catalogo e la Documentazione, Rome

39. Archaeological Institute, University of Leiden
40. Anderson 2936
41. Istituto Centrale per il Restauro, Rome 2430
42. R. J. Ling 33/12A
43. Soprintendenza Archeologica, Pompeii C 832
44. DAIR 82.2164
45. Drawing L. A. Ling, after G. Carettoni, *Das Haus des Augustus auf dem Palatin* (1983), fig. 16
46. Anderson 2519
47. A. Barbet 79/92/3
48. Soprintendenza Archeologica, Pompeii C 1103
49. R. J. Ling 35/3A
50. Catholic University, Nijmegen (P. Bersch and H. van de Sluis)
51. Anderson 26435
52. DAIR 56.1223
53. Mau 1882, pl. VIII
54. Metropolitan Museum of Art, New York 241553 B
55. DAIR 59.1972
56. DAI Berlin (P. Grunwald) 83.3.557
57. F. and F. Niccolini, *Le case ed i monumenti di Pompei* (1854–96), IV, part 2, pl. X
58. DAIR 66.1783
59. Mau 1882, pl. XIV
60. Drawing in German Archaeological Institute, Rome: DAIR 70.1472
61. DAIR 64.2249
62. R. J. Ling 5/33
63. Drawing L. A. Ling, after A. Barbet
64. A. Barbet 76/57/10
65. A. Barbet 80/42/10
66. DAIR 76.3
67. DAIR 64.2260
68. Drawing L. A. Ling, after A. Barbet
69. Drawing R. J. Ling, after A. Barbet
70. DAIR 64.2314
71. Soprintendenza Archeologica, Pompeii C 231
72. F. P. M. Francissen
73. Catholic University, Nijmegen (P. Bersch and R. Gras)
74. ICCD N 37017
75. A. Suzuki
76. DAI Berlin (P. Grunwald) 75.3.189
77. N. Ponce, *Description des Bains de Titus* (1786), pl. 25
78. Fototeca Unione (American Academy in Rome) 3295 F
79. Alinari 11982
80. Anderson 24874
81. Anderson 26468
82. DAIR 32.1689
83. Anderson 26396 = DAIR W 366
84. Alinari 43165
85. DAIR 56.1256
86. DAIR 56.1209
87. DAIR 38.572
88. Brogi 6534
89. R. J. Ling 70/26
90. DAIR 59.2019
91. Soprintendenza Archeologica, Rome (Forum and Palatine) C 471
92. Soprintendenza Archeologica, Rome (Forum and Palatine) C 467
93. DAIR 64.2291
94. ICCD E 54520
95. N. Ponce, *Description des Bains de Titus* (1786), pl. 5
96. Drawing J.-P. Adam
97. DAIR 56.1277
98. ICCD E 57501
99. Fototeca Unione (American Academy in Rome) 329 F
100. R. J. Ling 6/33
101. DAIR 72.1712
102. DAIR 71.490
103. A. Barbet 77/66/8
104. E. Hyman and P. Chorley
105. W. Swaan
106. Metropolitan Museum of Art, New York 163405 B
107. Metropolitan Museum of Art, New York 152359 B
108. Alinari 38033
109. Alinari 38031
110. Alinari 38030
111. Alinari 38032
112. Parker 3309, courtesy British School at Rome
113. Drawing by A. Sikkard: DAIR 61.299
114. Anderson 28840
115. Metropolitan Museum of Art, New York 242251 B
116. DAIR 66.1791
117. DAIR 64.2251
118. Drawing by G. Discanno: DAIR 53.507
119. DAIR 62.1478
120. British Museum I B 33
121. DAIR 58.1205
122. Anderson 23439
123. Alinari 12011
124. Anderson 23474
125. R. J. Ling 45/11
126. Anderson 23468
127. Alinari 12003
128. Anderson 23477
129. DAIR 35.1887
130. DAIR 31.2768
131. Alinari 43179
132. Brogi 6546
133. Brogi 6559
134. Anderson 23464
135. DAIR 68.272
136. R. J. Ling 45/3
137. Anderson 23409
138. Brogi 6536
139. Alinari 12021
140. Anderson 23453
141. Alinari 12023
142. British Museum IX D 42
143. Anderson 23475
144. Anderson 23634
145. Brogi 11289
146. DAIR 35.1886
147. DAIR 62.1477
148. Catholic University, Nijmegen (P. Bersch and H. van de Sluis)
149. ICCD N 47964
150. ICCD E 48635
151. Anderson 40809
152. Metropolitan Museum of Art, New York 241546 B
153. DAIR 59.1992
154. Soprintendenza Archeologica, Naples A 6303
155. Anderson 26723
156. ICCD E 54464
157. DAI Berlin (P. Grunwald) RM 88
158. Anderson 40855
159. Archaeological Institute, University of Leiden

160. E. Presuhn, *Pompeji. Die neuesten Ausgrabungen von 1874 bis 1878* (2nd edn, 1882), part 3, pl. VI: DAIR W 66
161. Drawing by A. Mauri: DAIR 73.2392
162. DAIR 60.2387
163. R. J. Ling 83/20A
164. Anderson 40814
165. DAI Berlin (P. Grunwald)
166. DAIR 56.1202
167. Soprintendenza Archeologica, Naples A 13509
168. DAIR 56.465
169. L. von Matt
170. Soprintendenza Archeologica, Naples A 2819
171. Alinari 1935
172. R. J. Ling 83/11A
173. Anderson 23415
174. Soprintendenza Archeologica, Naples
175. Soprintendenza Archeologica, Naples A 4913
176. Soprintendenza Archeologica, Naples
177. Soprintendenza Archeologica, Naples C 364
178. Brogi 11307
179. Alinari 12142a
180. Soprintendenza Archeologica, Milan D 2354
181. Y. Yadin
182. Landesmuseum, Kärnten (U. P. Schwarz)
183. R. Bersier, Fribourg
184. M. and R. Sabrié
185. A. Barbet 81/22/5
186. Rheinisches Bildarchiv 147766
187. Rheinisches Bildarchiv 143760
188. L. Abad Casal
189. *RömMitt* 34 (1919), pl. I top
190. Ripartizione X del Comune di Roma (Antiquarium Comunale)
191. ICCD E 40949
192. ICCD E 40696
193. Austrian Archaeological Institute, Vienna
194. DAIR 81.3028
195. Drawing R. J. Ling, after E. and G. Paparatti
196. Fototeca Unione (American Academy in Rome) 6182 F
197. DAIR 61.1847
198. A. Barbet 81/18/10
199. Direction Générale des Antiquités, Lebanon
200. DAI Cairo F 6865/66
201. Fototeca Unione (American Academy in Rome) 5965 F
202. Centre Camille Jullian, University of Provence, CNRS (G. Réveillac) 48.795
203. Istituto Centrale per il Restauro 740
204. Pontificia Commissione di Archeologia Sacra Lat. D 16
205. Pontificia Commissione di Archeologia Sacra Seb. L 14
206. Pontificia Commissione di Archeologia Sacra Lau E 40
207. Service Archéologique de Fribourg
208. C. Vibert-Guigue
209. DAIR 61.2166
210. Musée Romain, Avenches (M. Fuchs)
211. Austrian Archaeological Institute, Vienna
212. DAIR 31.2896
213. Istituto Centrale per il Restauro 5732
214. DAIR 77.113
215. Fototeca Unione (American Academy in Rome) 5235 F
216. A. Barbet
217. R. J. Ling 73/14A
218. Drawing R. J. Ling, after L. Jacobi, *Das Römerkastell Saalburg* (1897)
219. H. Blümner, *Technologie und Terminologie der Gewerbe und Künste bei Griechen und Römern* III (1884), fig. 23
220. Drawing R. J. Ling, after *BdA* 34 (1949), 149, fig. 8
221. S. Gregory
222. C. Allag
223. C. Allag
224. DAI Berlin (P. Grunwald) 82.2.136
225. R. J. Ling 79/6
226. A. Barbet 84/27/1
227. ICCD N 45285
228. DAIR 64.2300
229. ICCD N 61120
230. Drawing R. J. Ling, after Ritter
231. Museum für Vor- und Frühgeschichte, Frankfurt
232. Soprintendenza Archeologica, Naples C 413
233. DAIR 74.1227
234. Drawing J.-P. Adam
235. Soprintendenza Archeologica, Naples 5027, ex 1195
236. E. de Maré

INDEX

Place-names (other than well known ones) for which no country is given are in Italy.

This book is the first general history of Roman painting written specifically for English-language readers. A large number of wall-paintings have survived from the Roman world, and particularly from Rome itself and from the cities of Pompeii, Herculaneum and Stabiae, buried in the eruption of Mount Vesuvius in A.D. 79; they include examples of elaborate decorative schemes as well as mythological pictures, landscapes, still lifes, and scenes from everyday life. Their influence upon European artists of the Renaissance and Neo-Classical periods has been considerable. Recent research has provided a much clearer idea of the chronology of these paintings, of their sources of inspiration, and of their meaning to the various classes of patrons who commissioned them. Now for the first time all aspects of our knowledge are brought together in an up-to-date survey. Among other topics the book discusses the so-called Four Pompeian Styles, their spread to the provinces, the broad developments in scheme, style and subject-matter which followed them, the relation of mythological pictures to Greek 'old' masters, the factors which dictated the choice of particular subjects and the way in which they were represented, the technical processes of ancient wall-painting, and what we know about the painters and the organisation of their workshops.